The Splendor of Ruins

in French Landscape Painting

1630–1800

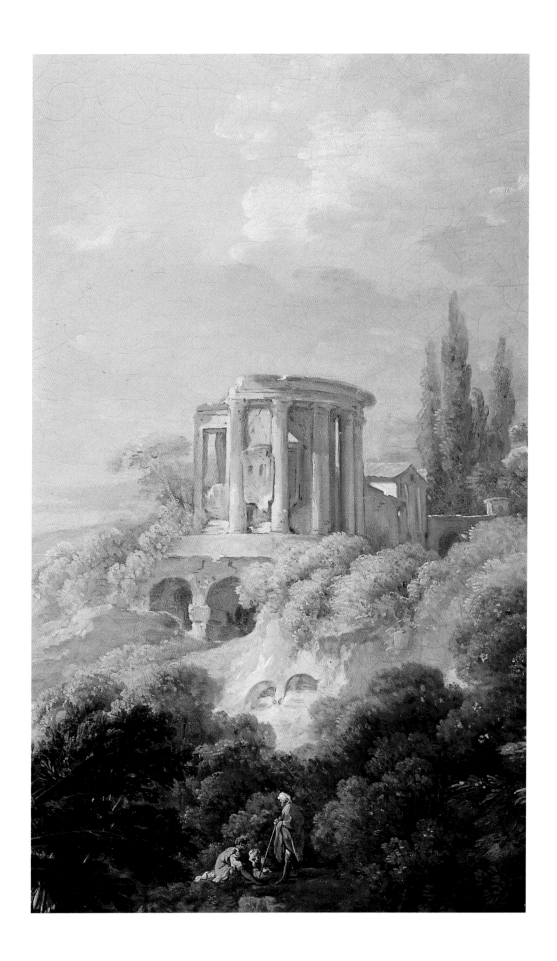

The Splendor of Ruins

in French Landscape Painting

1630–1800

STEPHEN D. BORYS

*with the assistance of students
in the Art History Department
at Oberlin College*

Essays by

T. BARTON THURBER
ALAN WINTERMUTE
STEPHEN D. BORYS

ALLEN MEMORIAL ART MUSEUM
OBERLIN COLLEGE, OHIO

For Hazel and Roman
con moltissimo affetto

Published in conjunction with the exhibition *The Splendor of Ruins in French Landscape Painting, 1630–1800*, curated and organized by Stephen D. Borys and circulated by the Allen Memorial Art Museum, Oberlin College, Ohio

The Allen Memorial Art Museum
19 March–19 June 2005

The Museum of Fine Arts, Houston
17 July–16 October 2005

The exhibition and catalogue were made possible by the generous support of the National Endowment for the Arts through the Access to Artistic Excellence program, the Samuel H. Kress Foundation through the Old Masters in Context program, the Ohio Humanities Council, and the Ohio Arts Council. Special thanks also to John N. Stern and the Friends of the Allen Memorial Art Museum.

NATIONAL
ENDOWMENT
FOR THE ARTS

Ohio Humanities Council

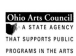
Ohio Arts Council
A STATE AGENCY
THAT SUPPORTS PUBLIC
PROGRAMS IN THE ARTS

LIBRARY OF CONGRESS CATALOGING-IN-PUBLICATION DATA

Borys, Stephen D. (Stephen Donald)
 The splendor of ruins in French landscape painting, 1630–1800 / catalogue by Stephen D. Borys ; with the assistance of students in the Art History Department at Oberlin College ; essays by T. Barton Thurber, Alan P. Wintermute, Stephen D. Borys.
 p. cm.
 Catalogue of an exhibition at the Allen Memorial Art Museum, 19 March–19 June 2005 and at the Museum of Fine Arts, Houston, 17 July–16 October 2005.
 Includes bibliographical references and index.
 ISBN 0-942946-04-9
 1. Architecture in art—Exhibitions. 2. Ruins in art—Exhibitions.
3. Landscape painting, French—17th century—Exhibitions.
4. Landscape painting, French—18th century—Exhibitions.
I. Allen Memorial Art Museum. II. Museum of Fine Arts, Houston. III. Title.
 ND1412.F73B67 2005
 758'.1'094407477123—dc22 2005004103

FRONTISPIECE: François Boucher, *Landscape with a Water Mill* (detail), 1740. See also cat. no. 4, page 62.

CONTENTS

LENDERS TO THE EXHIBITION

The Agnes Etherington Art Centre,
Queen's University, Kingston, Ontario

The Allen Memorial Art Museum,
Oberlin College, Oberlin, Ohio

The Art Gallery of Ontario, Toronto, Ontario

The Chrysler Museum of Art, Norfolk, Virginia

The Cleveland Museum of Art, Cleveland, Ohio

The Dayton Art Institute, Dayton, Ohio

The Frances Lehman Loeb Art Center,
Vassar College, Poughkeepsie, New York

The Hood Museum of Art, Dartmouth College,
Hanover, New Hampshire

The Indianapolis Museum of Art,
Indianapolis, Indiana

The J. B. Speed Art Museum, Louisville, Kentucky

The Memorial Art Gallery, University of Rochester,
Rochester, New York

The Metropolitan Museum of Art, New York

The Minneapolis Institute of Arts,
Minneapolis, Minnesota

The Montréal Museum of Fine Arts, Montréal, Québec

The Museum of Fine Arts, Boston, Massachusetts

The National Gallery of Art, Washington, DC

The Nelson-Atkins Museum of Art,
Kansas City, Missouri

The North Carolina Museum of Art,
Raleigh, North Carolina

The Smith College Museum of Art,
Northampton, Massachusetts

The Snite Museum of Art, University of Notre Dame,
Notre Dame, Indiana

The Spencer Museum of Art,
University of Kansas, Lawrence, Kansas

The St. Louis Art Museum, St. Louis, Missouri

The Toledo Museum of Art, Toledo, Ohio

The Worcester Art Museum, Worcester, Massachusetts

FOREWORD

It is a wonderful opportunity for the Allen Memorial Art Museum to host *The Splendor of Ruins in French Landscape Painting, 1630–1800* and to bring together this lively and beautiful group of paintings by eighteen French artists. The antique as a source of endless inspiration was codified in the seventeenth century by a number of artists, including Nicolas Poussin and Claude Lorrain. The beauty and variety of Claude's delicately observed compositions and his poetic response to antiquity to some extent provide a touchstone for all of the later paintings in the present exhibition.

Early French landscapes were both a source of artistic inspiration and an indicator of how the study of antiquity became a critical component of the program of the Académie royale. The founding of the Académie de France in Rome in 1666 offered young artists the opportunity to study abroad and to experience firsthand the monuments of Rome, the paintings of Italian Renaissance and Baroque masters, and classical sculpture. Rome, not surprisingly, was the most frequent focus of artists' studies abroad throughout the seventeenth and eighteenth centuries.

The thirty-six paintings on view here, borrowed from twenty-four museums across the United States and Canada, make it clear how these artists understood that antiquity could be used as a source of inspiration for the present. The exhibition provides a snapshot of their visual responsiveness to the architecture and ruins around them and their inventiveness in incorporating these within poetic landscape settings. Whether based on studies made firsthand in Italy or on other artists' interpretations of classical antiquity, these landscapes captured the imagination of a broad and diverse group of patrons in seventeenth- and eighteenth-century France.

The Splendor of Ruins has been three years in the making. Conceived of and organized by Stephen D. Borys, Curator of Western Art at the Allen, the show has provided an excellent opportunity for Oberlin students to participate in almost all phases of the exhibition planning and catalogue development. Two art history seminars, taught by Dr. Borys in 2004 and 2005, focused on the topic of this exhibition, and students from the first seminar assisted with the research and preparation of the catalogue entries published here.

Following its opening at the Allen, the exhibition will travel to the Museum of Fine Arts, Houston. The show and accompanying catalogue could not have become a reality without generous financial support from a variety of foundations and individuals. We are grateful to the National Endowment for the Arts, the Samuel H. Kress Foundation, the Ohio Humanities Council, and the Ohio Arts Council. We are especially indebted to John N. Stern (Oberlin College 1939), a loyal and generous donor to the Allen, who enthusiastically supported the exhibition from its inception. We are very grateful to him, as we are to the Friends of the Allen Memorial Art Museum for their continued support.

STEPHANIE WILES
John G. W. Cowles Director
Allen Memorial Art Museum
Oberlin College
Oberlin, Ohio

ACKNOWLEDGMENTS

M Y FIRST EXPRESSION OF GRATITUDE is to the lenders to the exhibition—the twenty-four institutions in the United States and Canada who graciously consented to part with their paintings for the exhibitions in Oberlin and Houston. The owners of the works and their custodians—directors, curators, registrars, and curatorial assistants—all rank as co-organizers by virtue of their extraordinary level of participation. I thank particularly the National Gallery of Art, Washington, DC, and the Art Gallery of Ontario, Toronto, for their generous loans. I would also like to extend my appreciation to Edgar Peters Bowron, Audrey Jones Beck Curator of European Art at the Museum of Fine Arts, Houston, for his enthusiasm and efforts in bringing the exhibition to Houston.

I am grateful to Stephanie Wiles, John G. W. Cowles Director of the Allen Memorial Art Museum, for her commitment to this exhibition since her arrival at the AMAM in the summer of 2004. Dr. Wiles took on the role of general editor for the catalogue and lent her expertise as curator and scholar to the many facets of the catalogue and exhibition preparation. A special debt is owed to Lucille Stiger for her tireless efforts as registrar working with the lenders and overseeing the loans to Oberlin and Houston; to Sara Hallberg, Curator of Education, and her students for organizing the educational and musical programs for the exhibition; and to Laura Winters, who handled with efficiency so many of the administrative tasks and challenges. I would also like to thank other members of the museum staff: Leslie Miller, Jian Sakakeeny, Michael Holubar, Stephen Fixx, Loren Fawcett, the security officers, and the student docents and volunteers. Barbara Prior and Paula Baymiller in the Clarence Ward Art Library at Oberlin College were most helpful with my catalogue research. I express my appreciation as well to Sharon Patton, former Director of the AMAM, who supported the purchase of Pierre-Antoine Patel's *Landscape with Classical Ruins and Figures* in 2002 and endorsed my exhibition proposal following the acquisition, and to Katherine Solender, who offered her assistance and guidance during her tenure as Acting Director. The successful realization of this exhibition depended heavily on the participation of these individuals, and I thank them all for their help and enthusiasm.

This catalogue is a collaboration that drew on the research of many of my students in the Art History Department at Oberlin College, and to them I offer my sincere thanks. First, I am grateful to Alexander Grogan, my curatorial assistant for the last two years, for handling my countless requests with intelligence and perseverance. Aside from his general research and administrative duties, Mr. Grogan wrote four of the entries for the catalogue (cat. nos. 8, 9, 34, 35), edited many of the artist biographies, and produced outstanding new photography of several of the Roman ruins illustrated in the catalogue. He is also responsible for organizing the exhibition *Surveying the Ruin: The Architectural Landscape on Paper*, which is presented concurrently with the paintings exhibition at the AMAM. Students Peter Bell, Catherine Zondervan, and Susanna Newbury spent many hours carrying out research and handling administrative tasks. In addition to writing the Millet entry and researching the Dughet entry, Mr. Bell oversaw the editing of the bibliography and the provenance and exhibition histories for the works; Ms. Zondervan assisted with provenance queries and reproduction rights requests; and Ms. Newbury prepared drafts of the biographies for Coypel, Lajoüe, Pater, and Vouet and helped with the final edit of the bibliography. Thomas Treadway and Mitali Routh assisted with the preparation of curatorial files and loan letters in the early planning stages of the exhibition project.

Twelve Oberlin students participated in my spring 2004 seminar and assisted with the research and preparation of the catalogue entries: Erin Allen (cat. nos. 20, 28), Peter Bell (cat. nos. 17, 22), Krista Egger (cat. nos.

5, 26), Julia Fritz (cat. nos. 1, 12), Alexander Grogan (cat. nos. 8, 9, 34, 35), Matthew Josephson (cat. nos. 29, 31, 32), Elizabeth Keegstra (cat. no. 4), Margaret Miles (cat. nos. 2, 3), Matthew Mutel (cat. nos. 33, 36), Elissa Papendick (cat. nos. 11, 30), Steven Weintraub (cat. nos. 13, 14), and Catherine Zondervan (cat. nos. 18, 19).

My gratitude goes to the distinguished authors who have written erudite and illuminating essays for the catalogue: T. Barton Thurber, Curator of European Art, Hood Museum of Art, Dartmouth College, and Alan Wintermute, Director, Artemis Fine Art, Inc., New York. I should also like to thank those scholars who participated in the exhibition lecture series—Edgar Peters Bowron, Claire Lyons, and T. Barton Thurber—and members of the Oberlin College faculty who delivered papers at the *Splendor of Ruins* symposium: William Hood, Susan Kane, Jennifer Hirsh, Leonard Smith, and Benjamin Lee, along with students Alexander Grogan, Joshua Castano, and Joshua Neckes. Mr. Castano also organized the exhibition *Books for the Grand Tour: Archaeology, Architecture, and the Dilettante*, presented in the Clarence Ward Art Library.

Space does not permit the listing of all the colleagues who responded so swiftly and helpfully to my loan requests and research queries; however, the largesse of several individuals must be noted: Louis Adrean, Ronni Baer, Colin Bailey, Sylvain Bellenger, Janet Brooke, Andrew Caputo, Ruth Cloudman, Guy Cogeval, Philip Conisbee, Christina Corsiglia, Susan Earle, Suzanna Fabing, Everett Fahy, David Franklin, Hilliard Goldfarb, Anne Halpern, Jefferson Harrison, William Hood, Ronda Kasl, Ian Kennedy, Michael Komanecky, Judith Mann, J. Patrice Marandel, Linda Muehlig, Lawrence Nichols, Patrick Noon, Nancy Norwood, Michael Pantazzi, Joel Smith, Stephen Spiro, Matthew Teitelbaum, Patricia Teter, Charles Venable, James Welu, Lawrence Wheeler, Patricia Whitesides, and David de Witte.

Specials thanks go to Christine Taylor and the staff at Wilsted & Taylor Publishing Services for their role in producing such a beautiful catalogue. The approachable layout and elegant design are due in large part to the excellent work of copyeditor Rachel Bernstein and designer Melissa Ehn. I am extremely grateful to Steven Brooke, who kindly provided me with prints of the original photographs from his celebrated *Views of Rome* for reproduction in the catalogue. The distinguished classical architect Susan Henderson was also truly generous with her time and insightful comments.

This exhibition would not have been possible without the support of research and exhibition grants from the National Endowment for the Arts through the Access to Artistic Excellence program, the Samuel H. Kress Foundation through the Old Masters in Context program, the Ohio Humanities Council, and the Ohio Arts Council. Special thanks to Pamela Snyder and Susan Morse in Sponsored Programs at Oberlin College for their untiring efforts in preparing these grant applications.

I also would like to extend a special tribute to John N. Stern, a great friend and patron of the AMAM, who made a generous contribution toward the costs of the exhibition and catalogue and has taken a special interest in my curatorial work at the museum. The exhibition is presented in the gallery named in his honor.

My greatest debt is to my wife, Hazel Mouzon Borys, who has spurred me on in this endeavor, and whose enthusiasm for both the exhibition and the catalogue have inspired me throughout the project. What I owe to her is far more than can be adequately conveyed in these acknowledgments. And to our son, Roman Mikhail, who arrived the week *before* my manuscript was due—thank you.

STEPHEN D. BORYS
Curator of Western Art
Allen Memorial Art Museum
Oberlin College
Oberlin, Ohio

PREFACE

THE HIGH REGARD for landscape painting at Oberlin is long-standing—both in its place within the museum and in the teaching of art history. Reflecting on the death of one of the Allen Memorial Art Museum's greatest patrons, R. T. Miller, Jr. (1867–1958), the distinguished art historian Wolfgang Stechow wrote in a special issue of the AMAM *Bulletin* in 1958: "What would it be like to teach the history of art in Oberlin if Mr. Miller had not been with us? It is hard to imagine, perhaps harder for this writer than for many others because he had been lucky enough to have some good original works of art at his disposal wherever he taught before coming to Oberlin, and arrived at Oberlin when the first Miller gifts were being made."

Shortly before his death in 1974, Stechow completed an article on landscape painting for a special issue of *Apollo* devoted to the AMAM (published in 1976), and he began the essay by stating, "If you want to find out whether a museum has a healthy climate, look at its landscapes. With painting, drawing and print-making, mistakes of acquisition may be more glaring and offensive; in none will success be more rewarding." In the same issue, the editor of *Apollo*, Denys Sutton, wrote in his introduction to the collection at Oberlin: "Sixty years of judicious buying have made the Museum a mecca for the lover of art. It is heartening to find the survival of connoisseurship of such a personal kind continues in an increasingly institutionalized and philistine world."

One of the museum's most recent acquisition, following in the legacy of patronage and connoisseurship established by Miller and Stechow and their successors, is Pierre-Antoine Patel's *Landscape with Classical Ruins and Figures* included in the present exhibition (cat. no. 25). Purchased with the R. T. Miller fund, this work joins an outstanding collection of landscape paintings and drawings that represent the major schools in the history of European art. That the collection is rich in seventeenth-century works from the low countries is due in no small part to the extraordinary vision of Stechow. Stechow was also one of the first modern art historians to devote a significant part of his research and scholarship to the Dutch Italianate artists of the seventeenth century, a group of artists whose influence on French and Italian landscape painters was particularly strong.

Without a Claude or a Poussin in its collection of paintings, the museum saw the Patel as an appealing compromise; it introduced to the collection one of the most vibrant and original responses to these earlier triumphs in French painting. Unlike that of Claude and, to a large part, Poussin, Patel's response to the landscape was wholly conceived and cultivated in France, forming the final chapter in the development of the classical landscape in European painting. Although he was influenced by traditions outside of France, namely those in Italy and the northern countries, Patel remained in his native country for his entire life, and he produced landscape paintings that reflected this nationalism. In the *Splendor of Ruins* exhibition, Patel sits comfortably at the midpoint in the nearly two-hundred-year survey: living within the lifetimes of both Claude and Boucher and foreshadowing the generations of artists who would reaffirm France's preeminent role in the development of landscape painting in the succeeding centuries.

The acquisition of the Patel largely inspired the organization of this exhibition. Represented in American public collections by fewer than ten paintings, the Patel family—father Pierre Patel and sons Jacques and Pierre-Antoine—is relatively unknown to American museum audiences. Therefore the occasion to bring together works by all three members of the family—including the only extant signed painting by Jacques Patel—is particularly rewarding and illuminating for our understanding of their contributions to French landscape painting. In light of the AMAM's strong collection of landscapes by other seventeenth- and eighteenth-century French artists, including Bourdon,

Coypel, Pater, and Fragonard, the prospect of curating an exhibition of French landscapes featuring the architectural ruin was compelling and plausible.

The exhibition's survey of the ruin begins with Claude and concludes with Robert, both of whom had an enormous influence on the development of what may be called the architectural landscape. Their impressive stature in French painting and, more broadly, within European painting is reflected in the number of their works included in the exhibition. In many ways these two artists anchor the presentation and discourse on the ruin in French painting. While the depiction of ruins appeared before and after these two artists, clearly it was within the span of their careers and the fifty years separating their lives that the ruin flourished in landscape painting. Dominating French landscape painting from the 1640s until his death in 1682, Claude was chiefly responsible for creating the pastoral landscape. A century later, Robert emerged as one of the most inventive and engaging landscape artists of his generation, and he immersed himself in many of the same monuments and sites that were embraced by Claude.

The catalogue essays by T. Barton Thurber and Alan Wintermute address a number of the themes raised by the paintings and artistic personalities in the exhibition. The authors have also introduced artists, namely Nicolas Poussin and Jean-Antoine Watteau, whose work it was not possible to include in the exhibition. In his essay Thurber discusses the subject of classical motifs and architectural styles and their role in French landscape painting of the period spanning the exhibition. Beginning with Claude and ending with Robert, Thurber considers the artistic responses to the physical remains and the printed documents illustrating these monuments of antiquity. Wintermute provides a summary of Watteau's critical role in the development of the pastoral landscape as it evolved in the eighteenth century, a genre explored through the *fêtes galantes* and the *genre pittoresque* of Watteau, Lancret, Pater, Boucher, and other French painters. The third essay examines some of the historical responses to the ruin:

its documentation and interpretation by artists, architects, and travelers; and the collecting of ruins as featured in the landscape painting by the art museum.

As is often the case with a survey, not all artists or subjects relevant to the theme of the exhibition can be presented. The decision to borrow paintings from only North American museums naturally placed certain limitations on the scope of the presentation. In spite of the unavailability of certain paintings—in particular, works by Poussin and Watteau—the exhibition's discourse on the depiction of ruins in French landscape painting of the seventeenth and eighteenth centuries is remarkably constant. For the most part, the presence of ruins in the landscape from this period is uninterrupted.

The eighteen artists and thirty-six pictures included in the exhibition offer a fascinating array of interpretations of the ruin. The ruin is shown in varied forms and styles, its presence sometimes subdued in the landscape and at other times the highlight of the composition. It is defined by architectural orders and artistic caprice, but rarely is it limited by the sources and motifs that inspired its creation in the painting. Within the two centuries covered in the exhibition, the depiction of the ruin in French painting experienced a complete cycle of intellectual and physical transformation. Much of what we understand about these ancient monuments is determined by the way they were documented by artists and presented to us as viewers. While there was a rich repository of classical images available to artists—particularly in Rome and its environs—some monuments were clearly favored, as is evident by the works in the exhibition. During the seventeenth century, Rome was the cultural and religious capital of Europe, the destination for foreign travelers and the forum for artistic traditions, and a city whose architecture encompassed the triumphs of the classical, the medieval, and the Baroque. In the midst of all this splendor was the ruin, reclaimed and revived in the life of the painted landscape.

STEPHEN D. BORYS

The Splendor of Ruins

in French Landscape Painting

1630–1800

T. BARTON THURBER

From "Learned Architecture" to the "Poetics of Ruins"

Classical Building Types and Motifs
in Selected French Landscape Paintings
from Claude to Robert

When Michel de Montaigne (1533–1592) arrived in Rome in late 1580, he eloquently described his impressions of the city's ancient remains in his posthumously published *Diary of the Journey to Italy*:

> The indications of Rome's ruin which still appear above the [ground] had only been preserved by chance, as evidence of that infinite greatness which so many centuries, so many conflagrations, the so often repeated conspiracy of the world to ruin her had not been able entirely to extinguish. Yet, in all probability, the mutilated members that survived were the least worthy of preserving, and the fury of the enemies of that immortal glory had impelled them to destroy in the first place what was most beautiful and most worthy. The buildings of this bastard Rome which were at the present time appending to the antique ruins, though they were fine enough to excite admiration of the present age, reminded [one] of those nests which the sparrows and crows in France append to the arches and walls of the churches which the Huguenots not long ago demolished.[1]

Montaigne's responses to Rome's past glory and present decay reflected common themes in late-sixteenth-century French literature.[2] In particular, he emphasized the paradox between profound reverence for monumental remains and overwhelming awe of the current state of deterioration. In addition, the extent of the destruction reminded him of his native country and the dilapidated condition of innumerable ecclesiastical structures, relics of the recent religious and civil conflicts.[3] The complex relationships between ancient history, contemporary circumstances, and future destiny continued to fascinate writers during the seventeenth and eighteenth centuries, and, as a result, antique ruins were repeatedly used as symbols of natural and human devastation.[4] At the same time, from about 1630 to 1800, many French landscape artists portrayed the vestiges of classical structures in order to evoke similar themes dealing with the deleterious effects of time and mankind. In the best examples these relics did not simply function as a provocative backdrop but were often included to

FIG. 1 (*facing*). Claude Lorrain, *Landscape with Nymph and Satyr Dancing* (detail), 1641. Oil on canvas. Toledo Museum of Art, Toledo, Ohio, 1949.170. See also cat. no. 14, page 93.

complement, explicate, or expand the subject of a history painting or a nostalgic genre scene.[5] In many instances painters alluded to well-known sites and monuments, drawing on their growing understanding about antiquity through direct observations and careful studies of texts and artifacts. Eventually, by the middle of the eighteenth century, a number of French artists became increasingly attracted to the notion of considering ruins as objects for pleasurable contemplation. In both cases, either as moralistic symbols or as picturesque settings, representations of antique remnants frequently drew upon changing architectural tastes and the latest archaeological discoveries.

Although ancient ruins appear in the background of many French landscape paintings produced during the seventeenth and eighteenth centuries, depictions of elaborate or monumental remains reveal the most information about contemporary architectural ideas and antiquarian interests. Rather than use them as incidental motifs, artists focusing on these structures as the dominant subject engage the viewer more directly with issues involving particular topographical contexts, physical features, and historical interpretations. In addition, the grander and more prominently displayed the ruins appear, the more they recall specific classical sources. However, in most *capricci* these references are rarely reproduced accurately but instead are represented in modified conditions and new settings. Beginning in the early Baroque era, artists and critics stress creative exaggeration, alteration, and juxtaposition of antique models in order to enhance the viewer's appreciation of painted compositions. Excessive reverence toward ancient examples is continually rebuked in favor of a greater role for judicious inventiveness.[6] As Antoine Coypel (1661–1722; cat. no. 16) notes, "It is always necessary to give spectators [of a painting] some occasion to allow their imagination to work."[7]

One of the first French artists to utilize this concept in landscape painting was Claude Gellée, also known as Claude Lorrain (1604/5–1682; cat. nos. 10–15). According to his earliest biographer, the young artist studied the paintings of Italian and northern European landscapists working in Rome and trained under the guidance of prominent landscape painters.[8] Like his near-contemporary Nicolas Poussin (1594–1665), Claude spent most of his life in Rome, where his art

was strongly inspired by the surrounding *campagna*, or countryside. By the early 1630s Claude had established his characteristic style, which combined fantastic natural scenes imbued with limpid light and familiar architectural elements to evoke pastoral and classical themes. While the imagined buildings frequently represented recognizable monuments and ruins, he rarely attempted to depict precise settings or details with archaeological correctness.[9]

One of the antique structures most commonly found in Claude's work was the round shrine at Tivoli, the so-called Temple of Sibyl, whose features were occasionally fused with those of the similarly shaped edifice in the Forum Boarium at Rome (see, for example, cat. nos. 12–14).[10] Circular in plan and surrounded by a peristyle composed originally of eighteen Corinthian columns, this relatively rare ancient type attracted the attention of artists and architects from the Renaissance onward. Its design was published in 1540 by Sebastiano Serlio (1475–1554) and in 1570 by Andrea Palladio (1508–1580), both reissued in various French editions. The basic model inspired Bramante (ca. 1443/44–1514) around 1502 and Raphael (1483–1520) in 1504 to invent slightly modified, two-story, round peripteral versions in architecture and painting, respectively.[11] Claude included permutations of the circular temple type in a variety of mythological, biblical, and pastoral compositions. Many French artists produced similar imaginative variations of the same structures (compare cat. nos. 4, 16, 17, 29, and 34), but no other seventeenth-century painter experimented with the essential form to the same extent. In eighteen different paintings executed between 1636 and 1677 Claude repeatedly manipulated the temples' scale, rearranged the topography, and transformed the appearance. The painter's most drastic reworking of the basic, round, peripteral type emerged in his *Landscape with Nymph and Satyr Dancing* of 1641 (cat. no. 14 and fig. 1). The partially destroyed, single-story edifice in the foreground on the right side of the canvas superficially resembled the ruined Temple of Sibyl at Tivoli, but with several important differences: it lacked the fluting on the columns and the elaborate entablature; it showed the addition of a socle or low pedestal below each column; and it substituted unusual Ionic capitals in place of the original Corinthian order. With the exception of

Raphael's polygonal temple in the *Marriage of the Virgin*, there was no precedent for the use of Ionic features for such a structure. Yet Claude's obvious reference was not ancient but rather modern, recalling the distinctive capitals on the lower order of the façade of the Palazzo dei Conservatori in Rome designed by Michelangelo (1475–1564) and completed by 1584 (fig. 2).[12] The painter's choice to highlight the shrine in the foreground was uncommon, but the obvious allusion to a prominent Renaissance monument in a mythological context reflected Claude's typical mixture of eclectic architectural models and diverse historical settings.

Claude's imaginative reconstructions of round, peripteral shrines were especially admired by his Parisian patrons. In France he enjoyed the support of leading political and ecclesiastical figures, foreign diplomats, and wealthy bourgeois collectors.[13] Among the artist's fourteen earliest painted landscapes that incorporated circular temples, executed between 1636 and 1644, at least half were sent to Paris (including cat. nos. 12 and 13).[14] Not surprisingly, nearly all of the first generation of Claude's clients living north of the Alps had traveled to Rome; a number of them owned other contemporary French landscape paintings; and several had a keen interest in ancient art and antiquities. Moreover, like many of the artist's patrons in Italy, some of his supporters in France belonged to the new, expanding class of affluent landowners with *châteaux* and country estates.[15] These common experiences and similar tastes established an immediate market for Claude's idealized depictions of the Roman *campagna*, classical structures, and antique ruins. Although these creative compositions lacked the specificity of time and place and had limited archaeological significance, they clearly recalled the legacy of the past and complemented the growing interest in ancient culture.

Although Claude's general avoidance of particular ancient forms and the frequent inclusion of obvious anachronisms in his depictions of architectural elements and narrative themes still satisfied many collectors, other French artists during the same period consciously aimed for a higher level of authenticity. They created scenes in which even the most erudite contemporaries could identify precise archaeological sources and proper historical contexts. In the case of Nicolas Poussin's work, for example, architectural settings for Greek

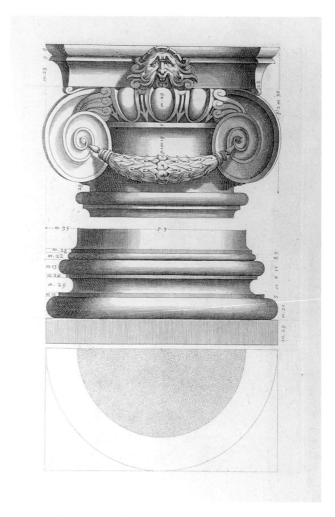

FIG. 2. Francesco Villamena, *Michelangelo's Ionic Capital*, 1619. Engraving. Courtesy of the Trustees of Harvard University.

subjects typically employed only the Greek orders—the Doric, Ionic, and Corinthian—and deliberately rejected the Tuscan and Composite orders invented by the Romans.[16] Poussin was known to have made antiquity "his chief study" during his long residency in Rome.[17] In spite of his vast knowledge of ancient and Renaissance architecture and his customary adherence to strict classical principles, he still almost always altered slightly either the position or proportions of recognizable designs in order to create new compositions. While fulfilling a desire for greater accuracy, Poussin nevertheless used explicit references to represent ideal types rather than merely selecting them for their ability to recall specific models.[18]

One of Poussin's closest colleagues was the French

FIG. 3. Nicolas Poussin and Jean Lemaire, *Theseus Finding His Father's Sword*, ca. 1633–35. Oil on canvas. Musée Condé, Chantilly, France. Giraudon/Bridgeman Art Library.

painter Jean Lemaire (1601–1659), who arrived in Rome by 1624.[19] They resided together from about 1629 to 1631 in a house in Rome, where Lemaire remained until 1638. Both artists were also accepted into the Accademia di San Luca, the Roman art academy, and listed alongside other French painters—including Claude—active in the Eternal City. During this period Poussin and Lemaire carefully investigated theoretical texts and physical remains documenting the splendor of antiquity, as well as prints and drawings recording historic relics and ideal reconstructions. Their studies led them to portray in their paintings what one mid-seventeenth-century French critic called *la docte Architecture*, or "learned Architecture."[20] Such a collaborative practice led to a well-documented instance of Lemaire painting the dominant architectural setting in one of Poussin's canvases, *Theseus Finding His Father's*

Sword, executed around 1633–35 (fig. 3).[21] The distinctive Doric columns and entablature were derived from the destroyed Basilica Emilia in the Roman Forum, which was recorded in engraved and drawn images and re-utilized in at least four other compositions produced independently by Lemaire.[22] Even though the original source was obvious to connoisseurs, the basic features were convincingly altered. Most important, the building's engaged columns were rendered as a freestanding order in an entirely idealized environment. The transformation of such objects epitomized the seventeenth-century concept of using ancient examples in the selection of the most superb elements, which were intended to create the "idea" of perfect harmony in the imagination of the artist and the spectator.[23]

Even though Poussin and Lemaire both manipulate antique models, Poussin's alterations are relatively

conservative. Compared to his colleague, Lemaire takes greater liberty in manipulating and transforming specific sources.[24] For example, in Lemaire's painting *Achilles Discovered Among the Daughters of Lycomedes*, possibly executed around 1640–45 (fig. 4),[25] the structure situated in the middle of the scene clearly resembles the so-called Porta dei Leoni at Verona, built in the first century B.C., but with several modifications to its main features.[26] The most notable changes involve the conversion of the original, double-arched structure into an extended series of bays and the elimination of the symmetrically arranged third story. (The same edifice appears in four other known canvases attributed to Lemaire, and in each one it is rendered differently.)[27] In addition to the building inspired by the Porta dei Leoni, the painter adds conspicuous references to other identifiable but displaced relics and ruins found in Rome. These include the Torlonia Vase or antique fountain,[28] on the left side of the canvas, and, in the background, the Pyramid of Caius Cestius, both constructed in the first century B.C. Along with the portrayal of recognizable monuments Lemaire depicts a large, fantastic portico surrounding the principal figures. Although the richly coffered barrel vault recalls descriptions of the lost, gilt-bronze, recessed panels at the entrance to the Pantheon,[29] the overall construction is completely fictive. A clue to the imaginary nature of the entire mise-en-scène is an enormous bas-relief above the architrave in the foreground. It is an exact copy of an engraving from about 1520 representing the *Judgment of Paris* by Marcantonio Raimondi (ca. 1470–ca. 1527),[30] based on a design by Raphael and inspired by two famous Roman sarcophagi.[31] The mythological story refers to events that would eventually lead to the Trojan War and, according to the account by Virgil (70–19 B.C.), to the foundation of Rome. Lemaire portrays another episode from the same story recounted by several ancient authors, the conscription of Achilles, as the subject of the painting. While one event is already commemorated in stone, another nearly contemporaneous incident is still unfolding. The painter's deliberate juxtaposition of space and time generates a complex web of meanings characteristic of the most sophisticated responses to antiquity. Along with a greater awareness of the art and architecture of the past comes a more highly developed ability to produce creative and meaningful reconstructions.

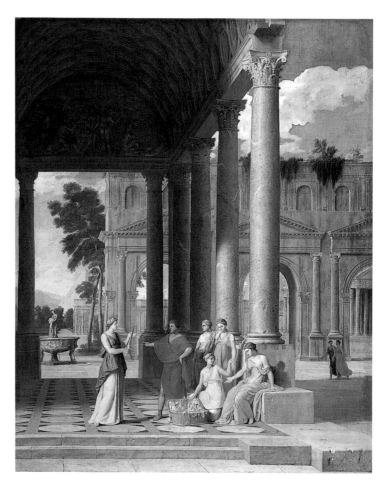

FIG. 4. Jean Lemaire, *Achilles Discovered Among the Daughters of Lycomedes*, ca. 1640–45. Oil on canvas. Los Angeles County Museum of Art, Los Angeles, California.

A powerful circle of men intent on launching a classical revival in France supported Lemaire upon his return to Paris in 1638. His vast knowledge about ancient culture and his considerable artistic abilities brought him to their attention. Their aim was to imitate the achievements of Rome and then to surpass them. They were led by the chief member of the King's Council, Armand-Jean du Plessis, Cardinal Richelieu (1585–1642); Richelieu's trusted Secretary of War and, from 1638 until his death, Superintendent of Royal Buildings, François Sublet de Noyers (1588–1645); and the latter's cousin, an important diplomat at the courts of both Louis XIII (1601–1643) and Louis XIV (1638–1715), Paul Fréart de Chantelou (1609–1694).[32] All three dignitaries commissioned works from Lemaire, and by 1657 the painting *Achilles Discovered Among the Daughters of Lycomedes* hung in the front hall of Chantelou's residence in Paris along with two other

works by the same artist.[33] The canvases were admired by Gian Lorenzo Bernini (1598–1680) during his visit in the summer of 1665, and he commented on Lemaire's imaginative depictions, "saying that the architecture was very good."[34] Bernini's positive observation reinforced the cultural program recommended by Lemaire's supporters, who advocated a modern aesthetic based on inventive imitation of the best classical examples.

During the period in which Chantelou's patronage fostered the emerging taste for classicism and an orientation toward Rome, his brother Roland Fréart de Chambray (1606–1676) undertook a series of writing projects aimed at establishing a theoretical foundation for their reform movement. Both brothers had been sent in 1640 by Sublet de Noyers to Italy to persuade Poussin to return to France and acquire antique sculptures on behalf of the king and Cardinal Richelieu. After a brief period of cultural influence, capped by Poussin's eighteen-month-long sojourn in Paris, the Fréart brothers witnessed a rapid end to their status following the death of Richelieu and Sublet's subsequent fall from power.[35] Chambray retreated to the family estate at Le Mans in the Loire Valley, where he completed several treatises and translations already under way. The first two volumes on architecture published in 1650, an edition of the *Four Books on Architecture* (originally issued in Italian in 1570) by Andrea Palladio (1508–1580) and Chambray's own *A Parallel of the Ancient Architecture with the Modern*, codified proper classical rules and proportions. In opposition to perceived "capricious and monstrous styles," such as the Baroque, the author defended a normative design process and a simplified manner of construction founded on principles first outlined by Vitruvius (ca. 90–20 B.C.).[36] His compilation emphasized the primacy of the three Greek orders, based on empirical evidence drawn from ancient and Renaissance examples, and promoted the notion of the orders as the basic element in characterizing an entire building (as either "solid" or "intermediate" or "delicate"). Although he attempted to establish a specific national approach to classicism, he also permitted considerable latitude by presenting multiple options. Chambray's texts were widely read, and the ideas expressed in *Parallel* attracted the attention of artists and critics throughout Europe. The

treatise was reissued in four subsequent editions in France, and a late-seventeenth-century English translation was published five times. Eventually, in the early 1660s, Chambray was chosen as the principal advisor for the construction of the east wing of the Louvre, and Chantelou was entrusted with the task of accompanying Bernini during his trip to Paris as a consultant on the project. The Fréart brothers carefully orchestrated their illustrious visitor's itinerary, focusing his attention primarily on contemporary buildings and prominent collections that reflected their tastes.[37] For his part, Bernini repeatedly confirmed his support for their program, quoting passages from Chambray's book and praising the work of the leading representatives of French classical architecture and painting.

Not surprisingly, many artists working in France in this milieu adopted a more learned approach toward their depictions of classical ruins. By the middle of the seventeenth century, painters such as Laurent de La Hyre (1606–1656; cat. nos. 18–20) demonstrated a greater concern for archaeological accuracy in their architectural settings.[38] Most of his early commissions were religious themes containing multiple figures and executed in bright, bold colors. He also made important contributions to the development of landscape painting by blending Claude's luminous effects with Poussin's antiquarian interests. Around 1640 La Hyre was asked to furnish three mythological subjects for the Salle des Gardes at Cardinal Richelieu's urban palace in Paris. One of these canvases, the only surviving picture from the group, represented *Theseus Aided by His Mother Aethra* and included a monumental Doric colonnade (fig. 5).[39] The appearance of such a dominant structure was rare for La Hyre, so much so that one scholar suggested that Lemaire, who was also working for Richelieu at the same time, may have advised his slightly younger colleague on the architectural background.[40] La Hyre may have been aware of Poussin's and Lemaire's collaborative conception of the same scene that also prominently showed a trabeated Doric colonnade (fig. 3). In any event, the most important aspect of the fictive building was that it represented the Doric order in correspondence with the specifications outlined in a contract of 1639 for the room's paintings and wall decorations.[41] This was especially significant since images of the cardinal's other residences were to be displayed in the same

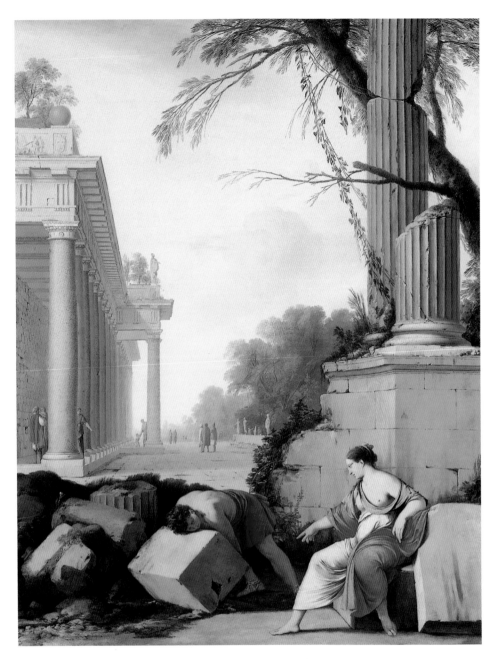

FIG. 5. Laurent de La Hyre, *Theseus Aided by His Mother Aethra*,
ca. 1639–41. Oil on canvas. Private collection.

space, and nearly all of them featured Doric columns and pilasters at the entrances and around the windows. The extraordinary emphasis on such details must have reflected the patron's personal predilection for the attributes of solidity and simplicity associated with this particular classical order,[42] which Chambray later described in the first chapter of his treatise.

La Hyre never went to Italy, and therefore his understanding of Roman antiquity relied almost entirely on secondary sources. Nevertheless he demonstrated an acute awareness of subtle architectural distinctions and surprising flexibility in developing innovative building solutions.[43] In both *Theseus Aided by His Mother Aethra* and another example employing the Doric order, *Rest on the Flight into Egypt* of 1648 (cat. no. 19 and fig. 6), La Hyre relied on a popular but controversial specimen for the basic design of the columns and entablature. He selected as his principal reference the illustrated manual *The Five Orders of Architecture*, originally published in Italian in 1562 by Jacopo

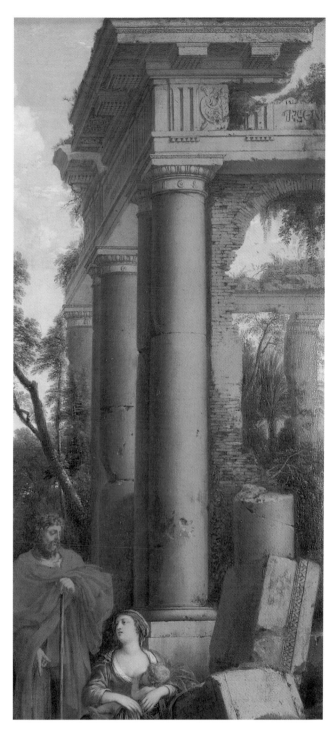

FIG. 6. Laurent de La Hyre, *Rest on the Flight into Egypt* (detail), 1648. Oil on canvas. J. B. Speed Art Museum, Louisville, Kentucky. See also cat. no. 19, page 113.

Barozzi da Vignola (1507–1573) and available in a French edition as early as 1632. La Hyre's architecture followed Vignola's example in nearly every detail from the cornice down to the unique base, and his later painting even borrowed the metopes of the frieze from the same treatise. Yet most French artists and critics continually rejected the form of the base invented by the Italian architect (compare, for example, the one used by Lemaire in fig. 3). As Chambray explained in his book, Vitruvius did not describe such an element in his text, and without the aid of clear archaeological evidence *les modernes* ("Renaissance architects") were left on their own to create a proper support for Doric columns.[44] Even though La Hyre's commitment to Vignola's solution for the base may have been unusual, his use of paired Doric columns in *Rest on the Flight into Egypt* was virtually unprecedented.[45] Similar innovations could be found in the work of several sixteenth-century architects and would be vigorously debated a generation later by writers such as Claude Perrault (1613–1688) and François Blondel (1617–1686).[46] Nonetheless, the occasional use of this feature by an early-seventeenth-century painter was truly exceptional. Instead of relying on actual classical remains, he adapted antique types and ornaments drawn from published sources and transformed them into well-defined, original structures. As a result several paintings by La Hyre elevated seemingly simple landscapes into exemplary building designs.

By the close of the seventeenth century, French landscape painting attained the status of a noble art. The greatest examples were avidly collected; accurate reproductive prints were widely disseminated; and written accounts praising their characteristics were published. Along with heightened recognition, however, came also certain limitations. Well into the next century most French artists conceived of the genre through the lenses of their predecessors. Even painters working in natural surroundings often selected scenery that conformed to established conventions. As a result many landscapists followed accepted traditions in the use of standard formats, familiar subjects, and common devices, which some later scholars considered derivative and lacking in imagination.[47]

Several critics attempted to define the essential features evident in the best examples. In *The Art of*

Painting of 1708 Roger de Piles (1635–1709) referred to two different styles of landscape painting, "heroic" and "pastoral." De Piles explained the former, under examination in this study, in the following manner:

> The heroic style is a composition of objects, gathering all from art and nature that which can produce a grand and extraordinary effect. The sites, there, are all agreeable and surprising, the fabrics nothing but temples, pyramids, classical tombs, altars, sacred to the Gods, or pleasure dwellings of regular architecture. And if nature is not represented as chance may depict her to our eyes every day, she is at least represented as one fancies that she ought to look.[48]

His characterization of the idealized landscape became an important reference for generations to come, and later critics often used the terms "surprising" and "agreeable" in response to complete scenes.[49] Meanwhile, early-eighteenth-century French travel writers began to provide detailed, contextualized descriptions of classical remains and recounted their personal impressions of them. At one point in Charles de Brosses's (1709–1777) publication of 1750 on excavations at Naples, *Letters on the Actual State of the Subterranean City of Herculaneum*, he stated that the overall image of large numbers of ancient building types and fragments was "actually pleasing."[50] These comprehensive descriptions reflected the rise of the aesthetic of the picturesque, which, according to some French theorists, emphasized the application of philosophical, artistic, and literary concepts in response to entire natural settings—either actual or imaginary. Most important, the notion that antique vestiges should be viewed as an integral part of their immediate environment marked a shift away from seeing them merely as relics of the past. Instead they were regarded as key components in the creation of a new poetic vision of ruins.

The best French landscapists active in Rome around the middle of the eighteenth century brilliantly rendered the combination of archaeological curiosity and dramatic potential suggested in various theoretical texts and practical handbooks. Claude-Joseph Vernet (1714–1789; cat. nos. 34–35), who remained in Italy from 1734 to 1753, Jean Barbault (1718–1762; cat. no. 2), who arrived at the Académie de France in Rome in 1749 and stayed in the capital until his death, and

Hubert Robert (1733–1808; cat. nos. 28–33), who lived and studied at the Académie from 1754 to 1765, were among some of the most notable practitioners. Attracted by its unparalleled collections of ancient and Renaissance works, all three artists went to the Eternal City to study classical art through years of direct observation. In addition, from the late 1740s onward their investigations were strongly influenced by the prints of Giovanni Battista Piranesi (1720–1778), who derived his principal inspiration from firsthand examinations of surviving antiquities. Throughout his career he produced carefully prepared views and measured images of antique structures and ruins in and around Rome. He infused conventional topographical scenes of well-known monuments and ideal reconstructions with novel compositional devices, such as exaggerating the scale of the buildings and manipulating the perspective through the use of multiple vanishing points.[51] Piranesi's vast production of etchings reflected a unique combination of remarkable imagination and a deep understanding of Roman construction, which helped to cultivate an unprecedented appreciation for Imperial architecture. As a result of Piranesi's extraordinary ability to both document and recreate the heritage of the past, contemporary artists—as well as many in the future—were inspired to reassess the magnificence of the classical world.

Robert was especially well acquainted with Piranesi, with whom he traveled, and they sketched together on several occasions during the French painter's prolonged sojourn in Italy.[52] Piranesi's workshop was located across the street from the Académie de France, then housed in the Palazzo Mancini on Rome's Via del Corso, where Robert resided. The younger artist arrived in Italy as a member of the entourage of Etienne-François de Choiseul-Stainville (1719–1785), the future Duc de Choiseul, who had been appointed French Ambassador to the Holy See in 1754. Choiseul financed Robert's residency at the Académie for five years until he was awarded an official position in 1759.[53] By that time Robert's lifelong fascination with architectural ruins was well established, and it was further refined through his acquaintance with the view painter Giovanni Paolo Panini (1691–1765), who was renowned for his actual and idealized depictions of ancient remains arranged in landscape settings.[54] Choiseul

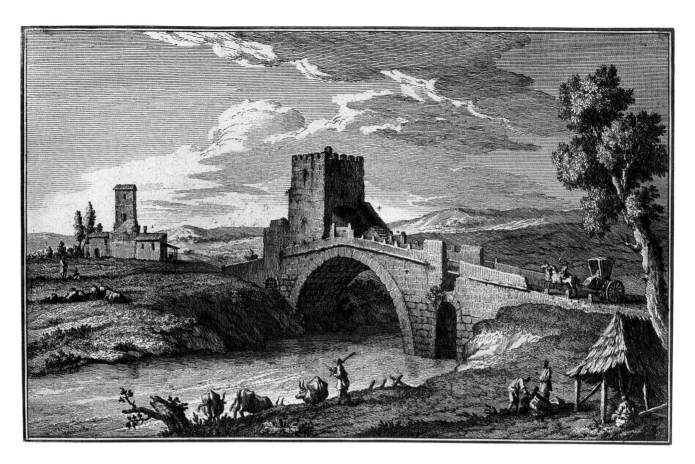

FIG. 7. Giuseppe Vasi, *Ponte Salario*, 1754. Etching.
Courtesy of the Trustees of Harvard University.

commissioned Panini in 1756–57 to execute two magnificent pairs of fanciful interiors displaying framed paintings of various monuments and other works from antiquity to the mid-eighteenth century.[55] His highly accurate panoramas and *capricci* filled with clearly rendered details and images of quotidian activities were popular with French patrons and foreign visitors. He taught perspective at the Académie de France in Rome and in 1732 was received as a member of the Académie royale de peinture et de sculpture in Paris—an honor bestowed upon few Italian artists.

Both Panini and Piranesi had a profound impact on Robert's choice of subjects, techniques, and even some compositions.[56] One example of the effect of these influences on Robert can be seen in the large canvas of the *Old Bridge*, executed about 1775, a decade after he had returned to Paris (cat. no. 30).[57] The painter adopted many of the features of the ancient Roman structure known as the Ponte Salario, rebuilt in the sixth century across the Anio River, a tributary of the Tibur. Situated a few miles north of the city gates and

away from the principal access routes, the bridge rarely inspired artistic curiosity until the nineteenth century. In 1754, however, it was illustrated in two separate series of prints, one by Giuseppe Vasi (1710–1782; fig. 7)[58] and the other by Piranesi (fig. 8).[59] Vasi selected a distant, high viewpoint in order to show realistically the scale of the bridge and the surrounding countryside. In contrast Piranesi chose a close-up, low vantage point that made the monument more imposing. Although both works represented the bridge in roughly the same condition and context, from Piranesi's standpoint the size and position of the stone blocks were rendered to form a convincing impression of a massive construction. Robert borrowed the most salient aspects from Piranesi's view, but he also added new elements and significantly modified the overall design. For example, the crenellated medieval building at one end, which appeared as a simple mass in Vasi's print and an abandoned edifice in Piranesi's etching, was refined with greater spatial and material specificity in the painting. Robert transformed Vasi's accurate topographical scene

into a Piranesi-like *veduta*, translating the realm of reality into an ideal vision. The French artist succeeded in surpassing both precedents by utilizing the bridge as an imposing classical structure to frame a view of a picturesque background. Robert portrayed the contrast between a dilapidated antique bridge and a lively rural setting and created a provocative image of the complex relationships between ancient culture and contemporary society.

Even though such creative portrayals of classical remains were immensely popular, especially with French aristocrats, they were also occasionally subject to criticism. The critic Denis Diderot (1713–1784) was an early supporter of Robert, but he also admonished him for including ordinary people involved in mundane daily activities in his landscapes. While the women washing laundry in the river below and the leaning figure reaching out to the cat from the balcony above functioned as attractive genre additions, Diderot complained that such animated details distracted the observer from comprehending the significance of the ruins. As he noted in reference to another painting by Robert in the Salon of 1767, "Don't you sense there are too many figures, that three-quarters of them should be removed? Only those enhancing the effect of solitude and silence should be retained. A solitary man who has wandered into these shadowy precincts, his arms across his chest and his head inclined, would have made a greater impression on me."[60] Other commentators denounced Robert's manipulation of the rules of perspective for dramatic purposes.[61]

In the case of *The Old Bridge*, two different vanishing points receding to the right generated a larger arched opening, but they also made the structure lopsided, with the top narrower than the bottom. For Diderot such extraneous embellishments and inappropriate use of standard artistic conventions violated the clearly defined "tenets of the poetics of ruins": "Monsieur Robert . . . you're completely innocent of them, acquaint yourself with them; you have the technique, but you lack the ideal."[62] Diderot appealed to painters to portray the meaning of relics rather than merely capture their outward appearance.

In spite of occasional negative critiques Robert continued to produce landscapes for an affluent clientele that shared his vision of the vestiges of the classical

FIG. 8. Giovanni Battista Piranesi, *View of the Ponte Salario* (detail), 1748–78. Etching. *Vedute di Roma*. Allen Memorial Art Museum, Oberlin College, Oberlin, Ohio. See also fig. 75, page 153.

world. While limiting himself for the most part to familiar antiquities in Italy, he nevertheless introduced important innovations. Beginning in the mid-1770s Robert was commissioned to devise a number of decorative ensembles, forming entire painted cycles for several private residences. In one pair of pictures completed around 1775 he displayed the use of pendants to convey repetitive processes and recurring patterns (cat. nos. 31–32). One large overdoor picture depicted a destroyed, trabeated structure with half-buried arched openings, and the other a dilapidated colonnade with rows of columns surmounted by a gabled roof. The historical sources for both works at Rome were obvious: the engaged Doric columns in the first canvas were modeled after a small portion of the lower story of the Amphitheatrum Flavium, generally known as the Colosseum, built between A.D. 70 and 76. The other showed a section of the southern wing of Bernini's freestanding, Doric colonnade at Piazza S. Pietro, begun in 1656 and finished in 1667.[63] Each canvas presented a major monument employing the same

FIG. 9. Claude Lorrain, *Copy after the so-called "Barberini Landscape"*
(ancient fresco), 1661. Pen and ink.
Courtesy of the Trustees of the British Museum.

architectural order, one ancient and the other modern; each view featured a curvilinear structure, one convex and the other concave; and each image contained figures in the foreground, in one case ignoring the remains and in the other carefully observing them. Robert was not the first artist to create separate works as a set in order to compare and contrast formal and contextual relationships, but he had introduced the novel idea of representing buildings from diverse eras, including—and most importantly—an existing edifice in ruins.[64] While one painting reflected the glory of the past, the other projected an imaginary future, revealing the inevitable destruction of contemporary monuments. Robert would return to this theme several years later during a more tumultuous period.

Although Robert had carefully studied most of the extant buildings of Imperial Rome, even precariously

scaling the Colosseum to examine it more closely,[65] he largely ignored surviving examples of ancient painting. The Roman frescoes at Herculaneum, which Robert visited with Jean Claude Richard de Saint-Non (1727–1791) in 1760, were considered by him and other French artists to be mediocre and of little interest.[66] Following a trend that had already manifested itself by the middle of the seventeenth century, the study of certain types of antiquities began to distance itself from artistic practice. Scholars privileged the search for historical principles over the pursuit of aesthetic ideals. Their focus shifted toward the development of precise stylistic and chronological classifications, replacing traditional antiquarian interests aimed at subject matter.[67] In the meantime, most painters followed the latest archaeological discoveries simply to refine their formal vocabulary. The actual works had little influence on

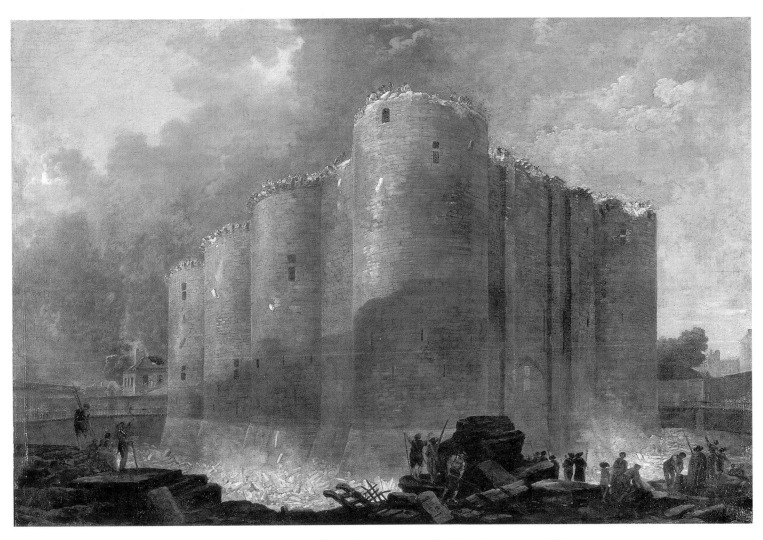

FIG. 10. Hubert Robert, *The Bastille in the First Days of Its Demolition*, 1789. Oil on canvas.
Musée de la Ville de Paris, Musée Carnavalet, Paris. Giraudon/Bridgeman Art Library.

contemporary painting. Even the greatest examples, such as the so-called *Aldobrandini Wedding* and the *Barberini Landscape* (fig. 9),[68] discovered and avidly studied in the early 1600s, rarely attracted much attention in eighteenth-century France. From the perspective of later generations, the finest painters of the Renaissance and Baroque eras had already assimilated the knowledge acquired from these ancient masterpieces.[69] They had thoroughly studied classical literature and investigated Roman remains in order to revive the perfection of the past. During Robert's lifetime these relics were generally regarded indifferently as mere footnotes to a previously well chronicled history of art.[70]

In the last two decades of the eighteenth century Robert was more responsive to the growing interest in documenting the monuments of his native country.

Following a tradition established in the late Renaissance to record "some of the most beautiful and excellent buildings that embellish France,"[71] Robert produced several canvases and drawings beginning in the late 1780s that evoked the glory of great French architecture from antiquity to the present.[72] These works were done after the publication of the first volumes of the *Description of France*, which presented everything in the nation "that was rare, interesting, and remarkable."[73]

Around the same time but in a completely different vein, Robert executed in July 1789 a poignant image of the demolition of the Bastille a few days after the siege of the medieval fortress (fig. 10).[74] The significance of the moment was immediately apparent, and Robert's picture utilized all of the devices that he had perfected over the years, such as the low viewpoint, the exaggerated proportions, and the dramatic lighting. As a result

the artist produced more than a mere visual record of an epic event but instead created a tragic vision of the French Revolution. (Robert himself was imprisoned for nine months from October 1793 to August 1794.) His scheme transformed ruins from picturesque relics into symbols of a new philosophy of history, in which both buildings and the societies that erected them would ultimately succumb to violent upheaval. Robert inaugurated a new era in which images of such vestiges no longer were merely associated with nostalgic ideas but also could be interpreted as signs of inevitable destinies.

NOTES

I would like to acknowledge the kind cooperation of several colleagues who provided advice and important references during the preparation of this essay: Mirka Beneš, Jean-Claude Boyer, Joseph Connors, Katherine Hart, Peter Parshall, and Richard Rand. I would also like to thank Robert Dance for reviewing an early draft and making many helpful suggestions.

1. Montaigne 1962, 1213; quoted in English in *The Diary of Montaigne's Journey to Italy*, trans. E. J. Trechmann (New York: Harcourt, Brace and Company, 1929), 131–32.

2. Daemmrich 1972, 449–57, esp. 454, regarding Montaigne's descriptions.

3. Daemmrich 1972, 450.

4. Daemmrich 1972, 449–57, passim.

5. For a general review of the appearance of architecture in idealized settings painted during the seventeenth and early eighteenth centuries, see Jörg Garms, "Architectural Painting: Fantasy and Caprice," in Millon 1999, 241–77.

6. See, for example, the debate at the Académie royale in 1668 over Nicolas Poussin's "servile" study of ancient art and his aesthetic ideals, published in English in Holt 1947, 388–94; and Mothe-Fénelon 1730, 216ff., cited in Bensiek 1972.

7. "Discours" (1721), republished in Jouin 1883, 234, cited in Garnier-Pelle 1989, 66.

8. Sandrart 1925, 184, cited in English in Roethlisberger 1982, 10–27.

9. Cf. Peter Paul Rubens's similar avoidance of portraying antique buildings as exact copies of existing structures (Blunt 1977, 609–21, esp. 610.

10. The real dedication of the temple at Tivoli, built in the first century B.C., is unknown, but some scholars have suggested Hercules (e.g., Spielmann 1966, 80). The temple of Hercules Victor at Rome, erected at the end of the second century B.C. and restored at the time of Tiberius, is commonly called the Temple of Vesta, or Mater Matuata. Ian G. Kennedy provides a complete list of Claude's paintings and drawings containing his favorite ancient building type in Kennedy 1972, 260–83, esp. 261–62 and nn. 6–7, to which should be added cat. no. 12 in the current exhibition, first published in Kitson 1980b, 834–37, figs. 20 and 22.

11. The essential relationships between ancient precedents and later Italian Renaissance examples are described and illustrated in Rosenthal 1964, 55–74. For an interesting sixteenth-century French variant, see Antoine Caron's drawing of Artemisia's mausoleum at Halicarnassus in Nicolas Houel's 1562 manuscript "L'Histoire de la Royne Arthémise," Bibliothèque Nationale, Estampes, Réserves, Ad 105, illustrated in Ehrmann 1986.

12. Michael Kitson inaccurately identified the capitals as Composite in his generally reliable publication *Claude Lorrain, Liber veritatis* (Kitson 1978, 87, cat. no. 55). A cursory examination of the detailed illustrations in Letarouilly 1840 shows the popularity of this particular design in the late sixteenth and early seventeenth centuries in Rome.

Michelangelo's invention, discussed in Morrogh 1994, esp. 178, was highlighted in two separate prints by Francesco Villamena (Houghton Library, Harvard University, Cambridge, MA, FA 2800.208.7 F*, engraving on laid paper, 13⅛ × 9¼ in. [33.4 × 23.5 cm.]). They appeared in the second part of a later edition of Vignola 1619, unnumbered sheets. Freestanding Ionic columns and capitals also appeared in a similar configuration in Cherubino Alberti's title page for the reissue of Vignola 1611.

13. An overview of Claude's principal Italian and French supporters is provided by Larry J. Feinberg, "Claude's Patrons," in Russell 1982, 450–64.

14. Kitson 1978, cat. nos. 7, 20, 45, 65, 67, 79, 81, and possibly cat. no. 57.

15. For a general discussion of contemporary patronage of Claude's paintings and landownership, with a brief reference to the French context, see Beneš 2001, 88–113, esp. 112. See also Bonfait 1985, 125–51, esp. 129.

16. Blunt 1944, esp. 162.

17. The observation about Poussin's intense study of antiquity was made by Gian Lorenzo Bernini in 1665, recorded by Paul Fréart de Chantelou in Chantelou 2001, 89, cited in English in Blunt 1985, 80.

18. In addition to Blunt's exemplary study of Poussin's use of architectural sources (Blunt 1967, 1, passim), see also Frommel 1996, 119–34; and Connors 2000, 191–204.

19. Complete biographical information and detailed analyses of Lemaire's work are documented in Fagiolo dell'Arco 1996. See also Boyer 1998.

20. Scudéry 1646, 106, cited in Fagiolo dell'Arco 1996, 259. For a broader explanation of this term in the context of the relationship between Lemaire and Poussin, see Connors 2000, esp. 192–93.

21. Musée Condé, Chantilly, oil on canvas, 38½ × 52¼ in. (98 × 134 cm.), Blunt 1967a, 1, cat. no. 182, and Fagiolo dell'Arco 1996, 22–25, and cat. no. 43.

22. Fagiolo dell'Arco 1996, 60–61.

23. T. Barton Thurber, "Survival and Revival of the Classical Tradition: Antiquity in Rome from the Baroque Era to the Age of Enlightenment," in Thurber 2001, 39–70, esp. 51–54.

24. Noted by Connors 2000, 192.

25. Los Angeles County Museum of Art, Los Angeles (49.17.16), oil on canvas, 61¼ × 50½ in. (155.6 × 128.3 cm.), first published by Blunt 1959, fig. 27. The painting was recently illustrated and described in Fagiolo dell'Arco 1996, cat. no. 53.

26. Described, for example, in Serlio 1540, 135, and translated into French already in 1550.

27. Fagiolo dell'Arco 1996, 212.

28. Fagiolo dell'Arco 1996, 89–91; and Leoncini 1991.

29. Serlio 1540, 10.

30. Noted by Rosenberg 1982, 262–63, cat. no. 43.

31. For a description of the sources, see Sheard 1979, unnumbered pages, cat. no. 90; and Viljoen 2004, esp. 235. See also Adrian W. B. Randolph, "'How Great Rome Was the Ruins Teach': Antiquity in Renaissance Rome," in Thurber 2001, 11–37, esp. 26–28.

32. Their position and influence is briefly analyzed by Connors 2000, 193–94; and Marc Fumaroli, "Richelieu, Patron of the Arts," in Goldfarb 2002, 15–47, esp. 42–44.

33. For a description of Chantelou's collection of paintings based on the inventory prepared upon his death (Paris, Archives Nationales, M.C., XI, 335, 29/03/1694), see Schnapper 1988–94, 2:234–38. The early date is mentioned by Boyer in Boyer 1998, 758, cat. no. 53.

34. Chantelou 2001, 87; and Blunt 1985, 77.

35. Fumaroli, "Richelieu, Patron of the Arts," in Goldfarb 2002, 43.

36. Wiebenson 1993, xiii and 194–96, cat. no. 76; and Hilary Ballon in Goldfarb 2002, 236, cat. no. 104.

37. Connors 2000, 199–200.

38. Complete biographical information and descriptions of La Hyre's work can be found in Rosenberg 1989–90.

39. Ca. 1639–41, oil on canvas, 80⅞ × 59⅞ in. (205.4 × 152 cm.), private collection. First published in Goldfarb 2002, 284–86, cat. no. 121.

40. Goldfarb 2002, 286.

41. Dussieux 1854, 1:108, cited in Goldfarb 2002, 284.

42. Goldfarb, "Richelieu and Contemporary Art: 'Raison d'État' and Personal Taste," in Goldfarb 2002, 1–13, mentioned on 5.

43. La Hyre's considerable knowledge of architecture is mentioned in his earliest biographies, and it is attributed to his association with the French engineer and mathematician Gérard Desargues (1591–ca. 1661). See, for example, Félibien 1666–88, 2:479; and Dézallier d'Argenville 1745, 217, both cited in Rosenberg 1989–90, 96–99. See also Pinault 1994, 249–62.

44. Chambray 1650, 24.

45. Cf. later examples by the same artist in Rosenberg 1989–90, cat. nos. 271 (ca. 1648–53), 318 (1654; cat. no. 20 in the current catalogue), and 329 (1656).

46. McEwen 1998, 328–37, esp. 331.

47. See, for example, Wright 1985a, esp. 118; and Mitchell 1989, esp. 647.

48. De Piles 1708, cited in English in Gombrich 1966, 152, n. 61. For an alternative analysis of this definition, see Puttfarken 1985, chaps. 2–4.

49. For example, Diderot 1995, cited in English in Goodman 1995, 2:197 and 220.

50. Daemmrich 1972, 454.

51. For one of the most recent contributions to the extensive bibliography on Piranesi, see Malcolm Campbell, "Piranesi and Innovation in Eighteenth-Century Roman Printmaking," in Bowron 2000, 561–67.

52. Roland-Michel 1978, esp. 483.

53. Victor Carlson, "Hubert Robert," in Bowron 2000, 434–35.

54. For an examination of Panini's relations with French painters in Rome, see Stéphane Loire's essay in Arisi 1993, reviewed by Edgar Peters Bowron in Bowron 1994, 117–18. Robert may have already known Panini's work in France, especially through the drawings and prints that circulated there by the middle of the eighteenth century. A few examples are briefly described and illustrated by Michael Kiene in Kiene 1992, 83–86, figs. 74–77.

55. Bowron 2000, 425–27, cat. nos. 275–76.

56. On the leading role of Panini and Piranesi at the Académie de France, see Serra 1997.

57. Baillio 2004.

58. Houghton Library, Harvard University, Cambridge, MA, Ital 4300.3*, etching on laid paper, 8¼ × 12¾ in. (21 × 32.4 cm.). Vasi's print first appeared in the fifth book of his ten-volume edition; see Vasi 1747–61, described in Pollak 2000, cat. no. 141.

59. Allen Memorial Art Museum, Oberlin College, Oberlin, OH, etching on laid paper, 16 × 24½ in. (40.7 × 62.3 cm.).

60. Goodman 1995, 198. For a later, alternative, interpretation, see Crown 1992, esp. 58.

61. Cited in Radisich 1998, 102 and 178 n. 13.

62. Goodman 1995, 198.

63. Cf. some of Robert's other interpretations utilizing Bernini's colonnade cited in Boulot 1990, 171, cat. no. 113.

64. Radisich 1998, 129–33.

65. Alessandra Themelly, "Les dessins d'Hubert Robert," in Paris 1998, 106.

66. See, for example, the comments by the Comte de Caylus (1692–1765) cited in Wine 2004. See also Joyce 1983, 423–40.

67. Thurber, "Survival and Revival of the Classical Tradition," in Thurber 2001, 56–57.

68. British Museum, London (no. Oo-7-239), pen and ink on laid paper, 8⁷⁄₁₆ × 12⅛ in. (21.4 × 30.9 cm.). Published in Roethlisberger 1968, 1:322, cat. no. 862.

69. Joyce 1992, esp. 245.

70. Joyce 1992, 245.

71. Cerceau 1576, cited in Wiebenson 1993, 13–15, cat. nos. 8–9.

72. Sébastien Allard, "Hubert Robert's 'Les Monuments de Paris,'" in Millon 1999, 598, cat. no. 641.

73. Laborde 1781–96, cited in Wiebenson 1993, 238, cat. no. 85.

74. Musée Carnavalet, Paris, oil on canvas, 30⁵⁄₁₆ × 44⅞ in. (77 × 114 cm.). Identified in Heim 1989, 326. See also the related drawing published in Cailleux 1979, i–iv, fig. 8 (Album Ernest May, no. 119, *La Bastille en démolition*).

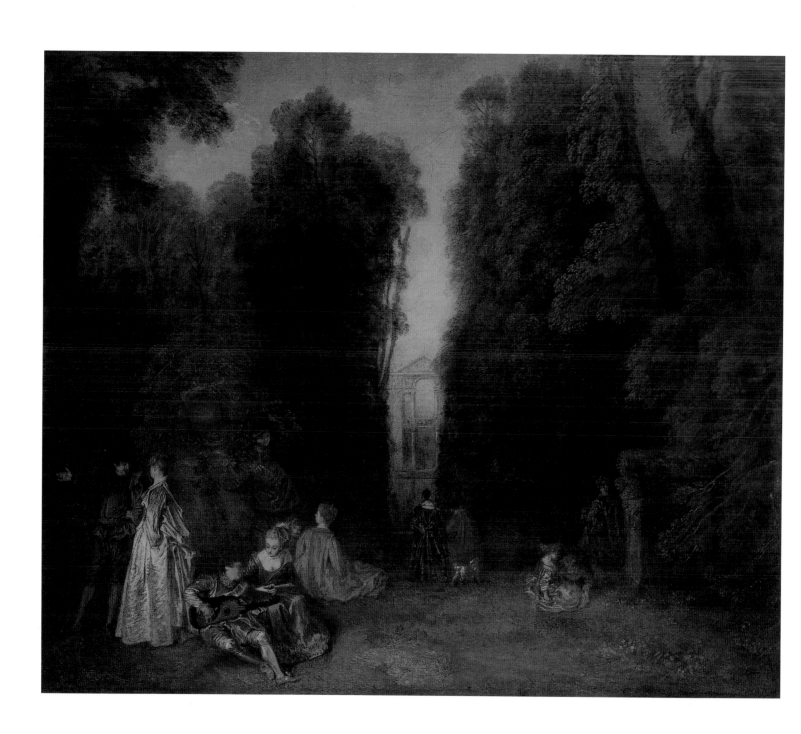

ALAN WINTERMUTE

Watteau, Ruins, and the Pastoral Landscape in French Painting, 1700-1750

When the eighteen-year-old painter Antoine Watteau (1684–1721) arrived in Paris in 1702 from his native Valenciennes, a passionate academic dispute that had divided French intellectual circles for nearly thirty years was only just drawing to an end. The battle had been waged principally within the walls of the Académie royale de peinture et de sculpture, and while it was a fight for control over the future pedagogy of that institution, it was also a larger philosophical battle over the meaning and purpose of the art of painting itself. The dispute centered on the comparative importance of drawing and color to the art of painting or, more specifically, whether the primary purpose of painting was to address the intellect through clarity of form and expression or to appeal to the senses through color and pictorial effect. As the great artists most associated with these divergent tendencies were Nicolas Poussin, the undisputed master of classical composition, and the Flemish artist Peter Paul Rubens, celebrated for his opulent color and painterly bravura, academicians identified themselves as "Poussinistes" or "Rubenistes." The latter faction triumphed only in 1699, when the Académie royale appointed the painter Charles de La Fosse as its director and elected the theorist Roger de Piles to its membership—the two acknowledged leaders of the Rubeniste camp.[1]

It would seem unlikely that Watteau, a provincial painter whose first job in Paris was turning out cheap copies of devotional pictures to be sold on the Pont Notre-Dame, should have had any entry into the exalted worlds of the Académie and the salon, where such debates were taking place. Within a decade, however, he had penetrated the most advanced artistic circles with impressive speed. By 1712, Watteau was working as an independent painter and was elected a provisional member of the Académie royale; here he came under the personal protection of La Fosse, who was said to have greatly admired Watteau's inventive depictions of scenes from the *commedia dell'arte*. It is almost certain that Watteau was introduced to the extraordinarily wealthy financier and art collector Pierre Crozat through La Fosse, who had long enjoyed Crozat's patronage and had lived in his house in 1708. De Piles was another member of Crozat's circle, and until his death he received an annual stipend from the financier. Watteau seems to have quickly become a

FIG. 11 (*facing*). Antoine Watteau, *La perspective* (*View through the Trees in the Park of Pierre Crozat*), ca. 1716–17. Oil on canvas, 18⅜ × 21¾ in. (46.7 × 55.3 cm.). Museum of Fine Arts, Boston. Maria Antoinette Evans Fund, 23.573.

regular at the weekly salons that Crozat held for artists and *amateurs*—a meeting place primarily for the Rubenistes—and, like La Fosse, he too spent a year under Crozat's roof.[2]

Watteau probably never met Roger de Piles (1635–1709), but no protégé of La Fosse and Crozat would have been unaffected by the ideas of this influential critic, connoisseur, and art theorist. De Piles's landmark treatise, the *Cours de peinture par principes*, was the summation of a lifetime of reflection on the art of painting; published in 1708, less than a year before his death, its ideas had long been in general circulation. De Piles's principal achievement was the formulation of a theory that privileged painting as a purely visual art, independent of any literary pedigree and validated not by the didactic merits of subject matter but by potent pictorial unity and painterly virtues. The *Cours de peinture par principes* considered painting from a variety of perspectives, but, for the purposes of the present essay, it was above all remarkable for its lengthy and searching analysis of landscape painting: more than a tenth of the text was devoted to this rarely considered subject.[3]

De Piles divided landscape painting into two styles: the heroic and the pastoral (or rustic). In essence, these two styles represented the difference between ideal nature and real nature—a distinction that formed the heart of de Piles's thesis. For de Piles, Poussin was the exemplar of the ideal style in painting, with its grand, formal, and noble vision of nature: "If nature appear not there, as we every day carefully see her, she is at least represented as we think she ought to be."[4] By contrast, Claude Lorrain assumed the role of principal modern practitioner of the pastoral, or rustic, style, his art indebted to the celebrated Italian masters of color, Titian and Annibale Carracci. Unlike the ideal style of landscape, the pastoral was informal and allowed for nature's imperfections, accidents, and whimsical charms, offering "a representation of countries, rather abandoned to the caprice of nature than cultivated."[5] In keeping with all critics and theorists of painting, de Piles refrained from considering examples in the work of living artists, but his ideas found a ready audience among practitioners and collectors alike.

By 1715, around the period of Watteau's closest contact with Crozat and La Fosse, Watteau was developing an original genre of painting that replaced the military pictures and theater scenes with which he had previously occupied himself. His most characteristic creations, the *fêtes galantes*—romantic landscapes with wistful lovers in fancy dress—represented a new sort of pastoral painting that was sanctioned, if not actually inspired, by de Piles's advocacy. The close relationship between de Piles's program for landscape painters as set forth in the *Cours de peinture par principes* and Watteau's practice in the *fêtes galantes* is worth considering in some detail.

Watteau's *La perspective* (fig. 11) represents the only identifiable site in any of the artist's *fêtes galantes*, depicting the *château* and grounds of Pierre Crozat's countryseat at Montmorency.[6] Within its autumnal garden clearing, enclosed by a screen of towering trees, a small party of young men and women, accompanied by children and a playful dog, enjoy the quiet pleasures of a sunny afternoon on the estate. Although it offers no traditional narrative, *La perspective* takes the developing stages of love as its subject, and three couples, by their compositional arrangement and physical interaction, create a visual metaphor for the temporal development of romantic ardor.

As was his habit, Watteau painted his landscape first, a practice de Piles had encouraged landscape painters to adopt. As de Piles advised, Watteau painted his sky a brilliant blue at the top of the canvas, but he allowed it to "[grow] clearer as it approaches the earth, because of the interposition of vapors arising between the eye and the horizon";[7] his grassy lawn is composed of "several sorts of greens intermixed and blended together … this diversity of greens, as it is found in nature, gives a character of truth to those parts"[8] and "the trees in them have different verdure and different colors from those grounds."[9] Watteau's admixture of trees, without regard to season—some leafless and dying; some with foliage turning to gold or red with the onset of autumn; some in the full, green bloom of summer—also found its rationale in the *Cours de peinture*: "Though diversity be pleasing in all the objects of landscape, it is chiefly in trees that it shows its greatest beauty … [The] sport of nature delights in making some [branches] very vigorous and thick, others more dry and thin; some more green, others more red or yellow. The excellence of practice lies in the mixture of these varieties."[10]

FIG. 12. M. Baquoy after Antoine Watteau, *La ruine*, ca. 1710.
Engraving, 9¼ × 12¼ in. (23.5 × 31.1 cm.). Private collection.

Watteau painted his figures over the completed landscape, adjusting them to accord with the background as de Piles instructed: "An artist may, as it commonly happens, have only thought of his figures after finishing his landscape . . . But, I am persuaded that the best way to make figures valuable is to make them agree with the character of the landscape, that it may seem to have been made purely for the figures. . . . Resting figures have to be made to appear inwardly active . . . [and] as landscape figures are generally small, they must be touched with spirit, and such lively colors as will attract, and yet preserve probability, and a general union."[11]

In the center of Watteau's *La perspective* is the framework of Crozat's mansion, a fairy-tale castle sparkling in the sun at the end of a long perspective of trees. In fact, when Crozat acquired Montmorency in 1709, he commissioned a second, larger *château* to be built in the southeastern corner of the property where it

would command more spectacular views. This was to become his main residence, while the original mansion, which overlooked a long reflecting pool, was gutted and its two-storied loggia turned into an open-air *maison de plaisance*. Watteau recreated this central, newly transparent section of the old house in the background of his painting. His scrupulously accurate depiction of the *château* uncannily evokes one of the most memorable sections of de Piles's treatise, a passage on the inclusion of buildings in landscape paintings that raises for the first time the aesthetic and intellectual appeal of ruins: "Buildings in general are a great ornament in landscape, even when they are 'Gothick,' or appear partly inhabited and partly ruinous: they raise the imagination by the use they are thought to be designed for; as appears from ancient towers, which seem to have been the habitation of fairies."[12]

Watteau had earlier included ruins in some of his compositions, notably in *La ruine* (fig. 12), a painting

FIG. 13. Antoine Watteau, *The Portal of Valenciennes*, ca. 1710.
Oil on canvas, 12¾ × 16 in. (32.5 × 40.5 cm.). The Frick Collection, New York.
Purchased with funds from the bequest of Arthemise Redpath, 1991.

from the collection of his patron Jean de Jullienne that has been lost since the eighteenth century and is known only from an engraving.[13] Beneath a moss-covered arcade, a small group of pilgrims pass through an ancient, crumbling aqueduct. The men wear whimsical troubadour costumes, but the central group—a man leading a donkey bearing a simply cloaked woman with a swaddled infant—is certainly meant to evoke images of the Holy Family on the flight into Egypt. Although Emile Dacier believed the ruins to be those of an actual site, the Abbaye de Saint-Maur near Nogent (where Crozat had a house), Watteau employed them not for their ecclesiastical associations or merely for their picturesque qualities but, counterintuitively, to signify the Old Testament, which the new Christian order (as represented by the infant Jesus) was to replace—a symbolic contrast made by artists since the Renaissance.

Watteau had also incorporated ruins into the settings

of some of the military paintings with which he first established his reputation around 1709–10. In the now-lost *Départ de garnison*[14] and *The Portal of Valenciennes* (fig. 13), architectural ruins allude not to the ancient world, either triumphant or in defeat, but to the physical scars that war had left on France's modern landscape.[15] In *The Portal of Valenciennes*, seven infantrymen relax at sunrise beneath the city gates, part of Vauban's recent fortifications. It is a tender appreciation of manly camaraderie, one of the artist's gentlest and most elegiac depictions of ordinary men at war. Like the shabby uniforms, antiquated weapons, and weary poses of the soldiers, the setting of decaying fortifications is picturesque at one level only: along with these motifs, its battle-scarred walls and crumbling masonry are also emblematic of the terrible cost inflicted on the city by the last, vain war of Louis XIV.

However, in *La perspective* and other *fêtes galantes*,

Watteau employed ruins with an originality and sophistication that expanded the potentialities of the pastoral genre. The loggia at Montmorency, though gutted and transparent, was not in any true sense a ruin; rather, Watteau recreated it as a ruin, to "raise the imagination," as de Piles wrote, like the "ancient towers . . . which seem to have been the habitations of fairies." A pronounced harmoniousness and equilibrium characterize *La perspective*; its Edenic atmosphere is heightened by the enveloping landscape setting that seems to isolate the small community of lovers from the outside world and by the marble loggia that shimmers in the distance like an enchanted palace.

Seventeenth- and eighteenth-century painters made use of ruins in their art for various reasons, and we interpret their meaning based on the larger context provided by the particular painting in which they appear. As we have observed, Watteau used ruins for different purposes: to suggest the biblical past, to invoke the depredations of war, and to evoke a fantasy of romantic aspiration. But he also called upon ruins to summon evocations of a lost arcadian past. Having never traveled to Italy (much to his regret), Watteau had no direct experience of the remains of ancient monuments that other French painters were able to study during their apprenticeships at the Académie de France in Rome. The ruins he reproduced, therefore, were almost never authentically antique; instead, he depicted modern structures—Renaissance and Baroque palaces, towers, and garden terraces—in a ruinous or decaying state.

In an act of imaginative transformation, Watteau used collapsing shacks and rustic buildings as surrogate ruins. For de Piles, Titian was the standard-bearer of the pastoral style, and young artists who inclined toward the pastoral mode were encouraged to emulate his works— in particular his many poetic landscape drawings and prints—before they ventured to study nature herself.[16] Watteau assiduously pored over the enormous and celebrated collection of landscape drawings by Titian and Domenico Campagnola assembled by Crozat, many of which had been purchased from de Piles's estate. Approximately twenty of Watteau's copies are known today, and they meticulously reproduce not just the rolling countryside of the Italian landscapes but also the groupings of windmills and thatched-roofed cottages that ornament them.[17] These dilapidated structures,

reproduced in Watteau's drawings, occasionally find themselves transplanted directly into the backgrounds of Watteau's paintings, as when a castle and water mill from a copy of a Campagnola in the Art Institute of Chicago reappear in the background of the *Leçon d'amour* in the Nationalmuseum, Stockholm,[18] or when similar *fabriques* are incorporated into the landscape of *Diane au bain* (Paris, Musée du Louvre), one of the artist's rare mythological paintings.[19] The ramshackle farm buildings that Watteau appropriated from sixteenth-century Venetian drawings would have found few parallels in Ovid's domain or in the real countryside around *Régence* Paris; instead, they enhance the elegiac mood that permeates his paintings by invoking memories of the pastoral groves of Titian, Giorgione, and their followers.

The *fêtes galantes* are set in a timeless world in which lovers wear contemporary street clothes, seventeenth-century garments, or theatrical costume; one in which modern musical instruments, decaying Baroque architecture, and classical statuary cohabit in the same panorama. Watteau sets his subjects in a latter-day Arcadia, and garden sculptures are marshaled to provide nostalgic allusions to an antique paradise in the same manner as ruined architecture. Sculptures appear in many of the *fêtes galantes*, but Watteau is not known to have directly copied any surviving works.[20] Though no precise prototypes have been found, Watteau's painted sculptures evoke the real ones that he would have seen in the grounds of great estates, such as Montmorency, and in royal parks, such as the jardin de Luxembourg, where he is recorded as having spent much of his time drawing *en plein air*. "It was to the Luxembourg that he would go to draw the trees of its fine gardens, which presented countless vistas since they were laid out and less manicured than those of the other royal residences," wrote his friend the Comte de Caylus in *La vie d'Antoine Wateau*, which he read to the members of the Académie royale in 1748. "These vistas could be enjoyed by the true landscape painter, one who is able to find variety in a single place either from the innumerable viewpoints he adopts, or from the conjunction of distant views, or, finally, from the light shed by the morning and evening sun, which is capable of transforming the same place." In this obituary, read out more than a quarter century after Watteau's death, Caylus implied that Watteau was "a true landscape painter."[21]

FIG. 14. Antoine Watteau, *Le pèlerinage à l'île de Cythère*, 1717. Oil on canvas, 50¾ × 76⅜ in. (129 × 194 cm.). Musée du Louvre, Paris, Inv. 8525.

Watteau's imagined sculptures communicate a Baroque vitality characteristic of seventeenth- and eighteenth-century statuary, but they depict classical subjects from antiquity: an armless herm of Venus, draped in garlands of roses, presiding benignly over her domain as pairs of lovers prepare to depart the Island of Love in *Le pèlerinage a l'île de Cythère* (fig. 14);[22] a full-length goddess of love withholding arrows and a quiver from her son, Cupid, in Jean de Jullienne's replica of the *Embarquement pour Cythère* (fig. 15);[23] the leering bust of a Greek philosopher who watches over the self-confident lovers in *La promenade* (fig. 16);[24] a pointy-eared satyr herm who closes his eyes to the awkward isolation of the *commedia dell'arte* clown *Gilles* (fig. 17).[25] Though they identify the settings of Watteau's paintings as contemporary parkland, the sculptures also serve to invoke classical antiquity and thus underline—

and comment upon—the themes of love and sexuality in Watteau's arcadian pastorals.

The small panel called *Amusements champêtres* (fig. 18) almost perfectly exemplifies Watteau's pastoral genre.[26] In an overgrown woodland two couples gather rosebuds. A few feet away a little girl carrying roses in her apron observes the couples with intense fascination, while a small boy watches her, rapt but perplexed; although the children's future may be unfolding, they are not yet ready to participate in it. Behind the figures are rustic buildings—a tower and a watermill, thatched and partly ruinous—that come from one of Watteau's red chalk copies of a drawing by Campagnola that had been in Crozat's collection.[27] Beside the figures is a garden sculpture of two putti mounting and wrestling a male goat. This sculpture was a great favorite of Watteau's (it reappears in *Récréation galante* in Berlin,[28]

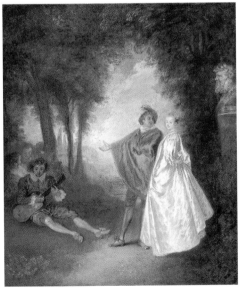

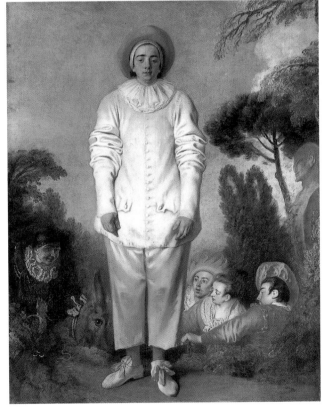

FIG. 15 (*top*). Antoine Watteau,
L'embarquement pour Cythère, ca. 1718.
Oil on canvas, 50¹³⁄₁₆ × 76⅜ in. (129 × 194 cm.).
Schloss Charlottenberg, Staatliche Schlösser,
und Gärten Berlin, Berlin.

FIG. 16 (*above*). Antoine Watteau,
La promenade, ca. 1719–20. Oil on canvas,
14¼ × 12⅝ in. (36.3 × 32 cm.). Private collection.

FIG. 17 (*right*). Antoine Watteau, *Gilles*
(or *Pierrot*), ca. 1718–19. Oil on canvas, 72⅜ × 58⅞ in.
(184.5 × 149.5 cm.). Musée du Louvre, Paris. Bequest
of Dr. Louis La Caze, 1869, R.R.C. 925.

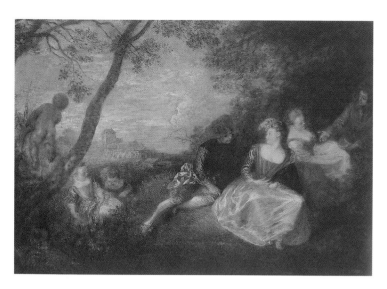

FIG. 18. Antoine Watteau, *Amusements champêtres*, ca. 1716–18. Oil on panel, 12⅝ × 18½ in. (32 × 47 cm.). Private collection.

La famille in the Ortiz collection,[29] and the lost *La cascade*)[30] and harkens back to early paintings of drunken, Bacchic scenes with putti cavorting with goats, such as *Les enfants de Sylene* and *Les enfants de Bacchus* (both lost).[31] Three of Watteau's chalk studies of the sculpture survive, showing the group from different angles.[32] The sculpture is similar to *Les enfants à la chèvre* (Paris, Musée du Louvre), a marble by Jacques Sarrazin, and Watteau may have copied a lost variation of Sarrazin's model.[33] In *Amusements champêtres*, the sculpture symbolizes the passionate, almost violent, nature of nascent love, alluding to emotions that lie beneath the surface as the two couples engage in decorous flirtation as well as to the passions that lie in store for the young children. Watteau enriches his scene of contemporary romance by embedding it in a poetic landscape whose architecture transcends time and geography, embellishing it with rituals that derive from classical poetry (gathering rosebuds), and contrasting its restrained civility to the unconstrained sensuality of the ancient world (as represented by the garden statuary).

Watteau's immediate followers were unable to match the subtlety and sophistication of his visual poetry, even if they adopted many of his ideas and motifs. Jean-Baptiste Pater[34] (1695–1736) and Nicolas Lancret[35] (1690–1743) entered the Académie royale as painters of *fêtes galantes* and were immediately recognized as Watteau's principal disciples. Pater, a compatriot from Valenciennes, actually studied briefly under Watteau

himself and made a highly successful career producing charming, if derivative, imitations of his master's works. He stepped into the commercial void left by Watteau's untimely death in 1721 and found himself supplying military subjects, theatrical scenes, and *fêtes galantes* for many of Watteau's patrons, including Jean de Jullienne.

Fête galante: La danse (*The Dance*), from the Art Gallery of Ontario (cat. no. 26), displays both Pater's obvious dependence on Watteau's example and the personal qualities he brought to his art. The painter did not neglect to include any feature that would be found in one of Watteau's canvases: the lush, enveloping garden with its grand, decaying stone staircase and columns; the rustic *fabriques* that ornament the background; the colorfully dressed lovers, dancers, and observing children, some in theatrical costume. The theme and composition are the same as can be found in Watteau's *fêtes galantes*, and some of the figures even are identical; they are just slightly rearranged. And yet something is lighter and more decorative in Pater's painting than in his master's prototypes. His brushwork is looser and more liquid, his palette of pearly pinks, silvery grays, and acid blues is cooler, brighter, and less autumnal than Watteau's. This difference in technique brings with it a lightening of mood and a reduction in the psychological complexity that is to be found in Watteau's paintings.

Although Pater left a large body of red chalk figure studies made in preparation for his paintings, they reveal little of the probing visual investigation and commitment to translating observed reality to paper that we find in Watteau's drawings from live models.[36] Pater's paintings display a similar shift of emphasis. Whereas Watteau's *fêtes galantes* are timeless romances that find their sources in Titian and Rubens, they are nevertheless rooted in the close observation of reality, whether it be the appearance of a particular landscape and its vegetation, the precise mechanics of human movement, or the physical expression of psychological and emotional states. Pater's paintings almost entirely ignore these fundamentals in order to achieve a generalized, ornamental simulacrum of reality whose principal function is decorative. In his masterpiece, the so-called *Fair at Bezons* (fig. 19), countless numbers of socially diverse, doll-like revelers—townsfolk, villagers, aristocrats, musicians, actors in masquerade (some of whom are directly

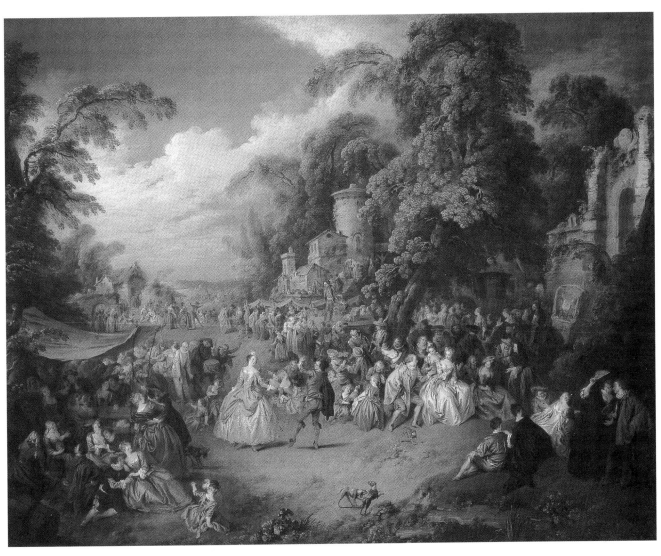

FIG. 19. Jean-Baptiste Pater, *The Fair at Bezons*, ca. 1733–36. Oil on canvas, 42 × 56 in. (106.7 × 142.2 cm.).
The Metropolitan Museum of Art, New York. The Jules Bache Collection, 1949, Accession no. 49.7.52.

quoted from Watteau)—dance, flirt, and watch theatrical performances in a vast, panoramic meadow.[37] Lacking any corporeal reality or individual expression, Pater's figures are still charming, lively, and colorfully attired. Despite the association of this event with a village on the outskirts of Versailles, the background of gracefully arching trees, rustic buildings, and ancient stone ruins resembles no known topography but creates an artificial and cheerful wonderland in which each element, included solely for its picturesque appeal, emits no deeper resonance.

Pater's Rubensian color and Titianesque freedom of brushwork—evident in Oberlin's *Fête champêtre* (cat. no. 27)—derive not from his direct study of the Old Masters themselves but are secondhand, a result of his

emulation of Watteau's works. Nevertheless, Pater would certainly have been familiar with de Piles's ideas, and he could have found support for his manner in the theorist's advocacy of greater pictorial unity, his appreciation of playful eccentricities, and his admiration for the sketchy or freely brushed. Indeed, the Oberlin picture, which has sometimes been considered a sketch or an unfinished canvas, is one of a group of finished paintings that Pater executed in an exceptionally free manner intended to appeal to the developing taste among sophisticated collectors for *ébauches*, or sketches. De Piles, who owned several oil sketches by Rubens, advocated this trend.[38]

Pater's robust and uncomplicated version of the *fête galante* emphasized the decorative possibilities of

Watteau's pastoral genre, a tendency that would be further developed in the overtly ornamental paintings of Jean-Baptiste Oudry[39] (1686–1755) and Jacques de Lajoüe[40] (1686–1761). Lajoüe is arguably the most important practitioner of what would come to be known as the *genre pittoresque*, a frankly artificial and consciously rococo style of painting that emerged following Watteau's death and was popular throughout the 1720s and 1730s. Its theoretical sources can be traced to de Piles's advocacy of the transitory but dramatic effect and the unexpected or accidental in painting, and to his appreciation of the oddness of natural forms—which he referred to as endowed with "une certaine bizarrerie."[41] Charles Coypel, a writer and history painter who dabbled in the *genre pittoresque*, defined it as "un choix piquant et singulier des effets de la nature."[42]

Lajoüe was accepted into the Académie royale in the year of Watteau's death as a painter of architecture, and his most inspired paintings are extravagant, whimsical, and highly improbable interpretations of Watteau's *fêtes galantes*. Not unexpectedly, architectural forms dominate his compositions. *The Fountain of Bacchus* (cat. no. 21), one of his masterpieces, includes most of the elements that de Piles described and that we have come to expect in a French pastoral painting, however unconventional: an extensive, untamed garden with colorful trees and autumnal foliage; fancifully costumed figures; garden sculpture and evocatively ruinous architecture. But in Lajoüe's painting, humanity is overwhelmed by a forest growth so tall and opulent that it seems almost prehistoric, and the great fountain—with its shooting jets of water, overgrown stone walls, and broken sculptures of Silenus and his satyrs—erupts from the earth like a geological phenomenon, towering unnaturally above its surroundings. The vigorous animation and coarse sensuality of the Bacchic fountain sculptures provide a piquant contrast to the civility and restraint of the two young women who, with their Moorish servant, rest at the pool's edge. Despite its whimsy, the painting seems less an imaginary confection than a heightened version of reality refracted through the artist's powerful imagination.

In *Rendez-vous à la fontaine* (fig. 20), perhaps dating from the mid-1730s, Lajoüe imagines the ruined remains of an immense, Italianate palace approached from a double staircase, similar to one that fronts the Palazzo Farnese at Caprarola.[43] The staircase rises from a winding river, and graceful figures in fancy dress nimbly sidestep toppled columns and heavy chunks of broken entablature to mount its stairs. The figures are all in the style of Watteau, and the principal couple is copied directly from a print after Watteau's lost painting *Le bosquet de Bacchus*. Lajoüe's ancient edifice evokes no nostalgia for a glorious past lost in the mists of time: its remains are so irregular and irrational that it is impossible to imagine it intact; it has meaning only as an ornamental ruin. Here, every detail is calculated for maximum picturesque effect: a great shell-shaped fountain provides a rocaille blueprint for Lajoüe's design, to which the swirling wings of the staircase, curving terraces, bowing trees, and ovoid oculi of the marble arcade harmoniously, if asymmetrically, conform.

A sometime practitioner of the *genre pittoresque*, François Boucher (1703–1770) would be the last great innovator in the pastoral landscape tradition in eighteenth-century France.[44] He passed a lengthy apprenticeship etching copies of Watteau's drawings and paintings—more than a hundred in all—for the corpus of Watteau's works published by his friend Jean de Jullienne between 1726 and 1735. Among these were more than a dozen landscape drawings, all of which were reproduced by Boucher. Upon his return to Paris in 1731, having completed a three-year stay at the Académie de France in Rome, the young painter produced for the market rustic landscapes of decidedly Italianate subjects painted in a Dutch *bambochade* style, such as the *Capriccio View of the Farnese Gardens* of 1734 (New York, Metropolitan Museum of Art).[45] Boucher's interest in the French countryside seems to have developed as a result of his contacts with Oudry, the director of the Beauvais tapestry manufactory who commissioned him in the mid-1730s to design the tapestry series *Fêtes italiennes*. Boucher joined Oudry's sketching parties at Arcueil—the dilapidated park and gardens of the small, abandoned *château* of the Prince de Guise—and in the area around Beauvais, where he made a number of studies later worked up in the studio into landscape drawings remarkable for their painterly handling.[46]

The beautiful *Landscape with a Water Mill* from Kansas City (cat. no. 4), which is dated 1740, is characteristic of Boucher's painted landscapes of the late 1730s and early 1740s. The russet brown and red

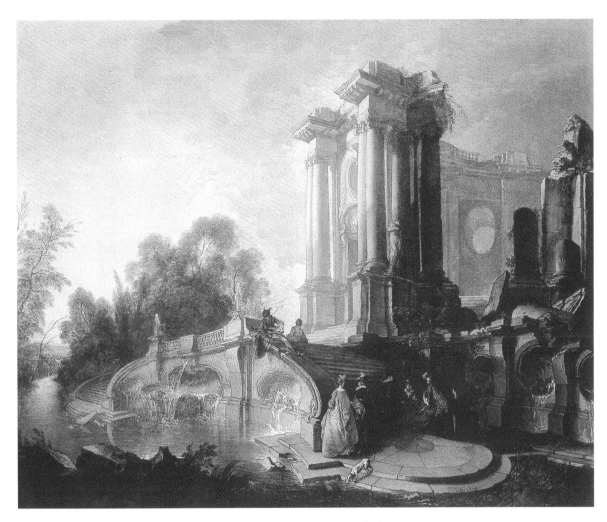

FIG. 20. Jacques de Lajoüe, *Rendez-vous à la fontaine*, ca. 1735.
Oil on canvas, 23¾ × 31¼ in. (65.5 × 79.5 cm.). Private collection.

palette of his earlier Italianate landscape has been replaced with cool, clear shades of blue and green, in keeping with the lighter colors favored in interior decoration of that decade. As Jo Hedley has recently observed, this brighter, bluish tonality may also have been inspired by the lyrical, decorative landscape paintings of the seventeenth-century French classicist Pierre Patel, one of whose pictures was in Boucher's own collection at the time of his death.[47] The wild vegetation and splayed tree stumps in the foreground of the Kansas City painting also betray the influence of the seventeenth-century Italian painter Salvator Rosa, whose paintings appeared regularly in Parisian collections of the day. (Indeed, the pendant *The Forest*, today in the Musée du Louvre, includes two figures of soldiers copied directly from a painting by Rosa.)[48] But the rustic water mill that dominates the left side of the

composition was studied at Beauvais on a sketching trip with Oudry (as is confirmed by an inscription on an engraving after a lost painting of the same mill by Boucher). Of course, similar water mills dotted the banks of the Seine and the Marne in the rural environs of Paris and were frequently depicted by Boucher's contemporaries, including Pater, Lancret, and Oudry; Boucher would have been predisposed toward them from his own experience years earlier etching Watteau's sketches of the mills and country cottages near Porcherons. A notable intrusion into Boucher's rustic idyll is the incongruous presence on the distant hill of the ruins of the Temple of Sibyl at Tivoli, surrounded by cypress trees. Three years later, Boucher would juxtapose a similar French water mill with the same ancient Roman monument in a ravishing landscape in the Bowes Museum. Alastair Laing has suggested that Boucher's

FIG. 21. Jean-Honoré Fragonard, *The Swing*, ca. 1775–80.
Oil on canvas, 85 × 73 in. (215.9 × 185.4 cm.).
National Gallery of Art, Washington, DC.
Samuel H. Kress Collection, 1961.9.17.

patent artifice in assembling these disparate elements in one location evokes the illusionism of the theater, and indeed the Abbé Gougenot praised Boucher's stage designs for their "heureux mélange des vues de Rome & de Tivoli, avec Sceaux & d'Arcueil."[49]

In his final decade, following Oudry's death, Boucher specialized in freely painted picturesque fantasies of the French countryside, created entirely in the studio and independent of any study from nature. Boucher honed his highly successful formula in small canvases like *The Dovecote* of 1758 from St. Louis (cat. no. 5) and *Idyllic Landscape with Woman Fishing* of 1761 from Indianapolis (cat. no. 6), which are amalgams of diverse elements absorbed during his long years as a master of many genres. He combined memories of Italy from his student days with his studies of real mills, dovecotes, and cottages encountered in the villages outside Paris. To this he added rustic architecture adapted from his etchings after Watteau and figural types

adopted from Abraham Bloemaert, whose drawings of peasants he also etched. Boucher assembled his sources in fluent and seamless arrangements, learned from years of designing tapestries, and sweetened the whole with touches of pastoral comedy, for which he drew on his experience as a theatrical designer. As late as the 1750s this frankly idealized, pre-Rousseauean vision of nature—a rural idyll for wealthy Parisians who rarely set foot in the actual countryside—could be seen as simple, informal, and "natural," even in advanced circles. However, by 1761, the year the Indianapolis *Idyllic Landscape* was painted, an anonymous Salon critic, praising Boucher as the preeminent landscapist of the day, nevertheless observed that "too much artifice and too many pleasing colors" were deployed in landscapes in which "plain and simple nature should reign."[50] The criticism, which reflected changing definitions of the natural as it had evolved since Watteau's era, failed entirely to comprehend Boucher's artistic aims. Like Watteau, Pater, and Lajoüe, Boucher had never set out to recreate nature faithfully on canvas; rather, his vision was of a domesticated nature in harmony with the people who inhabited it.

By the middle of the century, a new direction in landscape painting was taking hold in France, pioneered by the brilliant marine painter Joseph Vernet (1714–1789), who encouraged painting directly from nature as a corrective to the "faults" of those who studied the Old Masters and nature herself only as a preparation, and who then painted largely from the imagination. In the mid-1770s, Boucher's greatest pupil, Jean-Honoré Fragonard (1732–1806), would paint a final tribute to the pastoral landscapes of Watteau and Boucher in a huge suite of canvases for the Parisian collector Louis-Pierre Marchal de Sainscy that included the *Fête à Saint-Cloud* (Paris, Banque de France), *The Swing* (fig. 21), and *Blind Man's Buff* (Washington, DC, National Gallery of Art).[51] In overwhelming autumnal gardens that dwarf everything within them, beneath Italian cypresses and parasol pines, amid fountains and classical sculptures, lovers in fancy dress flirt with one another, play games, and watch traveling players perform. The paintings' gentle humor, lyric melancholy, and reverence for a timeless world in which man and nature are in perfect harmony return us momentarily to the island of Cythera and offer a graceful valediction for a passing tradition.

NOTES

My great thanks, as always, to Colin Bailey for carefully reading and editing this text and suggesting numerous improvements.

1. The bibliography on the debate between line and color in seventeenth-century French art is vast. The standard text is Teyssèdre 1957. An excellent summary in English appears in Thuillier 1964, 115–19.

2. Virtually everything we know of the life and career of Watteau comes from a half-dozen short obituaries, memoirs, and discourses written after his death by his friends or contemporaries. See Rosenberg 1984. The most important recent full-scale study of Watteau's career is Posner 1984. For a brief overview of his life and career, see Wintermute 1999, 8–49. On Watteau and Crozat, see Crow 1985, 39–57.

3. On de Piles and his theories, see Teyssèdre 1957; Puttfarken 1985; and Marianne Roland Michel, "Landscape Painting in the Eighteenth Century: Theory, Training, and Its Place in Academic Doctrine," in Wintermute 1990, 99–109.

4. De Piles 1708, 99; for English translation, see Marianne Roland Michel, "Landscape Painting in the Eighteenth Century: Theory, Training, and Its Place in Academic Doctrine," in Wintermute 1990, 99.

5. Marianne Roland Michel, "Landscape Painting in the Eighteenth Century: Theory, Training, and Its Place in Academic Doctrine," in Wintermute 1990, 100.

6. For the most thorough analyses of *La perspective*, see Alan Wintermute in Bailey 2003, 126–27, cat. no. 3; Zafran 1998, cat. no. 30.

7. De Piles 1708, 103; quoted in English translation in de Piles 1743, 128. For a more thorough discussion of de Piles and *La perspective*, see Alan Wintermute in Wintermute 1990, 129–38, cat. no. 20.

8. De Piles 1708, 108; quoted in English translation in de Piles 1743, 133.

9. De Piles 1708, 108; quoted in English translation in de Piles 1743, 135.

10. De Piles 1708, 114–15; quoted in English translation in de Piles 1743, 141–42.

11. De Piles 1708, 112–13; quoted in English translation in de Piles 1743, 139–41.

12. De Piles 1708, 109; quoted in English translation in de Piles 1743, 136.

13. Dacier 1921–29, vol. 3, cat. no. 171.

14. Dacier 1921–29, vol. 3, cat. no. 276.

15. Alan Wintermute in Bailey 2003, 122–23, cat. no. 1.

16. On de Piles and Titian and the Venetian influence on Watteau, see Robert Cafritz, "Rococo Restoration of the Venetian Landscape and Watteau's Creation of the *Fête Galante*," in Cafritz 1988, 149–81.

17. See Rosenberg 1996 for Watteau's copies after Venetian masters, especially Campagnola; see also Wintermute 1999, 22–24 and 120–22.

18. See Alan Wintermute in Wintermute 1990, 126–29, and cat. no. 19.

19. On *Diane au bain*, see Bailey 1992, 180–85, cat. no. 13.

20. The classic study of sculpture in Watteau's paintings is de Mirimonde 1962, 11–20.

21. Caylus's text is reproduced in Rosenberg 1984, 61–62.

22. Pierre Rosenberg in Grasselli 1984, cat. no. 61.

23. Pierre Rosenberg in Grasselli 1984, cat. no. 62.

24. Alan Wintermute in New York 1986b, cat. no. 5.

25. Pierre Rosenberg in Grasselli 1984, cat. no. 69.

26. Pierre Rosenberg in Grasselli 1984, cat. no. 52.

27. Rosenberg 1996, cat. no. 430.

28. Pierre Rosenberg in Grasselli 1984, cat. no. 63.

29. Pierre Rosenberg in Grasselli 1984, cat. no. 54.

30. Dacier 1921–29, vol. 3, cat. no. 28.

31. Dacier 1921–29, vol. 3, cat. nos. 273 and 221, respectively.

32. Rosenberg 1996, cat. nos. 428 and 429.

33. Rosenberg 1996, cat. no. 428, fig. 428a.

34. The standard study of Pater's life and works remains Ingersoll-Smouse 1928.

35. The standard study of Lancret's life and career is Wildenstein 1924. The most important recent study of Lancret is Holmes 1991.

36. On Pater's drawings, see Margaret Morgan Grasselli, "Problems of Connoisseurship in the Drawings of the Watteau School: New Attributions to Pater, Lancret, and Portail," in Wintermute 1999, 56–67.

37. See C. Martin Vogtherr in Bailey 2003, 160–61, cat. no. 21.

38. On de Piles's sketches by Rubens, see Wieseman 2004, 52–53.

39. Opperman is Oudry's most important modern biographer; see Opperman 1983.

40. Marianne Roland Michel has provided the most comprehensive study of Lajoüe; see Roland Michel 1984.

41. De Piles 1708, 125.

42. Quoted in Opperman 1983, 46.

43. Roland Michel 1984, 214–15, cat. no. P156.

44. For Boucher, see New York 1986.

45. See New York 1986, cat. no. 23.

46. New York 1986, 183–87.

47. Hedley 2004, 84–85.

48. New York 1986, cat. no. 35.

49. New York 1986, 212–13, cat. no. 46.

50. New York 1986, 291.

51. Rosenberg 2003, 247–57.

John Lord Wodehouse.
1762.

STEPHEN D. BORYS

Documenting and Collecting Ruins in European Landscape Painting

Yesterday ... I saw some ruins, beloved ruins of my youth which I knew already ...

I thought again about them, and about the dead whom I had never known and on whom

my feet trampled. I love above all the sight of vegetation resting upon old ruins;

this embrace of nature, coming swiftly to bury the work of man the moment his hand

is no longer there to defend it, fills me with deep and ample joy.[1]

GUSTAVE FLAUBERT, *CORRESPONDANCE*, 1847

Architecture—more specifically, architecture in the guise of the ruin—offers the viewer a sense of time and place and often provides the only evidence of man's existence, either heightening or obscuring these traces. Ruins tend to point to the past, but as a fixture of the landscape they remain linked to the present. In landscape painting, ruins have the distinction of belonging to the man-made as well as the organic fabric of the landscape, and artists have treated them as both. In his *Correspondance* Gustave Flaubert recalls the ruins of his youth, linking them to nature, decay, and the transience of life. In their depictions of ruins, painters have done the same—reclaiming these monuments, arresting their decline, and preserving their physical and spiritual presence in the painters' own views of nature. For some artists the ruin becomes a form of *memento mori* fixed

in the landscape setting, a motif or historical reference. Others regard the ruin as simply one element in the composition, merging with foliage and staffage and animating each ground. But with each occurrence in the landscape painting, it is reinterpreted and revived and, in a measure, given new life and meaning. As an object or motif separated from its original position and meaning, the ruin in art and literature is inextricably linked to those first observations and recordings that reconsidered its place in the past and the present.[2]

The Splendor of Ruins explores various interpretations of the ruin as envisaged by French painters of the

FIG. 22 (*facing*). Pompeo Batoni, *Portrait of John Wodehouse*, 1764. Oil on canvas. Allen Memorial Art Museum, Oberlin College, Oberlin, Ohio. Mrs. F. F. Prentiss Fund, 1970.60.

seventeenth and eighteenth centuries, a period span-
ning the careers of Claude Lorrain from the 1630s and
Hubert Robert at the close of the eighteenth century.
This essay examines some of the written and illustrated
responses to the ruin—by artists, architects, and travel-
ers, and by the art museum in the assembling of images
of ruins. For artists and patrons, these monuments
evoked the triumphs and mysteries of ancient worlds,
the glories of mythology and biblical narratives, archae-
ological discoveries, as well as the familiar images of the
Grand Tour.

Beginning in the early sixteenth century, the architec-
tural ruin took on a more prominent role in landscape
painting, first championed by the Italian artists and
later adopted by painters in France. Annibale Carracci,
emulating the great tradition popularized by Titian, is
often credited with creating the classical landscape in
which ruins played a central role in both the composi-
tion and the subject of the painting. By the seventeenth
century, the ruin had become an integral part of the nat-
ural topography of the landscape, as vital as the foliage
and staffage. Claude and Nicolas Poussin led the French
school in appropriating the ruin for their landscapes,
and, in the generations that followed, artists experi-
mented with the structural and spatial complexities
of monumental architecture. They began to combine
and contextualize disparate monuments arbitrarily
into visionary compositions filled with references to the
past and present. By the end of the eighteenth century,
Robert had brought the ruin to new levels of aesthetics
and historicism in his magnificent compositions, which
venerated the triumphs of classical, medieval, and con-
temporary architecture.

The life of the ruin as both an artistic and a histor-
ical phenomenon is closely linked to the culture of the
Renaissance and the ensuing centuries, reaching a high
point in the eighteenth century. At no other point in the
history of painting has there been so much focus on the
antique monument and a corresponding demand by
patrons for painted facsimiles of these historical struc-
tures. Many factors were involved in the architectural
ruin becoming popular in the Renaissance and subse-
quent centuries, and in what exactly fueled its develop-
ment and reception by the artistic and scientific circles
in Europe. The rise of the ruin was largely precipitated
by the ideas, inventions, discoveries, and respective

personalities and institutions associated with the
advancement of the arts and sciences in the Renaissance.
The appropriation and translation of what was consid-
ered noble and superior about the past had become a
serious preoccupation with artists and intellectuals and
their circles. The architecture of ancient worlds was part
of this transcendence of classical ideas and motifs: build-
ings and monuments long since abandoned were restored
to the physical and spiritual fabric of modern society,
and ruins became a new phenomenon. As the historian
of art and archaeology Claire Lyons writes:

> The evolution of ruins from disintegrating structures to
> historical monuments of cultural, political and historical
> significance occurred as the understanding of their form
> and meaning advanced. Abandoned buildings were ini-
> tially seen as little more than material remnants connected
> with legends and myths of origin, and they served to legit-
> imize the authority of sacred and secular traditions. As
> Northern European scholars applied more sophisticated
> technical and interpretive methodologies to the remains of
> ancient architecture, the ruins of classical antiquity came
> to be regarded as paradigms of artistic excellence through
> which humanistic values were transmitted.[3]

The desire to chronicle the cultural achievements of
the past and establish links with the present was very
much allied to the thinking of the Renaissance world.
By the end of the sixteenth century, Rome had become
the center for this academic and artistic activity and the
gathering point for those individuals dedicated to the
cause. The intellectual and stylistic evolution that came
to define the Renaissance was accompanied by the
rediscovery of antique models, which laid the foun-
dations for a modern humanism. In his study of the
revival of classical traditions, T. Barton Thurber notes:

> Historians, archaeologists, and theologians sought to
> chronicle and catalog ancient history, artifacts, and
> rites. . . . Gradually, systematic excavations replaced ran-
> dom discoveries, while existing collections were often
> reorganized according to different didactic criteria.
> Concurrently, the circulation of vast quantities of draw-
> ings, prints, and illustrated publications reproducing both
> notable monuments and common objects sustained an
> expanding international community of connoisseurs.
> The development of these antiquarian pursuits eventually
> led to the birth of modern archaeology and art history.[4]

When looking at the ruin in landscape painting, the question arises of what exactly artists saw and understood when documenting the ruin—what were the visual sources? Did they see the ruin in person; had it been dismantled, transplanted to another site, and rebuilt; was it taken from an earlier sketch, accessed through a painting or print, copied from an illustrated text or model, composed from images in a guidebook, or imagined and created entirely by the artist? These are the typical ways in which the ruin is introduced to the landscape painting. For the viewer, a number of factors help the investigation of the state and sources of the ruin in painting. Much is culled from the life of the artist: diaries and biographies, places of residence, travel itineraries, apprenticeships and studies, teachers and colleagues, academic associations, public and private commissions, and artists' personal art collections and libraries. Records that situate an artist in Rome or other centers of antiquity at a certain time are the strongest testimony to the particular sources in their paintings.

In addition to firsthand experience of the ruins, artists were inspired and influenced by their colleagues' works and by artists whose work was accessible through collections, salons, and other means. Copying a ruin from another painting was perhaps the most common way for artists to introduce the subject in their own paintings. Studios, salons, auctions, and private and public collections provided artists with an abundance of images for study and source material. Prints made after paintings were another way artists could see contemporary reproductions of works of art in other collections. Added to this was the production of illustrated architectural books, archaeological publications documenting recent excavations, guidebooks for the Grand Tour, and travel diaries. These relatively new and specialized recordings of architectural sites and monuments, often supported by firsthand accounts by architects and artists, significantly augmented the existing body of treatises produced in the fifteenth and sixteenth centuries devoted to the study and appreciation of classical and modern architectural orders and styles. By the end of the eighteenth century, artists, collectors, tourists, amateurs, and anyone interested in ruins had access to a large number of illustrated publications to guide them through their visits.

Rediscoveries of ancient sites and monuments, and the subsequent archaeological excavations in Italy, Greece, Syria (Balbec and Palmyra), and other countries in the Middle East, provided artists and travelers with new destinations to see ruins from ancient civilizations. In Italy, outside Rome and the *campagna*, travelers could now explore the ruins and excavations in Pompeii, Herculaneum, Naples, Paestum, and Sicily.[5] Supporting the discoveries and activities at these sites were newly published illustrated books containing engravings of the ruins accompanied by texts and measurements documenting the monuments and sites. These publications included Roland Fréart's *Parallèle de l'architecture antique et de la moderne* (1650); Antoine Desgodets's *Les édifices antiques de Rome* (1682); Robert Wood's *Ruins of Palmyra* (1753) and *Ruins of Balbec* (1757); David Le Roy's *Les ruines des plus beaux monuments de la Grèce* (1758); Jean Barbault's *Les plus beaux monuments de Rome ancienne* (1761); James Stuart and Nicholas Revett's *Antiquities of Athens* (1762–1816); Robert Adam's *Ruins of the Palace of the Emperor Diocletian at Spalatro in Dalmatia* (1764); Thomas Major's *The Ruins of Pæstum, otherwise Posidonia, in Magnia Græcia* (1768); Society of Dilettanti's *Ionian Antiquities* (1769); and Louis-François Cassas's *Voyage pittoresque de la Syrie, de la Phénicie, de la Palestine, et de la Basse Egypte* (1799). The prints of Giovanni Battista Piranesi, published from the 1740s until his death and then posthumously by his sons, also featured the antique and modern architecture and monuments of Italy.[6]

Piranesi (1720–1778) was a significant influence on artists and patrons in their depictions and views of the ruin. Six of the artists (and one-third of the paintings) in the *Splendor of Ruins* exhibition were directly or indirectly influenced by Piranesi's work. Piranesi devoted his early years to painting *vedute* as souvenirs for travelers on the Grand Tour; however, by 1750 he had begun a systematic documentation of the ancient buildings and monuments of Rome, the plates published in his *Le Antichità Romane* and *Vedute di Roma*. His depictions of ancient ruins and exhaustive visual analyses of antique artifacts, mixed with his architectural fantasies, not only dispersed images of ancient Rome throughout Europe but communicated a profound awareness of the triumphs of the Roman Empire. Piranesi was criticized for his obsession with the Roman

FIG. 23. *Foro Romano*, Overview. Steven Brooke, *Views of Rome*
(New York: Rizzoli, 1995), plate 28.

Empire; however, it was precisely his impressive vocabulary of the past that resonated with the later generations of neoclassical and Romantic artists.

In her anthology of British architectural books and writers, Eileen Harris notes that those publications known as archaeological books were "principally concerned with the remains of ancient buildings, measured and drawn *in situ*. They were a new species, deliberately conceived to replace the poorly illustrated verbal descriptions published by earlier travelers, in which architecture was one of several subjects treated, with a predominantly graphic work giving fuller, more detailed, more immediate information in plate."[7] Illustrated books and contemporary accounts of visits to the ancient sites provided the most accurate picture of the ruin, as well as correcting many of the discrepancies over the state of the ruin and the circumstances surrounding current and past excavations. That there were considerably more architectural publications in the eighteenth century than at any other time, and that

many of these books were first published in English, is directly related to the timing of these rediscoveries and the associated excavations. Moreover, it is a reflection of the impact of the Grand Tour and the increased demand for these books by travelers about to embark on their tours and those just returning.

Architectural books for the Grand Tour were used as reliable study documents for architects and artists, and they also functioned as a resourceful guide for the traveler. Two of the prototypes for these publications were actually conceived in Rome in 1749 by "a group of English travelers, collectors, scholars, and artists, planning separate expeditions to Greece and Asia Minor."[8] The journeys took place the following spring: Robert Wood embarked from Naples for Syria with his supporters James Dawkins and John Bouverie (visiting Palmyra and then Balbec on their return), and James Stuart and Nicholas Revett left Venice for Athens, resulting in *The Ruins of Palmyra*, *The Ruins of Balbec*, and *The Antiquities of Athens*.[9] The men saw

themselves as "reporters whose principal task was to provide a full, accurate and candid account of whatever remains of ancient monuments they found, 'as they found them,' " and their model was Antoine Desgodets's *Les édifices antiques de Rome* (1682).[10] The firsthand observations, detailed descriptions, and precise measurements that accompanied the prints were meant to give as much information as possible for each monument presented. Subscribers included royal personages, members of the upper classes and nobility, clergy and other church officials, architects, artists, academies, and institutions of higher learning. For artists who visited the sites and studied the ruins, the books served as guides and later as references when they were back in their studios. For those who never saw the ruins in person, the books were an invaluable tool for the depiction of antique monuments in their own work. While they could copy ruins from other pictures, these architectural texts provided artists with detailed information about the buildings. Used in tandem, the illustrated books and contemporary travel diaries afforded the serious reader the most current information on the buildings and their physical settings. Added to these earlier documents were the illustrated guides and topographical dictionaries that proliferated in the nineteenth and early twentieth centuries following the major excavations of ancient buildings and sites throughout Italy and Greece.[11] These later publications, followed by photographs in the mid-nineteenth century, are probably the most useful in helping decipher the actual state of the ancient ruins in the seventeenth and eighteenth centuries, especially in relation to their representation in the paintings.[12]

For the most part the Grand Tour was an eighteenth-century phenomenon created by the British for wealthy or well-patronized travelers, artists and architects among them, to see the great cultural attractions of Italy. But it was not exclusive to the British: the Italians had their *peregrinazione academica*; the Germans had their *Kavaliersreise*; for French artists there was the Académie de France in Rome; and Scandinavians and Americans also participated.[13] The Grand Tour began as early as the mid-1600s and ended with the Napoleonic Wars at the close of the eighteenth century, although its high point came in the early decades of the eighteenth century when there was a formal peace between Great Britain and France.[14] The goal of the Grand Tour was to introduce travelers to new cultures, languages, history, and politics, and at the same time to equip them with a comprehensive survey of the fine arts and architecture in these foreign cities. As David Watkin notes, the tour

coincided with the eighteenth-century Enlightenment, which promoted new ideals of international brotherhood and sociability, of intellectual and moral improvement in a secular context.... Moreover, the international nature of the Enlightenment meant that the Grand Tour became by definition something fundamentally pan-European, the French, the Dutch, and the Germans, who established a famous colony in Rome. It also involved travel throughout Europe.[15]

The term *Grand Tour* is attributed to Richard Lassels (1603–1668), a Catholic priest and scholar, who in his *Voyage of Italy, or a Compleat Journey through Italy* (1670) wrote about the necessity of a Grand Tour through France and Italy for the student of antiquity, art, and architecture.[16] In his *Voyage*, Lassels concludes his account of Rome with the following note:

Having thus (as Painters do) taken Rome in all her posture, I confess it happened to mee, as it did to Apelles taking the picture of Campaspè, that is, by looking so often attentively upon *Rome*, I began to be so farre in love with it, as not onely to subscribe to Cassiodorus his opinion, affirming it to be a kind of piaculary crime not to live in Rome when you can do it.[17]

This type of written account went hand in hand with the illustrated books and guides.

Although travel to Italy and Greece by people from the northern and eastern parts of Europe was not uncommon before this time, the more academically structured and culturally based itineraries for educated and wealthy tourists are linked to the 1700s. For the British travelers (and they came from all parts of the British Isles, including England, Ireland, Scotland, and Wales), the route went through France via Paris, entering Italy by way of the Alps or by boat from Marseilles. An alternate route was through the low countries and the Holy Roman Empire, approaching Italy via Switzerland or Austria.[18] Rome, Naples, and Venice were the most important cities on the itinerary, although Florence, Siena, Bologna, and Milan were also visited,

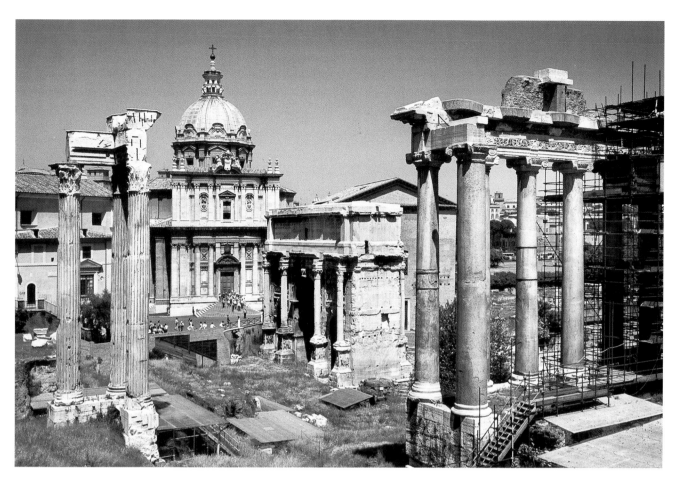

FIG. 24. *Tempio di Saturno, Arco di Settimio Severo, SS. Luca e Martina.*
Steven Brooke, *Views of Rome* (New York: Rizzoli, 1995), plate 33.

as well as Sicily. Rome and the surrounding hills and plains of the *campagna* had the greatest appeal to travelers. This was where, as Lindsay Stainton writes, "the battles between the ancient tribes of Latium and the Sabines, Volscians and Etruscans had taken place. The remains of temples, tombs and villas, picturesque monuments from the Imperial age, punctuated the landscape in a fashion that delighted travelers whose education had steeped them in ancient history and literature."[19] Traveling alone with a complement of servants or in small groups, participants on the Grand Tour stayed for weeks or months, depending largely on finances, weather, and the political climate. Others took several years to complete the journey, often becoming temporary residents of one of the cities on the tour.

VIRTUALLY ALL OF the antique structures depicted in this exhibition were subject to various physical modifications, both destructive and restorative, that significantly altered their appearance and function over the centuries. Aside from the earliest changes to these buildings under the direction of various rulers of the Roman Empire, most of the more radical modifications took place in the Renaissance, which witnessed a widespread conversion of pagan temples into Christian churches. Damage and losses also occurred as a result of new construction during this period, which involved the appropriation of building materials and the temporary utilization of the Roman Forum as an active quarry. Due to the systematic destruction of the Forum, including the removal of stones for other projects and the dumping of construction materials that could not be reused, sections of the main paved road through the Forum, the Via Sacra, were buried beneath forty feet of rubble.[20] In the eighteenth and nineteenth centuries, when many of the first archaeological discoveries and excavations began, the antique buildings sustained another series of modifications, most of them restorative in nature. By this time the cult of dismantling and

appropriation had been almost completely arrested, and ruins were actually being restored as ruins. In their depictions of these ruins, artists responded in a variety of ways. Examining the structures in person or using images from other paintings or illustrations, they could decide in what state of preservation the ruin would be presented in their paintings.

By the sixteenth century, all that remained of the Temple of Vespasian and Titus (figs. 24 and 39) were three columns and the corresponding sections of the entablature, as shown in Jean Barbault's painting *Ruins with the Temple of Jupiter* (cat. no. 2); the temple was erroneously called the Temple of Jupiter in the eighteenth century. Similar to the state of the temple in Barbault's picture, the fifty-foot-high columns were buried to two-thirds of their height by rubble from later buildings and excavations. Piranesi, a friend and colleague of Barbault, included a similar rendering of the temple in his *Alcune vedute di Archi Trionfali, ed altri monumenti* (fig. 38). Two other versions of the Temple of Vespasian and Titus included in Piranesi's works show the ruin from different viewpoints, and in both examples it is set against the backdrop of later buildings that surround the Forum.[21] In his painting, Barbault has done his best to avoid these later structures and adopts the view looking into the Forum, which is the same perspective taken by Piranesi in his first rendering of the temple from the *Alcune vedute*. Here the temple is viewed among other ruins in the Forum away from the intrusion of later structures. When excavations of the Capitoline Hill began around 1810, the ruins of the Temple of Vespasian and Titus were uncovered, the foundation was rebuilt, and the columns and entablature were reassembled.[22] The Temple of Saturn (fig. 24), with its thirty-six-foot granite columns visible in the distance at the right in Barbault's painting, was built on a much higher travertine base, which may explain why it was fully uncovered in the eighteenth century.

In its present state, the Temple of Vesta (figs. 23 and 53) near the Atrium Vestae in the Roman Forum is a nearly complete reconstruction of the temple, whose foundation dates to the rule of Augustus in the first century B.C. The circular temple contained the sacred fires that were kept burning by the Vestals, and, not surprisingly, the structure was burnt several times. Despite fire damage the temple stood until 1549, at which time the Fabbrica di S. Pietro dismantled the building, using the marble for other construction projects or burning it for lime. The foundation of the temple was rediscovered in the 1880s, completely excavated around 1900, and then partially restored in 1930.[23] The temple depicted in Claude's *Landscape with Nymph and Satyr Dancing* (cat. no. 14) is remarkably close to the design of the Temple of Vesta in the Forum; however, he must have drawn inspiration from the Temple of Vesta at Tivoli, as did many artists wanting to incorporate an antique temple in the round in their landscapes (fig. 41).

Across the Via Sacra from the Temple of Vesta is the Temple of Antoninus and Faustina (figs. 23 and 47), erected by the emperor Antoninus Pius (A.D. 138–161) in honor of his deceased wife Faustina (with Antoninus's name added by the Senate after his death). The remains of the temple are ten sixty-five-foot columns, six along the pronaos and two on each side, and fragments of the entablature, including a frieze of griffins, vases, and candelabra.[24] The conversion of the temple to the Church of S. Lorenzo in Miranda between the eighth and eleventh century actually did much to preserve the antique structure, saving it from destruction.[25] By this time, as a result of the deposits of debris in the Forum, the level of the Forum had risen to the height of the temple floor, covering completely the twenty-one steps leading to the pronaos. The reprieve from further destruction ended in the fourteenth century, when Pope Urban V (1310–1370) began appropriating stones and marbles from the temple for the rebuilding of the Lateran Palace. The spoliation ceased when Pope Paul III (1468–1549) handed the control of the temple-church over to the Fabbrica di S. Pietro, and, in 1811 when modern excavations began, the twenty-one steps were uncovered.[26] Sébastien Bourdon may have considered the Temple of Antoninus and Faustina as a prototype for the *Landscape with a Ford* (cat. no. 8); however, the artist diligently removed all traces of the Baroque architectural additions in order to present a more authentic classical landscape, inspired in part by the Old Testament caravan scenes made popular by Bassano and Castiglione.

Two of the oldest intact structures in Rome sit near the bank of the Tiber River on the Piazza Bocca della Verità, the ancient Forum Boarium: the so-called Temple of Vesta and the Temple of Fortune or Fortuna Virile

(figs. 55 and 56). According to Lanciani, no fewer than ten names have been attached to the circular Temple of Vesta, which was built in the second century B.C. and converted to a church, S. Maria del Sole, in the sixteenth century.[27] However, a more plausible dedication is to Mater Matuta, an Italian goddess of the dawn who is also associated with the sea and the harbor. Even before the conversion of the temple, the spaces between the twenty Corinthian columns were filled in to make the building larger and more functional. It was not until the early 1800s that the intercolumniations were reopened. The conversion of the Temple of Fortune to a church as early as the ninth century (and later dedication as the Armenian church of S. Maria Egiziacs in the sixteenth century) has undoubtedly added to its advanced state of preservation.[28] Like the Temple of Vesta, its Ionic columns were walled in at the time of Christian conversion, and not until 1551 was the temple properly excavated. The two temples that appear on the distant shore in Claude's *Coast View with the Embarkation of Carlo and Ubaldo* (cat. no. 15) are architecturally and symbolically linked to the two temples on the Forum Boarium. Aside from their corresponding positions in Rome and on the coastline in Claude's painting, the temples' dedicatory links to Mater Matuta and Fortune are equally compelling in a discussion of antique sources for Claude.

The Temple of Vesta at Tivoli (fig. 58) was one of the most popular classical buildings for seventeenth- and eighteenth-century landscape painters as well as for travelers on the Grand Tour. The temple, in its various states of preservation, appears in seven paintings included in the exhibition,[29] evidence that, for the composition of the pastoral landscape and its many incarnations from Claude to Vernet, the temple was a favored icon from the antique. Certainly its circular design and the dramatic setting on the Tiburtine acropolis, overlooking the waterfalls and river valley where the river Aniene descends to the Roman *campagna*, add to its appeal. Tivoli boasted several important ancient and Renaissance monuments, including Hadrian's Villa, Villa d'Este, the so-called Villa of Maecenas, and the two Roman temples overlooking the ravine. Artists and visitors alike often made the short trip from Rome to Tivoli to see the ruins and the great cascades. In the seventeenth century, only ten of the original eighteen Corinthian columns of the Temple of Vesta were intact.

Built in the first century B.C., the temple was converted to a church, S. Maria della Rotonda, in the fifteenth century. Several names and deities have been suggested for the dedication of the temple, including Tiburnus, Hercules, Vesta, and the two Sibyls Tibur and Albunea (the water goddess worshipped on the banks of the Aniene). The confusion between Vesta and the two Sibyls may be explained by the presence of an earlier temple situated next to the Temple of Vesta: the Temple of the Sibyl. Built in the Ionic style in the second century B.C., the rectangular temple was also converted to a church, S. Giorgio, in the fourteenth or fifteenth century. The representation of the Temple of Vesta by the artists in the exhibition reveals a surprisingly consistent and accurate rendering of the ruin as it appeared in the seventeenth and eighteenth centuries. Claude, Dughet, Boucher, Vernet, and Robert all visited Tivoli and were inspired by the Temple of Vesta and its breathtaking setting above the waterfalls and valley. As shown in their paintings, some of these artists went to great lengths to preserve the site and surroundings, while others transported the temple to a new locale to suit a particular composition or theme. Robert was fascinated with the different states of preservation and decay in the ruin; this is particularly evident when his depiction of the Temple of Vesta (cat. no. 29) is compared to Claude's various interpretations of the same structure (cat. nos. 12, 13, 14).

In the vicinity of the Temple of Vesta at Tivoli is the Temple of Tosse ("Temple of the Cough"), just outside the Porta del Colle off the via delle Cascatelle and built in the fourth century A.D. (fig. 44). Once thought to be a temple or possibly a tomb for the Turcia family, the structure is probably a monumental atrium with its cylindrical plan and cupola-styled roof. Situated on private land, the ruin is almost impossible to access today, and its structural instability prevents visitors from entering the building.[30] Its depiction in painting is sometimes confused with the Nymphaeum Hortorum Licianorum (the so-called Temple of Minerva Medica) in Rome, as in the case of Boucher's *Idyllic Landscape with Woman Fishing*, where the ruin is reminiscent of both structures (cat. no. 6).[31] However, the Nymphaeum is easily recognized in Jan Asselijn's *Landscape with Roman Ruins* (fig. 29). The large, originally domed structure in Rome was built by Emperor Licinius Gallenius (218–168 B.C.) and would have been situated in the Lician Gardens

FIG. 25. Domenico Zampieri, called Domenichino, *Landscape with Flight into Egypt*, ca. 1605. Oil on copper. Allen Memorial Art Museum, Oberlin College, Oberlin, Ohio. Mrs. F. F. Prentiss Fund, 1968.51.

on the Esquiline Hill.[32] Similar to the Temple of Tosse, the cylindrical brick and stone Nymphaeum has a series of semicircular niches (for sculpture) on the lower section of the exterior wall.

Ruins, by virtue of their frequent appearance in landscape paintings, hold a significant place in museum collections. Collecting the ruin—or assembling works of art that feature the architectural ruin—is closely linked to the viewer's comprehension and appreciation of the subject. The Allen Memorial Art Museum's holdings of paintings that include ruins represent a century-long tradition in collecting the ruin. The subject of ruins also extends to the collection of prints, drawings, and photographs. For the most part these works of art encapsulate the development of and response to the architectural ruin by both European and American painters represented in the collection. One of Wolfgang Stechow's goals as professor and curatorial advisor at Oberlin was to illustrate, with works of art, the development of landscape painting traditions from the sixteenth to the nineteenth century. Most of these major developments are represented in the museum with paintings and works on paper, and, for many of these works, the architectural ruin is very much a part of the compositions.

Domenico Zampieri, called Domenichino (1581–1641), is directly linked to the development of the classical landscape in European painting, and by extension to the depiction of the architectural ruin. Considering Domenichino's *Landscape with Flight into Egypt* (fig. 25), former AMAM director Richard Spear writes:

> It is true that the protean genius Titian opened wide the gates to the "classical landscape" early in the sixteenth century, and Annibale Carracci brought forth the first mature

FIG. 26. Abraham Jansz Begeyn, *Ruins of a Castle*, 1665.
Oil on canvas. Allen Memorial Art Museum, Oberlin College,
Oberlin, Ohio. Gift of A. Augustus Healy, 1919.6.

harvest at the century's close. But it was the latter's pupil
Domenichino, who, with characteristic patience and sensi-
tivity, developed a perfected hybrid that was destined to
play a major role in the development of French and Italian
landscape painting.[33]

For his choice of architecture in the Oberlin picture,
Domenichino has selected at least three classical monu-
ments for the group of buildings in the distance: the
Pantheon-like building at the right (also similar to the
Mausoleum of Caecilia Metella) and the two pyramids
in the style of the tombs of Scipio Africanus and Gaius
Cestius.[34] Ruins signify time and place with their veiled
references to Egypt, the decline of the Roman Empire,
and the arrival of a new world order. They also help to
define the role of architecture in the evolution of the
classical landscape. The convincing and elegant intro-
duction of these classical motifs marks a departure from
the painting tradition of Annibale Carracci.[35] In this
shift of artistic temperament we are aware of the style
that penetrates the oeuvres of Poussin and Claude,

as well as their followers. Of particular interest is the
architectural frieze employed by Poussin for *Moïse
sauvé des eaux* (fig. 48), which is also used by Sébastien
Bourdon (cat. no. 9) and Antoine Coypel (cat. no. 16)
in their paintings of the same subject. Moreover, all
three depictions of the ruins appear to be derived in
some manner from Domenichino's earlier arrangement
of the ancient buildings.

The northern artists who lived in Rome during the
seventeenth and eighteenth centuries played a significant
role in the shaping of European landscape painting,
and several of these artists are represented in the
AMAM collection, including Paul Bril, Jan Asselijn,
Bartholomeus Breenbergh, Herman van Swanevelt,
Thomas Wijck, Willem van Bemmel, Johannes Lingel-
bach, Jan Weenix the Younger, Jan Frans van Bloemen,
and Nicolaes Berchem.[36] On the contribution of the
Dutch Italianate painters to the development of land-
scape painting, Stechow writes:

> Like their French confrères, the Dutch landscape painters,
> while steeped in admiration for "Roma in Roma sepolta"
> and the delights of the Campagna, never surrendered their
> own mode of vision and style to formulas employed by
> painters of other schools; in essence, their eyes were as
> incorruptible as the eyes of the masters of the native Dutch
> scene.[37]

Ruins of a Castle, by the Dutch artist Abraham
Jansz Begeyn (1637/8–1697; fig. 26), was the first Euro-
pean painting depicting ruins acquired by the museum
in 1919.[38] Begeyn traveled to Italy and France and
became known for his Italianate coastal scenes, which
are often confused with the works of Nicolaes Berchem,
who is also represented in the collection.[39] Dated to
1665, the Oberlin picture shows the massive arches and
vaults of a Roman bath, remarkably similar to the baths
at Hadrian's Villa, Tivoli. The composition anticipates
the images of ruins by Piranesi, especially his *Carceri*
and *Carceri d'invenzione* series, and by Robert, whose
architectural elements encompass the entire composi-
tion. Begeyn is known to have collaborated with
Johannes Lingelbach (1622–1674) on several paintings
for which Lingelbach was responsible for the staffage.
The resemblance of the figures in their work is particu-
larly evident in Lingelbach's *Soldiers Looting a Peasant
Family* (fig. 27). A member of the *Bamboccianti* in

FIG. 27. Johannes Lingelbach, *Soldiers Looting a Peasant Family*, ca. 1650. Oil on canvas.
Allen Memorial Art Museum, Oberlin College, Oberlin, Ohio. Gift of Dr. Eva E. Sandis
in loving memory of Edith and Franz Gibian, 1999.13.

Rome, the German-born Lingelbach devoted most of his time in Italy producing these popular Italianate genre scenes featuring peasants, travelers, and soldiers. Lingelbach would have likely known Sébastien Bourdon, who was well acquainted with members of the *Bamboccianti* and produced several of these low-life scenes himself, such as the Oberlin *Encampment* (cat. no. 7).

Finished drawings and sketches—particularly those executed in Italy—by the northern artists form an important part of the landscape collection at Oberlin. Most of the artists represented were accomplished draftsmen, and, as a result, a major part of their work in Italy was devoted to sketching the sites of Rome and the *campagna*. One of the museum's earliest drawings

from Rome is *Landscape with Draughtsmen* (fig. 28) by the Dutch artist Herman van Swanevelt (ca. 1600–1655). Swanevelt's drawing characterizes much of the singular vision of the northern artist, a tradition founded in the north, cultivated in the south, and spread throughout Europe. In this particular drawing, Swanevelt's position between two generations of landscape painters—that of Adam Elsheimer and Paul Bril before him, and of Claude Lorrain and Jan Both after him—is clearly understood. Stechow writes: "The two figures in the foreground of the drawing probably represent a draughtsman and his friend absorbed in contemplation of the landscape stretching wide before them, a motif often found around that time; the subject is handled with the blend of French observation and serenity

FIG. 28 (*top*). Herman van Swanevelt, *Landscape with Draughtsmen*, ca. 1630–35. Brown ink and pen over black chalk on paper. Allen Memorial Art Museum, Oberlin College, Oberlin, Ohio. Charles F. Olney Fund, 1964.34.

FIG. 29 (*above*). Jan Asselijn, *Landscape with Roman Ruins*, ca. 1640. Brown and gray ink wash over black chalk on paper. Allen Memorial Art Museum, Oberlin College, Oberlin, Ohio. Gift of Janos Scholz, 1954.63.

FIG. 30. Bartholomeus Breenbergh, *Italian Landscape with Tomb*, ca. 1626.
Brown ink, pen, and wash on paper. Allen Memorial Art Museum,
Oberlin College, Oberlin, Ohio. Gift of Janos Scholz, 1959.50.

that Goethe admired in Swanevelt's works."[40] Swanevelt is known to have shared a house with Claude in Rome, and the two likely went on sketching trips to the *campagna*. The figures in the Oberlin drawing recall the artists depicted in Claude's paintings of the same period, including the Lawrence and Boston paintings in the exhibition (cat. nos. 10 and 11).

Jan Asselijn's *Landscape with Roman Ruins* (fig. 29), with its broad washes and bold brushstrokes, may be compared to the style and technique of Bartholomeus Breenbergh and Thomas Wijck. Asselijn (after 1610–1652) was part of a second wave of Dutch Italianate artists who traveled to Rome to study. The large two-storied ruin at the left is the Nymphaeum Hortorum Licianorum on the Esquiline Hill, although it was known (and wrongly identified) as the Temple of Minerva Medica in the seventeenth century.

A drawing by Asselijn's friend, Bartholomeus Breenbergh (1598–1657), *Italian Landscape with Tomb* (fig. 30), shows an unidentified Roman tomb, probably located along the Appian Way, which was also drawn by Asselijn, perhaps on the same sketching trip.[41] Related to Breenbergh's drawing is a sheet from a Roman sketchbook by the Dutch painter Willem van Bemmel, *View of*

a Chapel (Aqua Acetosa) on the Banks of the Tiber, Rome (fig. 31). Van Bemmel (1630–1704) traveled to Italy around 1647, spending two years in Venice and then four years in Rome and Naples. The sketchbook dates to around 1650 and comprises fifty-three drawings on forty-three leaves, and it may be the only documentation of the artist's stay in Rome.[42] Van Bemmel's Italian voyage was documented by Joachim von Sandrart, who singled out the artist's skills as a draftsman, noting that he "so diligently committed to paper everything appropriate to his landscapes after nature itself, as no one before him had ever done so perfectly."[43] The ruin sketched by van Bemmel bears a strong likeness to the one depicted in Breenbergh's drawing: both buildings have a cross mounted on the pediment, and they share a similar physical orientation, situated on a rocky outcropping along the riverbank. In her study of van Bemmel's sketchbook, art historian and former AMAM curator Marjorie Wieseman points out that he "eschewed archaeological accuracy and architectural detail in favor of a broader understanding of the disposition of light and shadows over forms.... the picturesque remnants of antiquity served to evoke an idealized vision of Arcadia."[44]

An eighteenth-century Italian drawing in the Oberlin

FIG. 31 (*top*). Willem van Bemmel, *View of a Chapel (Aqua Acetosa) on the Banks of the Tiber, Rome*, ca. 1650. Pencil and ink wash on paper. Allen Memorial Art Museum, Oberlin College, Oberlin, Ohio. Gift of Dr. and Mrs. Harold Jantz, 1986.22.

FIG. 32 (*above*). Michele Giovanni Marieschi, attributed to, *Imaginary View of Rome*, ca. 1750. Brown ink, pen, and gray wash on paper. Allen Memorial Art Museum, Oberlin College, Oberlin, Ohio. Mrs. F. F. Prentiss Fund, 1956.20.

FIG. 33. Giovanni Paolo Panini, *Roman Ruins with the Arch of Titus*, 1734. Oil on canvas.
Allen Memorial Art Museum, Oberlin College, Oberlin, Ohio. Mrs. F. F. Prentiss Fund, 1969.20.

collection, *Imaginary View of Rome* (fig. 32), has been attributed to several artists, including Marco Ricci, Giuseppe Mannocchi, and French artist Gabriel de Perelle the Younger; however, the most convincing attribution is to Michele Giovanni Marieschi (1710–1743), which was put forward by Hylton Thomas.[45] The drawing portrays an assortment of recognizable classical buildings and monuments from Rome, all of them reconfigured to accommodate the artist's goal of creating a picturesque landscape. It is precisely the type of view coveted by travelers on the Grand Tour, representing a painting tradition made famous by Canaletto, Guardi, and Panini.

Giovanni Paolo Panini's *Roman Ruins with the Arch of Titus* (fig. 33) is an excellent example of this genre created especially for the grand tourist. Specializing in scenes of the great Roman buildings and spaces, ancient and modern, Panini (1691–1765) was one of the leading painters of *vedute*, or topographical views. The buildings of the Roman Forum were a primary source for many of these *vedute essate* and *vedute ideate*, and in the Oberlin picture the ruins are easily identified: the Arch of Titus, the Temple of Saturn, the three remaining columns of the Temple of Vespasian and Titus, the Theater of Marcellus (in the distance), and the Temple of Fortune or Fortuna Virile. Misplaced in the composition are the Arch of Titus, which is actually located at the other end of the Roman Forum, and the Temple of Fortune, found on the Piazza Bocca della Verità, the ancient Forum Boarium. However, for Panini's purpose—or perhaps for a client—the two monuments are better situated among the other ruins in the Forum.

Panini's contemporary Pompeo Batoni (1708–1787), the foremost Roman portraitist of his day, shared Panini's patrons from the Grand Tour. Batoni's *Portrait of John Wodehouse* (fig. 22) captures much of the spirit

FIG. 34. Jasper Francis Cropsey, *Temple of the Sibyl, Tivoli*, 1876. Oil on canvas.
Allen Memorial Art Museum, Oberlin College, Oberlin, Ohio. Gift of Charles F. Olney, 1904.1186.

and color of the traveler on this voyage to Italy.[46] John Wodehouse, later 1st Baron Wodehouse of Kimberly (1741–1834), embarked on his Italian journey in 1764, at the age of twenty-three, and his portrait was executed that same year. In the Oberlin picture Wodehouse is dressed and coiffed in the latest English fashion, an exquisite blue silk, gold-braided coat and waistcoat with a black solitaire, and a lace jabot is at his neck. With the style and poise of a grand tourist, he stands on a terrace in the open air, leaning against a stone parapet upon which sits a large classical marble vase with a Bacchic relief, and looks out to the Roman *campagna*.[47] Describing the portrait of Wodehouse, Anthony Clark writes, "It is a secure and telling likeness of a self-assured, mature but very young man, who is shown favorably and typically.... Subtly, learnedly and genially wrought, the portrait has force and animation but avoids 'psychological depth' or at least skepticism."[48]

Long before Stechow arrived at Oberlin, and years before any French, Italian, or northern landscapes with ruins entered the collection at Oberlin, several American paintings with this subject were acquired by the museum. Four works by Hudson River artists featuring ruins were part of Charles F. Olney's bequest to the museum in 1904, and others were added to the collection in subsequent years. These canvases included Jasper Francis Cropsey's *Temple of the Sibyl, Tivoli* (1876), John Frederick Kensett's *The Temple of Neptune, Paestum* (1847), Thomas Cole's *The Ruins* (ca. 1831), and Edward Moran's *Ruins of Aspinwall Castle* (ca. 1880). From the early 1800s, when the American connection to Italy was particularly strong, a steady stream of American painters traveled to Italy and Greece to see for themselves the monuments of antiquity. In his recent study of American artists in Italy, Paul Manoguerra writes, "American republicanism carried

FIG. 35. John Frederick Kensett, *The Temple of Neptune, Paestum*, 1847. Oil on canvas.
Allen Memorial Art Museum, Oberlin College, Oberlin, Ohio. Gift of Charles F. Olney, 1904.432.

with it an affinity for the ancient history of the Italic peninsula, especially for pre-imperial Rome. During the formative years of the early republic in the United States, the classical world bewitched America."[49]

Cropsey's first and only trip to Italy was on his honeymoon in May 1847, and he spent the next two years traveling in Italy with his wife.[50] The *Temple of the Sibyl* (fig. 34) was executed in 1876, almost thirty years after the artist's Grand Tour voyage, and is one of several views of the temple produced after his plein air sketches. These Italian recollections provided Cropsey (1823–1900) with painting subjects for many years, although the antique monuments are often repositioned in landscape settings that appear more American in their topography.[51] John Kensett's *The Temple of Neptune, Paestum* (fig. 35) was probably painted during the artist's trip to Italy in 1847. Kensett (1816–1872) spent from 1840 to 1847 in Europe, and he visited Paestum in

May 1847. The Doric Temple of Neptune (so called because it was thought to have been dedicated to Poseidon, although it is actually dedicated to Hera) was built in the fifth century B.C. by the founders of the Greek colony of Poseidonia (Paestum) and rediscovered in the eighteenth century along with the other two temples on the site. Evident in both the Kensett and Cropsey paintings are the refined palettes, subtle tonalities, and heightened response to the effects of natural light that define the luminist works of the Hudson River school. It is fitting that the founding collection of the Allen Memorial Art Museum should contain several landscapes featuring the ruin—including two of the most celebrated classical monuments documented in the history of European landscape painting.

NOTES

1. Gustave Flaubert, *Correspondance: 1847* (Paris: Louis Conard, 1926), 271, as cited by Michael Roth in Roth 1997, 61.

2. Ruins in the history of art and architecture have been the focus of several studies, and in the last fifty years four works are particularly outstanding: Rose Macaulay, *Pleasure of Ruins* (1953); Paul Zucker, *Fascination of Decay: Ruins, Relic—Symbol—Ornament* (1968); Michael Roth, *Irresistible Decay: Ruins Reclaimed* (1997); and, most recently, Christopher Woodward, *In Ruins* (2001). These authors present four different approaches to studying and understanding the ruin. The last two works, by Woodward and Roth, continue to probe the philosophy behind the allure of the ruin, shared by artists, architects, and laypeople.

3. Claire Lyons in Roth 1997, 80.

4. Thurber 2001, 45.

5. The first archaeological findings at Pompeii date to 1595; however, official excavations began in 1748. Fragments at Herculaneum were discovered as early as 1707 when Prince Emanuel-Maurice d'Elboeuf found artifacts near his residence at Portici, although official excavations did not begin until 1738. The temples at Paestum were discovered in 1746 by the architect Mario Gioffredi. See Wilton 1996, 231–35.

6. See Illustrated Architectural Books in the Bibliography.

7. Harris 1990, 49.

8. Harris 1990, 49.

9. See Illustrated Architectural Books in the Bibliography for a list of the publications by Wood and Stuart and Revett.

10. Harris 1990, 50.

11. These included Robert Burn, *Rome and the Campagna: An Historical and Topographical Description of the Site, Buildings, and Neighbourhood of Ancient Rome* (1871); Rodolfo Lanciani, *Ancient Rome in the Light of Recent Discoveries* (1882) and *The Ruins and Excavations of Ancient Rome* (1897); Thomas Ashby, *The Roman Campagna in Classical Times* (1927); and Samuel Ball Platner, *A Topographical Dictionary of Ancient Rome* (1929).

12. The introduction of photography to Italy in the 1840s again changed the study and connoisseurship of ruins. By 1840, a portfolio of engravings, *Excursions daguerriennes*, based on the daguerreotypes documenting the historic sites and ancient monuments in Italy and Greece, was published in France. *Excursions daguerriennes* took two years to produce, and the printed images were based on the daguerreotypes made for the Paris optician N. P. Lerebours in 1839. See Heinz Henisch in Hager 1987, 280.

13. David Watkin in Hornsby 2000, 56.

14. Wars between Britain and France in 1689–97 and 1702–13 disrupted leisure travel through France and Italy, especially as the latter conflict involved northern Italy. The period of formal peace lasting from 1713 to 1739 saw the greatest rise in Grand Tour travel. See Black 2003, 2.

15. David Watkin in Hornsby 2000, 55–56.

16. Richard Lassels, *Voyage of Italy, or a Compleat Journey through Italy. In Two Parts. With the Characters of the People, and the Description of the Chief Towns, Churches, Monasteries, Tombs, Libraries, Palaces, Villas, Gardens, Pictures, Statues, and Antiquities. As Also of the Interest, Government, Riches, Force, etc. of all the Princes. With Instructions concerning Travel.* See Black 2003, 2; David Watkin in Hornsby 2000, 55; Wilton 1996, 13.

17. Lassels, *Voyage of Italy* manuscript (pp. 467–60), as cited in Chaney 1985, 421.

18. Black 2003, 23.

19. Lindsay Stainton in Wilton 1996, 141.

20. Keaveney 1988, 29.

21. These two prints are found in Piranesi's *Le Antichità Romane I* and *Vedute di Roma*.

22. Meade 1980, 33.

23. Meade 1980, 51; Lanciani 1967, 224.

24. Meade 1980, 46.

25. There is some disagreement on the date for the conversion of the temple into a church: Lanciani suggests the seventh or eighth century, and Meade suggests the tenth or eleventh century. See Lanciani 1967, 216–17; Meade 1980, 46.

26. Lanciani 1967, 46.

27. Lanciani 1967, 515–16; Keaveney 1988, 168–69.

28. Meade 1980, 95.

29. The Temple of Vesta at Tivoli is reproduced in the following paintings in the exhibition: Boucher (cat. no. 4), Claude (cat. nos. 12, 13, 14), Dughet (cat. no. 17), Robert (cat. no. 29), Vernet (cat. no. 34).

30. Brooke 1995, 102–3.

31. In the seventeenth century it was erroneously called the Temple of Minerva Medici, apparently after a street-side shrine situated about one half mile away and the account that a statue of the goddess was found in the ruins. See Lanciani 1967, 401.

32. Meade 1980, 156.

33. Spear 1969, 91. At the time of its acquisition by the AMAM in 1968, the Domenichino was one of only two paintings wholly attributed to the artist in North America, and the only landscape painting.

34. Andrew Butterfield in Oberlin 1998 (Domenichino entry).

35. While the structure of Domenichino's landscape is derived from Carracci's *Flight into Egypt* of the Aldobrandini lunettes (Rome, Galeria Doria-Pamphili), there is, according to Richard Spear, a loss of structural monumentality and, at the same time, a more unified panorama. Spear 1982, 143. Spear also suggests that the young Domenichino may have actually finished the Aldobrandini *Flight into Egypt* when Annibale was unable to finish the commission. See Spear 1969, 95.

36. See Stechow 1967 and Stechow 1976a for entries on the paintings, drawings, and prints by the Dutch Italianate artists in the AMAM collection.

37. Stechow 1964b, 1.

38. Prior to a cleaning in 1944 that exposed Begeyn's signature and the date (*A. Begijn f. 1665*), the painting was attributed to Jan Fransz. Soolmaker.

39. Nicolaes Berchem (1637/8–1697) is represented with two landscape paintings in the AMAM collection: *Resting Shepherds* (ca. 1645) and *The Country Farrier* (ca. 1660).

40. Stechow 1964a, 7.

41. The Asselijn drawing is in Hamburg (no. 21644; Gernsheim Corpus 17105). See Stechow 1976a, 9. The attribution of the Oberlin drawing by Asselijn has been questioned by Anne Charlotte Steland-Stief and omitted from her 1989 *catalogue raisonné*; see Steland-Stief 1989 and Steland-Stief 1980, 223–27.

42. No works by van Bemmel executed prior to this Italian voyage in 1647 are known, and the other Italianate landscape paintings were made after his return to the north. See Wieseman 1994, 4.

43. Joachim von Sandrart, as cited by Wieseman 1994, 6.

44. Wieseman 1994, 6–7.

45. After discovering several paintings by Marieschi related to the composition in the Oberlin drawing, it was Hylton Thomas's intention to publish the work as by Marieschi in *Master Drawings* in 1963 or 1964. See Stechow 1976a, 41, and the AMAM curatorial file for the drawing.

46. The painting is inscribed, by a later hand: *John Lord Wodehouse / 1762*. However, as Anthony Clark points out, "The portrait was on view 6 May 1764 in Batoni's showroom in the artist's palace several blocks from the Piazza di Spagna and noted by James Martin in his travel diary," and it can therefore be securely dated to 1764. See Clark 1985, 293.

47. Clark 1972, 4.

48. Clark 1972, 4.

49. Manoguerra 2004, 18.

50. New York 1987, 200.

51. Tuckerman 1867, 532–40.

Catalogue

I

Etienne Allegrain

PARIS 1644–1736 PARIS

Born in Paris in 1644, Etienne Allegrain belonged to a family of artists: his brother Jean-Baptiste (1644–before 1714) was a sculptor; his son Gabriel (1679–1748), a painter; and his grandson, Christophe-Gabriel (1710–1795), a sculptor whose last patron was Madame Du Barry. The presence of more than one painter in the family, with the father and son adopting a similar landscape style, has caused several of Allegrain's works to be misattributed to his son Gabriel and, more frequently, to another mid-century artist, Jean-François Millet, called Françisque Millet I (1642–1679). With so little known about Allegrain's life and work, these shifts in attribution are not surprising; only one securely signed and dated work by Allegrain is known, a drawing of 1697. However, scholarship in the past three decades has helped define the artist's oeuvre, correcting many of the misattributions, including his *Landscape with a Lake*.

Allegrain may have studied with Henri Mauperché (1602–1686), a French painter and printmaker who specialized in landscape painting and spent several years in Rome during the 1630s. Of particular interest is Mauperché's own acquaintance with Sébastien Bourdon (1616–1671) in Rome and his later collaboration with Pierre Patel (1605–1676) and two northern artists, Jan Asselijn (ca. 1610–1652) and Herman van Swanevelt (ca. 1600–1655), on a major decorative commission executed between 1646 and 1647 for the Cabinet de l'Amour at the Hôtel Lambert in Paris. Mauperché's Roman sojourn and association with Patel (to whom his own works have at times been attributed) makes the affiliation with Allegrain even more compelling.

Allegrain was approved by the Académie royale in 1676 and received the following year with his painting *The Flight into Egypt* (location unknown). He quickly perfected his landscape style and received a number of royal commissions, including views of the buildings and park for the Grand Trianon at Versailles for Louis XIV in 1691 (*in situ*) and two landscape paintings for the Ménagerie in 1700 (Paris, Musée du Louvre). By the turn of the century, Allegrain's manner of painting had become decidedly classical, although the appeal of both the pastoral and the heroic character of the landscape persisted, and the dependence on Claude and Poussin continued to develop. As much as Allegrain's landscapes evoke the work of these French masters, they belong as well to the stylistic milieu characterized by northern artists like Jan Frans van Bloemen, called Orizzonte (1662–1749), and Millet, who either spent time in Italy or copied the work of artists who did.

There is no record of Allegrain having visited Italy. His inclusion of classical ruins reflects both contemporary taste and his secondhand knowledge of Rome and its environs through the paintings and prints he encountered in Paris. His fascination with the Dutch Italianate painters (through Mauperché and others) also exposed him to the architectural ruin in landscape painting. At Versailles, Allegrain worked with a number of landscape and view painters and had the opportunity to see the royal collection, although it held few works by those French painters living in Rome or even by those who had spent time in Italy.

FIG. 36. James Stuart and Nicholas Revett, *A View of the Acropolis*, 1762. Engraving.
The Antiquities of Athens, vol. 2. Clarence Ward Art Library, Oberlin College, Oberlin, Ohio.

1. Etienne Allegrain, *Landscape with a Lake*, ca. 1700

Oil on canvas, 22¼ × 30¾ in. (56.5 × 78 cm.)
The Agnes Etherington Art Centre, Queen's University, Kingston, Ontario
Gift of Drs. Alfred and Isabel Bader, 20.90
PROVENANCE: Sale, Dorotheum, Vienna, 30 May 1967, lot 82 (as J. F. Millet); Alfred Bader; gift 1977
EXHIBITIONS: Kalamazoo 1967, p. 12 (as *Arcadian Landscape* by Millet); Ostrow 1968, cat. no. 38, ill. (as *Arcadian Landscape* by Millet); Rosenberg 1975, cat. no. 1, ill.; McTavish 1988, cat. no. 34, ill.

Etienne Allegrain's *Landscape with a Lake* (cat. no. 1) can be fairly securely dated to 1700, a time associated with the artist's mature landscape style influenced by his great predecessors Claude and Poussin and by Dutch contemporaries. Pierre Rosenberg was the first to compare the Kingston picture with two landscape paintings now in the Musée du Louvre that were executed for the summer apartments of the Ménagerie at Versailles.[1] One of the Paris pictures, *Landscape with a River*, shows the identical arrangement of trees framing the right-hand side of the composition. Before Rosenberg's attribution to Allegrain, *Landscape with a Lake* was thought to be by Millet (cat. no. 22).[2]

In his paintings, Allegrain employs a range of antique, medieval, and Renaissance architecture, often positioning the buildings within the landscape like terraced fields or extensions of the topography. Dominating the upper half of this picture is an imposing classical ruin on the hill overlooking the lake, which introduces a commanding tone to the otherwise tranquil scene. While not a direct reference to a specific building, the architecture suggests a combination of the Erechtheum and the temple of Athena Nike on the Acropolis at Athens, oddly positioned on a Renaissance-style porch. The impressive structure rises high above the lake, beyond the horizon line, and is carefully sited so that it straddles mountain and sky, assuming the outline of the mountain range in the distance. Interestingly, a caryatid-like figure can be found on the corner of another ruin at the extreme left of the painting, overlooking the figures in the foreground.

It is not known whether Allegrain ever traveled to

Italy or Greece, suggesting that his knowledge of the classical ruins was based on illustrated architectural books, contemporary paintings, and contact with artists who did travel or study in Rome. George Wheler's *A Journey into Greece* and Antoine Desgodets's *Les edifices antiques de Rome*, both published in 1682, are two examples of illustrated books that were available to artists and tourists in the late seventeenth century.[3] While their illustrations would be eclipsed by the work of James Stuart (1713–1788) and Nicolas Revett (1720–1804), including *The Antiquities of Athens* (fig. 36), and many others in the following century, these seventeenth-century publications provided readers and travelers with a solid understanding of the ruins and current excavations in these countries.

Allegrain's contact with northern painters probably occurred through his teacher, Mauperché, Millet, possibly van Bloemen, and a handful of Dutch and Flemish artists who worked in France. Van Bloemen spent most of his career in Rome immersed in the Italianate landscape affiliated with the Italian and northern painters producing these works. Van Bloemen's *Idyllic Landscape* (fig. 37), executed about the same time as Allegrain's *Landscape with a Lake* (both ca. 1700), bears a striking resemblance to the Kingston picture. Van Bloemen presents a similar landscape composition and introduces many of the same stylistic elements and architectural motifs employed by Allegrain. Van Bloemen, however, has substituted the classical ruin with Renaissance buildings, although they possess an almost equal stature in his picture. Present in both pictures is the distinctive palette of these late-seventeenth-century French painters—a blending of the rich colors of the northern painters with the brilliance of the paintings of Les Patel—which imparts a heroic mood in the manner of Poussin and his followers.

Allegrain's landscape projects a sense of ordered calm, where the essential components or passages of the pastoral landscape are highlighted by the use of light and color or by their placement in the composition. At the same time, aspects of the heroic landscape mode are present in the three figures clothed in classical dress seated on a rocky outcropping near the water's edge. The staffage, like the architecture, trees, and natural rock and water formations, is part of an elaborate maze-like composition, which zigzags from the path beginning in the left foreground to the town at the

FIG. 37. Jan Frans van Bloemen, called Orizzonte, *Idyllic Landscape*, ca. 1700. Oil on canvas. Allen Memorial Art Museum, Oberlin College, Oberlin, Ohio. Gift of Bernard Grebanier, 1971.10.

foothills of the mountain. Evident in the Kingston picture is the underlying structure of a Poussin landscape, particularly in Allegrain's attempts to create a sophisticated arrangement of planes or natural platforms, receding from the foreground into the middle and distant grounds. The painting, David McTavish notes, "relies on a type of ideal landscape brought to perfection by Nicolas Poussin in the late 1640s … elements are deployed with particular care, so that a stable balance is created and the recession into distance is strictly controlled."[4] However, the composition lacks both the cohesiveness and the finished surface of a landscape by Poussin: the light and shadow cast over the figures and the natural and architectural elements are at times harsh, resulting in an irregular and unconvincing transition from one plane to the next. We are more apt to think of Allegrain's northern contemporaries, and thus the original attribution to Millet is understandable.

NOTES

1. Rosenberg 1975–76, 19.
2. Dorotheum, Vienna, 30 May 1967, lot 82 (as J. F. Millet). See McTavish 1988, 138.
3. Wheler 1682; Desgodets 1682. See bibliography for additional seventeenth- and eighteenth-century illustrated architectural books.
4. McTavish uses the examples of Poussin's *Landscape with the Body of Phocion Carried Out of Athens* (1648) and the *Landscape with Orpheus and Eurydice*. See McTavish 1988, 140.

Jean Barbault

VIARMES 1718–1762 ROME

Born in Viarmes near Chantilly, Jean Barbault was a painter and printmaker who is thought to have studied briefly in Paris in the mid-1740s with Jean Restout II (1692–1758), an artist who specialized in religious scenes and history painting. In 1747, Barbault moved to Rome, where he spent the remainder of his short-lived career. There his work focused primarily on ancient and modern architecture of Rome and its environs. Barbault's paintings range from small landscapes with ruins to fashionable canvases depicting costumed figures in their native dress and portraits of his fellow *pensionnaires* at the Académie de France in Rome.

By 1748 Barbault had become friends with the artist who would have the greatest impact on his career, Giovanni Battista Piranesi (1720–1778). Almost immediately, the two joined forces to produce the well-known series of prints *Varie vedute di Roma antica e moderne* (1748). The following year Barbault was admitted as a *pensionnaire* into the Académie de France in Rome. During the next four years, he received several important commissions and counted among his patrons Jean-François de Troy (1679–1752), the director of the Académie de France, who had orchestrated Barbault's admission, and the Marquis de Vandières (1727–1781), the younger sibling of Madame de Pompadour and the future Marquis de Marigny. At the request of de Troy, Barbault painted a series of twenty full-length portraits of residents of the Palazzo Mancini at the Académie, outfitting his subjects in Turkish costumes for the oriental-themed *carnival* (eleven of the twenty portraits survive). Shortly after de Troy's commission, a similar series featuring people dressed in Italian costumes was ordered by the Marquis de Marigny, probably at the advice of de Troy. The elegant figures in their colorful garb fit into the category of eighteenth-century Italian genre painting, but they also display a flamboyance, perhaps influenced by Restout, that distinguishes them from those of his Italian contemporaries Giovanni Paolo Panini (1691–1765) and Giovanni Antonio Canal, called Canaletto (1697–1768). Barbault's lucrative commissions stopped following his abrupt removal from the Académie in 1753. The year before, the artist's protector, de Troy, had died and was replaced by a new Académie director, Charles-Joseph Natoire. Added to this professional setback was Barbault's personal debt and ill health, which plagued him throughout his stay in Rome; when his clandestine marriage was discovered by Natoire he was forced to give up his place at the Académie.

There is no record of Barbault leaving Rome, and it is thought that he continued to live and work in the city, supporting himself with the proceeds from the sale of his paintings and prints. Since the artist was ostracized from the academic community and consequently from the circles of patronage, his final years are not well documented, nor are there any records of major commissions. He continued working with Piranesi, and in 1756 he etched fourteen plates for Piranesi's *Antichità romane*. In due course Barbault produced his own series of etchings: *Les plus beaux monuments de la Rome ancienne*, comprising 128 plates, was published in 1761. By the time of his death the following year, Barbault had produced over five hundred prints.

2. Jean Barbault, *Ruins with the Temple of Jupiter*, ca. 1749–54

Oil on canvas, 24½ × 29¾ in. (62.2 × 75.5 cm.)
The Snite Museum of Art, University of Notre Dame, Notre Dame, Indiana
Gift of Mr. Sidney Farber, 60.40.2
PROVENANCE: Ruggero Sonino, Venice; Mr. Sidney Farber; gift 1960
EXHIBITIONS: Wintermute 1990, cat. no. 26, ill.

JEAN BARBAULT's *Ruins with the Temple of Jupiter* (cat. no. 2) and its pendant, *The Roman Forum: Arch of Titus*, were traditionally attributed by Rodolfo Palluchini as early works by Canaletto.[1] In 1976, Arnauld Brejon de

FIG. 38. Giovanni Battista Piranesi, *Temple of Jupiter Tonans, Temple of Concord*, 1778. Etching. *Alcune vedute di Archi Trionfali, ed altri monumenti.* Allen Memorial Art Museum, Oberlin College, Oberlin, Ohio.

Lavergnée examined the paintings at the Snite Museum of Art and immediately suggested the Barbault attribution. The same attribution was proposed by Pierre Rosenberg within the same year, and shortly thereafter the pair of paintings was added to Barbault's oeuvre.[2] As Rosenberg noted in his article published on the occasion of the 1976 colloquium at the Académie de France in Rome, Barbault's works, and in particular his landscapes, were often confused with those of his Venetian contemporaries.[3]

The figures in Barbault's Roman landscape possess grace and vivacity. In the left foreground a man converses with a woman while another figure approaches a caravan passing between the temples. The figures in contemporary dress are typical of the staffage for this type of architectural landscape, and they relate to those by Hubert Robert (1733–1808) and his Italian counterparts Canaletto and Panini. There are also references to the figural groupings associated with the genre scenes of the *Bambloccianti* working in Rome, and before that to the caravan and biblical scenes popularized by Jacopo Bassano and Giovanni Benedetto Castiglione. Barbault's

palette—with areas of strong red, blue, and white highlighting the costumed figures against darker earth tones marking the grounds and architecture—reflects the bold character of Roman genre paintings.

Barbault's *Temple of Jupiter* was probably inspired by an etching of the same subject by Piranesi, although the painting is dated earlier than the suite of prints (fig. 38). The composition was later repeated by Barbault in his own series of prints, *Les plus beaux monuments de la Rome ancienne*, published in 1761. The composition and perspective in Barbault's plate are almost identical to Piranesi's rendering. The painting was originally titled *Paysage d'Italie*, as the ruin in the foreground had not yet been identified; the title *Temple of Jupiter* came after the same temple was discovered in Barbault's etching.

Both Barbault and Piranesi refer to this ruined temple as the Temple of Jupiter Tonans ("the thunderer"), which was what it was commonly called in the eighteenth century. The temple is also known as the Temple of Vespasian and Titus because it was constructed in A.D. 79 by the emperors Titus and (following his death)

56 *Jean Barbault*

FIG. 39. Temple of Vespasian and Titus; Temple of Saturn, Rome.
Photograph © Alexander Grogan 2004.

his brother Domitian, in honor of their father, Vespasian, who died that year. In Barbault's painting the three remaining Corinthian columns of the pronaos and a section of the entablature and cornice are depicted. The temple was excavated in the early nineteenth century to expose the full fifty-foot height of the columns and their bases; however, in Barbault's day less than half of the full column height was visible. In the right background is the Temple of Saturn, the oldest temple in the Roman Forum, which is located across the Clivus Capitolinus from the Temple of Vespasian and Titus (fig. 39). Therefore an earlier suggestion that the latter structure was in fact the Temple of Saturn is understandable.[4]

The three-columned ruin of the Temple of Vespasian and Titus occupies the full height of Barbault's composition, dominating the activity and other elements in the picture. The artist has chosen a viewpoint that exaggerates the monumentality of the ruin even in its unexcavated state. Figures and animals are dwarfed, and the other ruins become pale silhouettes against a sky that is equally muted in its colors and brushwork. In contrast to Piranesi's print, which shows the temple—albeit at a slightly different elevation—set against a backdrop of Renaissance and later buildings, Barbault has eliminated all traces of later architecture to dramatize the scene. The pendant work, *The Roman Forum: Arch of Titus*, presents a similarly controlled vista featuring the Arch of Titus. Barbault's composition is taken directly from Piranesi's *View of the Arch of Titus* from the *Vedute di Roma*, with later architectural elements again eliminated to focus attention on the ruin.

NOTES

1. "Per gli esordi de Canaletto"; see Palluchini 1973, 155–88, fig. 214; and Beauvais 1974.
2. Pierre Rosenberg, 102, cat. no. 14, in Brunel 1976.
3. "Les oeuvres de Barbault se cachent souvent sous des noms vénitiens"; Pierre Rosenberg in Brunel 1976, 503.
4. Bronwyn T. Maloney in Wintermute 1990, 160. See also page 37 of this catalogue for a discussion of the two temples and the excavations.

Pierre-Nolasque Bergeret

BORDEAUX 1782–1863 PARIS

Pierre-Nolasque Bergeret was born in 1782 to a middle-class family in Bordeaux. His father, Guillaume, was a publisher influential in the rapidly expanding economic community of Bordeaux. Bergeret's uncle, François Bergeret, and son, Jean-Baptiste, were also printers who opened a publishing house in 1795, establishing the family firmly within the trade. Little is known about Bergeret's early years. His first documented artistic studies took place in the studio of Pierre Lacour the Elder (1745–1814). A native of Bordeaux, Lacour trained as an engraver and portraitist before moving to Paris to study under Joseph-Marie Vien, in whose studio he came into contact with Jacques-Louis David. Lacour moved to Rome in 1772, only to return two years later to Bordeaux, where he established an independent school for drawing and painting. He later became director of the Musée des Beaux-Arts in Bordeaux. Bergeret's training with Lacour began sometime after the establishment of Lacour's private academy.

In the late 1790s Bergeret moved to Paris to continue his studies, first with François André Vincent (1746–1816) and then with Jacques-Louis David (1748–1825). In David's studio, Bergeret found himself surrounded by a group of young French painters, including François-Marius Granet (1775–1849) and Jean-Auguste-Dominique Ingres (1780–1867), with whom he developed his skills as a history painter and was exposed to the troubadour style. Along with Ingres and Lorenzo Bartolini (1777–1850), Bergeret became a member of the *Académie à part* in the Convent of the Capuchines, an association linked with the troubadour painters. Emerging at the turn of the century, this offshoot of history painting and precursor of Romanticism glorified the historical moments and personalities (as well as the paintings) of the past, many of them documented in the new Musée du Louvre. Artistic sentiments were decidedly retrospective in the years following the Revolution, and the troubadour painters were determined to revive the splendor of the past, establishing a new historicism in painting.

Napoleon's purchase of Bergeret's painting *Honors Rendered to Raphael on His Deathbed* (fig. 40), at the Salon of 1806 for Josephine's collection at Malmaison, set in motion a relationship that greatly impacted the artist's career. Napoleon subsequently commissioned a number of works from Bergeret, including historical paintings, propaganda lithographs, and commemorative medals. Most notable was Napoleon's commission for the design of bas-reliefs on the great column in Place Vendôme depicting his military campaign at Austerlitz, the French emperor's response to Trajan's famous column in Rome.

Bergeret's immediate success with *Honors Rendered to Raphael* inspired him to continue producing similarly themed works venerating the lives—as well as the deaths—of historical artists and patrons. It was a fitting genre for the troubadour painter. Angelica Kauffman's *Leonardo da Vinci Dying in the Arms of Francis I* (location unknown), exhibited at the Académie royale in 1778, was one of the last paintings of this historical genre to be shown until Nicolas-André Monsiau's (also under Napoleon's patronage) *Honors Rendered to Raphael* was exhibited in 1804, and Bergeret's own version two years later.

In the first decade of the nineteenth century, Dominique Vivant-Denon—later director of the Musée Napoléon (which became the Musée du Louvre)—commissioned from Bergeret a series of lithographs after the most celebrated works in the museum. Bergeret is credited as one of the innovators of lithography in France and was among the first to raise its artistic profile from a purely commercial medium to an artistic one. Years later, Bergeret reflected on his career as a painter and voiced his strongest criticism of the state's administration of the arts in his well-known autobiographical account, *Lettres d'un artiste sur l'état des arts en France*, published in 1848.

FIG. 40. Pierre-Nolasque Bergeret, *Honors Rendered to Raphael on His Deathbed*, 1806. Oil on canvas. Allen Memorial Art Museum, Oberlin College, Oberlin, Ohio. R. T. Miller, Jr., Fund, 1982.93.

3. Pierre-Nolasque Bergeret, *Marius Meditating on the Ruins of Carthage*, 1807

Oil on canvas, 51 × 39 in. (129.5 × 96.5 cm.)
The Dayton Art Institute, Dayton, Ohio
Purchase with funds provided by the Berry and Dicke Families, 1997.20
PROVENANCE: David Johnston, Mayor of Bordeaux, Château de Lafon, Bordeaux (acquired from the artist); private collection, Château de Lafon (bought with contents of the *château*), 1825–30; thence by descent; Dr. and Mrs. Richard W. Levy, New Orleans, 1986; Richard L. Feigen and Company, New York; purchase 1997

THE SUBJECT of Bergeret's painting (cat. no. 3) is taken from Plutarch's *Lives*, a collection of more than fifty biographies of the most famous men of ancient Greece and Rome, written in the first decades of the second century. In "The Life of Caius Marius," Plutarch recounts the story of the great Roman general shamed by his enemy Lucius Cornelius Sulla, another general in the Roman army. (Sulla's biography is included in

Lives.) Caius Marius (157–86 B.C.), a plebian, entered the army and served under Scipio Africanus Minor at Numantia, and he immediately stood out as an exemplary Roman soldier. A rivalry between the two generals, Marius and Sulla, erupted into civil war, with Marius assembling his own army including slaves and peasants—Sulla emerged as victor, and Marius fled Rome. Marius returned to Africa, where he met with more opposition, was exiled from Rome, and was later taken prisoner at Minturnae. Escaping an assassination attempt, Marius sought refuge in the ruined city of Carthage, an outpost of the Roman Empire. There he was confronted by a messenger of Sextillus, the Roman governor of the city, who informed him that he must leave Africa at once or face the consequences of becoming an enemy of Rome. According to Plutarch, Marius responded at that moment: " 'Tell [Sextillus], then, that thou hast seen Caius Marius a fugitive, seated amid the ruins of Carthage.' And it was not inaptly that he compared the fate of that city with his own reversal of fortune."[1]

Marius is a pivotal work in Bergeret's early Romantic period, showing the artist's attraction to Romanticism but also betraying his strong ties to the classical influences of David and Ingres. The figure of Marius immediately recalls the powerful solitary subjects painted by David and his pupils, established by their stance and gaze and by the use of dramatic lighting and coloring. In a commanding pose Marius stares directly out at the viewer. He sits on a makeshift throne of stone fragments, tree stumps, and branches, covered in wild foliage. The defeated general appears both pensive and livid, reflecting on the parallels between his own fate and that of Carthage, two emblems of power ravaged by the Romans. He is dressed in a tattered white tunic and draped in a heavy red robe, his head and foot bandaged, his right arm clenched to his chest, and a shield strapped to his back. The messenger, mentioned in Plutarch's account, crouches behind the general at the left. On the other side three stone columns with papyrus-styled capitals catch the light of the setting sun that illuminates the general. The ruined columns are the only reference to this once noble city founded by the Phoenicians, built and rebuilt upon by the Romans, and now in ruins.

In a lecture given at the Free School of Drawing in Bordeaux in 1807, Lacour praised his young pupil's painting, remarking specifically on the romantic *terribilità* of Marius's expression: "In looking at him, one remembers this cruel and sanguine general, who had the most illustrious Roman senators slaughtered. His appearance is ferocious and his expression terrible."[2] While commending Bergeret for his ability to capture the emotional qualities of the sitter and even to accurately portray the Roman architecture in Carthage, Lacour criticized him for abandoning naturalism in favor of dramatic content (using two sources of light in the composition), and for presenting a natural terrain that fails to convey any sense of a ruined city or mirror Marius's own emotional torment.[3]

Marius is dated to 1807, which places Bergeret in Paris, probably in the studio of Vincent where Bergeret had just completed his famous *Honors Rendered to Raphael on His Deathbed* (fig. 40). It is also possible that Bergeret was already working with David by this time. Bergeret's painting bears a remarkable likeness to a painting of the same subject by the American artist John Vanderlyn (1775–1852). Vanderlyn's *Caius Marius Amidst the Ruins of Carthage* (San Francisco, Fine Arts Museum) was also painted in 1807, suggesting that the two painters were likely aware of each other's work.

NOTES

1. Plutarch 1920, 577.
2. Bihan 1984, 155–56.
3. el-Abd 1976, 17–19.

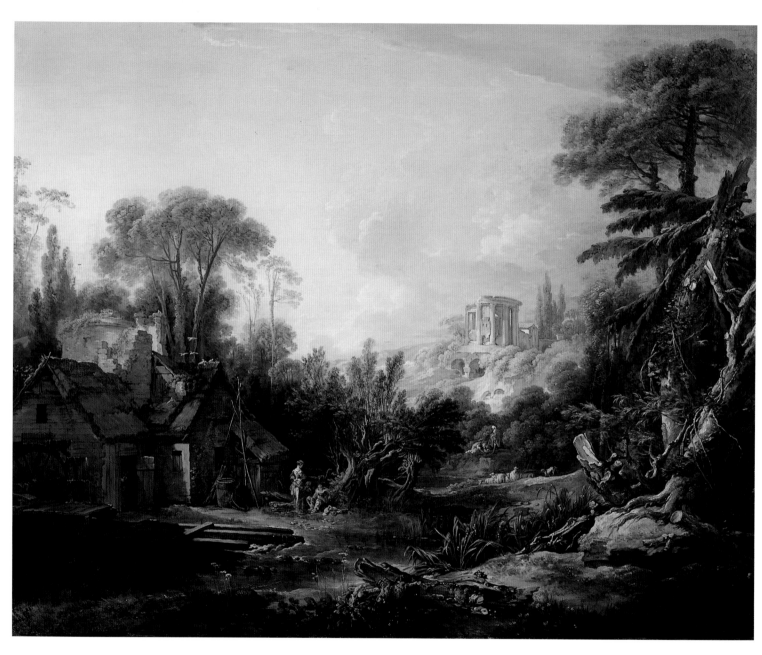

4

François Boucher

PARIS 1703–1770 PARIS

Born in 1703 in Paris, François Boucher trained briefly with his father, Nicolas Boucher (ca. 1672–1743), and then with François Lemoyne (1688–1737). In 1723, Boucher won the Prix de Rome for *Evilmerodach Releasing Jehoiachin from Prison* (location unknown), but as funding was not available his first trip to Rome was postponed. Instead, he worked as an engraver and book illustrator for Jean-François Cars (1661–1730). Boucher exhibited publicly for the first time in 1725 at the Place Dauphine. The following year he was hired by Jean de Jullienne (1686–1766), a textile manufacturer and one of Antoine Watteau's (1684–1721) most important patrons, to assist with the production of etchings after Watteau's drawings for the mammoth publication *Figures de différents caractères de paysages et d'études, dessinès d'après nature par Antoine Watteau* (1726 and 1728). Boucher executed one-third of the 351 plates. He also assisted with the production of other etchings after Watteau for the *Recueil Jullienne*, published in 1735. Although he never studied with Watteau, Boucher certainly became, as Alexandre Ananoff suggests, a student of the great master through his copies after Watteau.

Boucher traveled to Italy in 1728. Little is known about the time he spent in Rome other than that he likely paid his own way traveling there with the Vanloo family and quickly found favor with the director of the Académie de France in Rome, Nicolas Vleughels (1668–1737), who assisted Boucher with his accommodations at the Académie. Accounts differ on how long Boucher remained in Italy; some suggest he stayed as little as eighteen months, while others state that he remained as long as three years. Boucher was frequently ill and as a result did not participate in any major competitions or commissions, spending much of his time instead copying the work of such Italian Baroque artists as Giovanni Benedetto Castiglione, Pietro da Cortona, and Gianlorenzo Bernini. It is likely that he visited other Italian cities during his stay, although no record of these trips exists.

By 1731 Boucher was back in Paris and was approved by the Académie royale that year. In 1733 he married Marie-Jeanne Buseau. In 1734 he was received at the Académie as a *peintre d'histoire* with the presentation of *Rinaldo et Armida dans les plaisirs* (Paris, Musée du Louvre). Boucher's first royal commission—four grisaille paintings depicting the *Virtues* for the ceiling of the chambre de la Reine at Versailles—was completed in 1735. That same year, Boucher was appointed *adjoint à professeur* at the Académie. In addition to his painting and printmaking, Boucher began a lengthy association with the French tapestry manufacturers, first with Beauvais in 1736 and, twenty years later, with Gobelins. He was elevated to a full *professeur* at the Académie in 1737 and began designing sets and costumes for the Académie royale de musique (Opéra), at times collaborating with Charles-Siméon Favart (1710–1792), the director of artistic operations for the Opéra-comique. In 1745 the Marquise de Pompadour was installed as Louis XV's *maîtresse en titre*, and for the next nineteen years she would become Boucher's most important patron. The year after her death, in 1765, Boucher was appointed *premier peintre du Roi* and elected director of the Académie, following the death of Carle Vanloo.

Boucher's ability to master history, landscape, and portrait painting was profound, matched only by his remarkable aptitude in a variety of media, including painting, printmaking, and designs for the stage and for the royal tapestry and porcelain manufactories. His star pupil, Jean-Honoré Fragonard (1732–1806), who studied with Boucher in the 1740s and was received at the Académie in 1765, carried on this tradition of producing great decorative and easel paintings. Following in his master's footsteps, Fragonard succeeded in bringing the rococo landscape to its highest point.

FIG. 41. *Tempio della Sibilla, Tivoli*. Steven Brooke,
Views of Rome (New York: Rizzoli, 1995), plate 98.

4. François Boucher, *Landscape with a Water Mill*, 1740

Oil on canvas, 49¾ × 63 in. (126.4 × 160 cm.)
The Nelson-Atkins Museum of Art, Kansas City, Missouri
William Rockhill Nelson Trust, 59-1

PROVENANCE: Marin De la Haye (1684–1753); his widow, Mme De la Haye (d. 1776); sale, 1 December 1778, lot 30; sale Mme Lancret (d. 1782, widow of Nicolas Lancret), Hôtel de Buillion, 3 April 1782 (postponed until 5 April), lot 157 (with pendant, lot 156); M. Pinard, until 1860; his daughter, the Marquise d'Avrincourt; M. Jacques de Chefdebien, Paris; sold anonymously, Sotheby's, London, 2 July 1958, lot 111; Leggatt, from 1958; Frederick Mont, Inc., New York, by 1959; purchase 1959

EXHIBITIONS: Paris Salon 1740, cat. no. 11 (pendant to *The Forest*); Paris Salon 1741 (pendant to *The Forest*); Paris 1860, cat. no. 86; Paris 1932, cat. no. 74; New York 1986, cat. no. 34, ill.

THE PROVENANCE of Boucher's *Landscape with a Water Mill*[1] (cat. no. 4) and its pendant, *Forest Scene with Two Roman Soldiers* (Paris, Musée du Louvre), includes several important collectors of Boucher's work. Painted in 1740,[2] the two pictures were exhibited at the Salon of 1740 and probably went immediately into the collection of the affluent *fermier-géneral* Marin De la Haye (1684–1753), who owned the Hôtel de Bretonvilliers and the Hôtel Lambert in Paris. De la Haye also built the magnificent Château de Davreil (today known

as the Château de Paris-Jardins), situated about twelve miles south of Paris. After the death of De la Haye's widow in 1776, Boucher's paintings were included in her posthumous sale at the Hôtel Lambert in 1778,[3] and, four years later in 1782, the paintings were included in the sale of Marie Boursault (d. 1782), the widow of Nicolas Lancret (1690–1743), one of the celebrated painters of the *fête galante*.[4]

Alexandre Ananoff's *catalogue raisonné* of Boucher's paintings lists the Kansas City picture as *Paysage aux environs de Beauvais et souvenir d'Italie* with its pendant titled *La forêt* (The Forest). The memory of Italy is certainly present in this painting, particularly with the solitary image of the Temple of Vesta (also called the Temple of Sibyl) from Tivoli. Set into a wooded hillside, the ancient temple radiates with an afternoon light that Boucher has reserved for this far-off passage in the landscape. Contemporary accounts of the painting do not mention the temple: in the *livret* for the Salon, for example, the painting was listed as *Un païsage, où l'on voit du moulin*, and in the two sales in the seventeenth century, including the Lancret sale catalogued by Pierre Rémy, *moulin à eau* is given as the subject of the painting. Although rarely mentioned in titles and descriptions, classical ruins and sculptures linked to Boucher's time in Italy appear often in his early work, and they are an important part of his pastoral landscapes.

In 1734, six years before he painted *Landscape with a Water Mill*, Boucher was asked by Jean-Baptiste Oudry (1686–1755) to assist with the production of designs for a large tapestry series, called *fêtes italiennes*, at Beauvais. Boucher's commission was for two sets of four paintings for tapestry designs, the first filled with Italian references, including architectural ruins, sculptures, and trees found in the Roman *campagna*, and the second in the tradition of the *fêtes galantes* and more French in taste.[5] Working with the tapestry manufactory at Beauvais, which was located about fifty miles north of Paris in the agricultural area near the Somme, Boucher became familiar with the surrounding countryside. As a result, his landscape paintings from the 1740s, including the Kansas City picture, are among the most naturalistic in his oeuvre. At this stage Boucher was also incorporating elements from Dutch and Flemish landscape painters, as well as the wild, bucolic landscapes of the Italian painter Salvator Rosa (1615–1673). While in Rome, Boucher is known to have produced several pictures in the "Flemish manner,"[6] and the compositions of Paul Bril (1554–1626) and Joos de Momper (1564–1634) come immediately to mind, as do the foliage-laden wooded scenes of Jacob Ruisdael (1628/29–1682) and Meindert Hobbema (1638–1709).

The water mill and dovecote are the most familiar man-made structures in Boucher's landscapes, and in many ways they are fundamental to these pastoral settings, providing a context for the peasants, shepherds, fishermen, and washerwomen. The rationale for the temple ruin is less apparent, but it can be understood in the context of Boucher's landscapes from the 1740s—especially the Beauvais works—which often feature the *souvenir d'Italie*. Near the very center of the composition, at the horizon line, is the impressive Temple of Vesta set against a powdery blue and pink sky, surrounded by tall cypresses and the umbrella pines reminiscent of the *campagna*; the towering ruin seems worlds apart from the activity below. Boucher has been careful to depict the temple as it would have appeared in the eighteenth century, having seen it *in situ* as well as images of it in paintings and prints (fig. 41). Its placement in the hillside reflects its actual location; Boucher has also included the adjoining structures, built much later, and the stone and brick arched buttressing and vaults below. Twenty years later, his star pupil, Fragonard, would visit the same site and capture the well-known temple in his paintings and drawings. Fragonard spent the summer of 1760 at the Villa d'Este at Tivoli with his patron, l'Abbé de Saint-Non, and possibly with Hubert Robert. In Fragonard's splendid black chalk drawing *View of a Park* (fig. 42), the classical temple is presented completely intact and is transported to an overgrown garden setting,

embellished with sculptures, trellises, urns, and elegant staffage—recalling the once cultivated spaces surrounding the Villa d'Este.

NOTES

1. In the 1986 Boucher exhibition, the Kansas City painting was given the title *View of a Mill with Distant Temple*, and in the Ananoff *catalogue raisonné* it is called *Paysage aux environs de Beauvais et souvenir d'Italie*. See New York 1986, 183.

2. By 1740, Boucher was adding a date to the signature on his paintings. See New York 1986, 21.

3. New York 1986, 186–87. The paintings were described in the catalogue as "Un paysage des fabriques, un Moulin à eau, plusiers figures et des animaux sur des plans différents … ils sont riches et intéressants de composition, d'un faire savant et d'un coloris clair, mais agreeable et bon. François Boucher qui en est l'auter, les a fait en 1740, dans son bon temps"; see Ananoff 1976, 294.

4. According to Alastair Laing, it is possible that the two paintings may have been added to the Lancret sale from a separate collection. See New York 1986, 187.

5. New York 1986, 325.

6. In his *Extrait des différens ouvrages publiés sur la vie des peintres* (1776), Denis-Pierre Papillon de La Ferté (1727–1794) notes that Boucher made "several exquisite pictures in the Flemish manner" during his stay in Rome. See New York 1986, 16.

5. François Boucher, *The Dovecote*, 1758

Oil on canvas, 17⅞ × 27³⁄₁₆ in. (45.4 × 69.1 cm.)
The St. Louis Art Museum, St. Louis, Missouri
Purchase 75:1937

PROVENANCE: Berthélémy Augustin Blondel d'Azincourt (1719–1794), Paris; Blondel d'Azincourt sale, Hôtel de Louvois, Paris, 10 February 1783, lot 44; Baron L. d'Ivry; Ivry sale (posthumous), Galerie George Petit, Paris, 7 May 1884, lot 5; Comte Alexandre de La Borde, Paris, until 1932; M.H. Winterfield, Nice, by 1932; Winterfield sale, Sotheby's, London, 9 December 1936, lot 87; Robert Frank, Ltd., London, by 1936; Arnold Seligmann, Rey and Co., Inc., New York, by 1937; purchase 1937

EXHIBITIONS: Paris 1932, cat. no. 87; Toledo 1946; New York 1958, cat. no. 26, ill.

*T*HE DOVECOTE (cat. no. 5) fits well into François Boucher's rusticated country scenes and draws from a rich visual repertoire acquired through his printmaking, tapestry designs, and work with the opera. The subject and its picturesque treatment exemplify Boucher's talent with the brush and his adventurous palette, while its obscure subject matter attests to his interest in the landscape of rural France. Although Boucher trained briefly with François Lemoyne, it was his early work as an engraver for Jean-François Cars that prepared him for the traditions of the *fête champêtre* and his own pastoral forays through his production of etchings after Antoine Watteau for Jean de Jullienne.[1]

The composition of *The Dovecote* is carefully laid out, much like a stage setting, with the emphasis on the fore- and middle grounds and little attention to or development of the background. The horizon line is low, and most of the activity takes place in the richly painted and animated middle ground. The rustic landscape is dominated by the imposing stone structure of the dovecote at the left, surrounded by a collection of makeshift wooden structures and overgrown foliage. Attached to the dovecote is a simple wooden footbridge, which spans the waterfalls and rests on a stone pier on the opposite side of the stream. At the very center of the composition, dwarfed by the dovecote and almost lost against the enormous expanse of sky, are the picture's two figures—a man and a boy standing with a dog in the middle of the bridge. *The Dovecote* shows Boucher at his most luxurious in his treatment of the rustic landscape. Brilliant blue sky fills the composition, and a sweeping arc of white and gray clouds radiates out from a light source behind the dovecote. An array of trees and unruly foliage cover the surfaces of the landscape, fixing the palette of rich greens and browns that dominate the lower half of the picture.

Built to house flocks of pigeons, the dovecote served two important functions in the rural farming communities of France and England: it provided a shelter for the pigeons and so kept the birds from foraging the valuable standing winter crops, and it also provided farmers with another fresh food source. The stone and brick constructions were usually built in the style of the ancient cylindrical towers dating to Roman times, a design that remained popular until the end of the eighteenth century, when they were replaced with square buildings. Boucher depicts these structures in various states of ruin, possibly drawing inspiration from Giovanni Battista Piranesi, who took great liberties with his own renderings of the ancient Roman buildings that inspired these later designs. By the eighteenth century the architecture of the dovecotes reflected a wide range of vernacular styles of the day and had become part of the decorative vocabulary applied to the outbuildings of large estates and country houses.

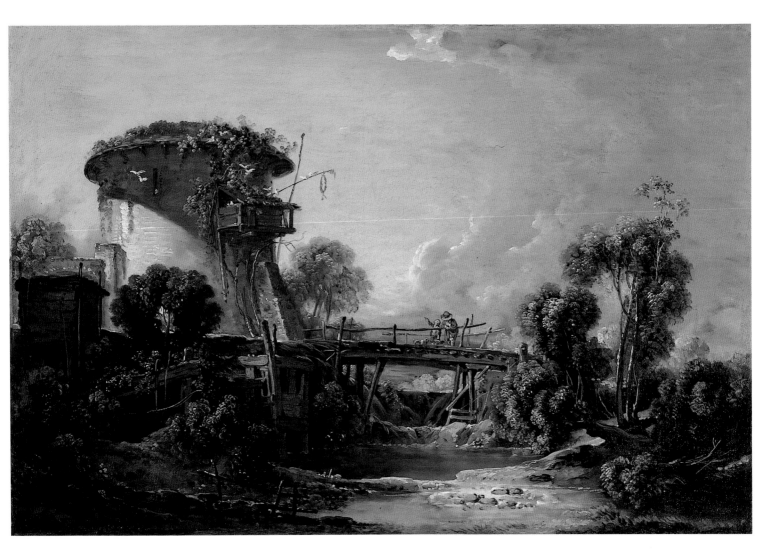

5

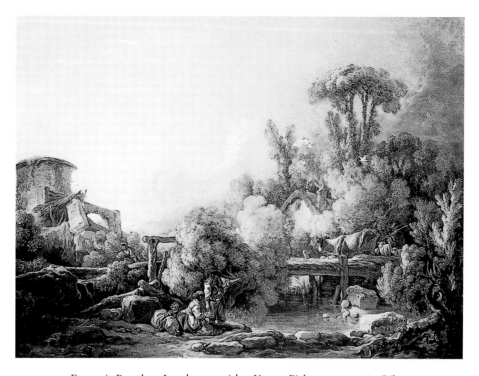

FIG. 43. François Boucher, *Landscape with a Young Fisherman*, 1768. Oil on canvas.
Manchester City Art Galleries, Manchester, England. Purchased with the aid of a grant from the
Victoria and Albert Museum and with the assistance of the National Art Collections Fund, 1981.60.

Dovecotes located on country estates, like the water mills situated along the Seine, are often featured in Boucher's paintings. As early as 1739 he had painted the famous mill of Quiquengrogne at Charenton, and he returned to this subject frequently over the next twenty years.[2] Situated upriver, just east of Paris where the Seine meets the Marne, Charenton was a popular destination for Parisians and the locale for many of the suburban residences of the Paris elite. An engraving by J-P. Le Bas after Boucher, *Seconde veue des environs de Charenton* (1747), shows the same dovecote that appears in the St. Louis picture, with the *Premiere veue* featuring the mill at Charenton.[3] Like the mills, the dovecotes in Boucher's landscapes were often depicted next to a river in the same heavily foliaged settings. *Landscape with a Young Fisherman* (fig. 43) illustrates a similar composition, with the arrangement of the buildings and activities centered around the river. In the Manchester picture the dovecote is shown in an abandoned state, reflecting more its origins as a ruin than a shelter for pigeons.

La noble pastorale was the last tapestry series produced at Beauvais in 1755 (the same year Boucher was appointed *inspecteur sur les ouvrages* at the Gobelins), and the rustic architecture along the Seine and its environs are included in these landscapes as well.[4] The charming, rustic scenes appealed to Boucher's audiences and patrons. They also complemented his designs for the Opéra-comique, where he and the director, Favart, had developed a genre that fit their time particularly well, that of the invented painted pastoral.[5] In his theatrical productions Favart capitalized on the "mood of the moment,"[6] much like Boucher; in the same spirit they quoted from other pictorial and literary sources to create their own orchestrated scenes of rural simplicity and contentment.

NOTES

1. *Figures de différents caractères* included 351 etchings and was published in 1726 and 1728, while the *Recueil Jullienne*, to which Boucher contributed a smaller number of prints, included 271 etchings and was published in 1735. See Wintermute 1999, 39–44.

2. New York 1986, 185. A dovecote similar to the one depicted in the St. Louis picture appears in Boucher's *The Dovecote* of 1750 (New York, private collection). See Wintermute 1990, 166.

3. New York 1986, 185.

4. New York 1986, 30.

5. Noted in New York 1986; Rand 1997, 52; Bailey 2003, 22–23.

6. Iacuzzi 1978, 11.

FIG. 44. *Tempio della Tosse, Tivoli*. Steven Brooke, *Views of Rome*
(New York: Rizzoli, 1995), plate 102.

6. François Boucher, *Idyllic Landscape with Woman Fishing*, 1761

Oil on canvas, 19½ × 26 in. (49.5 × 66 cm.)
The Indianapolis Museum of Art, Indianapolis, Indiana
Gift of Mr. and Mrs. Herman C. Krannert, 60.248
PROVENANCE: Collection of Christian IV, Herzog von
Zweibrücken, Duc des Deux-Ponts (1722–1775); his sale,
Hôtel d'Aligre, Rémy, 6 April 1778, lot 79 (with pendant
Landscape with a Weir); Mme De Polès, Paris; her sale, Paris,
22–24 June 1927, lot 14; Mr. Lennie Davis; Galerie Georges
Petit, Paris; Rosenberg & Stiebel, New York; Mr. and Mrs.
Herman C. Krannert, New Augusta, Indiana; gift 1960
EXHIBITIONS: New York 1986, cat. no. 73, ill.
(as *Landscape with a Distant Ruin*)

A NUMBER OF landscapes in Boucher's oeuvre do not
include mills, dovecotes, hamlets, and wooden bridges—
images associated more with his rococo scenes or *genre
pittoresque*—and instead feature classical ruins. In these
compositions, neither the topography nor Boucher's
selection of costumed peasants, travelers, or fishermen
has changed. But when completely separated from the
medieval and Renaissance structures so common in Bou-
cher's landscapes, the ancient ruin takes on new signifi-
cance, not just offering the only architectural reference
but also solidly referring to the importance of the artist's
Italian sojourn to his architectural vocabulary. The

antique ruins and sculptures from Rome and the *cam-
pagna* figure prominently in Boucher's landscapes, espe-
cially during his most active years with the Beauvais
tapestry manufactory in the 1740s, when images of the
fêtes italiennes as well as the *fêtes galantes* were in great
demand.

Idyllic Landscape with Woman Fishing[1] (cat. no. 6)
is divided in half by the river, which runs horizontally
across the composition. At the point where a weir or
dam has been built, a girl is seen fishing, accompanied
by a young boy who guards a basket of fish or bait,
or perhaps their lunch. Across the water, the terrain
appears strangely uninhabited except for the large ruin
that fills most of the visible portion of the bank. As in
the architectural ruins in the Kansas City picture *Land-
scape with a Water Mill* (cat. no. 4), Boucher chose to
illuminate the antique temple while keeping parts of the
foreground activity in shadow. At the same time, he
framed the ruined structure between two clusters of
trees and created a dramatic arc of clouds to highlight
its placement in the landscape.

Boucher spent between two and three years in
Rome, arriving in 1728 and returning to Paris by 1731.
During his stay, he would certainly have visited Tivoli
to see the great cascades and the Roman ruins. Not far
from the Temple of Vesta (shown in cat. no. 4) is the

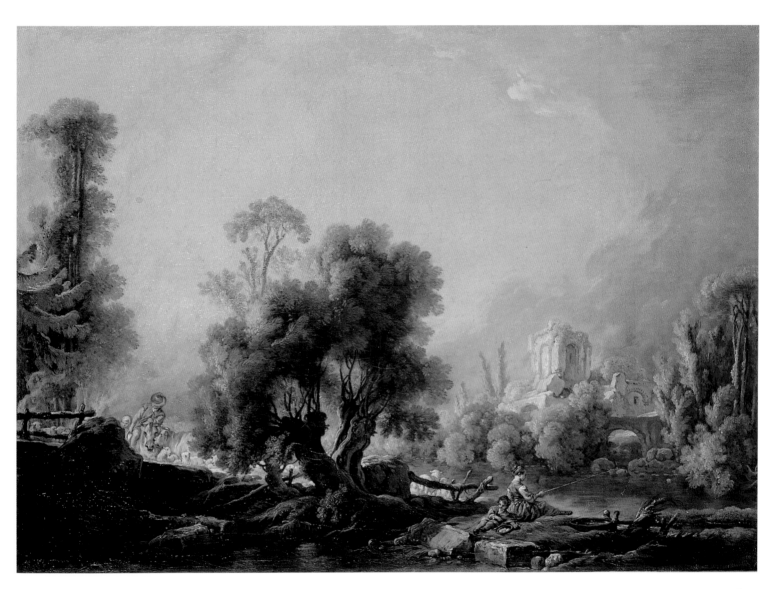

6

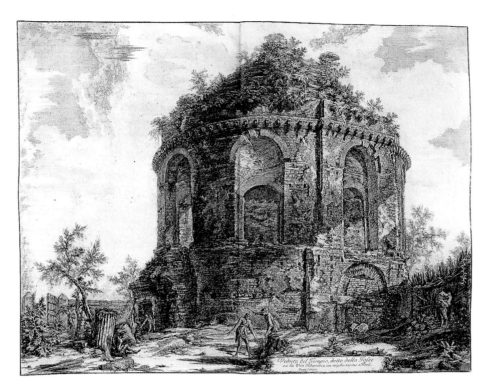

FIG. 45. Giovanni Battista Piranesi, *View of the so-called Temple of Tosse*, 1748–78. Etching. *Vedute di Roma*. Allen Memorial Art Museum, Oberlin College, Oberlin, Ohio.

Temple of Tosse ("Temple of the Cough"), located outside of the Porta del Colle off the via delle Cascatelle and dating to the fourth century (fig. 44). Although not as popular as the nearby Temple of Vesta and lacking the impressive setting above the famous waterfalls, the circular (actually seven-sided) Temple of Tosse was still an important attraction for many seventeenth- and eighteenth-century landscape painters in Rome. Piranesi made an etching of the Temple of Tosse in his *Vedute di Roma*, entitled *Veduta del Tempio, detto della Tosse*, which was first published in 1748 (fig. 45). The print, produced more than ten years before Boucher's painting, shows the temple in a similar state of decay. The temple in the Indianapolis picture does not appear to have been precisely identified in the Boucher scholarship, although Alastair Laing suggested it was reminiscent of the eroded tombs along the via Appia.[2] The temple shown in Boucher's painting is clearly distinct from the Temple of Vesta and other Roman temples that are included in his landscapes.

Idyllic Landscape with Woman Fishing and its pendant, *Landscape with a Weir* (Bielefeld, private collection), were assembled by Boucher's friend and patron, Christian IV, Herzog von Zweibrücken, known as "le duc des Deux-Ponts" (1722–1775). In the posthumous sale of the *duc*'s collection in 1778 in Paris, catalogued by Pierre Remy, the Indianapolis picture was listed as "dans l'un on voit un enfant près d'une femme qui pêche à la ligne: plus loin dans un chemin à gauche, un homme à cheval, & des moutons."[3] The Roman ruins are not mentioned in the catalogue. Its pendant features a large weir beside a water mill, which is the focal point of the composition, and all of the activity takes place around the wooden dam. Laing writes of the two paintings:

> As always, we are conscious of a splendid excess: effects intrinsically natural are piled upon one another in impossible and idyllic confusion. Taken alone, each detail ... has verisimilitude, but the whole defies belief. Nor is it ... the artificiality of the stage set—of which neither picture has either the components or the composition; it is rather, as Diderot said, the subordination of everything to the demands of the brush, which proclaims "Boucher" in every stroke.[4]

NOTES

1. In the 1986 Boucher exhibition, the Indianapolis painting is given the title *Landscape with a Distant Ruin*. See New York 1986, 289.
2. New York 1986, 292.
3. New York 1986, 289.
4. New York 1986, 292.

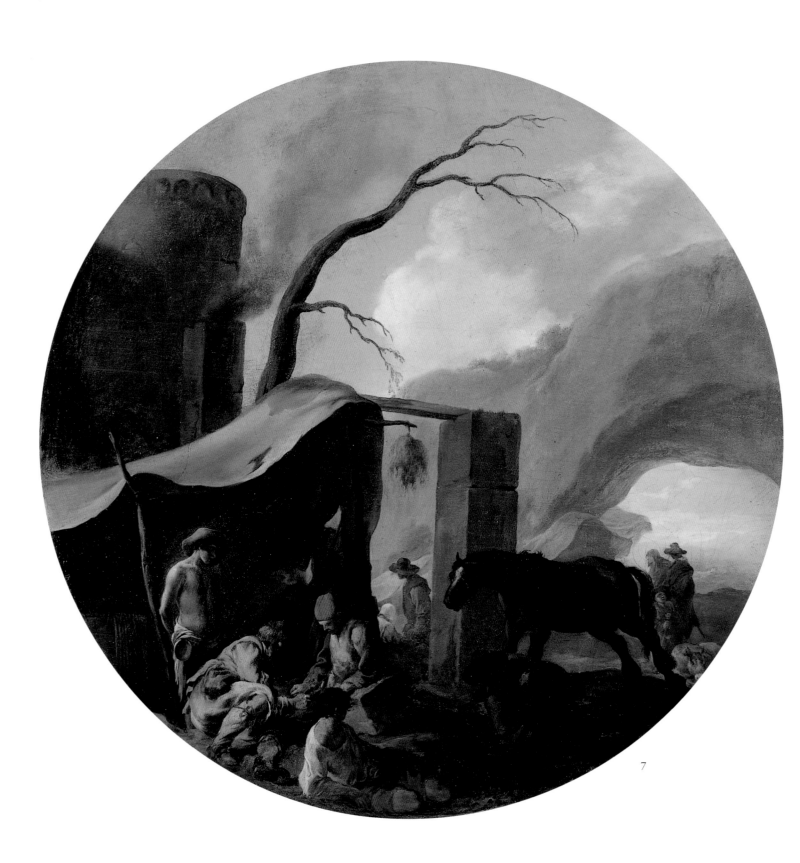

7

Sébastien Bourdon

MONTPELLIER 1616–1671 PARIS

Born in Montpellier in 1616 to the painter Marin Bourdon and Jeanne Gaultière, the daughter of a goldsmith, Sébastien Bourdon was first educated in Paris, possibly under Jean Barthélemy. When he arrived in Rome at the age of eighteen, Bourdon is known to have made copies after works by Claude Lorrain, Andrea Sacchi, and Giovanni Benedetto Castiglione, which he sold mainly to the tourist market. During Bourdon's early years in Rome, he associated with Pieter Van Laer (1599–ca. 1642) and Jan Miel (1599–1664), two leaders of the group of northern painters living in Rome known as the *Bamboccianti*. The small, naturalistic paintings produced by this group focused on everyday scenes, often featuring dramatized low-life subjects. This personal and artistic association inspired Bourdon to produce a number of fine genre scenes in the muted silvery and northern palette popular with upper- and middle-class patrons in Rome.

When Bourdon returned to Paris during the 1637 Inquisition (fearing that as a Protestant he would be persecuted), he continued to paint genre and religious subjects. In a series of biblical "departure" scenes executed in the late 1630s, the influence of the Italian painters Jacopo Bassano and Castiglione is evident. Typically showing Old Testament patriarchs like Abraham or Jacob, Bourdon's Italianate departure or caravan scenes were popular among contemporary collectors.

With the exception of two extended trips to Sweden and Montpellier, after 1637 Bourdon remained in Paris for the rest of his life. During this period, his work was at its most various, and he began to develop a unique personal style. Like his associate Charles Le Brun (1619–1690), whose history paintings dominated the Académie, Bourdon adopted the then popular historical format. *Augustus before the Tomb of Alexander* (Paris, Musée du Louvre) is characteristic of the Baroque style Bourdon brought to this genre. Following Nicolas Poussin's visit to Paris in 1641–42, Bourdon produced a number of important landscapes derived directly from Poussin's geometrically intricate compositions. Bourdon employed a similar scale for the figures, and he paid careful attention to the distribution of color and the arrangement of architectural ruins in landscapes evocative of Parisian classicism.

In 1648, along with Le Brun, Bourdon became one of the twelve *anciens* of the Académie royale, which helped to secure his place in the history of French academic painting. In 1652 he traveled to Sweden at the invitation of Queen Christina and assumed the post of court painter for two years, producing important portraits in a style similar to those of Anthony van Dyck. Upon his return to Paris in 1654, Bourdon was appointed one of the four *recteurs* of the Académie, where he continued to teach. He received several important commissions for architectural decoration and remained in France until his death in 1671. Bourdon's mature works—the finest of which is considered *The Finding of Moses* (cat. no. 9)—incorporate many of the compositional and stylistic elements developed during his Roman years. Highlighted in these later works are the elegantly balanced chromatic compositions and principles of classical form and space borrowed from Poussin. Bourdon's ability to expertly reproduce the styles he respected and to synthesize them in inventive ways constituted his greatest contribution to French painting toward the close of the seventeenth century.

7. Sébastien Bourdon, *Encampment,* ca. 1636–37

Oil on canvas, 22½ in. diameter (56.2 cm.)
The Allen Memorial Art Museum, Oberlin College,
Oberlin, Ohio
Gift of Mr. John J. Burling in memory of his wife,
Marguerite Bensinger, 1957.7
PROVENANCE: Louis François I de Bourbon, Prince de Conti
(1717–1776), to 1779; Conti sale, Paris, 15 March 1779, lot
52; with Dulac, Paris, 1779; Jean-Baptiste-Pierre Lebrun,
Paris, to 1782; Paris; Lebrun sale, Paris, 12 March 1782, lot
112; Dufour, 1782; A. Barclay, Compton Manor, England;
Edouard Napoléon Edmond Nortier (b. 1883), 5th Duc de
Trévise, Paris and Château de Livry-sur-Seine, Seine-et-Marne;
Julius Weitzner, London and New York; John J. Burling; gift
1957
EXHIBITIONS: Rosenberg 1982, cat. no. 7, ill.

Sébastien Bourdon's *Encampment* (cat. no. 7) was formerly attributed to both the Dutch painter Karel Dujardin (1626–1678) and the Flemish Jan Miel. These northern misattributions are not entirely surprising given the French painter's fascination with the *Bambocciantí* during his brief stay in Rome. Bourdon himself

FIG. 46. Sébastien Bourdon, *Voyageurs sous des ruines*
(Travelers in the Ruins), ca. 1636. Oil on canvas.
Musée du Louvre, Paris, France, Inv. 2819. Photograph ©
Réunion des Musées Nationaux/Art Resource, New York.

produced about a dozen *bambocciate* between 1636 and 1637, featuring rural scenes with peasants, gypsies, and soldiers. The low-life subject, gray and brown palette, and small scale of the Oberlin picture all reflect the style and genre of painting made popular by Van Laer and Miel. Van Laer, the leader, was also a member of the *Schildersbent*, a society of Dutch and Flemish artists in Rome who defended their rights as foreign artists working in Rome, often voicing their opposition to the Académie de Saint-Luc.

Despite the stylistic links to the *Bambocciantí* in Rome, Bourdon's *Encampment* may be set apart from the northern school by his own trademark style. Pierre Rosenberg notes that while certain motifs are borrowed from Van Laer in Bourdon's painting—including the horse, which is taken directly from a contemporary etching by Van Laer[1]—"it is the skillful interlocking of the planes, cleverly playing on the diagonals, and above all the range of colors, with harmonies of steel grays, and pale blues, that are characteristics exclusive to Bourdon."[2] Bourdon's remarkable skill in responding to and incorporating a range of painting styles and techniques is evident in the Oberlin work, confirming his ability to appeal to a varied audience at this stage in his career.

Gathered at an encampment, or bivouac, a group of gypsies or peasants play a game of *mora*, a simple amusement involving hand signals in which one hand gesture wins over another gesture. Despite their low estate, the male figures exhibit a variety of elegant poses, and the young man with the bare torso anticipates the splendid figures that appear later in Bourdon's classical works. The makeshift camp is situated between an ancient round stone tower and an impressive natural rock formation that may function as a bridge or shelter. In addition to the canvas structure in the foreground, the same tenting extends around the base of the rock behind the group of figures. A large square stone pier, perhaps a support from a ruin, is used for a corner of the tent, which is also held up by broken limbs. Smoke rises from a square chimney next to the tower, suggesting that the gypsies now inhabit the ancient ruin.

Bourdon uses the same figurative and landscape elements in these early Roman paintings: the figures are typically gypsies or bohemians and soldiers, and the

setting comprises a dreary landscape often lacking trees, foliage, or even a vegetative ground cover. Architectural ruins and interesting rock formations are frequently the only topographical features of interest. A palette of grays and browns with touches of silvery highlights for the staffage animates the surface of the landscape. Bourdon's *Voyageurs sous des ruines*[3] (fig. 46), dated to the late 1630s, shows an almost identical dead tree in the center of the composition, the same round tower (set back in the center middle ground), and an imposing rock formation that could easily be a continuation of the natural structure found in the Oberlin picture. It is the same Italian landscape and locale, possibly a Roman bath, which Bourdon has set into a mountainside or rocky outcropping.

The Oberlin picture was first noted in the 1779 sale of Louis François I de Bourbon, Prince de Conti (1717–1776). The description of a painting in the sale catalogue perfectly matches the Oberlin picture: "Un petit tableau de forme ronde dans la manière Jean Miel. Il représente plusiers figures, jouants sous une tente à porte d'un Cabaret, et près de là un homme descendant de son cheval et qui raccommode son soulier."[4] The painting was also sketched by Gabriel de Saint-Aubin (1724–1780) in the margin of his copy of the catalogue (above which he wrote "*perfectionné*"), confirming the link to the Oberlin picture.[5] An equally detailed description of the picture appears in the 1782 Verrier le Rouge sale in Paris, in which the figures are called bohemians, and, more important, the painting is attributed to Bourdon.[6]

<div align="center">

NOTES

</div>

1. The etching, entitled *Pissing Horse*, is taken from Van Laer's *Horse Series*, ca. 1635–40. See Wieseman entry in Oberlin 1998.
2. Rosenberg 1982, 227.
3. *Voyageurs sous des ruines*; also called *Halte de bohémiens*.
4. Sale Prince de Conti, Paris, 15 March 1779, lot 52: "A small circular painting in the style of Jean Miel. It depicts several figures playing under a tent at the entrance of a cabaret; close by, a man dismounts and fixes his shoe"; see Rosenberg 1982, 226; and Wieseman in Oberlin 1998.
5. Rosenberg 1982, 227.
6. Sale Verrier le Rouge, Paris, 12 March 1782, lot 112: "The circular-shaped work is silvery and painted in Bourdon's beautiful style"; Rosenberg 1982, 226–27.

8. Sébastien Bourdon, *Landscape with a Ford*, ca. 1640

Oil on canvas, 20 × 24½ in. (50.8 × 62.2 cm.)
The Smith College Museum of Art, Northampton, Massachusetts
Eleanor Lamont Cunningham ('32) Fund, 1961:1
PROVENANCE: Galerie Fleuville, Paris; private collection, Paris, ca. 1955–60; Schaeffer Galleries, New York; purchase 1961
EXHIBITIONS: Salmi 1956, cat. no. 23; Jerusalem 1965, cat. no. 16, ill.; Rosenberg 1982, cat. no. 9, ill.

EARLY IN HIS CAREER in Rome, Sébastien Bourdon was influenced by the style employed by Van Laer and his followers who were part of the *Bamboccianti*. The cool blues and grays and the dramatic lighting and heavy shadows in *Landscape with a Ford* (cat. no. 8) are characteristic of this influence. The departure scenes of Jacopo Bassano, featuring groups of animals, also seem to have impressed Bourdon, an influence perhaps partially communicated through Bassano's admirer Castiglione. Bourdon highlights a descriptive narrative in *Landscape with a Ford*, with the mood, setting, and figures crafting a unified story.

In the Northampton picture, Bourdon places the activity of his caravan scene in the foreground before a dramatic backdrop of Roman ruins and natural rock formations. At the center, a bearded male figure in a red robe leads a horse and a herd of sheep and goats across a stream, followed by two more figures and a dog. Much attention is given to each detail and gesture of the members of the entourage: the large workhorse is laden with cloth sacks and glinting copper pots; a dog heels between the man and woman; she lifts her garment away from her submerged feet while balancing a pot on her head; and the man, barefoot and holding his staff, stands on a dry rock in the river. Rising behind the group is an impressive temple ruin that spans almost the entire height of the picture. Four Corinthian columns with elaborate capitals comprise the front of the temple, and flanking columns at right angles complete what was likely the portico for a large Roman temple. A crumbling entablature with most of its cornice missing rests on the six columns.

For the design and ruined appearance of the temple,

FIG. 47. Temple of Antoninus and Faustina, Rome.
Photograph © Alexander Grogan 2004.

Bourdon presumably drew inspiration from the Temple of Antoninus and Faustina in Rome (fig. 47). Situated on the via Sacra on the Roman Forum, the imposing temple was built by the emperor Antoninus Pius in A.D. 141 shortly after the death of his wife, Faustina the Elder. Upon the emperor's death in A.D. 161, the dedication of the temple was changed to include both names. The temple was converted into a church, San Lorenzo in Miranda, between the eighth and eleventh century, and its later Baroque pediment now rises behind the colonnade of the ancient temple.[1]

The rustic landscape in the Northampton picture is reminiscent of Bourdon's early Roman landscapes and relates to the Oberlin *Encampment* (cat. no. 7). A barren, twisted tree climbs from the base of the temple to the upper right corner of the picture and is paired on the other side of the temple with a towering tree in full foliage. Aside from the trees, the landscape is largely defined by a series of rock formations set against the darkened mountain background. With the ruins and

trees pushed to the right and the sky opening to the left, the composition emphasizes the movement of the caravan to an open vista; the diagonal is supported by the declining height of the ruins, the horse preceded by the sheep, and the slope of the rocky horizon.

In the late 1630s and early 1640s (during which time he returned for a yearlong visit to Paris in 1637), Bourdon painted a series of biblical departure scenes in the style of Castiglione; Jacques Thullier has called the Northampton picture the masterpiece of this series.[2] However, the painting's subject has been debated. Some scholars have suggested that this picture is simply a pastoral landscape decorated with antique ruins and populated with anonymous travelers,[3] although it had previously been titled *Jacob's Departure* or *Laban's Departure for the Desert*.[4] In her dissertation on the biblical paintings of Bourdon, Geraldine Fowle retains the title of *Laban* but also suggests that the picture may represent Abraham's journey into Egypt, a conjecture that is supported by the depiction of two men and a

woman (Abraham, his wife Sara, and his son Lot).[5] An engraving by Bourdon entitled *Return of Jacob*, thought to be executed upon Bourdon's return to Paris, shows Jacob with a horse in a composition very similar to the central figures in the Northampton picture.[6] The shaggy white horse packed with goods appears in Bourdon's *The Voyage of Abraham into Egypt*[7] as well as in a painting, now lost, known as *The Ford* or *The Departure of Jacob*,[8] a probable copy of which was sold at Sotheby's in Monaco in 1992 (location unknown).[9]

NOTES

1. See page 37 of this catalogue for a discussion of the excavation of the temple.

2. "Sans doute le chef-d'oeuvre de cette sequence 'a la Castiglione' "; Thullier 2000, 164.

3. Rosenberg 1982, 228–29.

4. Genesis 31:22–23, "It was told to Laban on the third day that Jacob fled. And he took his brethren with him, and pursued after him seven days . . ."

5. Fowle 1970, 11.

6. Rosenberg 1982, 228.

7. Former collection of Denis Mahon, in Thullier 2000, cat. no. 18.

8. Thullier 2000, cat. no. 16.

9. Listed as *Le depart de Jacob*; Sotheby's, Monaco, 19 June 1992, lot 20.

9. Sébastien Bourdon, *The Finding of Moses*, ca. 1650

Oil on canvas, 47 × 68 in. (119.6 × 172.8 cm.)
The National Gallery of Art, Washington, DC
Samuel H. Kress Collection, gift, 1961.9.65
PROVENANCE: Possibly collection of Adriaen Paets, Rotterdam, 1713; possibly Mr. Bryan's sale, London, 6 November 1801, lot 44; Arthur L. Nicholson, London and Llandaff House, Surrey, by 1937 until at least 1939; Paul Drey Gallery, New York; Samuel H. Kress Foundation, New York, 1948; gift 1961[1]
EXHIBITIONS: Grenoble 1937, cat. no. 65; Liège 1939, cat. no. 24, ill.; Rochester 1948; Rosenberg 1982, cat. no. 11, ill.; Thullier 2000, cat. no. 170, ill.

THE SUBJECT of this painting (cat. no. 9) is taken from the Old Testament book of Exodus. When the Pharaoh commanded that all the male children of Israel be put to death, Moses's mother set him afloat in the Nile, and the Pharaoh's daughter finds him on the shore:

And the daughter of Pharaoh came down to wash herself at the river; and her maidens walked along by the river's side: and when she saw the ark among the flags, she sent her maid to fetch it. And when she had opened it, she saw the child: and, behold, the babe wept. And she had compassion on him, and said, This is one of the Hebrews' children.[2]

A popular theme among seventeenth-century French painters, the Finding of Moses was thought to be a specific foreshadowing of the life of Christ as well as a general allegory of salvation (cat. no. 16).[3] Bourdon has given the story a decidedly casual and pleasant mood; the Pharaoh's daughter and her servants seem relaxed and content, and Moses appears healthy and happy to be discovered.

In Bourdon's painting, Pharaoh's daughter, the princess, dressed in a golden yellow robe, provides the central vertical axis. Before her, two male servants wading in the river among the reeds hand a basket containing the infant Moses to the kneeling handmaidens. Moses smiles and reaches up toward his discoverer. Behind the princess are five female figures, elegantly posed in a symmetrical composition, and a sixth, a child, handing a bundle of flowers to one of the servants. At the left of the foreground is a stone wall used by one of the male servants to steady his balance as he emerges from the water. The strong diagonal created between the stance of the princess, her kneeling servants, and Moses's outstretched arm supports the biblical narrative dramatically.

Beyond the river is an imagined Egyptian city complete with ancient Roman temples, tombs, pyramids, and a monument bearing a triumphal chariot drawn by three horses set in the wooded hillside at the right. The skyline is marked by a hilly landscape, palm trees, and the outline of the various buildings. Two men in classical drapery, a woman with an amphora on her head, another figure resting near a tomb, and a fisherman in a boat are visible at the water's edge on the far shore.

Bourdon's composition derives from two versions of the same subject painted by Nicolas Poussin (1594–1665). The first is dated to 1638 and entitled *Moïse sauvé des eaux* (Moses Saved from the Water).[4] Bourdon's pose of the princess (Pharaoh's daughter) and the handmaiden to her left is a direct quotation in

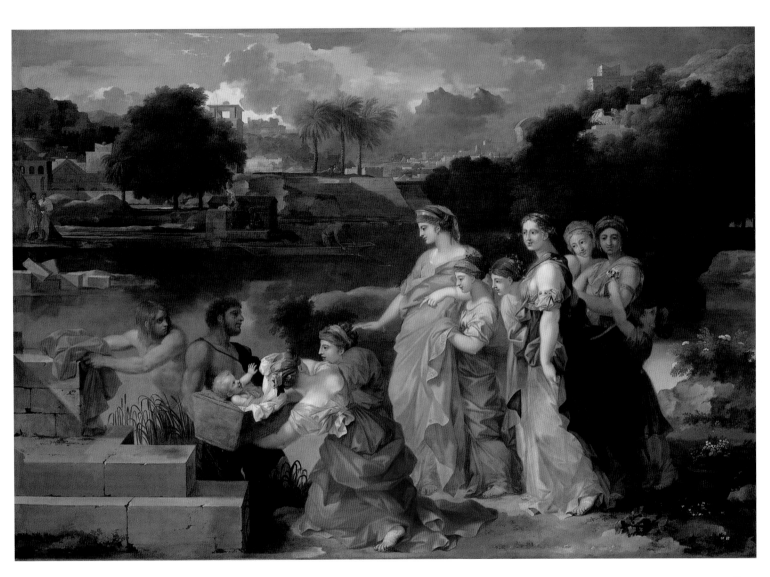

FIG. 48. Nicolas Poussin, *Moïse sauvé des eaux* (Moses Saved from the Water), 1647.
Oil on canvas. Musée du Louvre, Paris, France, Inv. 7272. Photograph
© Réunion des Musées Nationaux/Art Resource, New York.

reverse from Poussin's painting, as is the male servant bringing Moses to the shore. Poussin's second version—made almost ten years later—uses the same title and employs an invented backdrop of classical architecture.[5] Poussin uses the backdrop of classical architecture and palm trees to situate the scene in ancient Egypt. Bourdon had certainly seen Poussin's 1647 picture when he painted his interpretation of the subject, and he copies Poussin's larger group of figures and animated expressions. The low foreground, the scale and positioning of the figures, and the contrasting whites, grays, and blues of the sky are transferred to Bourdon's work. He also borrows the statuesque poses, classical costumes, and Egyptian setting. Based on the correspondences with Poussin's painting, Bourdon's *Finding of Moses* has been dated to about 1650. Pierre Rosenberg places it slightly later with the suggestion that the pictorial relationship is clear evidence of a mature rivalry between the two artists in the mid-1650s.[6]

The porcelain-like surfaces of the women's skin and the brightly colored garments in the Washington picture recall Simon Vouet's (1590–1649) decorative style. But the ordered, geometric composition and Bourdon's

penchant for detail challenge Vouet's decorative proclivity and point more to Poussin. In contrast, the male figures have a much more Italianate quality in their darker skin tones and pronounced musculature. These stylistic currents quite literally come together as the men hand over Moses to the group of classically inspired women. Bourdon's ability to imitate the finest elements of the styles of his predecessors and contemporaries can be seen in this remarkable synthesis. While his work at times has been dismissed as mimicry lacking a distinct style, the Washington picture represents well Bourdon's aptitude to respond to inspiration to create works that had a profound influence on French painting of the second half of the seventeenth century and well beyond.

NOTES

1. Feigenbaum 2004a.
2. Exodus 2:5.
3. Feigenbaum 2004a.
4. Feigenbaum 2004a.
5. The second version is also in the Musée du Louvre. Poussin made a third version, dated to 1651, which is in the National Gallery, London; however, it relates less to Bourdon's composition.
6. Rosenberg 1982, 230.

Claude Gellée, called Claude Lorrain

LORRAINE 1604/5–1682 ROME

Claude Lorrain was born in 1604 or 1605 in the tiny village of Chamagne, in the Duchy of Lorraine, to landowning peasants Jean and Anne Gellée. After training as a pastry cook, he moved to Rome sometime between 1617 and 1621. Little information on his early life exists. He is known to have been in Naples after 1618, where he studied with the German artist Goffredo Wals (1590/95–1638/40), a student of Agostino Tassi (ca. 1580–1644). Soon Claude was back in Rome studying with Tassi himself, and eventually he became Tassi's assistant. A leading architectural decorator, Tassi left Claude with a lifelong appreciation for the landscape and a foundation of illusionistic perspective technique.

After a brief return to Lorraine, where he assisted Claude Deruet (ca. 1588–1660) on frescoes in a Carmelite church in Nancy, Claude returned permanently to Rome in late 1626 or early 1627. He took up residence on the via Margutta, between the Piazza del Popolo and Piazza di Spagna, where he lived until 1650. For part of that time he shared the house with the Dutch painter Herman van Swanevelt (ca. 1600–1655). Claude became a member of the Académie de Saint-Luc in 1633 but was not active with the public affairs of the Académie. In 1650 he moved a short distance to the via del Babuino, known then as via Paolina, where he lived until his death. Claude never married, but he took into his care a girl named Agnes, born in 1653, who was possibly his illegitimate daughter. He died in 1682 and was buried in the French church of SS. Trinità dei Monti, above the Piazza di Spagna. The contemporary accounts of Claude's life come mainly from two biographers: the German painter Joachim von Sandrart (1606–1688) and the Florentine writer and collector Filippo Baldinucci (1625–1697). Sandrart arrived in Rome in 1628 (staying until 1635) and became friends with Claude, and Baldinucci probably met the artist when he visited Rome in 1680 to work on his biography of Bernini.

Claude began to receive praise for his distinctive landscapes in the early 1630s. Working slowly and meticulously, he produced about twelve canvases per year; by the end of the decade, Claude was the most sought-after landscapist in Europe. Ambitious and highly professional, he is known to have associated with Nicolas Poussin (1594–1665) and the Dutch painter Pieter van Laer (1599–ca. 1642) during the 1630s, and he began to amass an impressive array of patrons among the church, royalty, and nobility. Toward the end of the decade he counted among his admirers Pope Urban VII, King Philip IV of Spain, and many cardinals, dukes, and ambassadors. Claude's exquisite landscapes varied in their subject matter and thus appealed to a range of Romans and foreigners. The great commercial success of these landscapes inspired lesser artists to copy and forge pictures to sell as authentic works by Claude. When Claude became aware of this problem around 1635, he began to catalogue all of his work in his *Liber Veritatis*. Containing drawn copies of each of his works along with information about specific commissions, the *Liber* served as a means for collectors to authenticate paintings and today remains an indispensable resource for our understanding of Claude's work.

Though it is difficult to establish a solid chronology for Claude's early work, northern artists such as Paul Bril (1554–1626) and Bartholomeus Breenbergh (1598–1657), who were also active in Rome, seem to have had the most important influence on his development. As he matured, Claude's style became increasingly Italianate, incorporating aspects of the ideal landscapes of Venetian painters such as Giorgione and Titian. Inspired by the classical ideal, as conveyed in the pastoral poetry of Ovid and Virgil, Claude depicted scenes of rustic natural beauty populated by figures in contented repose and embellished with classical architecture and ruins. For Claude, light was the most important natural element; he often depicted scenes at morning or evening, when the landscape was illuminated at its most calm and

poetic. In his work during and after the 1640s, he showed an increasing trend toward classical and biblical allegory, though the emphasis always remained on the landscape. His late works gravitate toward subtler, moody compositions.

Claude's contribution to the landscape genre, as Michael Kitson notes, was perfection, not innovation. While he never fully mastered the principles of a formal, classical training, his poetic portrayal of the ideal landscape has rarely been surpassed, and he is widely recognized as the greatest landscape painter. He was certainly the most influential figure in French landscape painting, and the Claudian manner is celebrated as an important tradition in the history of European painting.

10. Claude Gellée, called Claude Lorrain, *Idyll: Landscape with a Draftsman Sketching Ruins*, 1630

Oil on canvas, 25¾ × 37⅜ in. (65.4 × 95 cm.)
The Spencer Museum of Art, University of Kansas, Lawrence
Anonymous gift to the Barbara Benton Wescoe Fund, 80.31

PROVENANCE: Lord Brassey of Apethorpe, London, by 1940; his sale, Christie's, London, 21 June 1940, lot 19 (as Herman van Swanevelt); Frederick Mont, New York (bought for five guineas); Newhouse Galleries, New York, by 1946; Hilton-Davis Chemical Company, Cincinnati, by 1946; Sterling Drug Company (which acquired Hilton-Davis), 1946; purchase 1980
EXHIBITIONS: Rosenberg 1982, cat. no. 57, ill.; Wintermute 1990, cat. no. 2, ill.

CLAUDE'S *Idyll: Landscape with a Draftsman Sketching Ruins*[1] (cat. no. 10) confirms the artist's prowess as the most gifted French landscape painter of the seventeenth century. Even at this early stage in his painting career—the Lawrence picture has been dated to the late 1620s or 1630[2]—the technical skills that characterize Claude's mastery of the pastoral landscape are evident. Writing about the picture shortly after it entered the collection at Lawrence, Pierre Rosenberg noted,

Claude's usual repertoire is already evident in this painting: the artist in a landscape, the antique ruins covered by luxuriant vegetation, the shepherd and his flock. The calm

serenity of the late sunlit afternoon is no less characteristic. What is striking, however, is the quality of immediacy and intimacy. Nothing could better introduce us to the work of the artist than this painting.[3]

When the Lawrence picture came onto the market in 1940 it was attributed to Swanevelt. After its reappearance, W. R. Valentiner ascribed it to Claude's early oeuvre, and this attribution was later confirmed by Marcel Roethlisberger.[4] A slightly smaller version of the painting in the Metropolitan Museum of Art, published for the first time in 1968, was thought to be an early copy of the original but is now accepted as a contemporary copy by a follower of Claude.[5] The attribution of the Lawrence picture to Swanevelt, who was living in Rome from 1629 to 1641, is not surprising, nor is its closeness to the landscapes of Breenbergh, who was part of the first generation of Dutch Italianates working in Rome.[6] According to his friend and biographer, Sandrart, Claude shared his house on the via Margutta with Swanevelt from about 1628 for an unknown period of time.[7] Sandrart also mentions in his biography of Van Laer that Claude made sketching trips with Van Laer and Poussin into the Roman *campagna* and "rode to Tivoli to paint or draw landscapes from nature," and that the two French painters went on other excursions together.[8]

Poussin's *Landscape with Travelers Resting* (fig. 49), probably executed for the artist's friend and patron Cassiano dal Pozzo (1588–1657) or his brother Carlo Antonio, shows a setting similar to that of the Lawrence picture. Both compositions (which are close in date and dimensions) were most likely inspired by sketching trips to the Roman *campagna*. Aside from the comparable palettes of muted earth tones, highlighted by olive browns and deep terra-cottas, that extend from the various grounds to the trees and shrubbery, the two artists depict both natural and cut-rock formations in the landscape. In the London picture, Poussin shows a ridge of rocky outcropping at the right, which extends into the middle distance, echoing the twisting path. On the extreme left-hand side is a vertical expanse of flat rock that towers above the figures and has the appearance of a wall made of enormous blocks of stone. In the Lawrence picture, Claude has depicted a construction of stone blocks that may be part of an ancient tomb or

FIG. 49. Nicolas Poussin, *Landscape with Travelers Resting*, ca. 1638.
Oil on canvas. National Gallery, London, England, NG6391.

possibly the tower on a military fortification. The two landscape compositions are among the most naturalistic and simplified in the artists' oeuvres. Interestingly, the London picture and another, *Landscape with a Man Scooping Water from a Stream* (London, National Gallery), are the only two strictly naturalistic landscapes ever produced by Poussin, and the figures do not relate to any religious or mythological source.[9]

Claude's figures are associated with plein air sketching along with the subject he often documented in the *campagna*: shepherds and their flocks set among the ancient ruins in a rustic landscape. At the left, two artists, one seated and sketching, document the ruins before them. The Boston picture, *Mill on a River*

(cat. no. 11), also shows artists sketching; however, the uncomplicated composition in the Lawrence picture has been transformed into a more complex setting incorporating additional figures, animals, buildings, and natural elements of the landscape. The influence of Claude's northern contemporaries is evident in both pictures, especially in the darker tonalities of the palette and the massing of the trees and foliage.

NOTES

1. Rosenberg titled the picture *Landscape with an Artist Drawing in the Roman Campagna*; see Rosenberg 1982, 277.
2. Rosenberg dates the work to 1630 (see Rosenberg 1982, 277); Russell dates it to the late 1620s (see Russell 1982, 71).

3. Rosenberg 1982, 277.

4. Rosenberg 1982, 277.

5. For discussions on the authorship of the Metropolitan Museum picture, see Rosenberg 1982, 277; Russell 1982, 71; and Wintermute 1990, 31–32.

6. See fig. 28. Swanevelt's drawing, showing a similar grouping of artists sketching in the *campagna*, was executed around 1630, when Swanevelt was living in Rome, possibly with Claude.

7. Russell 1982, 49.

8. As cited by Russell 1982, 53.

9. Wright 1984, 207.

11. Claude Gellée, called Claude Lorrain, *Mill on a River*, 1631

Oil on canvas, 24¼ × 33¼ in. (61.5 × 84.5 cm.)
The Museum of Fine Arts, Boston, Massachusetts
Seth K. Sweetser Fund, 44.72

PROVENANCE: Duc de Bouillon, Sedan (?); Woodburn, London, by 1837; Thomas Wright, Upton Hall, Newark, England; sale, Christie's, London, 7 June 1845, lot 44; Moore; Wynn Ellis, London; sale, Christie's, London, 17 June 1876, lot 4; Partington; Sir Berkeley Sheffield, Normanby Park, Scunthorpe, Lincolnshire; sale, Christie's, London, 16 July 1943, lot 40 (as Cornelius van Everdingen); Sandor; David M. Koetser Gallery, London and New York, 1943; purchase 1944

EXHIBITIONS: New York 1946, cat. no. 11, ill.; Northampton 1952, cat. no. 1; Kitson 1969, cat. no. 3, ill.; Russell 1982, cat. no. 6, ill.; Kofuku 1998, cat. no. 31, ill.

CLAUDE'S *Mill on a River* (cat. no. 11) is essential to our general understanding of the artist's oeuvre, the relationship of his paintings to the *Liber Veritatis*, and the development of the landscape tradition within his work. From the beginning of his career, Claude experimented with light and its ability to define and animate the landscape. In this early picture set in the Roman *campagna* along the Tiber River, the scene glows with the radiance of the sun's morning light.

Claude has captured a busy riverbank scene; the anecdotal nature of the staffage depicting daily activities is reminiscent of northern paintings. Workmen are seen loading timber onto a large open boat for transport down the river, and a ferry transports donkeys laden with dry goods. Scattered over the riverbank is a herd of goats and cows, most of them grazing near a stone gated enclosure next to the boat landing. At the left a

man milks a goat, and a group of men gather amid an array of architectural fragments. The three men are splendidly dressed in the costumes of cavaliers, including wide-brimmed hats, and the man seated on a stone block sketches the activity before them.

The Boston work fits neatly into the group of Claude's early paintings dating to the early 1630s. However, a similar drawing, *Landscape with a River*, no. 22 in Claude's *Liber Veritatis*, suggests a date around 1637–38 based on its position in the publication. This later date was supported by Marcel Roethlisberger, who read Claude's date as 1637 rather than 1631 (after the picture was cleaned in 1943 and before it entered the museum's collection).[1] The 1631 date is supported by a number of scholars, including William Constable, Michael Kitson, H. Diane Russell, and, most recently, Eric Zafran. Different explanations have been proposed for the discrepancy between the painting and drawing, but the most plausible is that the *Liber* drawing is after a later—and now lost—variant of the earlier Boston picture.[2] This suggestion would explain the six-year gap between the Boston picture and the drawing. Providing more evidence for an earlier date is a drawing in the Hermitage, St. Petersburg, dated 1632, featuring several figures closely resembling those in the Boston painting, including an artist sketching and a man milking a goat.[3] That Claude documented an almost identical sketch in 1632 suggests strongly the *Mill* was executed in 1631.[4] To add to the scholarly intrigue, John Smith's 1837 catalogue of Claude's paintings records that the Boston picture had a pendant (now lost), *A Hunting Party near a Waterfall*.

The authorship of the figures in the Boston picture has been debated. This may have been due to Claude's early biographers, including Baldinucci, who noted that Claude frequently employed artists more adept at figure painting to complete them. However, any skepticism about the figures in the Boston painting has been definitively resolved by Russell, who pointed out that the figures are thoroughly integrated into the landscape, and their authenticity is no longer questioned.[5] The rendering of the landscape is typical of Claude's early works, revealing his association with northern painters, especially Paul Bril, who was in Rome until his death and may have known Claude.[6] The *Mill* has a rich, dark

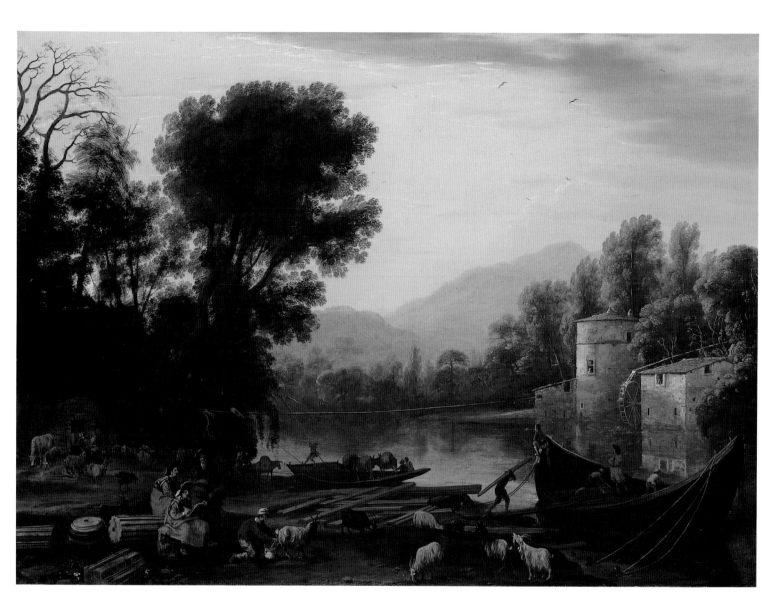

FIG. 50. Claude Lorrain, *La danse au bord de l'eau* (The Dance on the Riverbank), ca. 1631. Etching. Ashmolean Museum, University of Oxford, Oxford, England.

palette with shades of green and brown that is reminiscent of Bril's paintings. In 1620, Claude had served as a studio assistant to one of Bril's pupils, Goffredo Wals, further solidifying this link.

The composition of the Boston picture is one Claude often used in his drawings and paintings: the horizon line is positioned two-fifths up from the base line and is vertically divided into thirds. There is little development of the middle ground, characteristic of Claude's works from this period, and the activity on the riverbank in the foreground remains the main focus of the painting. Eric Zafran suggests that the view of the river and mill probably documents a real site on the Tiber that Claude could have seen; citing Constable, Zafran notes that the particular motif is used on several occasions in the artist's oeuvre.[7] One example is Claude's etching *La danse au bord de l'eau* (fig. 50), which presents a strikingly similar composition and riverbank scene. As in the Boston picture, the primary activity in the etching takes

place on the foreground side of the river opposite the water mill. Russell gives the etching a pre-*Liber* date of around 1634 based on the treatment of the subject and the handling of the medium, which reflects Claude's etching technique from the early 1630s.[8]

NOTES

1. Roethlisberger 1961, 141.
2. See Constable 1944, 312–13; Kitson 1978, 65; Russell 1982, 109; and Zafran 1998, 47–49. All agree with the 1631 dating. After the painting was cleaned and careful study of Claude's 7's (which he always crossed) was made, consensus was that the date should be read as 1631.
3. Zafran 1998, 48.
4. Dobroklonsky 1961, 395.
5. Russell 1982, 110.
6. Constable 1944, 311.
7. Zafran 1998, 48–49.
8. "In the present image, some technical problems occurred, notably the pit marks evident in the sky and the striations around the frame of the image"; Russell 1982, 344.

FIG. 51. Joos de Momper, *Mountainous Landscape*, ca. 1610–20. Oil on panel. Allen Memorial
Art Museum, Oberlin College, Oberlin, Ohio. R. T. Miller, Jr., Fund, 1948.321.

12. Claude Gellée, called Claude Lorrain, *Landscape with Shepherd and Shepherdess*, ca. 1636

Oil on canvas, 29⅛ × 38¼ in. (74 × 97.2 cm.)
The Hood Museum of Art, Dartmouth College,
Hanover, New Hampshire
Purchased through gifts from Peter and Kirsten Bedford
and Julia and Richard H. Rush, class of 1937, and
through the Mrs. Harvey P. Hood W'18 Fund, the
Guernsey Center Moore 1904 Memorial Fund, and
the Katharine T. and Merrill G. Beede 1929 Fund,
and through gifts by exchange, P.989.21

PROVENANCE: Painted for a Parisian collector, 1636; the
Earls of Liverpool, by the early nineteenth century; thence by
descent; Colnaghi, Ltd., New York; purchase 1989
EXHIBITIONS: Roethlisberger 1983, cat. no. 11; Thurber
2001, cat. no. 20, ill.; Goldfarb 2002, cat. no. 153, ill.

IN 1978 Michael Kitson described Claude's *Landscape
with Shepherd and Shepherdess* (cat. no. 12): "The
composition is a simplified version, without figures
except for a herdsman seen small in the middle distance,
of *LV* 3 [*Liber Veritatis*]. It is the only painting in
Claude's oeuvre, apart from paintings from nature,
without prominent figures."[1] When Kitson published
the painting it was unlocated, but scholars knew of its
existence based on its correspondence with Claude's
drawing (no. 7) in the *Liber Veritatis*. When this paint-
ing resurfaced on the art market in London in 1980,
scholars discovered that, in addition to the herdsman in
the middle distance, more figures were positioned along
the central path and tending to the large flock of sheep
on the hillside at the left. More important, in the right
foreground, Claude had prominently placed a young
couple in an intimate embrace. Apparently unhappy with
the position or character of the two figures—in both the
drawing and the painting—he removed them from the
drawing. As noted by Hilliard Goldfarb, Claude experi-
mented with different poses and gestures, eventually
covering them up with dark wash.[2]

In no other instance known in Claude's oeuvre does
he include such sexually explicit activity in his paintings—
the man is shown caressing the woman's exposed breast—
and it may be for this reason, according to Goldfarb, that
the artist covered up the amorous couple in his record
drawing for the *Liber*.[3] The artist's work includes exam-
ples where the figures seem to anticipate and suggest such
sexual activity, such as the Toledo *Landscape with Nymph
and Satyr Dancing* (cat. no. 14). More overt displays of
physical affection and sexual advances were common
among the low-life subjects of the *Bamboccianti*, and
Claude was well acquainted with their work in Rome.

The Hanover picture was painted about a year before
the Raleigh *Landscape with Peasants Returning with
Their Herds* (cat. no. 13), and it displays the same over-
all compositional approach to the pastoral landscape.
The sides of the composition are built up with trees,
heavy foliage, antique ruins, and later buildings and are
supported by topographical formations, which include

heavily treed hillsides, rocky cliffs, terraced fields, and waterfalls. The placement of the figures, usually featuring shepherds and their animals, travelers, sometimes on horseback or donkey, and peasants, is reserved for the lower elevation or valley in the center of the composition, which extends from the foreground to the middle ground. Aside from these compositional links, the Hanover and Raleigh pictures share many of the same figurative and architectural elements—staffage spread out through the middle ground, herds of cattle and goats, the stone bridge crossing the river, and the Temple of Vesta (also known as the Temple of Sibyl) from Tivoli, which has more prominence in the Hanover picture. Claude has modified the circular temple to fit comfortably into the side of the rocky hillside, and he has eliminated the steep drop beneath the temple (as seen in the Raleigh picture, which reflects the actual site of the temple at Tivoli). The great cascades that anchor the temple at Tivoli are transported across the valley in Claude's painting and installed in the mountainside at the right.

In the Hanover picture, Claude presents a more complex middle ground than in the Raleigh picture, lowering the elevation and heightening the topographical details and activities of the figures and animals. He also eliminates the large tree near the center of the Raleigh composition, opening up the interior or valley space in the landscape. This approach reflects a compositional scheme first developed by the Dutch and Flemish painters of the sixteenth and early seventeenth centuries. The artist closest in style and date to Claude in this tradition is Joos de Momper (1564–1635), who is recorded as spending some time in Rome, and whose work was greatly admired and praised by Karel van Mander I (1548–1606) in his *Schilderboeck* (Book of Painters). De Momper produced two types of landscape compositions—the panoramic or "world landscapes" and his valley or grotto landscapes, where the viewpoint is lowered to accommodate an expanded plain or valley area flanked by high mountains. The mountainsides are heavily treed and animated with waterfalls, rock formations, and buildings set into the sides and on the mountain or hilltop. The overall effect is not unlike a stage set, and, at their extreme, these compositions were known as "grotto landscapes." De Momper's *Mountainous Landscape* (fig. 51) displays the format that Claude later adopts and then modifies for his own

pastoral requirements. Much has changed from the de Momper picture, but the framework of the northern landscape remains present in Claude's idyllic setting.

Considering the evolution of the landscape in the Dartmouth picture, T. Barton Thurber writes,

In his early work, Claude often combined fantastic natural settings and familiar architectural elements to evoke pastoral and classical themes. The resulting imaginary effect was frequently accentuated by the appearance of shepherds and shepherdesses in modern clothing, who seemed to symbolize the human condition in an uncultivated environment. Compared to an artist like Poussin, for whom figures in open landscapes suggested a heroic harmony of nature and civilized virtues, Claude aimed to create more romantic and picturesque impressions.[4]

NOTES

1. Kitson 1978, 56.
2. Goldfarb 2002, 337.
3. Goldfarb 2002, 337.
4. Thurber 2001, 56.

13. Claude Gellée, called Claude Lorrain, *Landscape with Peasants Returning with Their Herds*, ca. 1637

Oil on canvas, 29¼ × 39 in. (74.3 × 99.1 cm.)
The North Carolina Museum of Art, Raleigh
Purchased with funds from the State of North Carolina, 52.9.125
PROVENANCE: Painted for a Parisian patron, 1647; W. Willet sale, London, 2 June 1813, lot 118; Lord Northwick, Thirlestone House, Cheltenham, until 1859; Northwick sale, Phillips, London, 26 July 1859; Mr. J. S. W. S. Erle Drax, Olantigh Towers, Wye, Kent, until 1910; his sale, Christie's, 19 February 1910, lot 102, bought by Simmons [or Simonson]; recorded as PWU by Isarlo, 1949; David M. Koetser Gallery, New York; purchase 1952
EXHIBITIONS: Dodge 1969, cat. no. 34, ill.; Durham 1973; Russell 1982, cat. no. 18, ill.

THE PAINTING (cat. no. 13) is dated to about 1637 based on Claude's drawing (no. 20) in the *Liber Veritatis*. It corresponds wholly to the drawing, with the exception of the adjustment in the scale of the figures,

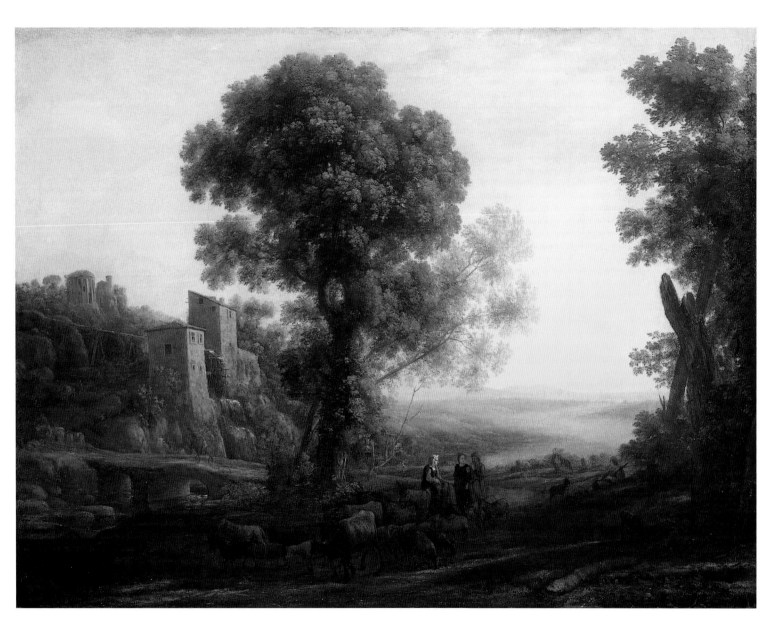

13

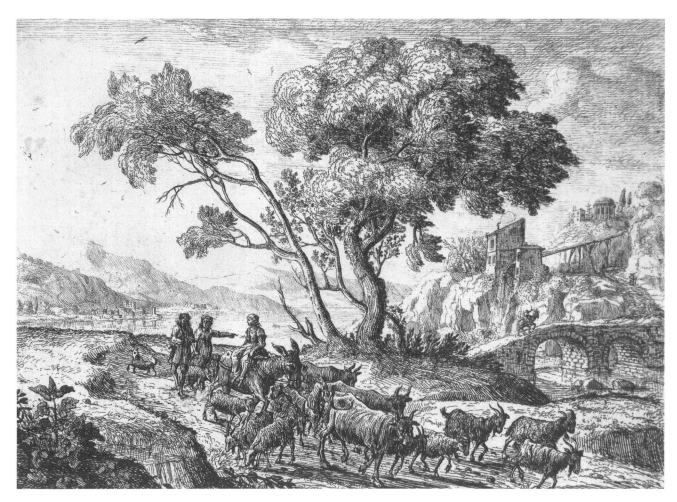

FIG. 52. Claude Lorrain, *Le départ pour les champs* (The Departure for the Fields), ca. 1637. Etching. Allen Memorial Art Museum, Oberlin College, Oberlin, Ohio. R. T. Miller, Jr., Fund, 1983.36.

animals, and architecture, and the addition of the reclining shepherd. The Raleigh picture also relates to Claude's etching *Le départ pour les champs* (The Departure for the Fields) (fig. 52) that is known in three states and dated to the late 1630s. Scholars have debated the date of the print and whether it was made after the drawing or painting or executed as an independent work. H. Diane Russell has argued that the etching is an independent work or was produced after a variant of the Raleigh painting.[1] She observes that the composition of the print has been simplified, with figures, foliage, and terrain adjusted, but it still shares the same landscape setting as the painting. The large, centrally placed tree remains the focal point of the landscape, but its bare lower trunk, free of heavy foliage, allows the viewer a clear perspective on the surrounding landscape, while the upper limbs fan out horizontally to

the left and right. The three figures with the goatherd stand out more in the etching, and their activity animates the foreground whereas the architecture recedes into the rocky hillside. Lacking the clump of trees that is on the right side of the painting sheltering the reclining shepherd, the landscape opens up to the riverbank and a view of a Renaissance townscape set against the foothills of a distant mountain range.

Claude produced the majority of his etchings between the 1630s and 1640s, making only five during the 1650s and 1660s. The prints served him publicly and privately: as a shrewd businessman, he recognized that prints opened up another market and additional revenue; as an artist, he took the opportunity to develop his compositions, often reworking them to his satisfaction.

Claude's *Landscape with Peasants Returning with*

Their Herds falls within a group of pastoral landscapes executed in the late 1630s and 1640s that share a number of architectural forms and naturalistic landscape motifs presented within a flexible compositional scheme. Commenting on Claude's practice, Russell writes, "In each case he was able to manipulate a standard set of forms—the mill, the bridge, a body of water, trees, shepherds, and herds moving about—in such a way as never to duplicate another work precisely."[2] The Hanover *Landscape with Shepherd and Shepherdess* (cat. no. 12), painted about a year before the Raleigh picture, shares many of the same motifs as well as the same basic composition, but the artist has managed to create two very different landscape paintings.

The landscape glows with the golden-red tones of the evening sun setting on the horizon. The light is reflected in the river snaking its way through the center of the landscape toward the mountains in the distance and disperses throughout the pastoral setting. It illuminates the face of the woman who is shown sitting on a donkey surrounded by a herd of cows and goats. Accompanied by two other figures, she pauses beneath an enormous tree, which spans the height of the canvas. The shepherd, wearing a red cap and identified by his long staff, reclines under a clump of large trees at the right. Another group of figures, some mounted and others leading their horses, can be seen crossing the stone bridge and moving up the hill toward the mill. Above the mill and the cascading waters is an antique ruin nestled into the crest of the wooded hillside. The structure can be identified as the Temple of Vesta at Tivoli. Next to a group of later buildings, the temple is at the highest point in the landscape and catches the final rays of the evening light. Built by Hadrian during the golden age of Rome, the ancient temple now evokes a nostalgic memory of the Roman *campagna* and the pastoral pleasures associated with this idyllic locale.

NOTES

1. For a complete discussion of the dating and circumstances surrounding the production of the etching, see Russell 1982, 364–65.
2. Russell 1982, 127.

14. Claude Gellée, called Claude Lorrain, *Landscape with Nymph and Satyr Dancing*, 1641

Oil on canvas, 39¼ × 52⅜ in. (99.5 × 133 cm.)
The Toledo Museum of Art, Toledo, Ohio
Gift of Edward Drummond Libbey, 49.170
PROVENANCE: Painted for a Venetian patron, 1641 (according to the *Liber* drawing); Vassal de Saint-Hubert, Esq., 1751; Allan Gilmore, London; his sale, Phillips, London, 2 May 1843, lot 117; 2nd and 3rd Lords Bateman, Shobdon, Herefordshire, England, by 1881; Daniel H. Farr, Co., New York, from ca. 1927–30; sale, Christie's, London, 14 July 1939, lot 119; Wildenstein, Paris, 1939; seized for Hitler's projected museum at Linz, 1940; Wildenstein, New York, 1945; gift 1949
EXHIBITIONS: London 1881, cat. no. 163 (as *Classical Landscape*); New York 1968, cat. no. 8, ill.; Russell 1982, cat. no. 28, ill.; Cafritz 1988, cat. no. 52, ill.; Kofuku 1998, cat. no. 39, ill.

OF ALL THE Venetian painters whom Claude admired, he probably learned the most from Titian: Claude's landscapes exhibit a use of brilliant color and light inspired by the Venetian master, and this influence probably accounted for some of the subjects Claude chose for his paintings. In April 1625, Claude left Rome for Nancy, the capital of Lorraine, traveling via Loreto, Venice, and Bavaria.[1] In Venice he studied at the local academy of art where he saw Titian's work. This period was crucial for his development, not only stylistically but also economically, as he executed several paintings during his stay. Claude returned to Rome in 1629 and spent the next decade mastering how light could unify the composition. In the early 1640s, Claude's approach to the landscape changed significantly as he began to carefully frame his pastoral compositions with architectural ruins. Using the historical memory of ancient Rome, which is embedded in the architecture, he began to develop a context to complement mythological and biblical subjects. *Landscape with Nymph and Satyr Dancing* (cat. no. 14), painted in 1641 and corresponding to a drawing (no. 55) in his *Liber Veritatis*, is one of the first paintings in which this tradition is introduced.

In the Toledo picture, Claude uses light to merge elements of the painting, giving the landscape an atmospheric veneer that defines his work of the 1640s. The light enters from the lower right side of the painting and

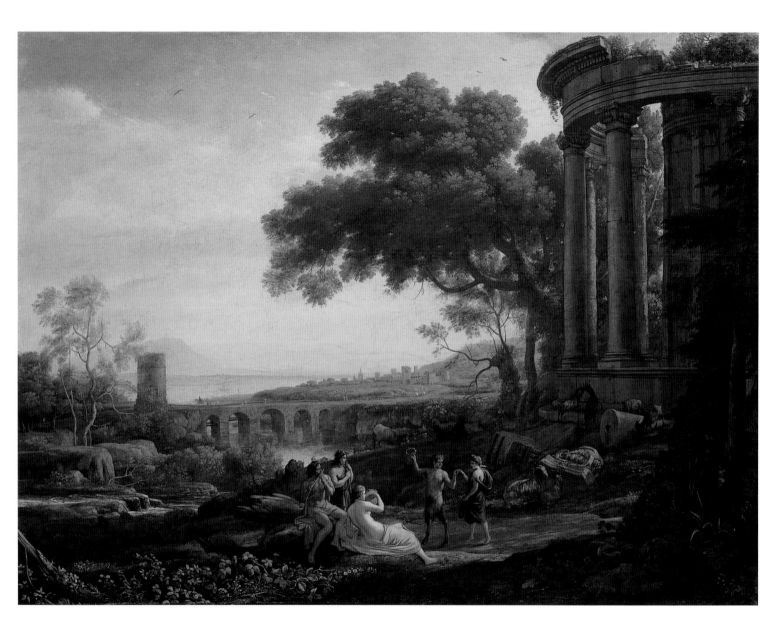

14

casts a red glow over the entire scene. A ruined structure similar to the Temple of Vesta on the Roman Forum and the Temple of Vesta at Tivoli frames this side of the landscape. The two temples dedicated to the Vestal Virgins are similar in size and design (the temple in Rome is slightly larger, with a circular *cella* spanning thirty feet and a podium that is approximately ten feet high), and both have Corinthian columns. The Temple of Vesta on the Roman Forum, between the Temple of Castor of Pollux and the House of the Vestal Virgins, dates to 191 B.C. when Julia Domna, wife of the emperor Septimius Severus, oversaw its restoration[2] (fig. 53).

Claude has presented the temple as an icon that contemporary viewers would immediately associate with ancient Rome and the architectural legacy of its emperors.[3] In bringing the ruins forward, Claude translates the architecture as part of the landscape as easily as a tree is accepted as part of the Roman *campagna*. In its classical splendor, the temple acts as a window that evokes the Arcadian world, as light streams through the columns and illuminates the figures in the foreground. The viewer's attention is drawn to the center of the painting where the sun strokes the flesh of a reclining nymph partially draped in a yellow robe. Holding a tambourine, she plays with two other musicians at the request of a satyr who stands in front of the trio. At the left side of the landscape, the light reflects off the rushing waters as it cascades toward a waterfall hidden from our view and reappears beneath the Roman towered bridge that links the middle ground to the Renaissance city in the distance.

Claude relied extensively on earlier drawings to provide inspiration for his later compositions.[4] However, while the subject of rural dancing is a common theme in his oeuvre, the bacchanal subject is rare and, in this instance, may be explained through the patron. The inscription on the back of the corresponding drawing in the *Liber* documents that this painting was sent to a Venetian patron, although his identity remains unknown. Claude executed only one other painting that had the subject matter of nymphs and satyrs dancing: *Landscape with Dancing Satyrs and Nymphs* (ca. 1646; Tokyo, National Museum of Western Art) painted for Phillippe-Sylvestre Dufour (1622–1687), a successful pharmaceutical merchant in Lyon. A personal friend of

FIG. 53. Temple of Vesta, Rome. Photograph © Leo Curran 2004.

the artist, Dufour chose the subject of the satyr,[5] and we can speculate that the Venetian patron of *Landscape with Nymph and Satyr Dancing* also chose the subject for the painting. Claude would have seen the great bacchic scenes by Titian and Bellini in Venice, as well as those paintings made for Isabella d'Este at Ferrara and transported to the Palazzo Ludovisi in Rome in 1598.[6] Aside from these Italianate sources, Claude found inspiration for this subject in northern painting, in particular the work of Paul Bril, who was active in Rome until his death in 1626. As a principal of the Académie de Saint-Luc in 1620, Bril was well known in artistic circles in Rome, and his work was enthusiastically collected by members of the church, nobility, and upper classes.

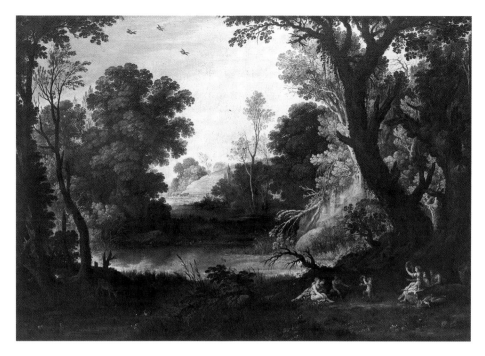

FIG. 54. Paul Bril, *Landscape with Nymphs and Satyrs*, 1623. Oil on canvas.
Allen Memorial Art Museum, Oberlin College, Oberlin, Ohio. Purchase, Friends of Art Fund,
A. Augustus Healy Fund, R. T. Miller, Jr., Fund, and Charles F. Olney Fund, 1953.257.

The two artists probably shared certain patrons. Bril's *Landscape with Nymphs and Satyrs* (fig. 54), executed about twenty years before Claude's painting, lays the groundwork for much of what would become Claude's trademark pastoral landscape. In place of Claude's Temple of Vesta, Bril installed an enormous tree as the backdrop for his enchanting group of nymphs and satyrs.

NOTES

1. Russell 1982, 38.
2. There is some question as to how much of the Temple of Vesta on the Roman Forum was exposed (and excavated) in the seventeenth century and what exactly Claude would have seen, and thus it is more likely that he was looking at the Temple of Vesta at Tivoli for inspiration. See pages 36–37 of this catalogue for a discussion of the temple in the Roman Forum.
3. MacDonald 1995, 267.
4. Cotte 1970, 59.
5. Roethlisberger 1972, 30.
6. Sandrart documents a visit to the Palazzo Ludovisi with Claude and others. See Russell 1982, 142.

15. Claude Gellée, called Claude Lorrain, *Coast View with the Embarkation of Carlo and Ubaldo*, ca. 1667

Oil on canvas, 36½ × 54½ in. (92.7 × 138.4 cm.)
The Art Gallery of Ontario, Toronto, Ontario
Gift of Group Captain H. L. Cooper, A.F.C., Salisbury, England, in appreciation of the contribution of Canadians in the Armed Services in the two World Wars, 1962/12
PROVENANCE: Prince Paolo Francesco Falconieri (according to the *Liber* drawing); Davenant, Paris, by ca. 1720 (according to the second index of the *Liber*); Henry Grey (d. 1740), Earl of Kent and Duke from 1710; thence by descent, Marchioness Grey, who married the Earl of Hardwick; Countess De Grey; Thomas, Earl De Grey to Baroness Lucas; given to the Art Gallery of Ontario by her husband, Group Captain H. L. Cooper, A.F.C., Salisbury, England, in 1962 as *Carlo and Ubaldo Embarking in Pursuit of Rinaldo*
EXHIBITIONS: London 1949, cat. no. 33; Montréal 1961, cat. no. 18, ill.; Russell 1982, cat. no. 48, ill.; Birmingham 1995; Nashville 2001, cat. no. 20, ill.

CLAUDE'S *Embarkation of Carlo and Ubaldo* (cat. no. 15) corresponds with a drawing (no. 168) in the artist's *Liber Veritatis*. It was one of four landscapes painted for the Florentine-Roman nobleman Prince Paolo Francesco Falconieri (1616–1686)[1] and his wife Vittoria del Bufalo (Alessandro Cardinal Falconieri [1657–1734] was his

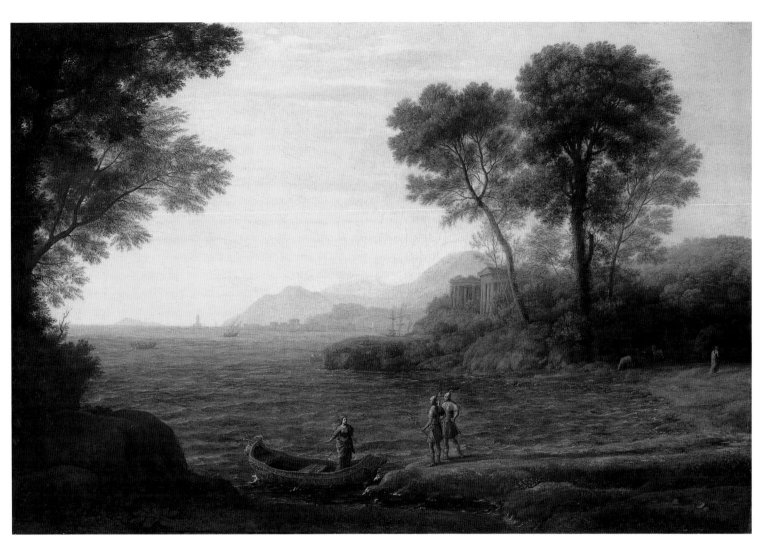

FIG. 55. *Tempio di Vesta*. Steven Brooke, *Views of Rome*
(New York: Rizzoli, 1995), plate 51.

son). The painting likely went directly to the Villa Falconieri (formerly the Villa Rufina) where the prince had overseen a major renovation of the villa that same year. Upon receipt of *Embarkation of Carlo and Ubaldo* and its pendant, *Erminia and the Shepherds* (Viscount Coke), Falconieri commissioned another pair of paintings from Claude, which featured scenes from Virgil's *Aeneid*.[2] Claude was in his sixties when he painted the four works, and the prince was his last important patron.

The subject of the Toronto picture is taken from a passage in Torquato Tasso's epic poem *La Gerusalemme liberata* (Jerusalem Delivered), one of the masterworks of *cinquecento* literature, first published in Parma in 1581 (translated into English by Edward Fairfax and published in London in 1600). The poem is based on the first Crusade of the eleventh century, which led to the sack of Jerusalem in 1099 by Christian knights and warriors supported by Pope Urban II. The central character of the story is Godfrey of Bouillon, who would become the new ruler of the liberated Jerusalem. The scene depicted in the Toronto painting takes place in Canto 15, after Godfrey has selected the Christian knights Carlo and Ubaldo to search for Rinaldo. Armida, who has fallen in love with Rinaldo, transports him by chariot to the Fortunate Islands (thought to be the Canary Islands).[3] The Magician of

Ascalon arranges for the two knights to meet Fortune, who guides them across the ocean in a skiff to rescue Rinaldo. Their journey with Fortune takes them along the shores of the Levant, past the African coast and Gilbraltar to the Atlantic Ocean, and eventually to Armida's island.

Standing on the shore of a small inlet, Carlo and Ubaldo, tall and elegant in their stances, are shown in full armor carrying their spears and swords. Fortune, in her changing blue dress, waits in an elegantly decorated skiff; at the far right, the magician is seen leaving. Claude, however, has not included the objects given to the knights by the magician: the magic wand to help them fight the wild beasts guarding Armida's island, the burnished shield to break the spell on Rinaldo when he sees his own reflection, and the map to guide them.

It is a remarkably beautiful scene; the morning light, aided by a fine mist that moves across the water and breaks near the shore, unites every element of the landscape. Captured here, Marcel Roethlisberger notes, is the serene, ideal world of Claude's late paintings in which a harsher morning or evening light has given way to "an infinitely subtle illumination," where the real subject of the painting is "the gradation of tones and colours from the foreground to the distance, in other words their atmosphere."[4] Added to the exquisite

FIG. 56. *Tempio della Fortuna Virile*. Steven Brooke, *Views of Rome*
(New York: Rizzoli, 1995), plate 50.

quality of light and atmosphere are the elegance and beauty of the figures and the depiction of the landscape setting. In the quietness of the morning light, Claude is still able to convey the rhythm of the waves hitting the shore and the soft wind moving through the trees, gently stirring Fortune's drapery. H. Diane Russell writes: "Claude's pendants for Falconieri are the most jewel-like of all of his paintings, including his coppers. The figures are unusually small and elegantly lithe.... and the natural forms are rendered with an extreme delicacy of touch and modeled with the most refined nuances."[5]

Although Claude has chosen the more familiar Italian coastline for his painting—perhaps the area around Naples—the passage from Tasso takes place near Ascalon, situated on the coast between Gaza and Jamnia in Syria. The harbor of Ascalon can be seen in the distance, marked by buildings lining the shore and the approaching ships and boats. Closer to the viewer are two classical temples positioned on a rocky crag set back from the shore. The buildings' design and close proximity are similar to two of the oldest extant buildings in Rome: the Temple of Vesta and the Temple of Fortune or Fortuna Virile, which are almost next to each other in the Piazza Bocca della Verità, the ancient Forum Boarium, by the Tiber River.[6] The circular marble Temple of Vesta (fig. 55), constructed of twenty

Corinthian columns (nineteen of which survive), dates to the late second century B.C. and was probably dedicated originally to Hercules Olivarius. The Temple of Fortuna Virile (fig. 56), dating to at least the second century B.C., has four Corinthian columns in the front and was dedicated to Fortuna, the Roman goddess of fertility (but also identified with the Greek Tyche associated with chance or luck), or to Portunus, the god of the harbor. The dedication of the two temples to Vesta, Fortuna, and possibly Portunus and their similarity to the ruins in Claude's painting are significant given the story of Carlo and Ubaldo's meeting with Fortune before their voyage out to sea.

NOTES

1. Russell gives Falconieri's dates as 1626–1696 (Russell 1982, 182).

2. Russell 1982, 182.

3. Canto 15, stanzas 1–6: "The knights for their fair guide to look begin; / And gazing round, a little bark they spy'd, / Wherein a damsel sat the stern to guide; ... Enter this boat, you happy men, / Wherein through raging waves secure I ride; / To which all tempest, storm, and wind obeys, / All burdens light, benign is stream and tide. / My Lord, that rules your journeys and your ways, / Hath sent me here, your servant and your guide"; as cited in Russell 1982, 185.

4. Roethlisberger 1965, 50.

5. Russell 1982, 183.

6. See pages 37–38 of this catalogue for a discussion of the two temples.

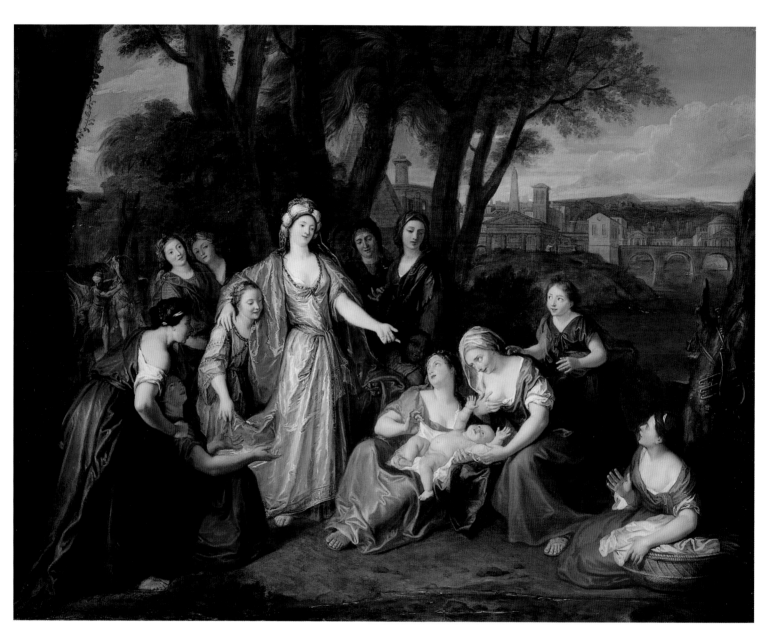

16

Antoine Coypel

PARIS 1661–1722 PARIS

Born in 1661, Antoine Coypel belongs to the second of his family's three generations of court painters. His father, Noël Coypel (1628–1707), in accordance with mid-seventeenth-century tastes of the Académie royale, painted in the Italianate style of Charles Le Brun and Nicolas Poussin, in a manner where drawing and design were considered the primary vehicles of painting. Coypel was introduced to this academic approach—often called *Poussinisme*—both in his father's studio and in his subsequent studies at the Académie de France in Rome and the Académie in Paris.

Upon Noël Coypel's appointment as director of the Académie in Rome in 1672, Coypel traveled with his father to Italy, remaining there for three years. In Rome, Coypel participated in classes at the Académie, copied Raphael's frescoes at the Vatican, and avidly drew after the antique as well as after Renaissance and Baroque models. He was also impressed by the Bolognese painters, especially the work of the Carracci and Domenichino that he encountered at the Palazzo Farnese. On his return trip to Paris in 1676, Coypel traveled through northern Italy, where he discovered the works of Correggio and the great sixteenth-century Venetian painters Veronese and Titian. All of these influences would surface again in his paintings of the next several decades.

Coypel's fame as a painter in Paris came quickly in the 1680s. In 1680 and 1681, he received his first important church commissions to paint the May of Notre-Dame in Paris (location unknown) and execute works for the Convent of the Assumption. In 1681 he was received at the Académie royale with his painting *Louis XIV after the Peace of Nijmegen* (Montpellier, Musée Fabre). His first royal commission came in 1683, and in 1684 he was made *adjoint à professeur* at the Académie. Soon after, he gained the patronage of the family of the Duc d'Orléans and was appointed *premier peintre* to Louis XIV's brother, Philippe I, in 1689.

At the very point when his own style of painting had matured and become well established, the political climate and patronage circumstances changed abruptly in France. The financial drain from the War of the League of Augsburg forced artists to seek out private commissions, and Coypel resorted to decorating the residences of the Parisian aristocracy and focusing on small-scale easel works, often with mythological subjects. During this period Coypel encountered the clashes between the Poussinistes and Rubenistes. The Rubenistes, their cause championed by the theorist Roger de Piles (1635–1709), espoused color and the Venetian tradition as the principal element of painting. Coypel firmly adhered to the grand manner of Poussin and his followers, yet, at the same time, he responded to the bravura brushwork and palette associated with Rubens, whose work he had seen in the collection of Cardinal Richelieu. Coypel's series of Old Testament scenes, painted between 1695 and 1697, is characterized by this merging of styles, reconciling for Coypel the debate between *disegno* and *colore*. This series, considered part of the artist's campaign to become *premier peintre du Roi*, represents some of the strongest Rubeniste elements in his oeuvre.

In the early 1700s, Coypel collaborated with Jean Jouvenet (1649–1717), Charles de La Fosse (1636–1716), and the Boullogne brothers on commissions for Philippe II, Duc d'Orléans, and Louis XIV. Beginning in 1702, he painted the ceiling of the Grande Galerie (*galerie d'Enée*) in the Palais-Royal and the ceiling of the chapel at Versailles in 1708, in both instances indulging his patrons in the flourishes of the Roman Baroque.

In his later years Coypel was hampered by illness, often turning over commissions to his son, Charles-Antoine Coypel (1694–1752). While his artistic output declined, honors and titles came to him in quick succession. Coypel was appointed director of the Académie royale in 1714 and *premier peintre du Roi* in 1715. In these last years of artistic production, Coypel revisited the academic painting of his youth, perhaps yielding to the enduring influence of Poussin at the Académie but at the same time anticipating the

FIG. 57. Jean Audran after Antoine Coypel, *The Finding of Moses*, ca. 1697.
Engraving. Bibliothèque Nationale de France, Paris, France.

painterly style of the rococo. Still, he advocated a
doctrinal compromise between the classicists and
colorists, the text of which exists in his *Discours
prononcés dans les conférences de l'Académie royale
de peinture et de sculpture* (1721).

16. Antoine Coypel, *The Finding of Moses*,
ca. 1695–97

Oil on canvas, 43⅞ × 57⁵⁄₁₆ in. (111.5 × 145.5 cm.)
The Allen Memorial Art Museum, Oberlin College,
Oberlin, Ohio
R. T. Miller, Jr., Fund and Friends of Art Endowment
Fund, 1978.2
PROVENANCE: European private collection; Heim Gallery,
London, by 1977; purchase 1978
EXHIBITIONS: Paris Salon 1699; Paris Salon 1704; London
1977, cat. no. 5; Bailey 1985, cat. no. 5, ill.; Gordon 1987,
cat. no. 4

In the Oberlin painting (cat. no. 16), Antoine Coypel
has focused not on the actual "finding" of the infant
Moses but on the scene recorded later in the same chap-
ter of the book of Exodus in the Old Testament: "And

Pharaoh's daughter said to her, Go. And the maid went
and called the child's mother. And Pharaoh's daughter
said unto her, Take this child away, and nurse it for me,
and I will give *thee* thy wages. And the woman took the
child, and nursed it."[1] A popular theme in seventeenth-
century French painting, the finding of Moses offered
painters the opportunity to document an important bib-
lical narrative set in an exotic landscape with classical
architecture, featuring an impressive assemblage of
women in elegant dress and a variety of poses (cat. no. 9).
Coypel did not disappoint the critics in his rendering of
the subject and drew on many painting traditions to pro-
duce one of the masterworks of his career.

The painting was exhibited in the Salons of 1699 and
1704 as *Moïse trouvé sur les eaux et présenté à fille de
Pharaon*, and it was very likely part of a series of at
least eight smaller-scale history paintings that Coypel
produced in the 1690s illustrating passages from the Old
Testament.[2] Included in the series was *Susanna Accused
by Her Elders* (Madrid, Museo del Prado), a painting
that his son, Charles-Antoine, considered "the most
perfect picture yet to come from his hand."[3] This group
of paintings was produced without the support of his
patron and protector, Philippe, Duc d'Orléans. Coypel
probably secured the patronage of members of the

Parisian elite or influential amateurs for this project.[4] One clue to the commissioning of the series may be the existence of an engraving (fig. 57) by Jean Audran (1667–1756), after the Oberlin picture, dedicated to the powerful Cardinal César d'Estrées, Coypel's protector since the 1670s.[5] Antoine Schnapper suggests that Coypel may have undertaken the series in an effort to secure the position of *premier peintre du Roi*, which was not given to him until 1716 when the Duc d'Orléans became Regent.[6] Impressed with Coypel's Old Testament series, Louis XIV commissioned a suite of tapestry cartoons after seven of the paintings in 1710 (not including the Oberlin picture), and the tapestries were produced the following year at the Gobelins manufactory. Interestingly, the Oberlin *Finding of Moses* was the first painting by Coypel to enter a public collection in the United States.[7]

The reliance on Poussin is evident in Coypel's picture. The poses of the women and the architectural landscape setting are taken from two different versions of the same subject painted by Poussin, each entitled *Moïse sauvé des eaux*, which at the time were both in the royal collection in Paris.[8] Coypel's depiction of Pharaoh's daughter, with a second woman close by her side, relates to the same figures in Poussin's 1638 version. The impressive frieze of classical and Renaissance architecture spans the width of the painting, showing temples, tombs, pyramids, obelisks, towers, and bridges, and it recalls the 1647 version by Poussin (fig. 48). The biblical story takes place along the banks of the Nile River in Egypt, and Coypel has made some attempt to give the viewer a sense of the exotic locale with the insertion of the Egyptian monuments, although these may also refer to Roman buildings.

In his treatment of the figures, especially the sumptuous attention to the women's beautiful skin and the array of rich drapery and jeweled adornments, Coypel has obviously responded to Rubens's palette and brushwork. The princess, elaborately dressed in a bejeweled turban, gestures to Moses's mother, who kneels in a sign of respect as she prepares to nurse the child. Between the two women, and standing in a softer light at the center of the painting, is Moses's sister, Miriam, covered by a blue mantle, gazing lovingly at the mother and child. Coypel has taken advantage of the large group of women by presenting a variety of poses and facial expressions appropriate for the subject.

The Finding of Moses was undertaken at a turning point in Coypel's artistic career. Faced with the disruption in his official patronage under the Duc d'Orléans, who was consumed with Louis XIV's war against the Grand Alliance, Coypel turned to private individuals for support.[9] At the same time, he had finally learned to synthesize the competing academic theories advocated by the Rubenistes and Poussinistes. The Oberlin picture demonstrates Coypel's loyalty to the draftsmanship and composition championed by the Poussinistes while at the same time displaying his reliance on color in the spirit of Rubens. Schnapper refers to this period in the 1690s as Coypel's own "crisis of Rubenism" where, under the influence of the Duc de Richelieu (who was now wholly converted to Rubens from Poussin), he wrestled with these opposing aesthetics in his work and came to a satisfying reconciliation as evidenced in a painting like *The Finding of Moses*.

NOTES

1. Exodus 2:8–9.
2. Schnapper 1979–80, 59.
3. Charles-Antoine Coypel, *Vie d'Antoine Coypel*, 6, as cited by Schnapper 1979–80, 63.
4. Wieseman in Oberlin 1998; Bailey 1985, 66.
5. Of the other seven canvases in the series, four have survived, and three of these have similar dimensions: *Susanna Accused by Her Elders* (Madrid, Museo del Prado), *Athaliah Chased from the Temple* (Paris, Musée du Louvre), *Jacob and Laban* (location unknown), *Sacrifice of the Daughter of Jephthah* (Dijon, Musée des Beaux-Arts), *Swooning of Esther* (Paris, Musée du Louvre), *Judgment of Solomon* (location unknown), and *Tobit Restoring Tobias' Sight* (location unknown). See Schnapper 1979–80, 69–70.
6. Schnapper 1979–80, 63.
7. Regarding the provenance of the Oberlin picture, Bailey points out that the 1804 Paris sale of the collection of M. Dutartre, *Ancien tresorier des bâtiments*, includes two paintings attributed to Noël Coypel, Antoine's father: *The Finding of Moses* and the *Judgment of Solomon*. The dimensions of the *Moses* painting and the Oberlin painting are almost identical, and the Solomon painting (now lost) was exhibited at the same salons as *The Finding of Moses*. See Bailey 1985, 66.
8. Both pictures by Poussin dated to 1638 and 1647 are in Paris, Musée du Louvre. A third version by Poussin, dated to 1651, is in the National Gallery, London. See also cat. no. 9 for *The Finding of Moses* by Sébastien Bourdon.
9. Bailey 1985, 65. See also Garnier-Pelle 1989.

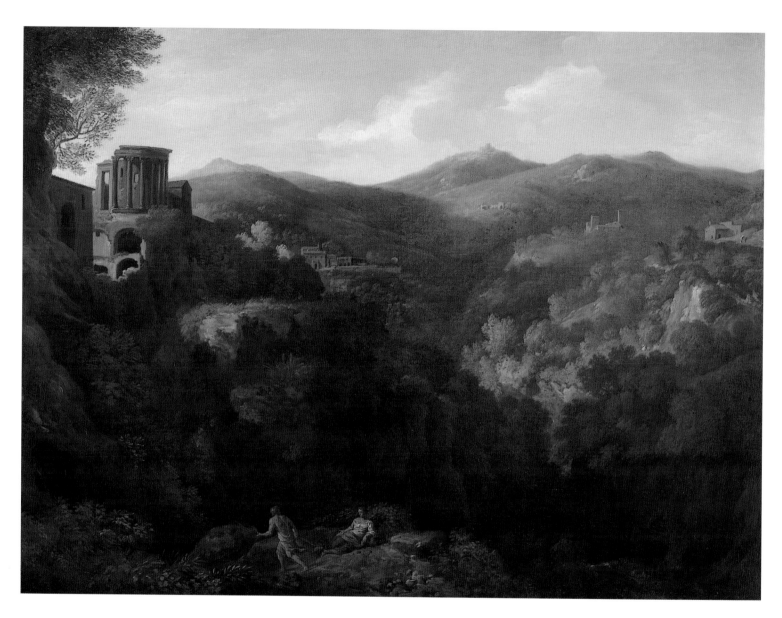

Gaspard Dughet

ROME 1615–1675 ROME

Dughet was born in Rome in 1615 to a French father and Italian mother, and he remained in and around that city for most of his life. In 1630, Nicolas Poussin married Dughet's sister, and by Easter of 1631 Dughet was apprenticed to his older brother-in-law. He remained in Poussin's studio until 1635, at which point he was successful enough to afford a comfortable lifestyle. Dughet rented four residences in Rome and the surrounding *campagna* from which to perfect the specialty that would define his career: the decorative landscape. Dughet quickly found his way to the highest echelon of patronage. He received commissions from Philip IV and Grand Duke Ferdinando II de' Medici in Florence and had a steady stream of business from the powerful princes of Rome, painting throughout his career for the Colonna, Pamphili, and Ottoboni families.

Although Dughet was renowned during his lifetime for the many fresco series with which he filled Rome's *palazzi*, much of his legacy is due to the easel paintings he continued to produce simultaneously. The Italian writer and collector Filippo Baldinucci (1625–1697), who referred to Dughet as an artist of the *fa presto* ("to make haste"), claimed that Dughet could produce one large painting each day. These easel pictures were widely acquired as mementos of the idyllic Roman *campagna* by visitors on the Grand Tour. Today there are many Dughet landscapes in British and German collections, as well as in France, Spain, and Italy.

Dughet did not sign or date his works, so establishing an undisputed chronology within his oeuvre is difficult. In the earliest discussions of Dughet's style, his biographers propose three distinct manners in his career, largely based on documentation by the artist and his patrons. This chronological division has been upheld in modern scholarship. In his first period, from his apprenticeship to around 1640, natural features dominate the composition, and the landscape setting features illuminated middle grounds and darkened borders. The second manner, from 1640 to 1660, becomes more restrained and programmatic, with scenes anchored on the left and right opening into a more developed progression of grounds. The third phase in Dughet's development, from the 1660s to his death in 1675, shows the influence of picturesque Romanticism. This stage completes his shift from the detailed depiction of single passages in nature to an emphasis on the unity of each composition. However, there seems to have been an overlap in the last two styles of Dughet's career, which complicates a definitive chronology.

With Claude and Poussin, Dughet has always been considered integral to the triumvirate of mid-seventeenth-century Frenchmen in Rome. The three are considered to have invigorated landscape painting and begun a tradition within this genre that continued through the early part of the nineteenth century with Pierre-Henri de Valenciennes and Camille Corot. Dughet's critical reception, however, has endured greater oscillations in the past three centuries than that of Claude or Poussin, largely due to changing tastes and the periodic revelations of connoisseurship. Nonetheless, his enormous and widely distributed body of work certainly helped to transmit that landscape tradition throughout Europe. It now seems that Dughet's influence on subsequent generations of landscape painters in Italy, France, the low countries, and, later, Britain was equal to if not greater than that of his two celebrated contemporaries.

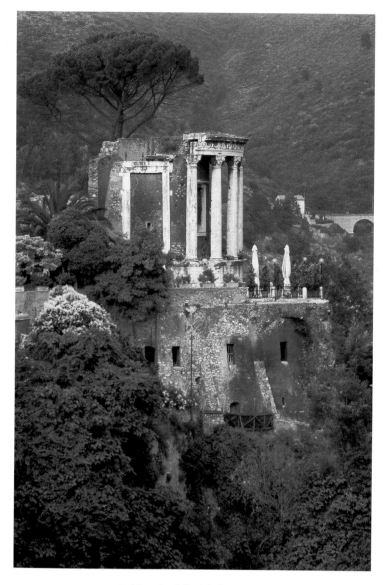

FIG. 58. *Tempio della Sibilla, Tivoli.* Steven Brooke, *Views of Rome* (New York: Rizzoli, 1995), plate 100.

17. Gaspard Dughet, *A View of Tivoli*, ca. 1667

Oil on canvas, 29 × 39¼ in. (73.7 × 99.7 cm.)
The Art Gallery of Ontario, Toronto
Purchase, 53/9

PROVENANCE: Collection of Humphrey Morice (1723–1785; as seen and recorded in June 1781 by Horace Walpole as "Two fine small views of Tivoli by Gaspard Poussin"); bought with the Morice Collection in 1786 by the 2nd Earl of Ashburnham; sale, Sotheby's, London, The Ashburnham Collections, Part I, 24 June 1953, no. 75; Mrs. Gronau, London; sold through Sir Anthony Blunt to Art Gallery of Toronto, 1953

EXHIBITIONS: Toronto 1954, cat. no. 16; Regina 1968; London, Ontario 1979; Scott 1980, cat. no. 12; McTavish 1981, cat. no. 65

DUGHET'S *A View of Tivoli* (cat. no. 17) and its pendant, *A View of Tivoli with the Cascades*[1] (Newcastle-upon-Tyne, King's College, Hatton Gallery), are very likely the two paintings described by Horace Walpole in 1781 as "two fine small views of Tivoli by Gaspard Poussin" in the collection of Sir Humphrey Morice (1723–1785), Lord Warden of the Stannaries, for his house at Grove near Chiswick.[2] The pendant to the Toronto picture features another view of the Temple of Vesta. The somewhat odd pairing of two pictures with identical dimensions and similar views of Tivoli confirms the great appeal the town and its attractions held for artists and tourists. Situated on a terraced parcel of land east of Rome in the Lazio region, the historic town is celebrated for its waterfalls formed by the Aniene River, the ruins of Hadrian's Villa and the Temple of Vesta (fig. 58), and the gardens of the Villa d'Este. Dughet's paintings of Tivoli and its environs were the ideal mementos for travelers on the Grand Tour, and as a result a great number of his landscapes are in British collections as well as throughout Europe.

As Dughet never signed or dated his paintings, scholars have grouped his pictures into three periods of artistic production, which have been supported in part by his commission records. The Toronto picture has been dated to the later periods and, more recently by Marie-Nicole Boisclair in her *catalogue raisonné*, to the third and final period, which spans the last years of Dughet's career (after 1665).

In his first period of artistic output—dating from his apprenticeship to about 1640—Dughet painted through a direct connection with nature employing studied observances of his natural surroundings. These exercises were often supported by plein air studies, resulting in a crisp naturalism. Often a few trees fill the foreground and animate the scene, with the deeper landscape visible behind as a backdrop. In these works, the middle ground frequently is the most strongly illuminated, surrounded by a dark border of fore- and backgrounds. The group of paintings attributed to the "Silver Birch Master" is associated with these early paintings.[3]

In the second period (1640–1665) to which scholars first attributed the Toronto picture,[4] there is a greater sense of order, even restraint, to the landscapes, and, in many ways, they become more Poussinesque. As Luigi

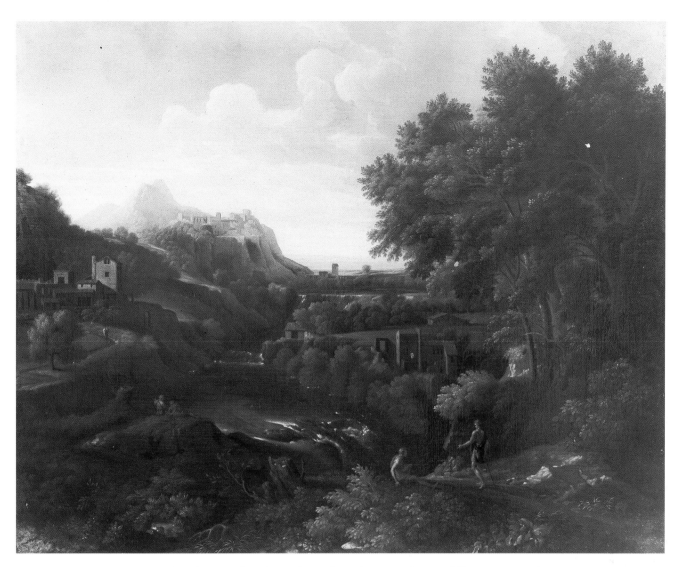

FIG. 59. Gaspard Dughet, attributed to, *Classical Landscape with Waterfalls*, ca. 1650. Oil on canvas. Allen Memorial Art Museum, Oberlin College, Oberlin, Ohio. R. T. Miller, Jr., Fund, 1945.34.

Salerno observes, Dughet's increased exposure to the work of Claude and to Poussin's landscapes of the 1640s allowed him to "overcome the instinctive naturalism of his youth and orient himself towards a new classical dignity."[5] *Classical Landscape with Waterfalls*[6] (fig. 59), which has been attributed to Dughet and is dated to this period, possesses many of the architectural, figurative, and landscape motifs that point to this classical phase in the artist's career. The compositional forces that characterize Poussin's landscapes are also evident in *A View of Tivoli*, where each ground or plane of the composition is carefully addressed in terms of light and color. Malcolm Waddingham, however, describes Dughet's emphasis on idealization as a concession to the popularity of Poussin's landscape style,

made after a lack of critical support for his earlier landscapes that featured a highly detailed representation of nature rendered in "flat, monochromatic technique."[7]

The third period in Dughet's development (after 1665), to which Boisclair ascribes the Toronto picture,[8] is characterized by a Romanticism that overtakes his paintings. It seems clear that the Toronto picture belongs to this final phase of the artist's career. Foliage is often rendered in large, unarticulated masses, but larger compositional elements such as architecture, a lake, or the line of a road or a valley acquire new significance, grounding the painting from within the composition. In the Toronto picture, the Temple of Vesta, seen in strong light and shadow, dominates the upper left side of the composition. The architectural ruin is shown as it would

have appeared in the late seventeenth century, including the later outbuildings. Also identified is the group of buildings to the right of the temple, near the center of the composition, which are the Convent of San Antonio.[9] Dughet has managed to capture the heavily treed, hilly landscape around Tivoli, which features the Monti Tiburtini hills.

Dughet was a highly sought-after decorative artist. He frescoed rooms in a number of palazzi and churches and even painted landscapes on several harpsichords (none survive). He produced a great number of pictures, some of which began arriving in France at the same time as Poussin's, in the 1650s. In fact, his influence on subsequent generations rivaled that of both Poussin and Claude. Although the scope and duration of Dughet's influence is helped by his extremely productive career, his stylistic treatment and broad conception of the landscape genre that he helped mold cannot be overlooked, for these qualities have intrinsic value within Dughet's oeuvre and merit attention in a discussion of his legacy.

Roger de Piles gives us another way to understand Dughet's contribution to landscape painting. In his *Cours de peinture par principes*, de Piles describes two types of landscape, the heroic and the pastoral. Poussin's landscapes typify the heroic model, while Claude and many of the northern painters produced landscapes in the pastoral style. Michael Kitson aptly describes Dughet's style as a compromise between these two characteristics, pointing out that he paints with an eye toward both a veristic depiction of nature and the sublime achieved only through careful crafting of each composition.[10]

NOTES

1. Titled *Paysage de Tivoli avec le temple de la Sibylle* and *Vue de Tivoli avec cascade* in Marie-Nicole Boisclair's *catalogue raisonné*. See Boisclair 1986, 396.
2. Corsiglia 2004; Boisclair 1986, 396; McTavish 1981, 65.
3. Blunt 1950; Blunt 1980.
4. Arcangeli 1962, cat. no. 106.
5. Salerno 1977–78, vol. 2, 523.
6. Formerly in the collection of the Earls of Yarborough, London, and noted in Waagen 1854, 86. Though supported by several scholars, including Walter Friedlander and Wolfgang Stechow, the Oberlin picture's attribution to Dughet has been questioned by Boisclair. See Boisclair 1986.
7. Waddingham 1963, 45.
8. Boisclair 1986, 61.
9. Corsiglia 2004.
10. Kitson 2000, 288.

Laurent de La Hyre

PARIS 1605–1656 PARIS

Laurent de La Hyre was the son of painter Etienne de La Hyre (ca. 1583–1643), who was employed in the Polish royal court before returning to Paris to work as an inspector of wines. Eight of Etienne's eleven children were painters, Laurent and his brother Louis de La Hyre (1629–1653) being the most celebrated. La Hyre's training and education was extensive. After studying with his father, he spent three years at the Château de Fontainebleau making copies after the Italian mannerists Francesco Primaticcio and Rosso Fiorentino before entering the studio of Georges Lallemant (ca. 1580–1636). The mannerist tradition had a lasting effect on La Hyre's career. By the 1630s he had received important painting commissions in Paris, including work for the Capuchin order for their Chapel of St. Francis in the Marais and for mythological pictures for the Salle des Gardes, Palais Cardinal, for Cardinal Richelieu at the end of the decade. In 1639, the year of the Richelieu commission, La Hyre married Marguerite Coquin, whose father was a personal guard for Louis XIII.

La Hyre was a founding member—one of the twelve *anciens*, or professors—of the Académie royale de peinture et de sculpture, created in 1648. This association accompanied a shift in patronage to private patrons who commissioned allegorical subjects and fewer religious works. Easel pictures rapidly became La Hyre's preferred format. Following the death of his father in 1643, La Hyre inherited a sizeable fortune, which enabled him to spend more time in the country and to devote more time to landscape painting. These later landscapes reveal his commitment to the close observation of nature and atmospheric perspective. La Hyre displayed a remarkable facility to capture the time of day, the effects of sunlight and clouds, and the subtle suggestion of wind blowing through the trees and over the water's surface.

Unlike for many of his contemporaries, no documentation exists of La Hyre having ever left France to pursue studies or travel in Italy, and yet it is clear from his work that the artists working there influenced him. Like Pierre Patel (1605–1676) and his son Pierre-Antoine Patel (1648–1708), La Hyre built his career in and around Paris, replicating antiquity secondhand. His knowledge of architecture, although formally correct, is often more academic in its representation and probably was learned from books and prints.

La Hyre's paintings often are characterized by their allegorical or religious subject matter, focusing on staffage to convey narrative and meaning with figures marked by a distinct sense of volume and gravity. They are typically attired in brightly colored robes that fall into stylized drapes around their solid forms. Distinct from the landscape, La Hyre's figures reference a tradition pursued by Simon Vouet (1590–1649) and his student Eustache Le Sueur (1616–1655). La Hyre is a master of his palette, and he is wonderfully adept in his ability to manipulate color to suggest warm golden light or murky foliage and rich jewel tones to highlight his figures. The application of paint is smooth with a high finish that parallels the detailed calculation evident in his compositions.

FIG. 60. Nicolas Poussin, *The Holy Family*, ca. 1651. Oil on canvas. The J. Paul Getty Museum, Los Angeles, California, 81.PA.43. Photograph © The J. Paul Getty Museum.

18. Laurent de La Hyre, *Holy Family*, 1646

Oil on canvas, 45½ × 56 in. (116 × 141 cm.)
The Frances Lehman Loeb Art Center, Vassar College,
Poughkeepsie, New York
Purchase, 59.4

PROVENANCE: Sale, Paris, 27 March 1787, lot 166
(*Catalogue des tableaux capitaux ... le tout provenant des
Cabinets de M. le Chevalier Lambert et de M. Du [Portail]
par J. B. Le Brun*, as *Un repos en Egypte*); private collection,
Europe; Ilsa Auebach, Montevideo, Uruguay, through Ida
Rubin; purchase 1959

EXHIBITIONS: Rosenberg 1989–90, cat. no. 233, ill.

La Hyre's *Holy Family* (cat. no. 18), painted in
1646, is one of his most beautiful and majestic repre-
sentations of the subject. The Poughkeepsie picture was
painted two years before *Rest on the Flight into Egypt*
(cat. no. 19). The landscape settings for the two paint-
ings are extremely close, with the architectural elements
maintaining their symbolic and compositional roles in
the painting. The Poughkeepsie picture is more impos-
ing, but, beyond the scale, its splendor reflects the
Roman tradition of Poussin and echoes the magnificent
figural compositions of Domenichino and Titian.

La Hyre's figures—the Holy Family with John the

Baptist and four winged putti—have a commanding
and graceful presence in the picture. They fill the fore-
ground, forming a sculptural frieze that extends across
and upward, overtaking any semblance of a middle
ground space. Architectural ruins and rustic foliage set
against a luminous sky make up the rest of the composi-
tion, creating a stage-like backdrop for the figures. In
the earlier *Rest on the Flight into Egypt*, the ruined tem-
ple towers over the figures, while in the Poughkeepsie
picture, the architectural elements—an array of care-
fully placed fragments—act as props for the figural
group, which remains the primary focus of the painting.

Mary, clothed in garments of royal blue, red, and
gold and holding the Christ child, is enthroned on a
foundation stone from the ruined temple, her right foot
resting on a ledge that bears La Hyre's signature and the
date of the painting. She looks up, her head in full
profile, to Joseph, who stands behind her clasping his
staff with both hands and leaning on a section of the
temple. He is dressed in a blue tunic and rust-colored
robes, and with his striking curly brown hair and beard
he can be identified with the model used in the Louisville
picture. The Christ child sits on Mary's lap holding the
end of a garland of flowers supported by Mary and the

FIG. 61. Laurent de La Hyre, *The Holy Family*, 1646. Oil on canvas.
Staatliche Kunstsammlungen, Dresden, Germany, 52.114F.

group of putti. The infant John the Baptist, wrapped in an animal-skin loincloth, holds up a wooden cross with a banner bearing the proclamation ECCE AGNUS DEI. While not specifically mentioned in the Gospels, the playful interaction between the Christ child and John was a standard devotional subject in Baroque painting.

Although the architectural ruins cannot be precisely identified, the pyramid-like monument at the extreme left-hand side is similar to the pyramidal Tomb of Gaius Cestius Gallus (d. A.D. 67) near the Porta S. Paolo in Rome (engraved in the next century by Piranesi). The one recognizable architectural element is the stone relief bust of the Roman emperor Nero (A.D. 15–68), fashioned like a wreathed medallion. Nero's presence among the ruins is appropriate given the persecution of the early Christian church under his reign. John the Baptist's banner proclaiming the Lamb of God also offers an interesting juxtaposition with the portrait of Nero.

La Hyre treats the stone ruins in a manner analogous to Poussin's—as an impressive setting for his biblical subject. Poussin's *Holy Family* (fig. 60) offers a similar arrangement to La Hyre's composition with the addition of Elizabeth (Mary's cousin and the mother of John the Baptist) and three more putti. Here the ruin serves as a

backdrop for the Holy Family, and its scattered fragments become platforms for the other figures. Both Poussin and La Hyre have used the ancient blocks of stone to strengthen and animate their compositions. In La Hyre's *Holy Family*, the neatly placed ruin fragments—the cornice fragment supporting the reclining putto, the broken column at Joseph's feet, and the walled balustrade behind him—reinforce the horizontal and diagonal lines and receding planes of the painting.

Another version of the Poughkeepsie picture is found in the Staatliche Kunstsammlungen in Dresden (fig. 61). Dimensions of the two pictures are practically identical, and the signature and date (1646) are both located on the rectangular stone beneath the hem of the Virgin's red robe. In a 1988 exhibition catalogue, the Dresden picture's width is listed incorrectly as 1.75 meters (rather than the actual 1.45 meters).[1] Perhaps more problematic is that the version reproduced in color in the 1988 catalogue is the Poughkeepsie picture (distinguished by the small number 317, which appears in white in the extreme lower left corner and is likely an inventory number for a European collection) and *not* the Dresden picture as is listed.[2] Correspondence in the mid-1960s between Vassar and two leading authorities

on La Hyre, Anthony Blunt and Pierre Rosenberg, yielded no consensus on the relationship between the two pictures, although Blunt felt that the Poughkeepsie picture was completely convincing, as it was autographed, and that it was highly unlikely that it was a later copy by another hand.[3] In the discussion of the Poughkeepsie picture (which is listed as a copy) in the 1988 catalogue, Rosenberg and Jacques Thuillier note, "cet exemplaire porte également la signature *de la Hire Inv. Et F. 1646*; mais sa facture molle indique une copie ancienne."[4] Another version (now lost, known only through an engraving by William Faithorne) of the Poughkeepsie and Dresden pictures shows a slightly modified composition with a sparser landscape setting and the pyramid or tomb in the left background removed. This lost version is dated to ca. 1646–48, based on the date of the print.[5] The existence of a third version of the same Holy Family composition would suggest that this was a particularly successful composition for La Hyre, giving him reason to make at least two other copies.

NOTES

1. Rosenberg 1989–90, 268.
2. Rosenberg 1989–90, 229.
3. Curatorial file for Laurent de La Hyre, *Holy Family*, Frances Lehman Loeb Art Center, Vassar College.
4. Rosenberg 1989–90, 268.
5. Rosenberg 1989–90, 268.

19. Laurent de La Hyre, *Rest on the Flight into Egypt*, 1648

Oil on canvas, 38½ × 25½ in. (96 × 64 cm.)
The J. B. Speed Museum, Louisville, Kentucky
Preston Pope Satterwhite Fund, 63.10
PROVENANCE: Sir Alfred Jodrell; The Hon. Roger Coke; Robin Combe; his sale, Sotheby's, London, 28 November 1962, lot 74; purchased by H. Bier; purchase 1963
EXHIBITIONS: Rosenberg 1989–90, cat. no. 248, ill.

THE REST on the flight into Egypt is mentioned only once in the New Testament (Matthew 2:13–14),[1] although the brief passage is expanded greatly in the Gospel of Pseudo-Matthew (chapters 17–22) in the New Testament Apocrypha. The subject was a popular one for artists in the sixteenth and seventeenth centuries, as it engaged a rich narrative of religious personages, animals, and ancient architecture within an exotic landscape setting. The rest on the flight was also a theme taken up by the painters of the classical landscape in sixteenth-century Italy, a tradition that began with Titian and his circle and continued with Annibale Carracci, his pupil Domenichino, and their followers. In the seventeenth century, the subject continued to be popular with French painters mainly through the influence of the Italian painters.

La Hyre's Holy Family (cat. no. 19) is almost identical in physiognomy, drapery, and palette to the Holy Family in the Poughkeepsie picture (cat. no. 18), although the Christ child appears to be several months younger in the Louisville painting. In this tender scene, Mary is shown nursing the child while Joseph stands at her side. Joseph is often shown standing a few steps away, appearing deep in thought or reading, but in this instance he is fully engaged, standing in a protective, paternal stance at Mary's side and gazing intently at his young wife and infant child. The golden aura of the scene, with a warm, seeping light, evokes the hours of the early evening. Although the specific light source is not apparent, Mary's upturned face is softly illuminated while Joseph is placed in the soft shadow of the same light. She looks out into the distance, and her languid gaze seems almost dreamlike in its passive focus as she nurses the child. Mary is clothed in a flowing blue mantle with a red undergarment and white blouse. The bearded Joseph appears in a full-length blue tunic, amply draped with a flowing rust-colored cloak. Holding a staff in his left hand, he points down to the ground with his right hand in a gesture that would suggest that this is the place for their night's rest after their journey. The donkey that bore the mother and child is tied to a tree behind Joseph.

The place of rest and refuge for the Holy Family is a ruined temple in the countryside near Egypt, well suited for the biblical narrative. The imposing structure, which takes up the full right side of the picture, may reference a pagan past now in a state of ruin and displaced by the new celestial foundation brought down to earth. The temple also becomes an important compositional tool for La Hyre, for the entire landscape is measured against this immense structure. The ruin, perhaps the portico of a temple, is constructed of terra-cotta brick walls, green stone columns, and a sandstone entablature in a

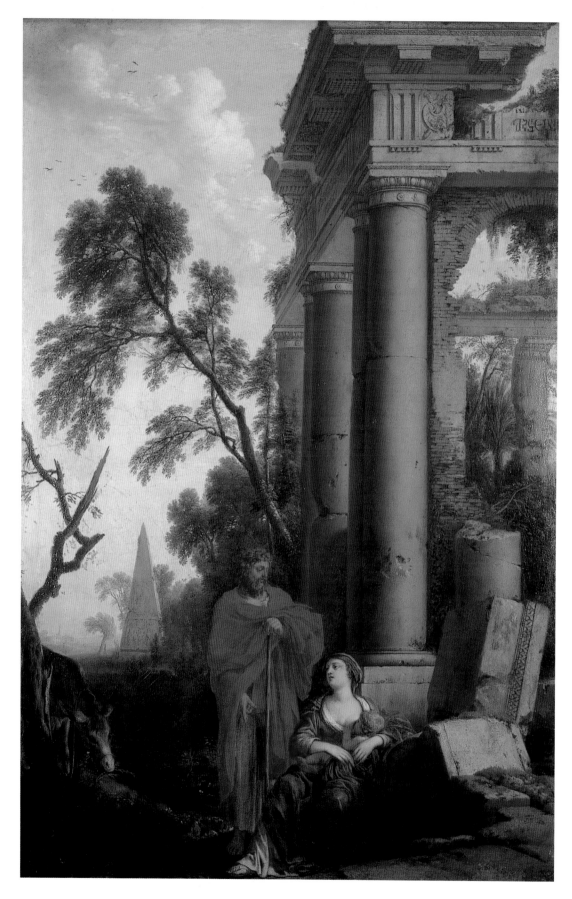

FIG. 62. Nicolas Poussin, *The Rest on the Flight into Egypt*,
ca. 1630–35. Oil on canvas. The Metropolitan Museum of Art,
New York. Bequest of Lore Heinemann, in memory of her husband,
Dr. Rudolf J. Heinemann, 1996 (1997.117.6). Photograph,
all rights reserved, The Metropolitan Museum of Art.

modified Ionic order. Fragments of the broken entabla-ture are scattered around the structure, and one large section, resting as a cornerstone, supports the seated Mary and becomes a place for La Hyre's signature and the date of the painting. At the top right of the canvas, on the outside frieze below the broken cornice, are large letters that appear to read REGINA, in reference to Mary. Below, an elegant palm tree can be seen protrud-ing between the rear column and a section of the brick wall, alluding to Egypt and the palm tree that is men-tioned in the Apocrypha. Another historical reference is the pyramid or obelisk-like stone structure—resembling a Roman funerary monument—in the middle ground at the left, which bears a carved relief of a large wreath above a processional scene with figures. In the far dis-tance at the left, the outline of buildings can be seen, including another pyramid construction that may ref-erence the Tomb of Gaius Cestius Gallus in Rome.

The treatment of the figures—their drapery, color-ing, and careful arrangement in the landscape—looks back to sixteenth-century Italian prototypes, especially the Venetian school, and even earlier to Giorgione. However, La Hyre's handling of the architecture, the foliage, and the physical landscape is more French in tone. He would have known well the architectural ruins of Pierre Patel, with whom he collaborated and shared the distinction of never having traveled to Italy.[2] How-ever, Patel's structures are usually more sophisticated in their design and finish, and his figures have less of a physical presence. Through Patel and the followers of Claude in Paris, La Hyre would have seen the work of northern painters Herman van Swanevelt (1600–1655) and Jan Asselijn (1648–1708), both of whom had worked with Patel. Their influence is seen in the expres-sive handling of the trees and foliage. Poussin's *Rest on the Flight into Egypt* (fig. 62), painted in the early

1630s, offers a similar setting, with the Holy Family positioned at the base of a ruined temple set against the open landscape. Poussin has added Jesus's cousin, the infant John the Baptist, and two groups of putti who surround the Holy Family and occupy the tree above.

NOTES

1. "And when they were departed, behold, the angel of the Lord appeareth to Joseph in a dream, saying, Arise, and take the young child and his mother, and flee into Egypt; and be thou there until I bring thee word: for Herod will seek the young child to destroy him. When he arose, he took the young child and his mother by night, and departed into Egypt." Matthew 2:13–14.

2. La Hyre collaborated with Pierre Patel (the Elder) and Eustache Le Sueur (1616–1655) on the production of a series of landscapes for the *appartements* of Anne of Austria in the Louvre in 1660.

20. Laurent de La Hyre, *The Kiss of Peace and Justice*, 1654

Oil on canvas, 21¼ × 29¾ in. (54.9 × 76.2 cm.)
The Cleveland Museum of Art, Cleveland, Ohio
John L. Severance Fund, 71.102
PROVENANCE: Evrard Titon du Tillet (1715–1789), Paris, before 1757; Randon de Boisset, Receveur Général des Finances, Paris; sale, Paris, 27 February–25 March 1777, lot 170; Joulin (possibly Joullain); J. B. P. Lebrun, 1796; Francis Codman, Hôtel de Créqui, Paris; Claude Tolozan; his sale, Paillet, Paris, 25 February 1801; sale ["a Lady of Title"], Christie's, London, 27 November 1970, lot 52; Lady Nathan; probably Cyril Humphris, London; purchase 1971
EXHIBITIONS: Boston 1832, cat. no. 140; Johnson 1980, fig. 4, ill.; Rosenberg 1982, cat. no. 34, ill.; Rosenberg 1989–90, cat. no. 318, ill.

A SMALL AND intimate canvas, *The Kiss of Peace and Justice* (cat. no. 20) depicts two beautiful women caught in a tender embrace in an exquisitely composed classical landscape. A temple and antique elements set the tone for this idyllic scene and provide a fitting backdrop for the antique-inspired figures. While La Hyre's primary interest in the painting is the landscape, the scale of the figures implies that a biblical and allegorical theme was an important part of the commission. A lion-spouted fountain, bearing the inscription IUSTITIA ET PAX OSCULATAE SUNT, occupies the center of the composition and introduces the narrative of the picture.[1]

The inscription on the fountain is taken from Psalm

85: Mercy and truth are met together: righteousness and peace have kissed each other. Truth shall spring out of the earth and righteousness shall look down from heaven. Yea, the Lord shall give that which is good; and our land shall yield her increase.[2] The Old Testament passage was a popular subject in seventeenth- and eighteenth-century painting, and it afforded artists the opportunity to depict two beautiful women in an intimate embrace.[3] In La Hyre's representation, a further allegorical interpretation has been suggested: painted in 1654, the theme may represent an appeal for peace in Paris after the battle of the Fronde, and Mazarin's return to Paris to oversee the reconciliation of the court and parliament in 1753.[4] This political translation resonates with the presence of the ruins, whose blocks, torn from their foundation and littered with armor, seem to have sustained a warlike force. With her flame Peace destroys the armor of war, and new growth has overtaken the abandoned remnants of man-made civilization. Justice puts down her scales, underscoring the end to unrest and symbolizing the calm that will follow.

The Cleveland picture was painted shortly after the movement known as Parisian Atticism had dominated the official painting circles in Paris. In the mid-1640s a group of French artists, including La Hyre, Vouet, Le Sueur, and Philippe de Champaigne, began painting in a new restrained, classically inspired manner frequently using subjects drawn from mythology. Patrick Ramade notes that La Hyre "rejected excessive virtuosity and developed a careful and refined style of expression full of restraint and sincerity, aptly known as 'Parisian Atticism.'"[5] La Hyre's figures are inspired by Vouet's allegorical figures but also relate to his own paintings of these subjects: *Allegory of Peace of Westphalia*[6] (1648; Paris, Musée du Louvre) and *Allegory of Music* (fig. 83).[7] The sharper, at times light-toned colors found in the Cleveland picture are markedly different from the warmer tones that characterize such earlier works as *Holy Family* (cat. no. 18) and *Rest on the Flight into Egypt* (cat. no. 19). With his interest in mythological figures, the architecture of ruins was well suited to La Hyre, and he has used antique elements to great advantage in *The Kiss of Peace and Justice*. Aside from instilling a thematic tone, the temple and urn, antique fountain, and architectural fragments define the natural setting.

The landscape in *The Kiss of Peace and Justice*

20

FIG. 63. Laurent de La Hyre, *Landscape with a Shepherd Playing a Flute*, 1647.
Oil on canvas. Musée Fabre, Montpellier, France, Inv. 837.1.50.

is also more refined. Composed of cool blue, green, yellow, and brown tones, the palette is comparable to that of Pierre Patel's *Landscape with the Journey to Emmaus* of 1652 (cat. no. 23). The naturalistic setting also relates to La Hyre's *Landscape with a Shepherd Playing a Flute* (fig. 63). The Montpellier painting, executed seven years before the Cleveland picture, shows a similar landscape but in a more advanced state of natural abandon. The trees, foliage, and ruins have taken on the patina of decay, and animals occupy the once cultivated space. In both these landscapes La Hyre succeeds in capturing a measure of the idyllic mood so fundamental to Claude's pastoral compositions. Assessing La Hyre's treatment of the landscape in the Cleveland picture, Rosenberg writes:

> He rendered the finest nuances of the morning light, the haze of distant horizons, the dappled effect of light and shadow on foliage and on rock ... nature in its sumptuous diversity. La Hyre, an artist drawn to grace and beauty rather than to tragedy, offers, above all, a sense of appeasement, tranquility, and spiritual peace.[8]

Though La Hyre often made engravings of his works, none is known for *The Kiss of Peace and Justice*. A red-chalk drawing after the painting by the Dutch artist Gerard de Lairesse (1640–1711), also in the Cleveland Museum of Art, confirms its accessibility in the seventeenth century.[9] Similarly, mention of the work in the travelogues of Louis Courajod and Dezallier d'Argenville place the work within prominent collections in the eighteenth century, including that of the Parisian collector and financier Evrard Titon du Tillet (1715–1789) in the 1760s.[10]

NOTES

1. Cleveland 1982, 76–78.
2. Psalm 85:10–12. Scholars have also referenced Psalm 84:11 in connection with the painting.
3. Rosenberg 1974, 304.
4. Rosenberg 1974, 305. Rosenberg and Thuillier write, "One cannot help thinking of the cruel civil battles of the Fronde which had just torn apart Paris and France. In 1853 Mazarin had returned to the capital more powerful than ever. The 'turmoil and misery seemed to dissipate' and a 'good and sure peace' seemed reestablished in the kingdom through the reconciliation of the court with the rebel princes and parliament."
5. Montréal 1993, 210.
6. As Rosenberg and Thuillier note, La Hyre did not seem to be indifferent to the political events of his day. Rosenberg 1974, 305.
7. Cleveland 1982, 76.
8. Rosenberg 1982, 252.
9. Cleveland Museum of Art, 72.216.
10. Rosenberg 1974, 308.

Jacques de Lajoüe

PARIS 1686–1761 PARIS

Born in Paris in 1686, Jacques de Lajoüe was influenced by architecture from an early age. The son of an architect and master mason inspired by the work of the Italian Baroque architect Francesco Borromini, Lajoüe became one of the inventors of the *genre pittoresque*, a style of painting heavily dependent on architecture and the use of composition to create grand, sweeping spaces on the picture plane. The details of Lajoüe's early formal training are slightly ambiguous; he most likely apprenticed with an ornamental craftsman and may also have studied under François Lemoyne (1688–1737), himself a student of Antoine Watteau (1684–1721) and teacher of François Boucher (1703–1770). Contact with Lemoyne placed Lajoüe within a collegial context of painters working to further genre painting as a viable art form, and it lent further authority to Lajoüe's link, along with Watteau and Boucher, to the *genre pittoresque*.

Lajoüe was received at the Académie royale in 1721 with two painted architectural *capricci*. In addition to his decorative ornamental work—including carriage panels, fire screens, picture frames, and harpsichord cases—Lajoüe specialized in using architecture (typical of the *capriccio*) to make fantastic, broad perspectives in his outdoor scenes. These often featured elegant sculptured gardens with classical ruins and pairs of figures, in the tradition of the *fête galante*, tucked into the setting. Lajoüe's allegorical works were widely distributed in collections of engravings after his designs published throughout the 1730s. *Recueil nouveau de differens cartouches*, *Livre nouveau de douze morceaux de fantasie*, and the four volumes of *Livres de divers morceaux d'architecture, paysage, et perspective* highlight Lajoüe's successes at combining rocaille decoration with the exotic trappings of *chinoiserie* and *turquerie*. In the same period, Lajoüe produced a number of exotically themed canvases, often copying Watteau and Boucher in their experimentation with orientalizing design.

Collaborating at times with both Watteau and Boucher, Lajoüe likely executed some of the architectural elements in their paintings. The *genre pittoresque* was an evolved variant on the *fête champêtre* and *fête galante* of Watteau, Pater, and Lancret, characterized by the prominence of architectural features. These buildings, fountains, bridges, and statuary embellished the scene, creating a sense of the imaginary and providing stage sets for graceful staffage to act out the scene. Lajoüe's garden scenes, with their combination of decorative detail and expansive perspective, anticipate the paintings of Jean-Honoré Fragonard (1732–1806) and the rising generation of rococo artists in France.

Though working in a decidedly nonacademic genre, Lajoüe was widely exhibited during his career: in 1725 at the Exposition de la Jeunesse and, beginning with its reinception in 1737, at every Salon through 1753. He enjoyed great commercial success especially in the 1730s and 1740s, with commissions from various members of the nobility and ecclesiastical institutions. Notable commissions included overdoors of maritime scenes for Louis-Alexandre, Comte de Toulouse; a masterful *trompe l'oeil* scene for l'abbaye de St. Geneviève in Paris in 1730–31; medallions and overdoors for the *hôtel* of Joseph Bonnier, Baron de la Mosson (1734); and decorative panels for the Prince de Tonnay-Charante in 1729–30 (Stockholm, National Museum). These types of works constituted a large part not only of his commissions but also of his exhibited material, furthering his reputation as designer as well as painter. Lajoüe also continued to design sets and plans for fountains and gardens for noble families. After 1748 his favor began to diminish as the taste for classicizing paintings came once again into vogue. After a poor reception at the Salon of 1753 for *Allegory of the Glory of Louis XV* (location unknown), painted for the Marquise de Pompadour's Château de Bellevue, Lajoüe stopped exhibiting altogether. Accounts of the last ten years of his life are rather unclear, as he slipped from the world of professional painting. He died in Paris in 1761.

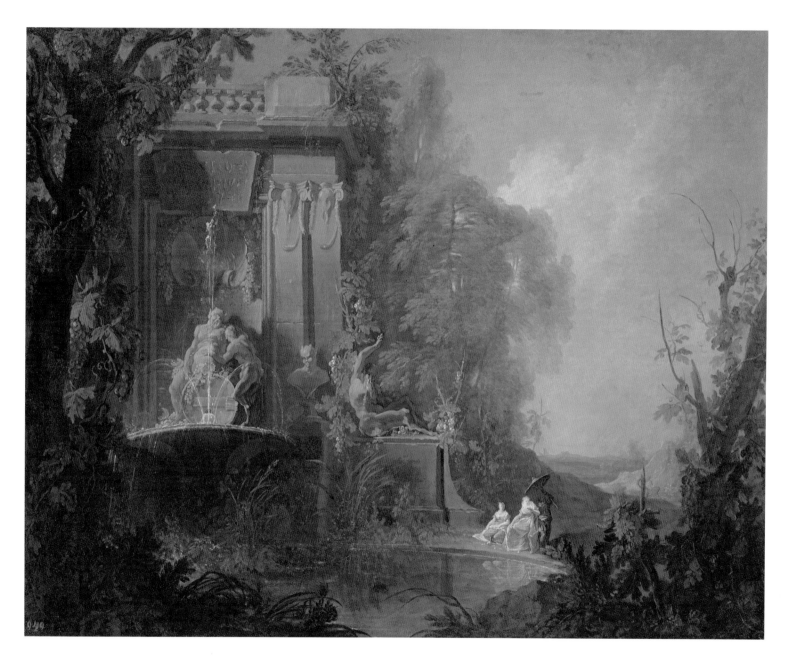

21. Jacques de Lajoüe, *The Fountain of Bacchus*, ca. 1725

Oil on canvas, 28⅛ × 35⅞ in. (71.5 × 91 cm.)
The Frances Lehman Loeb Art Center, Vassar College,
Poughkeepsie, New York
Gift of Mr. and Mrs. E. Powis Jones, 1977.66
PROVENANCE: Dolgorouki; B. Narischkine; his sale, Paris,
4 May 1868, lot 48 (as *Fontaine monumental dans un parc*);
Collection Dépinay, Senlis; Galerie Cailleux, Paris; Mr. and
Mrs. E. Powis Jones, 1971; gift 1977
EXHIBITIONS: Poughkeepsie 1977, cat. no. 3, ill.; Zafran
1983, cat. no. 62, ill.; Wintermute 1990, cat. no. 148, ill.;
New York 1993

IN *The Fountain of Bacchus* (cat. no. 21), Jacques de Lajoüe introduces both classical and Baroque elements in his fantastical rendering of an eighteenth-century *fête galante*. No shortage of painterly forms and flourishes of brush define the rococo landscape to which Lajoüe is closely linked. First educated in his father's architectural studio, he had the opportunity to study the designs advocated by his father and was well versed in the role of ornamental decoration and classical motifs in the architectural landscape. Lajoüe was accepted at the Académie as a painter of architecture, but this did not prevent him from creating landscapes that at times rival those of Watteau and Boucher in their rococo splendor. In fact, Lajoüe is known to have worked with Boucher on several commissions, completing the architectural ornamentation in Boucher's paintings.[1] It is not surprising that the three painters are considered the inventors of the *genre pittoresque*.

The primary subject of the Poughkeepsie picture—the enormous stone fountain named after Bacchus—dominates the left side of the composition. Masterfully placed in a parklike setting, the monument with its sculptural fountains, massive buttresses, and circular pond defines the space. The scene bears the painted elegance and fabricated structure of a stage set, an art form for which Lajoüe was particularly gifted. Many of his commissions, including royal orders, were for stage sets, fantasy ruins, and ornamental designs.[2] A pen and ink drawing, *Study for a Stage Set: Portico in a Garden* (fig. 64), shows a similar treatment to the architecture in the Poughkeepsie picture. Presumably executed for a stage set for a theater or opera production, the drawing confirms Lajoüe's skill in creating the decorative landscape, which is fundamental to the *genre pittoresque*.[3]

Bacchus, the Roman god of wine, is the Latin equivalent to Dionysus, the Greek deity of wine and ecstasy, whom the Romans also identified with their wine god, Liber. However, seated comfortably on the fountain throne is Silenus, not Bacchus (who is usually shown as a beautiful youth with long hair), the elderly tutor of Dionysus. Half-man and half-animal with horse ears, Silenus represents the spirit of lust and revelry in Greek mythology. Frequently shown with a large belly and aged body, he is sometimes confused with satyrs, the youthful attendants of Dionysus. On the throne, which is crowned by a large shell motif and hanging clusters of grapes, Silenus is attended by a satyr, identified by his human-bestial form with the legs of a goat and a horse's tail. To the right of the two figures is a Baroque-style bust of a satyr, identified by his horse ears, which is positioned between two large square pilasters, crowned by an Ionic capital with an animal skull and garland motif, appropriate for the painting's theme. The mask often identifies the cult of Dionysus, symbolizing the relinquishing of identity, and it is usually shown on a column draped with a piece of cloth. Another satyr is seated on a large platform or buttress that extends to the right side of the fountain.

The group of figures—two women in elegant dress and a man holding an umbrella—is dwarfed by the immense fountain and almost overlooked except for the light illuminating their forms. They are the *fête galante* component of Lajoüe's landscape and help align the composition with other eighteenth-century examples. Despite the amorous and frivolous nature of their gathering, they appear somewhat removed and more restrained than the carnal revelry connected with the mythological figures. Nonetheless, the connection is clear, and Lajoüe succeeds in bringing together these complementary themes of love and passion in the painting. Symbols from ancient mythology are cleverly arranged as a backdrop—and impetus—for the activity of the three visitors to the secluded park. As Eric Zafran notes, "*The Fountain of Bacchus* is an excellent example of the *genre pittoresque* that Lajoüe helped invent. All the elements—the ruins of classical statues, the Silenus fountain, the tasteful garden, and the elegant

FIG. 64. Jacques de Lajoüe, *Study for a Stage Set*, ca. 1730. Pen and gray ink over black chalk and graphite on paper. The Metropolitan Museum of Art, New York, Harris Brisbane Dick Fund, 1935 (35.76.2). Photograph, all rights reserved, The Metropolitan Museum of Art.

tiny figures—combine to create an enchanted environment."[4] Surrounded by overgrown trees, climbing foliage, and a great fountain that doubles as a classical ruin, the two women with their male companion are well placed in this rustic garden setting, which comes to define much of the rococo landscape.

NOTES

1. Wintermute 1990, 148.

2. Wintermute 1990, 148.

3. The architecture in the drawing is similar to Lajoüe's *Décoration pour les tragédies du collège Louis le Grand* of 1732. There are also connections to the artist's *Décoration d'un théâtre* and the *Vue du jardin des délices*. See Roland Michel 1984, 282.

4. Zafran 1983, 136.

Jean-François Millet, called Françisque Millet I

ANTWERP 1642–1679 PARIS

Born in Antwerp in 1642, Françisque Millet moved by 1659 to Paris, where he remained for most of his short life. In Paris he lived and studied with his first Flemish master, Laureys Franck (fl. 1622–1662), whose daughter he married in 1662. Despite the distinctly Italianate topography and flora that figure prominently in all of Millet's compositions, he never traveled to Italy but was introduced to the Roman *campagna* through the work of other artists. The 1695 inventory of the collection of the wealthy Parisian banker and patron Everard Jabach (1618–1695) reveals that many of Millet's commissions were copies after sixteenth- and seventeenth-century Old Master paintings. At his death in 1695, Jabach owned fifty-seven paintings by Millet: thirty-six copies after Old Masters and twenty-one original works. For Jabach, Millet copied the work of Titian, Domenichino, Guido Reni, Annibale Carracci, and Nicolas Poussin, among others. Millet's style is indebted to the circles of the latter two artists, most notably to Poussin and his brother-in-law Gaspard Dughet. Evidence suggests that Millet studied Poussin's landscapes firsthand, as a number of Poussin's works were owned by Parisian collectors and artists with whom he was acquainted, including Parisian merchant Jean Pointel, Charles Le Brun, and Jacques Stella.

From 1666 to 1668, Millet executed four paintings for the Cabinet de la Reine in the Tuileries Palace, his only royal commission. He was approved by the Académie royale in 1673, exhibiting two landscapes in the Salon of that year. Millet died unexpectedly in 1679, apparently by poisoning, before he was received at the Académie.

Millet's oeuvre has been difficult to reconstruct for a number of reasons. Both his son Jean (ca. 1666–1723) and grandson Joseph (ca. 1688–1777) painted landscapes in his style and adopted the name Françisque. Millet never signed or dated his works, and the only contemporary author to record his biography was Florent Le Comte in his *Cabinet des singularitez*

d'architecture, peinture, sculpture, et graveure (Paris, 1699–1700). Millet's aptitude for copying a variety of styles and artists also makes it difficult to securely attribute his paintings. This combination of circumstances has led scholars to emphasize the series of twenty-eight engravings after Millet's work executed by Théodore, a little-known contemporary who is described by Le Comte as a student of Millet. Although few known paintings closely match these engravings, this folio remains a touchstone for Millet connoisseurship because the prints are signed *Francisque Pinxit* and remain the few surviving visual resources to which his name is firmly attached.

A Flemish contemporary of Millet, the painter Abraham Genoels (1640–1723), said that Millet was capable of copying anything, and copy-work undoubtedly comprised many of his commissions. These commissions were almost exclusively given by the upper merchant class and leisure travelers for easel paintings in the popular mode of the classical landscape. Millet's popularity during his day is confirmed by his close relationships with two of the greatest Parisian collectors of the later seventeenth century, Jabach and Pointel.

Millet's paintings attracted followers from France and the Netherlands, and his personal style—with its distinctive combination of the Flemish-inspired classical landscape and the synthetic artistic vision adopted from Poussin—continued into the nineteenth century. Allegrain was one of his most faithful followers in Paris, causing the two painters' works to frequently be misattributed to the other. Many of Millet's stylistic progeny were Flemish painters who made their way through Paris on their way to or from Rome. This group includes Jan Baptist Huysmans (who copied *Landscape with Christ and the Woman of Canaan*; Christie's, London, 30 October 1998, lot 26), Abraham Genoels II (cousin of Laureys Franck), Johannes Glauber, and Jan Frans van Bloemen, called Orizzonte (1662–1749). Van Bloemen continued painting classical landscapes similar

to Millet's throughout the first half of the eighteenth century. However, even without a follower such as van Bloemen, it is easy to see Millet's place in a progression from the crafted idealism of Poussin and Dughet to the cool realism of the late-eighteenth- and early-nineteenth-century landscape tradition popularized by Pierre-Henri de Valenciennes.

22. Jean-François Millet, called Françisque Millet I, *Landscape with Christ and the Woman of Canaan*, ca. 1670–79

Oil on canvas, 37¾ × 51⅝ in. (95.8 × 131.2 cm.)
The Toledo Museum of Art, Toledo, Ohio
Gift of Edward Drummond Libbey, 60.28
PROVENANCE: Chevalier Sebastien Erard, Château de la Muette, Passy, Boulogne, France (d. 1831); sale, LaCoste, Paris, 23 April 1832, lot 96 (Lugt 12962); sale, LaCoste, Paris, 7–14 August 1832 (Lugt 13071); sale, Christie's, London, 22 June 1833, lot 17 (Lugt 13350) [bought in at all sales]; Comtesse de Franqueville (née Schaeffer; Sebastien Erard's great-niece and the adopted daughter of Mme Pierre-Orphée Erard; Mme Darcy, Belgium; Chevalier de Schoutheete de Tervarent, Ridder Guy, Brussels (1891–1969, Ambassador, member of l'Académie Royale de Belgique); Count Zamoyski; his sale, Sotheby's, London, 8 July 1959, lot 63, ill.; Colnaghi, London; gift 1960
EXHIBITIONS: Rosenberg 1982, cat. no. 71, ill.

*L*ANDSCAPE WITH *C*HRIST and the *Woman of Canaan* (cat. no. 22), a painting of compositional complexity and visual cohesion, is a fine example of Françisque Millet's mature style. It depicts the passage from Matthew 15:21–28 in which a woman begs Christ to help her daughter, who is "grievously vexed with a devil." The woman uses the metaphor of a dog eating crumbs from its master's table to reveal her faith, upon which Christ heals her child. Centrally placed in the foreground, Christ and his disciples are depicted meeting the woman of Canaan. This figural group—and, cleverly, a dog—are on a path that loops through the landscape, providing a believable meeting point for Christ and the Canaanite. The path unites the composition, arcing across the foreground and eventually reappearing in the middle ground to ascend to the city—a fictive agglomeration of classical and Renaissance architecture. A lake continues the path's receding motion,

revealing the plains and mountains of the deep background. The whole composition is framed by stands of trees; the trees at the left are set deeper into the landscape to draw the viewer's gaze into the scene.

Though not signed or dated, this painting may be confidently attributed to Millet both on stylistic grounds and on its connection with one of Théodore's engravings after Millet's works (fig. 65).[1] The carefully crafted spatial narrative of this landscape places it comfortably in Millet's mature style, a period from about 1670 to 1679. The placement of figures, architecture, and framing elements are all characteristic of his work at this time, and the composition is highlighted by the rhythmic staggering of fore-, middle-, and backgrounds.[2] Millet developed this style after moving to Paris and studying the paintings of the Franco-Italian followers of Poussin and Claude. Unlike many of the second- and third-generation painters in this tradition, Millet is more closely associated with Poussin and Dughet. The landscapes of Claude and the Patels show a distinct preference for recession into the grounds along a linear diagonal, as opposed to Poussin, Dughet, and Millet's preference for staggered grounds, which creates a serpentine progression from fore- to background.

Millet's palette—the blues of the sky and mountains and the saturated solid colors of the draperies—comes to him from Rome through the previous generation of French painters and is reminiscent of Poussin. Although Millet's pastoral classicism is clearly Italianate, his style is tempered by the early years he spent under the tutelage of Franck, who never traveled to Rome. Unlike many of his Flemish (or French) contemporaries in Rome, Millet was not inclined to experiment with atmospheric effects. Instead, he was engaged in the project that most Academicians who remained in France endorsed—the codifying of an abstracted, ideal model for landscape painting, arrived at through careful scrutiny and reworking of Poussin and Claude.[3]

Among the techniques that Millet learned from his Flemish training rather than from the French tradition were the efficacy of a high horizon—with at least half the canvas depicting terrain—and the use of trees in the foreground that push to the top of the canvas or beyond. These elements give the picture intimacy and an easy order, helping to connect the viewer with the scene despite the great depth of the depicted space.

FIG. 65. Théodore after Jean-François Millet, called Françisque Millet I, *Christ with the Woman from Canaan*, ca. 1675. Engraving. *Illustrated Bartsch*, vol. 7, 161.

The early-seventeenth-century Flemish painters Paul Bril, Herman van Swanevelt, and Jan Both used this format, which is inconsistent with the unimpeded visibility often sought by Poussin and with the sweeping, strongly horizontal panoramas of Claude.

Millet's use of architecture became synthetic in his mature style. The city is a tight grouping of buildings situated off-center and in the middle ground, featuring Greek, Roman, Egyptian, and later Italian building types. All of the buildings, regardless of period, appear in a fine state of preservation; in fact Millet rarely depicts a classical building in compromised or abandoned condition. Displaying a colorful array of building materials and construction techniques, the structures form a peculiar frieze of styles and epochs. We see a

similar approach to the architectural landscape in Antoine Coypel's *The Finding of Moses* (cat. no. 16), which is taken directly from Poussin.

NOTES

1. See the Millet biography on page 123 of this catalogue for more on the work of Théodore.

2. Other examples of this mature style include *Shepherds and Flock on a River Bank* (Christie's, London, 4 May 1999, lot 120); *Landscape with Conopion Carrying the Ashes of Phocion*, Southampton, Art Gallery; *An Extensive Landscape with the Flight into Egypt* (Christie's, London, 22 July 1988, lot 86); *Le Christ et Jaïre*, York, City Art Gallery; and, to a certain degree, *Paysage italien* (Sotheby's, Monaco, 6 December 1987, lot 22); and *Classical Landscape with Christ Healing the Blind* (Sotheby's, London, 12 December 1984, lot 120).

3. Salerno 1977–78, vol. 2, 818.

Pierre Patel, called Patel the Elder

PICARDY 1605–1676 PARIS

The family of painters called *Les Patel* holds an important place in the history of seventeenth-century French landscape painting. Pierre Patel, known as Patel the Elder, was born in 1605 at Chauny, a tiny village in Picardy. His father, Léon Patel, was a mason, and little else is known about Pierre's youth. He clearly must have received some artistic training during this period, probably with a local master in Picardy. He was married in 1632 to Marguerite Verdier, and records confirm that by this time he was living in Paris in the parish of Saint-Eustache and was established as a painter. Judging from the witnesses present at his wedding, Patel was already part of the Parisian artistic community: several painters, including Nicholas Le Brun, Jean-Michel Picart, and Jean de Saint-Igny, served as witnesses. Patel's marriage to Verdier produced five children: Claude, Jacques, Simon, Elisabeth, and Pierre-Antoine.

In Paris, Patel studied with Simon Vouet (1590–1649) and undertook much of the artistic training of his sons Jacques (ca. 1635–1662) and Pierre-Antoine, called Patel the Younger (1648–1708). The Patels devoted their artistic activity to landscape painting, often working together and copying each other's work. Pierre Patel was admitted to the Guild of Saint-Germain-des-Prés in 1633–34 and was accepted to the Académie de Saint-Luc in 1635. By 1636 he had moved across the Seine to the parish of Saint Gervais and was enlisted in the workshop of Vouet, probably in the Louvre, where he designed tapestries. In 1651 he was involved in an unsuccessful attempt to merge the Académie royale with the Académie de Saint-Luc.

Patel was awarded several important decorative commissions, including the Cabinet de l'amour in the Hôtel Lambert for Nicholas Lambert in 1646–47. For this project, he worked with two northern painters, Herman van Swanevelt (1600–1655) and Jan Asselijn (1648–1708), who had both lived in Rome in the circle of Claude. In 1660 Patel was commissioned by Anne of Austria to paint a series of landscapes for her *appartements* in the Louvre, where he collaborated with another student of Vouet, Eustache Le Sueur (1616–1655), Laurent de La Hyre (1606–1656), and probably Patel's son Jacques.

Patel himself never visited Italy, and no records show that he traveled outside of France. In spite of this, the influential dealer and publisher Pierre-Jean Mariette (1694–1774) referred to Patel as the "Claude Lorrain of France." Patel's landscapes incorporate a combination of a sweeping natural light illuminating a palette of rich blues and greens and darker browns. His landscapes are crisper than Claude's and more animated than the Dutch and Flemish, placing them in a class of their own rivaled only by the work of his youngest son, Pierre-Antoine. Patel died in 1676, leaving the artistic legacy in the capable hands of his son.

Besides his extraordinary artistic accomplishments, Pierre Patel can be credited for elevating his family's status from a modest provincial background to the highly educated class of Parisian artists. Natalie Coural's 2001 *catalogue raisonné* of the paintings and drawings of the Patels gives us the long-awaited study of this fascinating though little-known family of painters. For the first time the oeuvres of Pierre, Jacques, and Pierre-Antoine have been examined separately and together, resulting in a much clearer understanding of the artists' individual output, as well as their contribution to each other and French landscape painting.

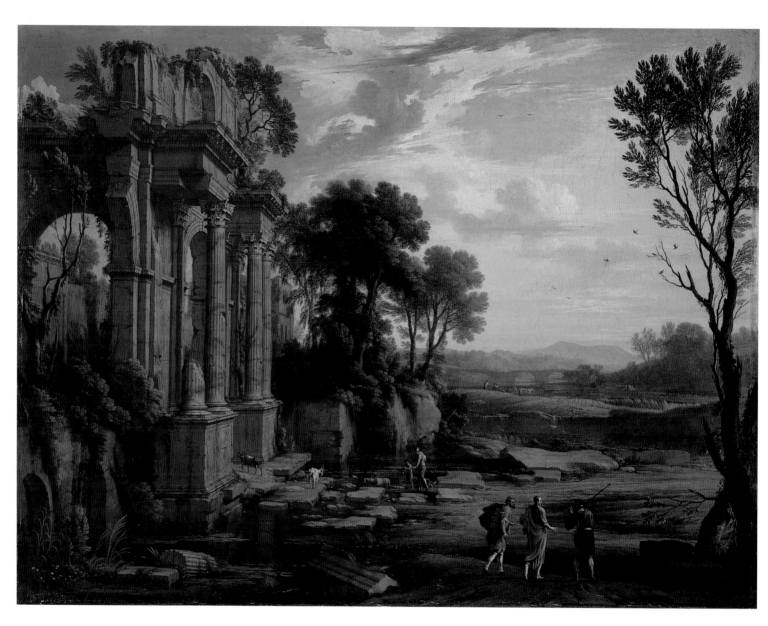

23

23. Pierre Patel, called Patel the Elder, *Landscape with the Journey to Emmaus*, 1652

Oil on canvas, 27⅜ × 36½ in. (69.5 × 92.7 cm.)
The Chrysler Museum of Art, Norfolk, Virginia
Gift of Walter P. Chrysler, Jr., 71.686
PROVENANCE: Private collection, Great Britain; sale, Christie's, London, 29 May 1952, no. 39; David M. Koetser, New York; Walter P. Chrysler, Jr.; gift 1971
EXHIBITIONS: Manning 1967, cat. no. 28, ill.; Harrison 1986, cat. no. 3, ill.

IN MID-SEVENTEENTH-CENTURY France, no other painter produced classical landscapes in the distinctive and delightful style established by Pierre Patel, called Patel the Elder. Some painters, such as Jean Lemaire, Laurent de La Hyre, and Henri Mauperché, incorporated classical ruins in their landscapes and responded to, as Patel had, the pastoral and heroic landscape traditions of Claude and Poussin. But in their remarkable cohesiveness and completeness as classical landscape compositions—including their skillful merging of imaginary architecture or *capricci* with the Roman *campagna*—Patel's landscape paintings remain in a category of their own. Writing about Patel in the landmark exhibition *France in the Golden Age*, Pierre Rosenberg noted that without a doubt he was a *petit maître*, at times even monotonous, but added, "Those who are willing to take the time to really look at his paintings will discover therein a hidden detail, an exquisite blend of colors, nuances in the atmosphere and in the light, delicate tonal passages."[1] In his appraisal of the Norfolk Patel, Rosenberg maintained it was the finest Patel in America.[2] It is precisely in this careful and patient looking at Patel's landscapes that the true discovery of and enchantment with his art begins.

Patel's *Landscape with the Journey to Emmaus* (cat. no. 23) was painted in 1652, at the height of his career. He had just completed an important decorative commission for two oval canvases (Paris, Musée du Louvre) for the Cabinet de l'amour in the Hôtel Lambert (1645–47).[3] Patel joined forces with several artists on this commission, including Le Sueur, Swanevelt, and Asselijn. Also during this period, Patel experienced a significant professional setback: his attempt (as one of the original signers of the act) to merge the Académie de Saint-Luc, where he was a member, to the newly established Académie royale had failed in 1651. As a result Patel remained outside the Académie royale for the remainder of his career. However, this did not prevent him from producing some of the most important and beautiful landscapes of his career during the 1650s.

The Norfolk picture depicts the passage from the Gospel of St. Luke in the New Testament in which the newly risen Christ meets two of his disciples on the road from Jerusalem to Emmaus:

> And, behold, two of them went that same day to a village called Emmaus, which was from Jerusalem about threescore furlongs. And they talked together of all these things which had happened. And it came to pass, that, while they communed together and reasoned, Jesus himself drew near, and went with them. But their eyes were holden that they should not know him.[4]

Patel has placed the three figures on a raised piece of barren ground in the right foreground of the landscape, as if to emphasize the importance of the biblical moment. The men are dwarfed by the enormous classical and Baroque-style ruin, which has overtaken the entire left side of the picture, but they do not go unnoticed. The surrounding ground is free of any vegetation or cover, and the three men, elegant and Claudian in their proportions, stand boldly in the stream of light that filters through the trees at the right. Flanked by his disciples, the barefoot Christ is robed in purple with a flowing red mantle, unencumbered by staff or satchel, and one almost senses the lightness to his walk.

Patel's debt to the great Roman painters of the seventeenth century is understood. His fascination with the landscapes of Claude are palpable, especially in his attention to the topography, the ancient architecture, the conscientious and decorative placement of staffage throughout the grounds, and his reliance on natural light to create a mood and a sense of time. And yet Patel's landscapes stand apart from those of Claude in that they lack the subtle veneer that seems to coat or fuse together every aspect and element of Claude's pastoral settings. In one way Patel's landscapes are more precise, more tactile, and in another they are separated from the Claudian tradition by a remarkable clarity of light and color. The architectural ruin is magnificent in its classical splendor: both real and fantastic in its

FIG. 66. Pierre Patel, called Patel the Elder, *Classical Ruins in a Landscape*, 1652.
Black chalk on paper. Chrysler Museum of Art, Norfolk, Virginia. Museum purchase.

construction, the weathered stone bears a patina that allows it to rest convincingly in the natural setting. Rosenberg and, more recently, Natalie Coural in her *catalogue raisonné* of the Patel family list two preparatory drawings by Patel that relate to the Norfolk picture—one in the Crocker Art Gallery, Sacramento,[5] and the other in the Chrysler Museum, entitled *Classical Ruins in a Landscape* (fig. 66). The Norfolk drawing shows the identical ruin and demonstrates Patel's partiality to the architectural form, confirming at this early stage in the composition that the ruin is paramount in his landscape. With only twenty extant drawings in Patel's oeuvre,[6] the existence of two drawings connected to a securely signed and dated

painting is extremely useful in understanding Patel's painting method and style.

NOTES

1. Rosenberg 1982, 297.
2. Press release for *France in the Golden Age* exhibition, 26 March 1982, The Chrysler Museum.
3. Coural 2001, 17.
4. Luke 24:13–16.
5. *Landscape with Ruins and Figures* (Sacramento, Crocker Art Gallery, inv. 1871.394 B) and *Classical Ruins in a Landscape* (Norfolk, The Chrysler Museum, inv. 84 180). See Rosenberg 1982, 297; and Coural 2001, 184–86. Coural uses the titles *Paysage de ruines avec des figures* (Sacramento) and *Paysage avec un portique* (Norfolk). In 1982, at the time of the *Golden Age of French Painting*, the Norfolk drawing was in a private collection.
6. See Coural 2001, 175–94.

Jacques Patel

PARIS CA. 1635–1662 PARIS

Very little is known about the family of painters known as *Les Patel*, and even less is known about Jacques Patel, the second son of Pierre Patel and Marguerite Verdier. He was born around 1635 in Paris and lived in the parish of Saint-Eustache. His first teacher was his father, Pierre, called Patel the Elder (1605–1676), who studied with Simon Vouet. Jacques likely followed in his father's footsteps, joining the Guild of Saint-Germain-des-Prés and possibly the Académie de Saint-Luc where his father and younger brother, Pierre-Antoine, called Patel the Younger (1648–1708), were both members. Jacques Patel is alleged to have been killed in a duel in 1662; hence his title *Patel le Tué*. His short life and modest output have been overshadowed by the work of his father and brother, and only one known painting is signed by him, the *Classical Landscape*, dated to about 1660.

At an early age, Jacques assisted his father painting commissions, including a series of landscapes for the *appartements* of Anne of Austria in the Louvre in 1660, completed shortly before Jacques' premature death. Jacques would also have experienced firsthand the northern painting traditions through the Dutch and Flemish artists who worked in Paris and were acquainted with his father.

A handful of unsigned works, some attributed to Pierre and Pierre-Antoine, bear stylistic elements that relate closely to the Louisville picture, and it is possible that these paintings are by the hand of Jacques Patel or reflect his participation in some measure. However, with only one known painting firmly connected to his oeuvre and a relatively small number of extant works securely attributed to his father and brother, it is difficult to confirm new attributions to Jacques. Certainly his painting style is closer to his father's, and, beyond the family's studio, it bears the influence of his father's friend and associate La Hyre, with whom they both worked on various commissions in Paris. Jacques' subtle treatment of light and particular attention to the details of foliage and vegetation recall the elegant and naturalistic landscapes of La Hyre.

24. Jacques Patel, *Classical Landscape*, ca. 1660

Oil on canvas, 14 × 16 in. (35.6 × 40.6 cm.)
The J. B. Speed Museum, Louisville, Kentucky
Bequest of Alice Speed Stoll, 1998.6.9
PROVENANCE: Galerie Heim, Paris, 1974–75; Alice Speed Stoll, Louisville; gift 1998
EXHIBITIONS: Paris 1975, cat. no. 22, ill.

THE LOUISVILLE PICTURE (cat. no. 24) is the only extant signed painting by Jacques Patel. It serves as a valuable link in this exhibition's survey of the Patel family and expands our understanding of their contribution to French landscape painting. The son of Pierre Patel and brother of Pierre-Antoine, Jacques worked largely in the shadow of his father. Jacques would not have known the important output of his younger brother, Pierre-Antoine, as Jacques is recorded as being killed in a duel in 1662.[1] If it were not signed the Louisville picture would probably be attributed to Pierre Patel.[2] This difficulty of purely stylistic attribution raises the question of whether more works by Jacques are presently attributed to his father or brother. However, a recent exhaustive reexamination of the Patel family's work, published by Natalie Coural in 2001, did not change the number of extant works in his oeuvre. Only the present painting is accepted as an autograph work by Jacques Patel.

About twelve years older than his brother and old enough to work with his father on various commissions, Jacques Patel produced work closely aligned to his father's style and to painters working in the Patel circle at mid-century. Jacques presumably studied at the Guild of Saint-Germain-des-Prés and possibly also at the Académie de Saint-Luc. His own development as a painter would have still been in its formative stages when he died in 1662. The French historian and author of *Paris ancien et moderne*, Henri Sauval (1623–1676), noted that two members of the Patel family worked on the commission for the *appartements* of Anne of Austria

24

in the Louvre in 1660.[3] Although he didn't identify the artists by name, Sauval was clearly referring to Pierre and Jacques Patel. Coural also suggests that Pierre-Antoine, who would have been twelve years of age, was present, helping with studio tasks as well as learning to paint.[4] Throughout the seventeenth and eighteenth centuries, and even later, writers and biographers confused members of the Patel family. For example, Pahin de la Blancherie and Jean-Baptiste Deperthes (1761–1833), at different times, referred to Jacques as "Bernard Patel, dit le Tué," and his father Pierre as "Jean-Baptiste Patel,"[5] causing later scholars to speculate that the family may have included another painter. Coural's research, however, has clarified these errors and shows that it was a discrepancy over names involving the same two artists.

Patel's landscape betrays the influence of his father and the northern painters in their immediate circle, namely Swanevelt and Asselijn. The palette, saturated with deep greens and blues and golden tones, is closely connected to the glowing landscapes of the Dutch and Flemish schools, the same tradition that figured prominently in Patel the Elder's development. The luxuriant foliage, complicated rock and water formations, and the disposition of natural phenomena are reminiscent of the naturalistic landscapes of Paul Bril (ca. 1554–1626), whose work was also familiar to Patel. The landscapes of La Hyre (see cat. nos. 18–20), another French painter who came by his Italian sources through paintings and prints, are also linked to Patel's work. La Hyre's *Landscape with Swineherd* (fig. 67) reveals the same Flemish influences: an intimate landscape with complex topography, filled with foliage and rock formations, interesting figures and animals, and carefully integrated ruins.

The ruined temple with elegant Corinthian columns is the most prominent element in the Louisville landscape, but it does not overwhelm the composition as is characteristic of his father's paintings. A broken column positioned on a tall base featuring a Roman relief of larger-than-life figures suggests the remnants of a portico. The soft, even light bathing the scene helps to assimilate the antique ruins in the landscape. While the viewer is drawn to the picturesque temple, there is an almost equal pull toward the path of the river from the marshy pool in the middle ground to the stone bridge

FIG. 67. Laurent de La Hyre, *Landscape with Swineherd*, 1648. Oil on canvas. Musée des Beaux-Arts, Montréal, Québec, Canada. Purchase, gift of Murray G. Ballantyne and the Horsley and Annie Townsend Bequest, 1972.4.

and past the circular temple situated on the horizon line at the center of the picture. The ivy-covered temple is inspired by the Temple of Vesta at Tivoli. Nestled firmly in the rocky riverbank and catching the final rays of sun, it is very much a part of Patel's landscape.

NOTES

1. The duel took place on 23 July 1662. See Coural 2001, 113.

2. The signature appears on the rock in the lower right corner: *Jacob Patel*.

3. Sauval noted that the walls of the *appartements* of Anne of Austria "sont pares de quantité de petits payisages [*sic*] peints par Patelle & son fils"; Henri Sauval, *Histoire et recherches des antiquités de la ville de Paris*, vol. 2, 1724, 34 (published posthumously in 1724 by his collaborator, Claude Bernard Rousseau, under the title *Histoire et recherches des antiquités de la ville de Paris*), as cited by Coural 2001, 113.

4. Coural writes, "Mais Pierre-Antoine, qui avait alors une douzaine d'années, accompagnaits sans doute son pèrem l'aidait dans ses tâches matérielles et recevait ses leçons"; see Coural 2001, 113.

5. Mammès-Claude-Catherine Pahin Champlain dit Pahin de La Blancherie's "Essai d'un tableau historique des peintres de l'Ecole Françoise, depuis Jean Cousin, en 1500" is found in *Nouvelles de la République des Lettres et des Arts*, no. 27, 1783. Deperthes was the author of *Histoire de l'art du paysage, depuis la Renaissance des Beaux-Arts jusqu'au dix-huitième siècle*, Paris, 1822. See Coural 2001, 113.

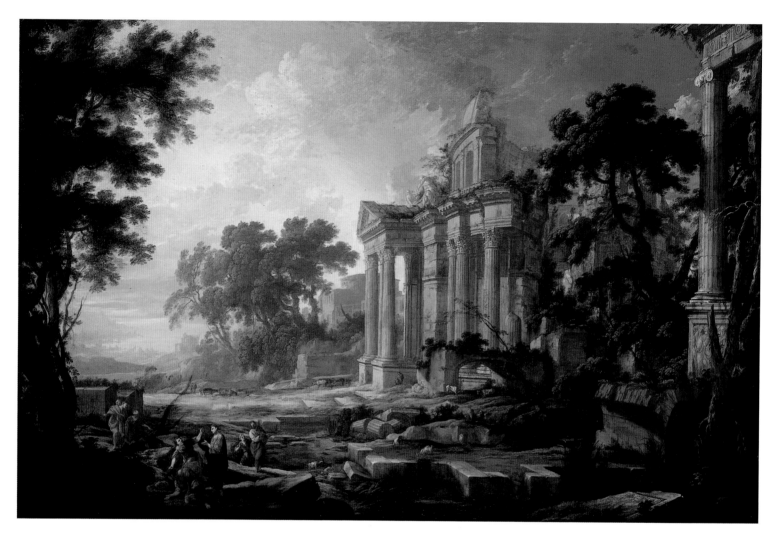

Pierre-Antoine Patel, called Patel the Younger

PARIS 1648–1708 PARIS

Pierre-Antoine, called Patel the Younger, was the fourth son of Pierre Patel and Marguerite Verdier. He was born in Paris in 1648. His father, Pierre Antoine Patel, called Patel the Elder (1605–1676), studied with Simon Vouet and was responsible for the early artistic training of his sons Pierre-Antoine and Jacques (ca. 1635–1662). Pierre-Antoine married Marie Varier (probably in 1699), and the couple had three sons, Nicolas-Benoit, René, and Jean-Raphael. Pierre-Antoine died in 1708 and not, as has been earlier recorded, in 1707 (clarified in Natalie Coural's 2001 *catalogue raisonné* of the Patel family).

Patel first studied with his father in Paris and was admitted to the Académie de Saint-Luc in 1677. Like his father and older brother, he remained independent of the Académie royale throughout his career. The Patel family was extremely close-knit, and Pierre-Antoine frequently sketched and painted with his father and probably assisted him with major commissions. No record of Pierre-Antoine traveling outside of France exists, and his Claudian landscapes were created without the benefit of firsthand experience in Italy. To master the classical landscape—with its architectural ruins and mountainous horizons framed by rich foliage and enlivened with animals and elegant groups of figures—the Patels turned for inspiration to the French painters whose landscapes are intimately linked to the Roman *campagna*, namely Claude and Poussin. Pierre-Antoine was also influenced by the work of two other Parisian artists: Laurent de La Hyre, who also apparently never traveled to Italy, and Gabriel Perelle (1604–1677). The ruins in Patel's compositions often possess a combination of Roman, Greek, and Baroque architectural elements, the various stones of each order and member carefully illuminated and set off by a luxuriant backdrop of green vegetation and Mediterranean-blue skies. In addition to French sources, the northern tradition, so close to Pierre-Antoine's father through his association with Herman van Swanevelt and Jan Asselijn, is evident in the palette and treatment of the light. The peculiar scale employed by Pierre-Antoine, showing groups of diminutive figures dwarfed by massive ruins and at times lost in the landscape, is reminiscent of late-sixteenth-century northern painting, when figures were first introduced to the landscape in a convincing manner.

It was not until the death of his father in 1676 that Pierre-Antoine finally developed his own style, and it took another twenty years before he produced his greatest work, a series of twelve landscapes representing the months of the year for the Maison professé des jésuites (today l'église Saint-Paul-Saint-Louis) in Paris in 1699. But even after two decades of working independently, Pierre-Antoine was never very far from the style and spirit of his father. Their paintings were frequently misattributed to each other at the time, a problem that continues today. In his 1776 biography on the Patel family, l'Abbé de Fontenay briefly mentioned Pierre-Antoine: "Il y a eu un autre peintre de ce non, dit le Jeune, qui a travaillé dans le même genre. Ses tableaux son agréables et d'un coloris brillant."

The groundbreaking 1925 exhibition *Paysage français*, held at the Petit Palais in Paris, included no fewer than nine works by Pierre-Antoine. In her recent *catalogue raisonné* of the Patel family's work, Natalie Coural lists one hundred twenty-two paintings and seventy-seven gouaches by Pierre-Antoine; however, the present location of over half of these paintings is unknown. Only a handful of Patel's extant paintings are signed and dated. While the majority of these works are found in French collections and several European museums, a few have made their way into North American collections in the last decades.

25. Pierre-Antoine Patel, called Patel the Younger, *Landscape with Classical Ruins and Figures*, 1698

Oil on canvas, 25½ × 38¼ in. (65 × 97 cm.)
The Allen Memorial Art Museum, Oberlin College,
Oberlin, Ohio
R. T. Miller, Jr., Fund, 2002.8

PROVENANCE: John Campbell (1762–1834), 4th Earl and 1st Marquess of Breadalbane (marries Mary Turner Gavin, Langton House, Scotland), Taymouth Castle, Perthshire, Scotland, ca. 1810–20; John Campbell (1798–1862), 5th Earl and 2nd Marquess of Breadalbane (dying without issue; the Marquisate of Breadalbane and Earldom of Ormelie became extinct); his sister (and eldest daughter of the 1st Marquess), Lady Elizabeth Pringle (d. 1878); her daughter, the Hon. Mrs. Robert Baillie-Hamilton (d. 1912); her sister, Lady Harvey (d. 1913); her first cousin twice removed, Colonel Hon. Thomas George Morgan-Grenville (1891–1965; third son of Major Luis Ferdinand Morgan-Grenville and Mary Chandos, Baroness Kinloss; Mary Chandos was the eldest daughter of Richard, 3rd Duke of Buckingham and Chandos and Caroline Harvey, Stowe House), Wooton House; thence by descent to Audrey Marigold (youngest daughter of Colonel Hon. Thomas George Morgan-Grenville, and wife of Hon. Edmund Oslac, 2nd Baron Ironside); from whom acquired through John Somerville, London, 2002

No RECORDS EXIST of Pierre-Antoine Patel, his father, Pierre, or his brother Jacques ever having visited Italy. The careers of the Patel family of painters were devoted almost entirely to working in Paris. However, their education and experience was such that their exposure to painting traditions outside of France, namely in Italy and the low countries, was rich and varied, impacting greatly their own painting styles. Not only did they have direct access to many of the painting collections and print cabinets in Paris, but they also had the opportunity to work with several French and foreign artists who themselves had studied and lived in Italy.

Patel's *Landscape with Classical Ruins and Figures* (cat. no. 25) relates directly to the rich artistic traditions and personalities he encountered while working with his father in Paris. At the same time, his paintings of magnificent classical ruins and modern buildings exhibit an architectural genre that is unique to the family's studio and a handful of other French artists working in the late seventeenth century. In addition to the influence of his father, the subtle, naturalistic palettes of La Hyre

and Mauperché can be discerned in the Oberlin picture. As well, the influence of northern painters who were closer to Patel the Elder, especially Jan Asselijn, is still present in Patel the Younger's work and evident in the naturalism of the landscape setting in Patel's paintings.[1]

The primary subject of the Oberlin picture is the impressive collection of ruins that fills the entire right side of the composition and continues in diminishing scale to the bay in the distance. The other subject of the painting, largely overshadowed by the ruins, is the activity that takes place in the left foreground, comprising three small groups of figures. It appears to be the Stoning of Stephen, which is recorded in the Acts of the Apostles in the New Testament: "And [they] cast him out of the city, and stoned him: and the witnesses laid down their clothes at a young man's feet, whose name was Saul. And they stoned Stephen, calling upon God, and saying, Lord Jesus, receive my spirit. And he kneeled down, and cried with a loud voice, Lord, lay not this sin to their charge."[2] According to Old Testament law, the "whole congregation" was expected to participate in the stoning of the condemned person;[3] however, the New Testament account of Stephen's stoning makes no reference to a large crowd being present. Patel's portrayal follows other seventeenth-century depictions of the event where only a few people are shown carrying out the act and witnessing the event. A bearded Stephen, clothed in a blue tunic and red mantle, is kneeling as one of the executioners grabs his hair and prepares to strike with a rock held in his other hand.

As is often the case in Patel's landscapes, human activity is secondary to the role given to the architectural ruins. A sweeping natural light coming from the left side of the picture fully illuminates the façade of the two-storied temple ruin, washing the barren middle ground and lighting as well the single Ionic column of the portico at the extreme right. However, Patel has chosen to place the figures at the left in the shadow of immense trees that frame the picture, with their faces and garments in a much softer, diffused light. Stephen is shown almost completely in shadow.

Patel has spared no effort in his depiction of the ruins. The white and rose-colored marble, yellow sandstone, and red terra-cotta surfaces all stand out in the light, animating the details of the architecture. The

FIG. 68. Pierre Patel, called Patel the Elder, *Classical Landscape with Roman Ruins and a View over a Distant Valley*,
ca. 1655. Black chalk on paper. Collection Frits Lugt, Institut Néerlandais, Paris, France, Inv. 1973-T.45.

corner of a Hellenistic-inspired temple portico is visible
at the right, next to a much larger classical structure
that combines Greek and Roman elements with Corin-
thian columns and the elaborate façade of a Baroque
church. The sculptural group in white marble, set back
on the moss-covered center pediment, is also inspired by
Baroque sculpture, similar to the sculptural arrange-
ments that bear the coats of arms or papal escutcheons
surmounting a façade. In the middle distance is a low-
domed structure with a temple front that relates to the
Pantheon in Rome. The overall composition is one that
is used over and over by Patel; however, it is rarely
repeated precisely in his oeuvre. The placement and
character of the ruins change each time, and the land-
scape is arranged accordingly. A drawing attributed to
his father, *Classical Landscape with Roman Ruins* (fig.
68), presents a remarkably similar composition to the

Oberlin picture, alluding to their reliance on the same
pictorial sources and the constant sharing of ideas
between father and son. Of particular interest is the
comparable placement of receding architectural façades
at the right, and the trees and figural groups at the left
side of the picture. Studying the paintings and prints of
the French painters who saw firsthand the ruins of Italy
and Greece, the Patels had an incredible repository of
images at their disposal.

NOTES

1. For the painting commission for the *appartements* of Anne of
Austria in the Louvre (1660), Patel the Elder worked with La Hyre,
Eustache Le Sueur, and Simon Vouet. For the Cabinet de l'amour in
the Hôtel Lambert in Paris (1646–47), he worked with Herman van
Swanevelt and Jan Asselijn.
2. Acts 7:58–60.
3. Leviticus 24:14–17.

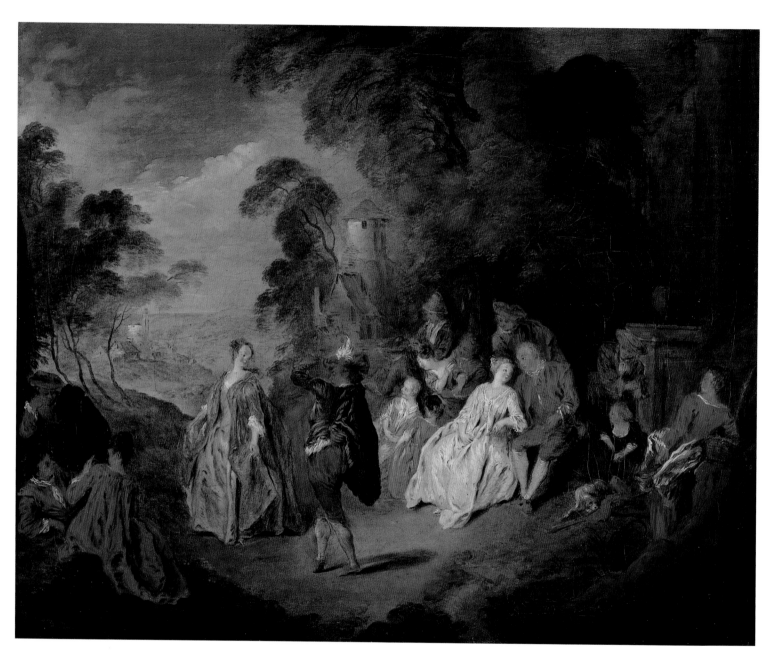

Jean-Baptiste Pater

VALENCIENNES 1695–1736 PARIS

Jean-Baptiste Pater, son of sculptor Antoine Joseph Pater (1670–1747), was born in 1695 at Valenciennes. He showed artistic promise at an early age and as a youth began studying with Jean-Baptiste Guidé (fl. 1697–1711). In 1710, Pater's father placed him in the Parisian studio of Antoine Watteau (1684–1721), who was eleven years Pater's senior and a native of Valenciennes, in the hopes that the painter would take his young compatriot under his wing. Although their early rapport was poor—Pater left his master's studio by 1716 to return to Valenciennes—both his early apprenticeship and later tutelage under Watteau provided Pater with his sole artistic inspiration. Known especially for his *fêtes galantes* in the style of Watteau, Pater spent his career as a genre painter mainly outside the academic mainstream, continuing in the shadow of his master. Pater's reputation suffered after his death in 1736, but his work was fervently collected by some, including English connoisseur Sir Richard Wallace and Frederick the Great of Prussia.

In the period after his studies with Watteau, Pater spent two years in Valenciennes, until he was forced to leave that city over a dispute with the local Guild of Saint-Luc. In Paris again by 1718, Pater gained the patronage of some of Watteau's own sponsors, notably the art dealers Edmé-François Gersaint and Pierre Sirois. In 1721, Pater was summoned to Watteau's deathbed, and he spent the last month of the master's life under his instruction. Pater would later state that he learned everything he knew about painting from this period of study. He then began his tenure at the Académie royale, being approved in 1725 and received in 1728 with *Soldiers Celebrating* (Paris, Musée du Louvre) as his *morceau de réception*. Pater was received at the Académie as a painter of *fêtes galantes*, a position created a decade earlier by the Académie for Watteau. Unlike many of his contemporaries, Pater did not travel abroad and remained in France for his entire career.

Pater was a prolific painter, relying nearly exclusively on private commissions. His patrons included Jean de Jullienne, the Comtesse de Verrue, and Glucq de Saint-Port. Afflicted throughout his life by a virulent fear of poverty, Pater created an oeuvre of more than six hundred paintings, consisting almost entirely of *fêtes galantes*. He also copied the works of Watteau for a collection of etchings, the *Recueil Jullienne*. Though his patron Gersaint lamented Pater's neglect of composition and design, Pater was an avid draftsman, generating volumes of sketchbook studies of figures, details, and drapery from which he would draw his painting compositions. His greatest pictures lie within his chosen genres: *fête galante*, *fête champêtre*, and *bambochade*, all terms denoting painting with courtly etiquette and gallant couples arranged in an ideal landscape, most often a country setting. Among them are his Flemish-influenced country fair scenes (*The Fair at Bezons*, ca. 1733; New York, Metropolitan Museum of Art), bathing scenes, and other cheerful subjects such as *Gallant Conversation* (London, Wallace Collection). Pater's landscapes are much the same—light and pleasant, employing a silvery palette of pale pinks, greens, and blues applied with a delicate touch, which would later be adopted by François Boucher (1703–1770) in his own variations on the *fête galante*. Pater eliminated chiaroscuro from his pictures, creating what is perhaps a more purely French style.

Though less original in their execution than Watteau's pictures, Pater's genre paintings hold an important place in eighteenth-century art. Ever since the art historian and critic André Félibien produced a hierarchy of academic art in 1667, trivial scenes had been scorned as poor painting, and not until Watteau were they accepted by the Académie. The pioneering of this highly desired and collectible art by Watteau and, in another vein, by Jean-Baptiste Greuze was continued by Pater, Lancret, Oudry, and others late into the eighteenth century.

FIG. 69. Jean-Baptiste Pater, *Fête galante: Le cadeau des pêcheurs*
(The Gift of the Fishermen), ca. 1735. Oil on canvas. Art Gallery of Ontario,
Toronto. Bequest of Miss L. Aileen Larkin, 1967 (67/2).

26. Jean-Baptiste Pater, *Fête galante: La danse (The Dance)*, ca. 1730–35

Oil on canvas, 15⅞ × 19 in. (40.3 × 48.3 cm.)
The Art Gallery of Ontario, Toronto
Bequest of Miss L. Aileen Larkin, 67/1
PROVENANCE: Collection of Lady Peters, London; Durlacher
Brothers by 14 May 1919; Agnew's, London; collection of
C. Morland Agnew, Esq.; sale, Christie's, London, 9 July
1926, lot 137; Spink, London; Hon. Peter Larkin, Toronto,
Lillian Aileen Larkin, Toronto, bequest, 1967
EXHIBITIONS: New York 1954–55; Halifax 1986, ill.

In Pater's *Fête galante: La danse (The Dance)*
(cat. no. 26), several couples and individuals dressed in
elegant costumes gather to dance in a clearing in the
woods adjacent to an estate. The artist focuses on the
one couple engaged in the dance: each figure caught in
the graceful gestures of the dance, their rapt attention
heightening the excitement and frivolity of the scene. In
this wonderfully balanced composition of courtly affairs
set in the open air, Pater presents the subject that is cen-
tral to his oeuvre. As Watteau's only student, and an
ardent one at that, Pater produced a body of work that
primarily consisted of *fêtes galantes* and scenes such as
The Dance.[1] These works provided a glamorous land-
scape setting in which to document the outdoor activi-
ties of members of the French elite. Well-manicured

gardens and rustic wooded settings were often merged
and embellished with rich foliage, statuary, and a
complement of architectural ornamentation, both new
and old.

The Dance is set in a secluded outdoor space, the
surrounding woods partly cultivated and partly rustic.
Men, women, and children relax in the open air, enjoy-
ing each other's company. Beyond the festive gathering,
the clearing opens out to the hilly countryside where
two clusters of medieval and Renaissance-style build-
ings with towers are visible in the distance. At the right,
the richly colored foliage of deep greens and golden
browns fuses with a towering columned portico. In
shadow and without detail or ornament, the structure
takes on the character of a great ruin, dulled by time
and obscured by trailing vines and foliage. At the front,
the termination of the balustrade and steps, supporting
what appears to be a large urn, offers the only orienta-
tion to the abandoned structure. Pater uses the architec-
tural ruin as a decorative and compositional element: it
helps frame the scene and provides an elegant backdrop
for the figures of this *fête galante*. It brings a sense of
order and splendor to the setting in contrast to the ver-
nacular buildings in the distance, which have a more
charming appeal in the picture.

The pendant to Pater's *The Dance* is *Fête galante:
Le cadeau des pêcheurs* (The Gift of the Fishermen)

(fig. 69). The pairing of the two subjects offers Pater the opportunity to juxtapose corresponding outdoor scenes and activities featuring the same players dressed in a variety of costumes. These pendants were a common occurrence in his work and quite fashionable at this point in French landscape painting. Colin Bailey writes that at the mid-century, "Such was the convention of hanging pictures in pairs ... that it is hardly surprising that so many genre paintings were produced in twos (or fours). As individual works, they had far less appeal for collections that were rigorously symmetrical in their arrangement."[2] Three other pairs bear a marked resemblance to the Toronto pair: *Fête champêtre* and *Le cadeau des pêcheurs* (Washington, National Gallery of Art), a pair at Waddesdon Manor, England, and a pair formerly in the collection of Frederick the Great and now thought to be at Doorn in the Netherlands.[3]

While Watteau was largely responsible for the creation of the *fête galante*, Pater and Nicolas Lancret (1690–1743) carried on the tradition, making it a staple of French art in the eighteenth century. François Boucher and Jean-Honoré Fragonard (1732–1806) also emerged from a painting tradition that intersected with and expanded upon the work of Pater and Lancret, developing into a new genre known as the *genre pittoresque*. The *fête galante* was officially recognized as a genre category with Watteau's *L'embarquement pour Cythère* (fig. 15) and his reception into the Académie.[4] Prior to this, little attention was afforded pictures outside the official genres, and the new category was established specifically with artists like Watteau in mind.[5] The presentation of the *fête galante* brought together on canvas the culture of the *bourgeois*, often featuring the *forains* (or fair players), and painters found ample inspiration from a number of popular events, including the Foire Saint-Germain and the Comédie française.[6]

NOTES

1. Although Nicolas Lancret (1690–1743) followed in Watteau's style, he never was formally a student of Watteau. Instead, Lancret studied under Claude Gillot (1673–1722), who had been Watteau's teacher.
2. Bailey 2003, 19.
3. Corsiglia 2004.
4. Otherwise known as *Embarkation from the Island of Cythera* or *Pilgrimage to the Island of Cythera*.
5. See Bailey 2003, viii, 2–12.
6. Crow 1985, 45–55.

27. Jean-Baptiste Pater, *Fête champêtre*, ca. 1736

Oil on canvas, 13⅛ × 16¼ in. (33.3 × 42.1 cm.)
The Allen Memorial Art Museum, Oberlin College, Oberlin, Ohio
R. T. Miller, Jr., Fund, Charles F. Olney Fund, and Mrs. F. F. Prentiss Fund, 1980.83
PROVENANCE: Vente X sale, Groult, Paris, 21–22 June 1920, lot 94; A. M. Gutzwiller, Paris; Rosenberg & Stiebel, New York, by 1978; purchase 1980
EXHIBITIONS: New York 1978, p. 10, ill.

As WATTEAU's only pupil, Jean-Baptiste Pater is frequently compared with his master and recognized as a capable follower in the tradition of the *fête galante*. Despite the brevity of his early apprenticeship with Watteau—possibly cut short by what some believe was Watteau's challenging personality—Pater remained devoted to his master's style and spirit of painting. He went on to complete several of Watteau's unfinished commissions and assisted the collector Jean de Jullienne in making copies of Watteau's work for the *Recueil Jullienne*.

Outside the oeuvre of his famous teacher, Pater had a distinguished career, producing a body of work that was distinctly his own. Considering Pater's unique contribution, Richard Rand writes:

> Among the emulators of Watteau, Pater perhaps has been the least well appreciated; he is still often thought of as a mere pasticheur of his master, and his work is generally considered to be unoriginal and merely derivative. Yet in the best examples of his paintings ... Pater was able to reach a high standard indeed. His distinctive feathery brushwork and pale, misty landscape backgrounds—sharply offset by the richly colored figures—distinguish his oeuvre from that of Watteau.[1]

Pater's *Fête champêtre* (cat. no. 27), in the Oberlin collection, was produced in the mid-1630s, a time when Pater's personal style was expressed in a new body of work quite separate from Watteau. He was a skilled draftsman, and Pater's sketch-like composition defined by dark outlines and filled in with pastel feathery washes is compelling. Describing one of Pater's red chalk drawings dated to the same period, Alan Wintermute writes, "It is typical of Pater's mature style: the soft, loose, and squiggly strokes, and the sharp and rapidly applied accents that serve to indicate shadows, the relative flatness of form."[2] This

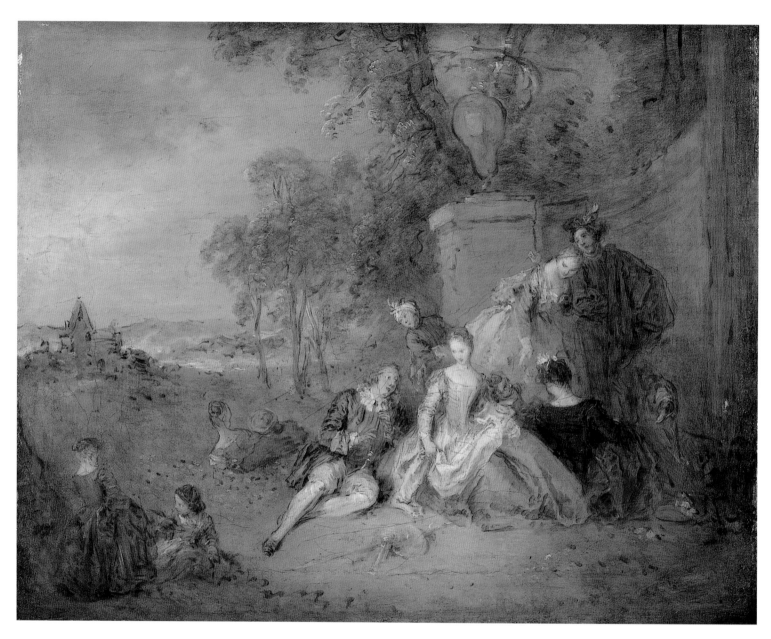

FIG. 70. Jean-Baptiste Pater, *The Fortune Teller*, 1731. Oil on canvas. Los Angeles
County Museum of Art, Los Angeles, California, Accession no. 82.8.

same graphic style conveyed by his *porte crayon* is trans-
ferred to the brush in the Oberlin picture. Added to this is
a delicate application of paint, giving the impression of
luminous flourishes of watercolor and wash rather than
oil paint. Passages in the painting remain unfinished;
however, Pater's skillful use of thinned pigments, selec-
tive impasto, and sweeping brushwork is deliberate and
understood as a highlight of these outdoor compositions.
The picture's diaphanous surface also appears in two
larger works from the same period: *On the Terrace* (ca.
1730–35; Washington, National Gallery of Art) and *The
Fortune Teller* (fig. 70). For these enchanting landscapes,
Pater has subtly merged the trees, foliage, architecture
and sculptures, and sky to form a series of patterned
grounds and forms before the final placement of the more
worked-up, painterly figures. The overall effect is one of
radiant light, with the colorful gatherings of figures de-
lighting the eye.

The elegant figures, probably members of the gentry
or bourgeoisie with abundant leisure time, comprise the
musical gathering in the Oberlin picture. The group is
also the most resolved part of the composition, at least

in the amount of paint and brushwork reserved for each
figure. The dark outlines that define the rest of the land-
scape, including the trees, the great curving wall behind
the group, the buildings in the distance, and the moun-
tains, are covered in wash, filled in for the figures. Posi-
tioned on the square column at the end of the wall is a
large classical urn, which is finished only to its black
outline and brown-colored form. A handsome couple,
the man in a flowing dark robe and tricorn hat, stands,
while the others sit around a musician holding an
oboe.[3] Leaning next to a woman resplendent in a pale
pink and green silk dress, who is obviously the object of
his affection and music making, he is about to play or
just finishing a song. On the ground before him is a
musette, perhaps to be used for another song.

NOTES

1. Rand 1997, 101.
2. Wintermute 1999, 234.
3. Unlike Watteau, who often portrayed musicians (and their pre-
cise fingering) with great accuracy as they played their instruments,
Pater does not appear interested in the same level of precision. See
Wintermute 1999, 237.

28

Hubert Robert

PARIS 1733–1808 PARIS

Hubert Robert was born in 1733 to Nicolas Robert, a chief servant to the Marquis de Stainville in Paris. Nicolas Robert's position afforded his son an excellent education at the aristocratic Collège de Navarre, where he studied Latin, ancient history, and literature. Against the will of his parents, Robert studied drawing under the sculptor René-Michel Slodtz (1705–1764), who taught him perspective and awakened Robert's passion for architectural ruins. He may also have studied briefly with the painter Pierre-Jacques Cazes (1676–1754).

In 1754, Robert traveled to Rome with the Comte de Stainville (later Duc de Choiseul), the son of the Marquis and the French ambassador to the Vatican. With Stainville's support and the assistance of Abel-François Poisson, Marquis de Marigny, the brother of Madame de Pompadour (and new *Directeur des Bâtiments du Roi*), Robert bypassed the Prix de Rome competition and was accepted to the Académie de France as a *pensionnaire* in 1759. Robert studied there under Giovanni Paolo Panini (1691–1765) from 1754 until 1765, during which time he met classmate and lifelong friend Jean-Honoré Fragonard (1732–1806). The sociable Robert also befriended Giovanni Battista Piranesi (1720–1778), whose workshop was located across from the Académie on the via del Corso, and often sketched buildings and ruins with him. Robert's growing social network would provide him with many opportunities throughout his career; in 1760, the Abbé de Saint-Non brought Robert and Fragonard to Naples, and the three visited Herculaneum and Pompeii. With Saint-Non and Fragonard, Robert is thought to have also traveled to the abandoned Villa d'Este in Tivoli, where the Ambassador of Malta to the Vatican, Bailli de Breteuil, had arranged for them to stay. On these trips, Robert and Fragonard sketched continually together, and it is often difficult to differentiate between the two artists' work from this period.

In 1761, Fragonard returned to Paris and Robert went to Florence with de Breteuil, where they translated Virgil and continued on the Grand Tour. Robert was back in Rome in 1763, returning permanently to Paris in 1765. A year later in 1766, he had the unusual honor of being approved and received at the Académie royale in the same year. His *morceau de réception* was the *Port of Ripetta, Rome* (Paris, Ecole des Beaux-Arts), a fantastic *capriccio* of three Roman monuments: the Port of Ripetta, the Pantheon, and the Palazzo dei Conservatori on the Capitoline. Images of classical ruins were very much in vogue at the time, and Robert would exhibit at the Salon every year from 1766 until 1798. His paintings incorporate antique architectural elements that he had recorded during his travels in Italy, often in imaginative fantasies. These works were populated with lively figures going about their daily business and evoked an appealing juxtaposition between the silent monuments of antiquity and bustling contemporary life. Robert met François Boucher (1703–1770) at the Académie and took an interest in the elder painter's figures, copying his drawings and inviting Boucher to paint the staffage in several of his decorative works.

Robert was married soon after being received by the Académie to the fashionable socialite Anne-Marie Soos, who bore four children, all of whom died in infancy. In 1771, Robert took up lodging at the Arsenal in Paris, where he lived until 1778. During the 1770s and 1780s —the height of his career—Robert was widely known, and he enjoyed commissions from royal patrons as well as wealthy private clients. Among his most prominent admirers were Louis XVI and the French writer and critic Denis Diderot (1713–1784), as well as Baron Stroganov and Tzarina Catherine the Great of Russia. In 1778 Robert earned the honorable position of *Dessinateur des jardins du Roi* and moved to an apartment in the palace of the Louvre. Amid the political turmoil during the revolution, Robert was arrested by the Jacobins in October 1793. Active in the uprising, Robert had frequently painted politically motivated pictures of the

FIG. 71. Giovanni Battista Piranesi, *View of the Upper Story of the Cages for Wild Animals*, 1748–78. Etching. *Vedute di Roma*. Allen Memorial Art Museum, Oberlin College, Oberlin, Ohio.

crumbling ruins and monuments of the *ancien régime*. He spent the next year in prison but continued to work, completing more than fifty paintings and numerous watercolors and drawings. After his release in 1794, he returned to the Louvre and assumed the position of curator at the new Musée du Louvre, where he remained until Napoleon took control of the museum in 1802. In 1806, Napoleon relocated the artists living at the Louvre, and Robert moved to the rue Neuve-du-Luxembourg, where he lived until his death in 1808.

28. Hubert Robert, *Roman Ruins*, ca. 1760

Oil on canvas, 29¼ × 24½ in. (74.295 × 62.23 cm.)
The Worcester Art Museum, Worcester, Massachusetts
Theodore T. and Mary G. Ellis Bequest, 1940.102
PROVENANCE: Colnaghi, London, 1925; Theodore T. Ellis, Worcester, by 1933; gift 1940
EXHIBITIONS: Hourticq 1925, cat. no. 303; Smith 1960, cat. no. 101; Poughkeepsie 1962, cat. no. 1; Parker 1971, cat. no. 30, ill.; New York 1988, p. 82, ill.

ACCORDING TO the signature and date on the base of the large sculpture between the columns at the left, Robert's painting *Roman Ruins* (cat. no. 28) is dated to 1759. The inscription, however, has been repainted, and the last two digits of the date are in question.[1] It is plausible that the work is more accurately dated to the early 1760s during Robert's final years in Rome.[2] Whether earlier or later in his stay (he arrived in Rome in 1754 and returned to Paris in 1765), the picture shows Robert as master interpreter of the ruin. Exposed first to the antique ruins of Rome and then to their fantastical treatment by his Roman contemporaries Piranesi and Panini, Robert became fully immersed in their classical splendor. He is widely recognized as the painter of "living ruins," showing not only the architecture but also the daily life and activity that now animates these ancient structures centuries later.

The composition of Robert's *Roman Ruins* is framed by the vertical expanses of an enormous barrel vault supported by Corinthian columns. At the picture's center, the remains of a crossing shows lateral vaults extending to the left and right and then forward to a dramatic expanse of open sky. It is an impressive ruin, and Robert has adjusted the architectural forms so that the viewer is presented with the most spectacular view, in the bravura style of his mentor, Piranesi (fig. 71). The columns appear remarkably sound, unscathed by the decay that has transformed the rest of the structure. Above, large sections of the entablature have collapsed, filled in with trailing vegetation, and entire divisions of the coffered ceiling have fallen, replaced by openings to the sky surrounded by heavy foliage. Beneath the soaring vaults, the majestic space has become the domain of eighteenth-century

peasants, a makeshift wooden fence and gate marking the new quarters. The peasants are joined by cattle and sheep and the trappings of country life in the city: timber, wooden barrels, wicker and terra-cotta pots, and an array of plant life fill every corner of the interior space. The washerwoman shares her water supply—a pool created from the enormous opening in the ceiling above—with the animals. At the left, set between the pairs of columns, is an imposing sculpture of a seated figure in robes, possibly an emperor or senator.

The colossal vault in various states of repair was one of Robert's favorite subjects and compositional tools, and he returns to it many times in his work, varying only the perspective, the architectural order, or the activity below. With ease, he shifts from the displaced rural setting, as seen in the Worcester picture and *The Return of the Cattle* (1773; New York, The Metropolitan Museum) to the more patrician scenes set under enormous expanses of vaulted naves, like his *Vaulted Chambers* (1787–88; Chicago, Art Institute) and *The Finding of the Laocoön* (1773; Richmond, Museum of Fine Arts).

The Worcester picture relates to a series of works that feature a grand interior space defined by two rows of columns supporting a crumbling barrel vault, the most famous being *View of the Grande Galerie of the Louvre as a Ruin* (1796; Paris, Musée du Louvre).[3] In the 1993 *Exploring Rome* catalogue Jean de Cayeux discusses a drawing by Robert, *A Vaulted Chamber with the Statue of Menander* (1775–80; Toronto, private collection), previously titled *The Baths of Diocletian*, which relates to the series. The Baths of Diocletian, built around A.D. 306, were the largest of the imperial baths in Rome and were later converted to the church of Santa Maria degli Angeli in the sixteenth century. Cayeux notes, however, that no structure like the one depicted in the Toronto drawing existed in or around Rome during Robert's lifetime, suggesting that "the author of these constructions, in his flight into the future, reveals his nostalgia for a past grandeur that has completely disappeared."[4] Robert appears to have created a composite of ancient structures, and, as with many of these fanciful arrangements, the role of fantasy and *capriccio* cannot be overlooked.

An interesting and more direct compositional link to the Worcester picture is a painting by Panini, his professor of perspective at the Académie in Rome. Panini's *Roman Capriccio* (fig. 72) offers an almost identical

FIG. 72. Giovanni Paolo Panini, *Roman Capriccio*. Oil on canvas. Ashmolean Museum, University of Oxford, Oxford, England.

composition to Robert's painting, with a mirror image of a vaulted chamber supported by twin Corinthian columns terminating in the open air. The connection, however, ends with the architectural structure, as Robert's rustic setting is substituted for Panini's penchant for celebrated ancient buildings and sculptures in Rome—in this instance, the Colosseum, the Arch of Titus, Trajan's Column, the Farnese *Hercules* and *Flora*, and groupings of elegantly robed men and women gathering at the public baths.

NOTES

1. Rich 1971, 485.
2. This inscription is transcribed as "D. M. Hubert Robert Romano, 1759" in *Palais des beaux-arts* (Paris 1925, 41) and as "D. M. HUBERT ROBERT ROMA 1759" (Paris 1926, 138). See also Worcester 1974, 279–80.
3. Jean de Cayeux in Denison 1993, 185.
4. Hubert Robert, *A Vaulted Chamber with the Statue of Menander*, 1755–80, Toronto, private collection. See Jean de Cayeux in Denison 1993, 186, no. 105.

29

FIG. 73. Giovanni Battista Piranesi, *Another View of the Sibylline Temple at Tivoli*, 1748–78. Etching. *Vedute di Roma.* Allen Memorial Art Museum, Oberlin College, Oberlin, Ohio.

29. Hubert Robert, *Figures Amidst Ruins,*
ca. 1775

Oil on canvas, 25¾ × 32⅛ in. (65.41 × 81.6 cm.)
The Memorial Art Gallery, University of Rochester,
Rochester, New York
Marion Stratton Gould Fund, 63.14
PROVENANCE: Private collection, France; Mitchell family;
Wildenstein & Co., Inc., New York, purchase, 1932
EXHIBITIONS: Houston 1951, cat. no. 9; Houston 1952, cat.
no. 43, ill.; Palm Beach 1952–53, cat. no. 15; London 1956,
cat. no. 26; Paris 1956, p. 25, ill.; Rochester 1965, cat. no.
62; Utica 1967, cat. no. 48; Rochester 1976; Sutton 1977,
p. 48, ill.; New York 1988, pp. 83–84, ill.

THE COMPOSITION of Robert's *Figures Amidst Ruins*
(cat. no. 29) brings to mind Claude's *Landscape with
Nymph and Satyr Dancing* (cat. no. 14). Robert's art
was firmly rooted in the Claudian tradition, but a com-
parison of the two pictures also reveals the difference
between Claude's sun-washed lyricism and Robert's
late-eighteenth-century naturalism. Both compositions
depict a partial view of a ruined circular temple situated
on the right side, filling the height of the canvas. The
classical structure is based on the Temple of Vesta
at Tivoli, although Claude's temple is also linked to
the Temple of Vesta on the Roman Forum. Robert's

treatment of the physical landscape is where his depar-
ture from Claude is most evident: he replaces Claude's
pastoral landscape entirely with architecture and illu-
minates the scene with a duller, more natural lighting,
which differs significantly from the dramatic effects pre-
ferred by Claude. Where Claude's balanced landscape
leads the viewer gently into the background, Robert's
architectural perspective recedes abruptly, implying vast
distance. Claude imagines an ornate Ionic order for his
temple, while Robert remains faithful to his observation
of the temple's Corinthian order, although he replaces
the fluted columns with smooth ones (fig. 73).

Figures Amidst Ruins also shows the strong influence
that the great *vedute* painter Panini had on Robert's
development. Robert was an assistant and a student of
Panini at the Académie de France in Rome. Panini's cre-
ative reconstructions and fantastical combinations of
Roman monuments inspired Robert's architectural
vision. In the Rochester picture, the triumphal arches,
based on the design of the Arch of Constantine (fig. 74)
and the ruinous state of the Arch of Trajan, have been
squared three-dimensionally to form grand pavilions.
Between them part of a pediment is visible, suggesting a
temple overlooking a fantastic Imperial Forum.

Robert orients the viewer to a place on the shore of

FIG. 74. Giovanni Battista Piranesi, *View of the Arch of Constantine*, 1748–78. Etching.
Vedute di Roma. Allen Memorial Art Museum, Oberlin College, Oberlin, Ohio.

the river (or canal) by the bridge, which leads from the spit of land in the foreground to the first triumphal arch. From this vantage point, the viewer is afforded a glimpse that celebrates Robert's fascination with perspective and grand vistas. His interest in arches, bridges, and tunnels is directly inspired by the same monuments made famous by Piranesi. Piranesi was Robert's elder by thirteen years, and he produced prints of Roman buildings and sites during Robert's time in Rome, encouraging frequent imitation by the French painter. It was Piranesi who introduced the picturesque Roman arch and drastically advanced the notion of archaeological accuracy in French visual art.

Robert also absorbed the influence of contemporary French neoclassical architects who, like him, drew inspiration from Piranesi's *Carceri, della magnificenza ed architettura de'Romani*, and other works.[1] Most notable among them were Claude-Nicolas Ledoux (1736–1806) and Etienne-Louis Boullée (1728–1799), two of the leading architects of the *ancien régime*. Schooled in the classical tradition, Ledoux combined architectural elements from a variety of styles, including the antique and Renaissance, in his masterful creations that won the

praise of all levels of patronage, including royal commissions from Madame du Barry. A student of Jean-Laurent Legeay, Boullée learned early in his career to combine perspective with natural pictorial effects in his designs, forging a direct link between the practice of architecture and Robert's profession as a painter of architecture. As was often the case, Boullée's colossal utopian interiors and endless vistas could be constructed only in the imagined spaces of Robert's paintings. Robert's endless columned façade in the Rochester picture recalls both the grand museum designs of Boullée and the great colonnade of the Louvre, designed a century before by Claude Perrault, Louis Le Vau, and Charles Le Brun in 1667.

Robert includes various sculptural motifs and images that would appeal to the visitor on the Grand Tour: a basalt Egyptian lion fountain lurks in the shadows at the lower left, reminiscent of those in the Piazza del Popolo or near the Piazza Campadoglio in Rome. An elegant balustrade, resembling a design from a Renaissance villa, is used for the bridge design and for the landings of the pavilions. Fragments of architectural ruins litter the foreground, and several classically inspired statues

stand watch over the imaginary forum. Robert has scattered figures throughout this elaborate scene: walking among the columns, looking out behind the railings, sitting on the *vestigia* in the foreground, and bathing and doing laundry where the steps descend into the water.

Robert's loose painterly technique was often criticized (most notably by the French critic Denis Diderot) as hasty or simply unfinished. This trait, which he shared with Fragonard and Boucher, is what made his paintings of ruins in the landscape setting (rather than of architecture alone) so successful and attractive to his clients and patrons. Although Robert's subjects were almost exclusively architectural, reflecting the designs of great architects and draftsmen, his technique and imagination made him one of the finest artists in the tradition of French landscape painting.

NOTE

1. See the bibliography of illustrated architectural books (page 183 of this catalogue) for a listing of Piranesi's works.

30. Hubert Robert, *The Old Bridge*, ca. 1775

Oil on canvas, 35⅞ × 47⅝ in. (91.3 × 121 cm.)
The National Gallery of Art, Washington, DC
Samuel H. Kress Collection, gift, 1952.5.50
PROVENANCE: Jean Frédéric Perregaux (1744–1808), Paris and Viry-Châtillon; by inheritance to his daughter, the Maréchale Duchesse de Raguse (1779–1855), Paris and Viry-Châtillon; her sale, Paris, Hôtel des Commissaires-Priseurs, 14–15 December 1857, lot 42; Mme Louis Stern, Paris, by 1911; [Stern?] sale, Galerie George Petit, Paris, 22 April 1929, lot 19, repro. in cat.; Wildenstein, London, Paris, and New York, 1929; Samuel H. Kress, New York, 23 December 1946; gift 1952
EXHIBITIONS: Cambridge 1931 (as *Le vieux pont*); Heil 1934, cat. no. 53, ill.; New York 1935, cat. no. 32

THE PONTE SALARIO, depicted in Robert's *The Old Bridge* (cat. no. 30), dominates the composition and plays a central role in the painting. Robert has succeeded in presenting the ancient Roman bridge, ravaged by time and changed by medieval additions and temporary fortifications, as an impressive ruin and captivating landmark. Through its many altered states and reconstructions since Roman times, the Ponte Salario

continued to function as a bridge, even during the period in which Robert painted it. However, the appearance of the bridge was to change dramatically shortly after his historic documentation.

As one of the oldest bridges in Rome, the Ponte Salario (fig. 75), named after the Via Salaria, which leads to the Sabine area outside of Rome, has a long architectural and military history.[1] Built in the fourth century B.C., the bridge was situated on the Aniene River close to where the river meets the Tiber, north of the city. During the sixth century, it was destroyed by the Ostrogoths and then rebuilt in the same century by Narses, one of the great generals under the Eastern Roman emperor Justinian I. Medieval additions were made in the later centuries, including the tollhouse marked by its crenellation and Gothic arched windows. The bridge's appearance in Robert's painting is largely the way the Ponte Salario remained until the very end of the eighteenth century. In 1798, about twenty years after Robert's painting was made, the Neapolitan army destroyed portions of the bridge in an attempt to delay the approaching French Republican forces. The bridge was blown up in the Siege of Rome of 1849 when the advancing French of the Second Republic, under the command of General Charles Oudinot, sought to topple the Roman Republic led by Giuseppe Mazzini. In subsequent clashes that followed in the 1860s between General Giuseppe Garibaldi and the French forces supporting the return of pontifical rule in Rome, the structure was completely destroyed except for its two stone piers on each bank. These classical remains were obscured by a later reconstruction in the 1870s, followed by the widening of the bridge in 1930, making it almost impossible to identify any architectural remnant of the ancient Ponte Salario.

Several eras of construction and repairs characterize the appearance of the Ponte Salario in Robert's painting. The main stone structure of the bridge reflects the rebuilding by General Narses around A.D. 565 under Justinian I.[2] Added to this sixth-century construction is the two-story late medieval tower, which in Robert's day was probably occupied by the tollmaster and his family and still bears the papal coat of arms above the doorway. The medieval addition, like the earlier structure, is crumbling: complete sections of the fortress-like parapet are missing, filled in by foliage and grapevines,

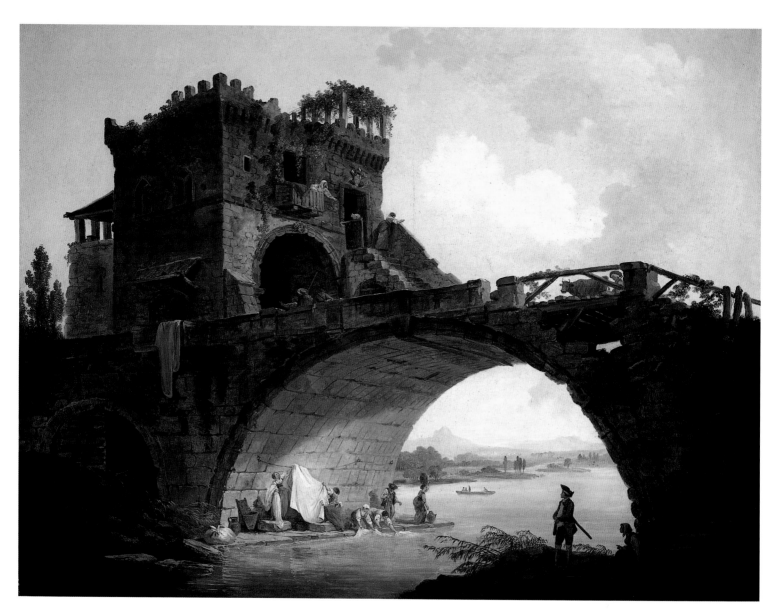

30

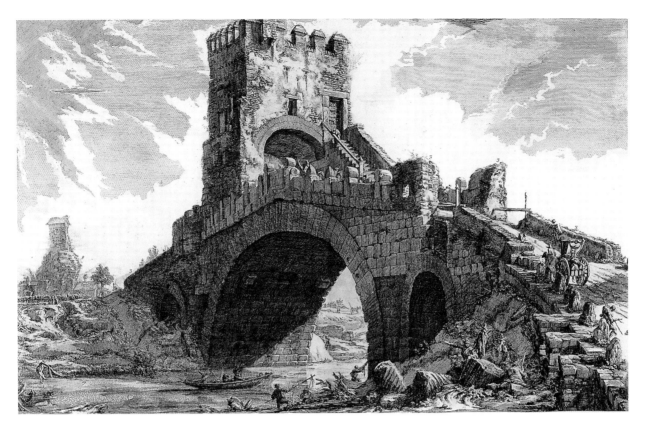

FIG. 75. Giovanni Battista Piranesi, *View of the Ponte Salario*, 1748–78. Etching.
Vedute di Roma. Allen Memorial Art Museum, Oberlin College, Oberlin, Ohio.

which are also covering the wooden pergola on the roof. Precisely that kind of decay and loss inspired Robert's highly popular paintings of ruins. The bridge platform and balustrade appear structurally sound, with the exception of the significant portion at the right that is missing and replaced with timbers and planks. Perhaps most impressive are the great stone block piers support-ing the enormous central span, which provides another setting for staffage in Robert's landscape, featuring the washerwomen, boaters, and a few bystanders.

Robert's bridge is populated with figures and ani-mals dwarfed by the massive stone structure. They appear on three levels of the structure, animating the spaces with their various activities and confirming that the bridge is functioning as well as occupied. Leaning out of the medieval tower, a woman lures a cat sitting on the ledge while another woman looks out to the river landscape. Below them, three men stand on the bridge platform, and a herdsman leading a cow can be seen approaching the bridge at the right. Under the shelter of the enormous span, women are washing laundry in the river and carrying jugs of water. Two figures on the opposite bank, including a man in formal dress or

uniform, and four figures in a boat on the river complete the staffage in the scene.

Robert's composition is almost identical to an earlier etching of the same bridge made by his mentor Piranesi for his *Vedute di Roma* in 1748–78 (fig. 75). Robert shared Piranesi's love for architecture, especially the artful juxta-position of classical ruins with medieval and modern buildings and monuments, which was a common occur-rence in Rome. Both artists' versions of the bridge appear architecturally correct; however, Piranesi is more inter-ested in the physical makeup of the bridge, the dramatic lines of perspective, and the way in which the structure is situated in the landscape. Although Piranesi and Robert both show a working bridge with its centuries-old piers and façade, Robert presents a more assimilated, personal-ized rendering of the bridge, very much a living record of its present use. He has taken a step forward and chosen to focus on the central section of the bridge, dominated by the medieval tower and the arch spanning the river.

Recorded some twenty years after Piranesi's etching, Robert's bridge also has sustained further decay, evident in the crumbling parapet and balustrade and the over-growth of foliage. Another version of the Ponte Salario,

painted by Robert in 1783, eight years after the Washington picture, is larger and more monumental in scale. This second work (location unknown) is likely the painting Robert exhibited at the Salon of 1783, as confirmed by the title and dimensions listed in the Salon handbook.[3]

NOTES

1. The history of the Ponte Salario, from its construction in the fourth century to its final reconstruction in the twentieth century, is outlined in Baillio 2004.
2. Baillio 2004.
3. Baillio 2004.

31. Hubert Robert, *Arches in Ruins,*

ca. 1770–79

Oil on canvas, 23⅛ × 61¼ in. (58.7 × 155.6 cm.)
The Metropolitan Museum of Art, New York
Gift of J. Pierpont Morgan, 17.190.31
PROVENANCE: Armand Verdier (1819–1893), Comte de Flaux, for his *château* near Uzès (Gard); his son, Comte Roger de Flaux (d. 1898); his sister, Mme Madeleine Berger; dowager countess, née Clémence Pascal (d. 1908); Eliane Berger (granddaughter of Armand Verdier); Maurice de Verneuil; J. Pierpont Morgan, London and New York, by 1911; on loan to Metropolitan Museum of Art, from 1912; gift 1917
EXHIBITIONS: Paris 1912 (with the Bagatelle Paintings, 17.190.25–30); New York 1912; New York 1988, p. 89, ill.

32. Hubert Robert, *A Colonnade in Ruins,*

ca. 1770–79

Oil on canvas, 23 × 61⅛ in. (58.4 × 155.3 cm.)
The Metropoiitan Museum of Art, New York
Gift of J. Pierpont Morgan, 17.190.32
PROVENANCE: Armand Verdier (1819–1893), Comte de Flaux, for his *château* near Uzès (Gard); his son, Comte Roger de Flaux (d. 1898); his sister, Mme Madeleine Berger; dowager countess, née Clémence Pascal (d. 1908); Eliane Berger (granddaughter of Armand Verdier); Maurice de Verneuil; J. Pierpont Morgan, London and New York, by 1911; on loan to Metropolitan Museum of Art, from 1912; gift 1917
EXHIBITIONS: Paris 1912 (with the Bagatelle Paintings, 17.190.25–30); New York 1912; New York 1988, p. 89, ill.

THESE TWO OVERDOORS (cat. nos. 31 and 32) came to the Metropolitan Museum of Art in 1912 as a long-term loan from the collection of J. Pierpont Morgan, then President of the Metropolitan Museum. Upon Morgan's death in 1917, the two paintings were accessioned by the museum together with six Italianate panels by Robert that comprised his commission for the Château de Bagatelle, the late-eighteenth-century pavilion built for Charles Philippe, Comte d'Artois (1757–1836), the youngest brother of Louis XVI and Louis XVIII and the last of the Bourbon kings (Charles X). Robert's eight panels found their way into the collection of Armand Verdier (1819–1893) and, subsequently, to Morgan's collection. When Morgan acquired them in 1911 in Paris, the overdoors were thought to be part of the Bagatelle commission; this connection, however, was later disproved.[1]

Designed as overdoors, the two paintings differ significantly from many of Robert's works in that they are specifically decorative, and they were intended to be installed farther from the eye. They may have been part of a larger series that was split up. Robert's brushwork is at its fastest and loosest in these paintings. The most frequent critiques of Robert's paintings were that he worked too fast and was sloppy with his figures and that his paintings lacked the polish or finish of a Vernet or a Claude. However, these overdoors were the lightest and most decorative of all his works, and certainly by modern standards they can be celebrated as spontaneous expressions of rococo painting. Many of his paintings were accomplished quickly, in a morning or an afternoon, something that sets his work apart from his contemporaries painting in the Claudian manner. An exception is Robert's close friend, Fragonard, whose series of brilliantly painted portraits know as the *figures de fantasie*, some executed in one hour, received little praise in his lifetime and were considered only sketches and not finished works.[2]

With the New York paintings, Robert has created the impression that we are looking up and over the top of a hill into his landscape, as we would, in fact, be looking up and over elaborate door frames to see into his paintings. In *Arches in Ruins*, two bays of an arcade protrude from the top of a hill at the right, buried almost to the springing points of the arches. The antique source for Robert's ruin is the Colosseum in Rome, with its combination of arches with columns, entablatures, and cornices. Robert has chosen the plain Doric order, which is the order used on the ground-level arcade of the Colosseum (fig. 76). Set into a rustic landscape, the ruin is situated high up on a rocky projection of land overlooking a wooded valley with a mountain range in the distance.

31

32

FIG. 76 (*top*). Colosseum, Rome (detail). Photograph © Leo Curran 2004.

FIG. 77 (*above*). Giovanni Battista Piranesi, *View of the Famous Vatican Basilica with Its Spacious Portico and Its Piazza*, 1748–78. Etching. *Vedute di Roma*. Allen Memorial Art Museum, Oberlin College, Oberlin, Ohio.

Robert inserts a few figures—a family of three—into the landscape; they add an element of picturesque charm to the scene as well as providing the viewer with a sense of the impressive scale of the ruin, which is remarkably close to the actual scale of the ground arcade of the Colosseum.

For the pendant, *A Colonnade in Ruins*, Robert adopts a different compositional principle. This time the much larger ruin of a semicircular colonnade stands in the middle ground, just behind and below the two foothills that frame our view of the landscape. The source for Robert's columned ruin is Gianlorenzo Bernini's colonnade at St. Peter's in Rome, easily identified by its unusual Doric order and its impressive arcing around the square. The colonnade was documented by many of Robert's contemporaries, including the celebrated views painted by Panini and the prints by Piranesi (fig. 77). The state of ruination of Robert's transplanted colonnade is similar to that of his *Arches in Ruins*, where the construction is intact up to its entablature, but its cornices are fragmentary and overgrown with vines. Leaning on a column fragment next to her artist companion, a woman gestures to the extraordinary view of the colonnade set against a backdrop of open sky and distant mountains. Bernini's colonnade recurs in other paintings by Robert, particularly in his early work of the 1760s. In *The Obelisk* (1787; Chicago, Art Institute), Robert has fancifully re-imagined St. Peter's piazza according to his own architectural preferences, replacing Bernini's Doric order with his own Corinthian and framing the view through one of his typical vaulted rooms with columns and entablatures.

In *Colonnade in Ruins*, we can see exactly where Robert was standing in the piazza in Rome when he made the sketch that he later used for this painting. Considering the way in which Robert has incorporated two of the most well-known monuments of ancient and modern Rome as a minor theme in a decorative ensemble, it is clear that part of the service he provided was bringing the Grand Tour home to his French patrons. In overdoors like these two panels, components of the tourist painting have been reconfigured so as to make piquant, but not obvious, references to the great buildings of Rome.

NOTES

1. For a discussion of the provenance of the overdoors, see Baillio 1992, 149.
2. Rosenberg 1988, 257.

33. Hubert Robert, *Young Girls Dancing around an Obelisk*, 1798

Oil on canvas, 46 × 38.6 in. (119.7 × 99 cm.)
The Montréal Museum of Fine Arts, Montréal, Québec
Lady Davis Bequest, 1964.1464
PROVENANCE: Artist's estate, Paris; sale, Paillet sale, Paris, 5 April 1809, lot 79; Castelli, Paris; Lady Davis, Montréal and Cannes, before 1939; gift 1964
EXHIBITIONS: Montréal 1960, cat. no. 139, ill.; Montréal 1966, cat. no. 80, ill.; Taggart 1969, cat. no. 22, ill.; Ottawa 1973, cat. no. 159, ill.; Ottawa 1994, cat. no. 26, ill.; Hardin 1996, cat. no. 32, ill.

ROBERT'S *Young Girls Dancing around an Obelisk* (cat. no. 33) was completed in 1798, the year that Napoleon led his military expedition into Egypt. Robert may well have intended that this painting should stand as a memorial to Napoleon's mission. The expedition was a mixture of triumph and failure; although Napoleon successfully captured Malta, Alexandria, and Cairo early in the year, he later sustained an upsetting defeat against Admiral Nelson at Aboukir Bay. Robert's painting, with its glorification of the ruin of the Egyptian monuments and the sublimity created by the festivities in their midst, pays homage to both success and defeat. The scene may also represent the profound feeling of unrest and uncertainty associated with Napoleon's campaign and the subsequent response of the French people to this tentative victory in Egypt.

Robert's depiction of an exotic desert landscape is dominated by a broken obelisk at the center, its fragmented upper section resting on the shattered stone head of an Egyptian pharaoh. The obelisk is disproportionate in size; its base is greatly exaggerated while its shaft is shortened relative to its width, in a style well suited to a Roman funerary monument. In the left middle ground, a diminutive stone sphinx, its body cut neatly in half, faces out to the left. Its dimensions are much smaller than those of the Great Sphinx at Chephren's Valley Temple, only the head of which was excavated in Robert's lifetime. Although possibly partly inspired by the Great Sphinx, Robert's sphinx is likely derived from European sculptures found in gardens and squares. In the background, three pyramids, presumably representing those at Giza, are set in descending size to accentuate the grand perspective of the picture.

The dancing garland around the obelisk is formed by

33

nine maidens—and several more who are out of sight—dressed in festive white robes and adorned with matching red and blue ribbons and sandals. Three musicians, mandolin and recorders in hand, sit precariously on the upper ledge of the obelisk, performing for the dance troupe. Two long wooden ladders show us how the musicians managed to mount the obelisk, calling attention to the immense ruin and the work of archaeologists. Figures are scattered throughout the desert landscape—spectators in the foreground, a group by the sphinx, and a large procession moving in front of the large pyramid in the distance.

The sky dominates Robert's picture, occupying a full two-thirds of the canvas composition. An ominous display of dark blue and gray clouds, suggesting an approaching wind- or rainstorm, surround the monuments and frame the picture. A break in the clouds above the pyramids allows the sunlight to cover the middle ground and presumably accounts for the strange light illuminating the obelisk and dancing women. Robert's figures, in their attractive poses and colorful though muted attire, recall the decorative staffage of his contemporaries Boucher and Fragonard. Robert's architectural ruins, on the other hand, dominate the scene, betraying the influence of his two Italian mentors, Piranesi and Panini.

Young Girls also stands as a testimony to Robert's keen interest in Egyptian archaeology. Egyptian architecture and motifs are often found in his paintings and drawings, placed in both indigenous and European settings; however, most of these examples are not as politically overt as the Montréal picture. Although the fascination with Egyptian culture dates to the Greco-Roman period, with the display of Egyptian artifacts taken from the Nile Valley during the eighteenth century, artists' and architects' recordings of the artifacts and monuments they saw in Egypt proliferated. The resulting Egyptomania, as it came to be called, inspired the construction of follies of obelisks, pyramids, and hieroglyphics throughout France and Italy. Considering Robert's Montréal picture, Michael Pantazzi writes, "The composition, with its accumulation of Egyptian ruins, is an antiquarian anthology of monuments of a type that would soon become the trademark of the frontispieces of books on Egypt."[1] Piranesi's *Diverse maniere d'adornare i cammini*, published in 1769,

FIG. 78. Giovanni Battista Piranesi, *Egyptian Obelisk Erected by Pope Sixtus V*, 1748–78. Etching. *Vedute di Roma*. Allen Memorial Art Museum, Oberlin College, Oberlin, Ohio.

includes extensive and detailed Egyptian depictions, and the great obelisks installed in Rome and Paris are documented in his prints (fig. 78). Jean-Marcel Humbert notes, "This obelisk (for the Pont-Neuf in Paris) was not intended merely to commemorate the Egyptian Campaign; above all, it was meant to contribute to the myth of the emperor, as were other Napoleonic obelisks."[2] Other important illustrated works followed, recording the Napoleonic expedition at the end of the century, including *Description de l'Egypt* in 1809.

NOTES
1. Michael Pantazzi in Ottawa 1994, 82.
2. Jean-Marcel Humbert in Ottawa 1994, 219.

34

Claude-Joseph Vernet

AVIGNON 1714–1789 PARIS

Born in 1714 at Avignon, Claude-Joseph Vernet probably began his career studying with his father, Antoine Vernet, a minor local painter. He later joined the workshop of painter Philippe Sauvan (1697–1792) at Avignon, before moving on to apprentice with a painter of landscapes and marines, Jacques Viali (1681–1745), at Aix-en-Provence. Vernet's earliest known landscapes are decorative overdoors produced as an independent commission from the Marquis de Simiane for his *hôtel* at Aix-en-Provence (*in situ*).

Under the sponsorship of Joseph de Seytres, the Marquis de Caumont, Vernet arrived in Rome in November 1734. He quickly became part of the community of foreign artists there and made important connections on the basis of recommendations from Adrien Manglard (1695–1760), with whom he probably studied, and Nicolas Vleughels (1668–1737), the director of the Académie de France. Vernet's work was enthusiastically received, and he soon counted private citizens, nobility, and church officials among his patrons. He was accepted to the Académie de Saint-Luc in 1743, and three years later he was approved by the Académie royale. He exhibited at the Salon of 1746 and was received at the Académie in 1753, the same year he returned permanently to France. Vernet's enormous skill for observation and naturalistic representation earned him a reputation as one of the finest marine painters in Europe. In his specialized genre, he had no true rivals in France, and in Italy Vernet's closest competitors as view painters were Giovanni Antonio Canal, called Canaletto (1697–1768), and Bernardo Bellotto (1721–1780). Upon his return to France in 1753, Vernet began work on a prestigious and ambitious project, *The Ports of France*, a series of topographical paintings of the French seaports commissioned by Louis XV through the artist's acquaintance with the Marquis de Marigny and the Marquis de Vandières. Vernet worked on the project for almost ten years, although only fifteen of the projected twenty-four works were completed.

Vernet was most famous for his coastal views; his violent storms and shipwrecks as well as his tranquil harbor scenes were highly praised by critics at the Salon and avidly collected by British and French nobility. These paintings were often produced as pendant pairs or suites, showing contrasting weather conditions, the times of day, or the seasons. In the tradition of great French landscape painting begun by Claude Lorrain a century earlier, Vernet emerged as the first of his generation. Throughout his career he remained strongly linked to Claude. The French critic Denis Diderot (1713–1784) greatly respected Vernet's talent for representing the brutal forces and sublime beauty of nature. Beyond the Claudian tradition, these powerful landscapes recall Salvator Rosa's work of the previous century. By the mid-century, as poets and naturalists took a new interest in nature, the idyllic pastoral scenes of Boucher and Fragonard had fallen from favor. Modern taxonomy found its beginnings in this century, and taste and collecting trends in the visual arts reflected this new desire to observe and classify the natural world. Vernet's observational technique, which involved sketching in oil outdoors, exerted great influence on the development of European landscape painting, as is seen in the work of his followers Pierre-Jacques Volaire, Lacroix de Marseille, Joseph Wright of Derby, and Pierre-Henri de Valenciennes.

FIG. 79 (*left*). Domus Tiberiana, Rome. Photograph © Alexander Grogan 2004.

FIG. 80 (*right*). Temple of Vesta, Tivoli. Photograph © Alexander Grogan 2004.

34. Claude-Joseph Vernet, *Imaginary Landscape, Italian Harbor Scene*, 1746

Oil on canvas, 38½ × 48½ in. (97.79 × 123.19 cm.)
The Minneapolis Institute of Arts, Minneapolis, Minnesota
Gift of Mr. and Mrs. G. Nelson Dayton, 66.61.2
PROVENANCE: Commissioned by the Duc de la Rochefoucauld (1701–1757) in 1746; Hatt; Hatt sale, Christie's, 1850; Seligmann, Rey and Co., Inc., New York, by 1937; George Nelson Dayton (1886–1950) and Grace Crothers Bliss Dayton (1890–1967), Minneapolis, by 1939 through 1966; gift 1966
EXHIBITIONS: Wadsworth Atheneum 1937; Rouen 1999, cat. no. 9, ill.

LIKE MANY of Vernet's seaports, this picture (cat. no. 34) is an invented collection of parts observed from actual locations. The artist has built a portion of the ruins of the Domus Tiberiana (fig. 79) on the north corner of the Palatine Mount in Rome into a rocky coastline overlooking a busy port. Overgrown foliage skirts the face of the ruin. Atop the structure he has placed the Temple of Vesta at Tivoli (fig. 80). Beside the temple is a large leafy tree, and behind it a group of Italian pines consistent with the actual appearance of the Domus Tiberiana on the Palatine in Rome.[1] He has dotted the top of the ruin with tiny flowerpots and included a railing at the outermost corner of the structure—details are taken from the area surrounding the Temple of Vesta. Beyond the coast at the center of the picture is a hazy view of Naples, with the twin peaks of Mount Vesuvius faintly visible in the distance. The jagged rocky shoreline resembles the geography of the Italian coast near the bay of Naples, and the golden light suggests early evening.

Vernet depicts figures engaged in purposeful commotion, evidencing his familiarity with maritime activity gained from observation of contemporary ports.[2] A group of six figures is gathered on the rocks at the center of the foreground: one man passes a fish that he has just caught up to the basket of the day's catch, while another

prepares his pole, and others watch the activity. To the left of the group sits a shirtless man with a dog, and on the far right, two men in foreign dress—perhaps merchants—stand on the shore, apparently in conversation. The activity continues along the shoreline with workers attending to ropes, nets, and rowboats and then moves up the stone steps at the base of the ruins to the temple above, where people can be seen enjoying the ocean view.

Such a mixture of Italian motifs would have appealed to a collector wishing to have a visual reminder of his time spent in Italy. Like his older contemporary Giovanni Paolo Panini (1691–1765), Vernet has synthesized different Italian attractions into one picture intended for a foreign visitor, and the topographical accuracy and delicate brushwork is reminiscent of the *veduti* of his Venetian contemporary Giovanni Antonio Canal, called Canaletto (1697–1768). Remarkably, Vernet is able to synthesize both the man-made and the natural into a believable scene. Each element is carried out with painstaking attention to naturalistic detail, and his allegiance to nature and skill for representing observed detail was consistent with the changing role of nature in science and literature of the day. Extraordinarily fine detail is throughout, and he has made only slight alterations to the architectural elements as he observed them in his synthesis of the two ruins.

This view of an imaginary Italian seaport was commissioned by the Duc de la Rochefoucauld (1710–1757), who was then French ambassador to Rome, and the la Rochefoucauld coat of arms is depicted as a stone relief on the lower left of the face of the ruin.[3] The picture is dated 1746, the year Vernet was approved by the Académie française. Vernet's signature and the date appear on the rock in the right center foreground beneath the seated woman. The Minneapolis picture was engraved by Vernet's contemporary Jacques Aliament (1726–1788), and the print was advertised in the *Mercure de France* in 1779 with the caption "the talents of the painter and of the engraver are already so well known by the public, that it is a sufficient eulogy of this engraving to say that it is one of their productions."[4] According to the artist's records, the commission was for two paintings; it has been suggested that the pendant is a picture in the Musée Rath in Geneva.[5] However, the Geneva picture has since been dismissed as a copy of the original pendant in the Bristol City Art

Gallery and Museum.[6] The Bristol picture is a stormy scene of approximately the same dimensions, and it bears Vernet's signature and the date 1746.

NOTES

1. Conisbee 1976, cat. no. 66.
2. Cordingly 1976, 208–13.
3. The Duc de la Rochefoucauld would become Cardinal the following year.
4. Conisbee 1976, cat. no. 66.
5. See Minneapolis 1971, 191; Ingersoll-Smouse 1926, 48.
6. Conisbee 1976, cat. no. 66. See also curatorial file for the Vernet in the Minneapolis Institute of Arts.

35. Claude-Joseph Vernet, *Seaport with Antique Ruins: Morning*, 1751

Oil on canvas, 26⅜ × 34⅛ in. (66.7 × 86.7 cm.)
The Nelson-Atkins Museum of Art, Kansas City, Missouri
Sophia K. Goodman Fund, F84-66/1

PROVENANCE: M. Peilhon; Peilhon sale, Paris, 16 May 1763, lot 71; Le Brun sale, Paris, 16 April 1811, lot 228; (purchased by) Laneuville for 3,000 francs; Biancourt and Portalis sale, Paris, 12–13 May 1893, lots 93–94; Fold Family, Paris; thence by descent; sale, Sotheby's, Monte Carlo, 26 May 1980, lots 540–541 (FF 830,000); Richard Green and Edward Speelman, London; Mrs. Charles Atkins, New York, by 1981; purchase 1984

EXHIBITIONS: Paris Salon 1753, cat. no. 129

V ERNET'S *Seaport with Antique Ruins: Morning* (cat. no. 35) and its pendant, *Coastal Harbor with a Pyramid: Evening* (fig. 81), were commissioned in 1750 by M. Peilhon, a senior advisor to Louis XV in Paris and one of Vernet's major patrons. The paintings were executed in Rome and sent to Paris in time for the Salon of 1753 (along with several other pictures by Vernet from Peilhon's collection), the year Vernet was admitted by the Académie royale.[1] *Seaport with Antique Ruins* was previously referred to as *Matin bien frais, vue d'un port méditerranéen*. It was engraved by Jean Daullé (1703–1763) in 1760 with the title *Le pèlerinage*, presumably referring to the travelers in the lower left.

Vernet's paintings were often executed as pairs and sold in this manner; the Kansas City pendants were

35

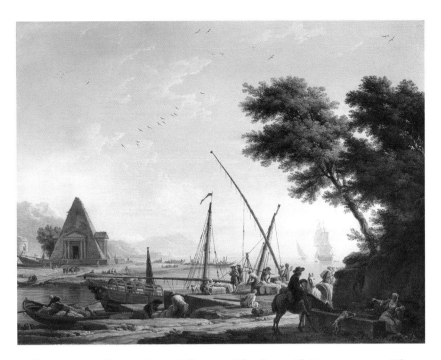

FIG. 81. Claude-Joseph Vernet, *Coastal Harbor with a Pyramid: Evening*, 1751. Oil on canvas. Nelson-Atkins Museum of Art, Kansas City, Missouri, F84-66/2. Purchase, acquired through the generosity of Sophia K. Goodman, F84-66/2. Photograph by Mel McLean.

catalogued under the same number for the Salon.[2] These landscapes and marine scenes feature the different times of day, the seasons, and contrasting climatic conditions. The pairing of pictures afforded Vernet the opportunity to explore his ideas of the sublime and naturalism in his painting. For these complementary scenes, he also shows people from different locales carrying out the corresponding activities for the particular time of day or season: in the Kansas City pictures, people who live and work by the seaport go about their tasks for the morning and then again in the evening.

Vernet has chosen early morning light to illuminate *Seaport with Antique Ruins*. Golden morning sunlight rakes across the foreground, striking the colorfully dressed figures, and rises up to fill the sky above the picturesque Italian seaport. The scene is alive with activity—from the flurry of dockworkers and townspeople on the cobblestone pier and arched stone dock to the loading and launching of boats in the middle distance. Looming above the harbor setting is an enormous Roman ruins resembling a bridge or aqueduct but also bearing a likeness to one of the walls of the great baths in Rome. The proportions of the arched structure—with alternating large and small arches—are reminiscent of the Ponte Senatorio in Rome, which in Vernet's day was called the Ponte Rotto ("Broken Bridge"). Vernet executed a

painting of the famous bridge in 1745, *Ponto Rotto à Rome* (fig. 82), and Piranesi made an etching of the bridge for his *Alcune vedute di Archi Trionfali* in 1778. Erected in 179 B.C. as the first stone bridge over the Tiber, the bridge was reconstructed by Pope Gregory XIII in the 1570s only to be partly destroyed by a flood in 1598. Wooden trusses eventually replaced the missing stone arches. By the eighteenth century the bridge was in a state of ruin, as captured in Vernet's painting. Looking at the antique structure in Vernet's Kansas City picture, the narrow dimensions, level top, and absence of a river below confirms that Vernet also considered a Roman aqueduct as his model. The Aquedotti Neroniani, which was engraved by Piranesi for his *Vedute di Roma*, is particularly close in scale and design to Vernet's ruin. Although this is a rather improbable location for an aqueduct, it must be understood as an architectural ruin added to the scene for purely aesthetic reasons.

For the pendant painting, *Coastal Harbor with a Pyramid: Evening*, Vernet shows the harbor at the end of the day, with the activity revolving around the unloading and mooring of boats. The setting sun casts long shadows on the tranquil scene, and the frenetic pace of the morning rush has calmed down with the close of day. The harbor site has shifted down the coast from the morning scene, judging from the mountains in

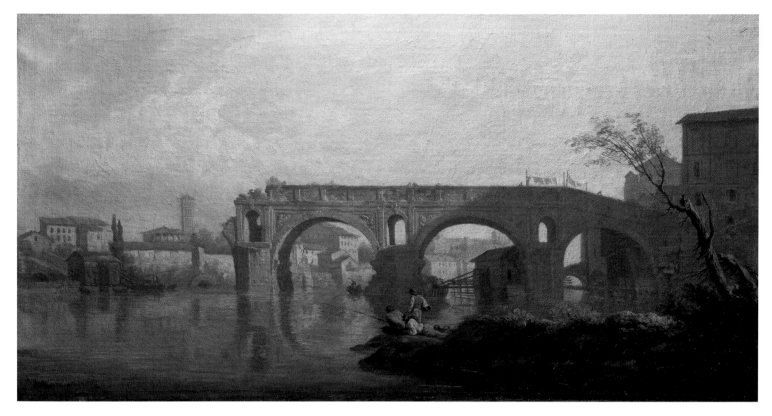

FIG. 82. Claude-Joseph Vernet, *Ponte Rotto à Rome* (The Ponte Rotto, Rome), 1745. Oil on canvas. Musée du Louvre, Paris, France, Inv. 8348. Photograph © Réunion des Musées Nationaux/Art Resource, New York.

the distance and the expanse of open water. An impressive pyramid-style building similar to the Tomb of Gaius Cestius Gallus (d. A.D. 67) in Rome is set close to the water next to a circular temple that resembles the Temple of Tosse near Tivoli.

Vernet's port in the Kansas City pictures appears to be the Italian coast in the vicinity of Naples, a favorite inspiration for the artist's fanciful seaports. The impressive mountain rising behind the port may be Mount Vesuvius, but again the artist has taken liberties with the topography for the benefit of his composition. Vernet made his marine painting pendants (the majority of which were executed in Italy and thus reflect the Italian coastline) to highlight either the time of day or the condition of the sea—calm or stormy. The open harbor setting, with its bustling figures and sweeping view, especially prominent in *Coastal Harbor with a Pyramid: Evening*, evokes seventeenth-century Dutch marine landscapes, such as those by Jan Weenix (1642–1719) and Johannes Lingelbach (1622–1674), identified by their low horizons, expansive skies, and compelling staffage and activity. Vernet's treatment of the terrain and foliage also relates to the rustic naturalism of the northern tradition.

The greatest stylistic link for Vernet's marine pictures, however, is to the magnificent seaports painted by Claude Lorrain a century earlier. Some critics saw Vernet as the rightful heir to the Claudian landscape tradition, and Diderot in fact preferred Vernet to Claude. The modifications that Vernet has made on Claude's marine formula are evident in the lowered horizon line and the expansiveness suggested by the unrestrained span of water opening out to the right. The animated yet graceful lines of the figures, and their harmonious integration with the landscape, also contrast with Claude's at times awkward staffage. With this highly detailed but wholly imagined scene, Vernet has retained the appeal of the idyllic landscape and, at the same time, introduced elements of the sublime that are entirely fitting for these mid-eighteenth-century compositions.

NOTES

1. Although the existence of the two pictures was continuously noted in the literature on Vernet, the pair was not exhibited publicly since their showing in the Salon of 1773 until their acquisition by the Nelson-Atkins Museum of Art in 1984. Ward 1984.

2. "Deux, paysages et marines sur la meme numero"; Salon of 1753, cat. no. 129. Ward 1984.

Simon Vouet

PARIS 1590–1649 PARIS

Born in 1590, Simon Vouet was privy to life in the French court from his earliest days. Vouet's family had been in the service of the king for at least two generations, and his father, Laurent (born ca. 1553/58), was a minor court painter for Henri IV. Although little is known about Vouet's formal education, by age fourteen he was an established portraitist with commissions to paint members of the nobility, including a commission in England. At age twenty, he accompanied a royal attaché to Constantinople to paint the portrait of a sitter identified as a *Grand seigneur*. In 1613, Vouet traveled to Rome, where he would remain for more than a decade, and where he developed his characteristically Italianate voice.

Vouet arrived in Rome three years after the death of Caravaggio, whose enigmatic and powerful work still dominated the artistic scene. Rome in Vouet's day was saturated with foreign artists who, like Hendrick Terbrugghen and Valentin de Boulogne, trained in the Caravaggesque style. In Rome, Vouet received a sizeable pension from the French Crown and enjoyed the patronage of Cassiano dal Pozzo (1588–1657) and Cardinal Maffeo Barberini (1568–1644), the future Pope Urban VIII. During a yearlong stay in Genoa and subsequent travel through northern Italy, Vouet received commissions from the Doria and Orsini families of Genoa and made connections in Modena, Bologna, and Florence. His earliest signed and dated work is *St. Bruno Receiving the Rule of the Carthusian Order* (1620) at the Certosa di San Martino. While based in Rome, Vouet was elected *principe* of the Académie de Saint-Luc and ran a large atelier, which included at times the painters Claude Mellan (1598–1688), Charles Mellin (ca. 1600–1649), and even his contemporary Nicolas Poussin (1594–1665).

Based on the impressive reputation he developed in Italy, Vouet was recalled to Paris by Louis XIII in 1626. He returned the following year after a brief stay in Venice. His Italianate manner was unfamiliar and intriguing to the Parisian aristocracy, and he soon became the city's most sought-after painter. His major patrons remained Louis XIII, who made him *premier peintre du Roi* and granted him generous lodgings at the Louvre, and the Queen Mother, Marie de' Medici, for whom he created tapestry designs and other decorative works. Vouet's reputation also earned him commissions for the *hôtels* of the Parisian aristocracy, including those of Claude le Ragios de Bretonvilliers, Chancellor Pierre Séguier, and Cardinal Richelieu.

Although his artistic output slowed after the 1630s, Vouet's contribution to French painting did not. His masterful blending of Venetian coloring and large-scale composition, with emphasis on figural representation and Caravaggesque lighting, reinvigorated French painting. His Parisian atelier was vast and produced some of the best painters of the next generation, including Charles Le Brun (1619–1690), as well as a host of engravers, like Michel Dorigny (1616–1665), whose prints are often the only extant record of Vouet's work. In fact it is through engravings that much of Vouet's oeuvre can be securely attributed.

Vouet was not an advocate or supporter (like his pupil Le Brun) for the creation of the Académie royale de peinture et de sculpture, founded in 1648. Vouet helped establish a rival institution, the Académie de Saint-Luc, the same year. Its rival campaign was short-lived, as Vouet died the following year, in 1649.

Almost all of Vouet's early portraiture is lost or exists only in engravings. The remainder of his oeuvre consists of religious, allegorical, mythological, and historical themes executed in a highly idealized style with strong Italian influences. Although he lived and worked in Italy for fifteen years, Vouet did not develop a particular taste for the revived classical subject, often relegating architecture and landscape to accessory components of his composition. It was in his later work in France, especially in his series of mythology and allegory for members of the aristocracy, that his unprecedented style coalesced to help establish the foundation for generations of French painters to come.

36. Simon Vouet, *The Muses Urania and Calliope*, 1634

Oil on panel, 31⅛ × 49⅜ in. (79.8 × 125 cm.)
The National Gallery of Art, Washington, DC
Samuel H. Kress Foundation, gift, 1961.9.61
PROVENANCE: M. de Mauméjan; Mauméjan sale, Paris, 29
June 1825, lot 47; private collection, England; sale, Christie's,
London, 1 July 1955, lot 154; David M. Koetser Gallery,
New York, London, and Zurich; sold to the Samuel H. Kress
Foundation, New York, 1957; gift 1961
EXHIBITIONS: Washington 1961, cat. no. 101

RESPLENDENT IN brightly colored robes and seated at the base of a large plinth are the two muses Urania and Calliope. Urania, the muse of astronomy, is draped in a lavish blue mantle over a white undergarment, crowned with a six-starred diadem, and she leans against her celestial globe. Pink and blue roses bloom by her left side, and an ivy plant grows near the base of her globe as she gazes out to the viewer, her hand resting on the shoulder of the muse of epic poetry, Calliope. She is dressed in a shimmering pink robe and yellow blouse, with a golden crown, and she holds Homer's *Odyssey* in her hands. The Greek poet Hesiod named the nine muses in his *Theogony*: the daughters of Zeus and Mnemosyne, these goddesses represented literature, music, and dance, and, eventually, all of the intellectual disciplines. In Roman times, the muses each represented one of the arts, and they remained the source of inspiration and gifts for artists.

The setting for the muses is a classical temple, its ancient stone marked with a stained patina and a pale covering of moss. Above the plinth are the bases of two fluted columns, and a second plinth at the left supports a sculpture of a figure of which only the lower drapery is visible. The two muses have been separated from the landscape by this wall-like plinth, or portico, its carved form creating a classical environment for their own mythology. The landscape recalls the palette and rich foliage of the Roman *campagna*, as documented by the Roman and northern painters of the early seventeenth century.

Vouet painted *The Muses Urania and Calliope* (cat. no. 36) in 1634 in Paris, six years after his return from Rome, and the composition exhibits a combination of Italian and Parisian influences. The life-size figures and Caravaggesque use of sweeping light to describe the qualities of flesh and drapery are reminiscent of Vouet's early Roman years. However, Vouet's taste for dramatic chiaroscuro and boldness of brushwork have been disguised and overshadowed by the brilliant colors of the Venetian school. Still they remain considerably more muted than their sixteenth-century models. In fact all of these Italian influences have been modified by the French aesthetic and sense of restraint marking the decorative and elegant period in Vouet's art after his return to Paris. The refining of his forms and colors was well suited for the allegorical and mythological commissions that Vouet received in Paris.

Vouet has used Cesare Ripa's *Iconologia* as his source in representing the muses, and he takes some liberties with his representation of Calliope. Ripa describes Calliope holding three laurel garlands and Homer's literary trilogy, while Vouet has the putti carrying the garlands, and only *The Odyssey* (Odiss) is in her possession.[1] Scholars have agreed that the unusual pairing of Calliope and Urania, especially as an independent composition, suggests that the painting probably belonged to a series, perhaps featuring the nine muses.[2] Robert Manning was the first to identify and connect four of the panels, and since then the number of works in the series has grown to seven.[3] The Washington picture has been connected to the other pictures, all of similar dimensions, all painted on panel, and all with settings featuring classical architecture. At present, the proposed ensemble includes *Euterpe*, muse of lyric poetry (Neuilly-sur-Seine, Riechers Collection); *Polyhymnia*, muse of sacred music and oratory (Paris, Musée du Louvre); *Clio*, muse of history (Karlsruhe, Kunsthalle); *Thalia*, muse of comedy (location unknown); *Erato*, muse of love poetry (art market); *Terpsichore*, muse of dance (location unknown); and possibly *Apollo and the Nine Muses* (Budapest, Szépmüveszeti Museum).[4]

There are sixteenth-century precedents in France and Italy for painted series highlighting the muses of classical mythology, and the practice of arranging the individual works in a room dedicated to the muses, known as a *musaion*, has its roots in France, particularly the School of Fontainebleau.[5] The tradition continued into

FIG. 83. Laurent de La Hyre, *Allegory of Music*, 1649. Oil on canvas. The Metropolitan Museum of Art, New York, Charles B. Curtis Fund, 1950 (50.189). Photograph, all rights reserved, The Metropolitan Museum of Art.

the seventeenth century, and, along with Vouet, his pupil Eustache Le Sueur (1616–1655) and François Perrier (1594–1649) both executed similar series of muses. Another intriguing connection is Laurent de La Hyre's *Allegory of Music* (fig. 83), which depicts a life-size allegorical figure before a backdrop of a classical temple and relates closely to the setting and scale used by Vouet for his muses.

NOTES

1. Ripa 1976, 371–72.
2. Feigenbaum 2004b.
3. Manning 1959.
4. For further discussion of the series and authorship of the individual panels, see Feigenbaum 2004b, and Manning 1959, 292–99, for *Euterpe* and *Polyhymnia*; Brejon de Lavergné 2000, 169, for *Clio, Thalia, Erato, Terpsichore*, and *Apollo and the Nine Muses*. Although *Euterpe* is currently in the Riechers Collection, it was in the Cailleux Collection pre-1973. *Polyhymnia* was originally titled *La muse de l'eloquence* until it was alternatively titled *Polyhymnia* by Manning.
5. Feigenbaum 2004b.

References and Exhibitions

Ajello 1988 Ajello, Raffaele. *Le Antichità di Ercolano*. Illustrations from *Delle Antichità di Ercolano*. Text by Ferdinando Bologna, Marcello Gigante, and Fausto Zevi. Naples: Banco de Napoli, 1988. (Orig. pub. 1957–92.)

Allen 1954 Allen, Josephine L., and Elizabeth E. Gardner. *A Concise Catalogue of the European Paintings in the Metropolitan Museum of Art*. New York: Metropolitan Museum of Art, 1954.

Ananoff 1966 Ananoff, Alexandre. *L'oeuvre dessiné de François Boucher (1703–1770), catalogue raisonné*. Paris: F. de Nobele, 1966.

Ananoff 1976 Ananoff, Alexandre. *François Boucher*. 2 vols. In collaboration with Daniel Wildenstein. Lausanne: La Bibliothèque des arts, 1976.

Arcangeli 1962 Arcangeli, Francesco. *L'Ideale classico del seicento in Italia e la pittura di paesaggio*. Exh. cat. Bologna: Edizioni Alfa, 1962.

Arisi 1993 Arisi, Ferdinando, ed. *Giovanni Paolo Panini, 1691–1765*. Milan: Electa, 1993.

Ashby 1927 Ashby, Thomas. *The Roman Campagna in Classical Times*. London: E. Benn, Limited, 1927.

Askew 1984 Askew, Pamela. *Claude Lorrain, 1600–1682: A Symposium*. Washington, DC: National Gallery of Art, 1984.

Baetjer 1980 Baetjer, Katharine. *European Paintings in the Metropolitan Museum of Art, by Artists Born in or before 1865: A Summary Catalogue*. New York: Metropolitan Museum of Art, 1980.

Baetjer 1993 Baetjer, Katharine. *Glorious Nature: British Landscape Painting, 1750–1850*. Denver Art Museum. Exh. cat. New York: Hudson Hills Press, 1993.

Baetjer 1995 Baetjer, Katharine. *European Paintings in the Metropolitan Museum of Art by Artists Born before 1865: A Summary Catalogue*. New York: Metropolitan Museum of Art, 1995.

Bailey 1985 Bailey, Colin B. *The First Painters of the King: French Royal Taste from Louis XIV to the Revolution*. New York, Stair Sainty Matthiesen; New Orleans, Museum of Art; Columbus, OH, Museum of Art. Exh. cat. New York: Stair Sainty Matthiesen, 1985.

Bailey 1992 Bailey, Colin B. *The Loves of the Gods: Mythological Painting from Watteau to David*. With the assistance of Carrie A. Hamilton. Paris, Galeries nationales du Grand Palais; Philadelphia, Museum of Art; Fort Worth, TX, Kimbell Art Museum. Exh. cat. New York: Rizzoli, 1992.

Bailey 2002 Bailey, Colin B. *Patriotic Taste: Collecting Modern Art in Pre-Revolutionary Paris*. New Haven, CT: Yale University Press, 2002.

Bailey 2003 Bailey, Colin B., ed. *The Age of Watteau, Chardin, and Fragonard: Masterpieces of French Genre Painting*. Ottawa, National Gallery of Canada; Washington, DC, National Gallery of Art; Berlin, Staatliche Museum. Exh. cat. New Haven, CT: Yale University Press, 2003.

Baillio 1992 Baillio, Joseph. "Hubert Robert's Decorations for the Château de Bagatelle." *Metropolitan Museum Journal* 27 (1992): 149–82.

Baillio 2001 Baillio, Joseph. *A Hermit in a Garden by Hubert Robert, 1733–1808: A New Acquisition for the Speed Art Museum*. Louisville, KY: Speed Art Museum, 2001.

Baillio 2004 Baillio, Joseph. "Draft entry for Hubert Robert's 'The Ponte Salario,'" *French Paintings from the Fifteenth through the Eighteenth Centuries*. Washington, DC: National Gallery of Art, forthcoming.

Bandes 1981 Bandes, Susan J. "Gaspard Dughet's Frescoes in Palazzo Colonna, Rome." *Burlington Magazine* 123, no. 935 (February 1981): 77–89.

Bandes 1984 Bandes, Susan J. "Notes on Gaspard Dughet." *Burlington Magazine* 126, no. 970 (January 1984): 28–33.

Bass 1985 Bass, Jacquelynn. *Treasures of the Hood Museum of Art, Dartmouth College*. With an essay by Charles W. Moore. Exh. cat. New York: Hudson Hill Press, 1985.

Beau 1968 Beau, Marguerite. *La Collection des dessins d'Hubert Robert au Musée de Valence*. Exh. cat. Lyon: Audin, 1968.

Beaucour 1990 Beaucour, Fernand E., Yves Laissues, and Chantal Orgogozo. *The Discovery of Egypt*. Trans. Bambi Ballard. Paris: Flammarion, 1990.

Beauvais 1974 Rosenberg, Pierre, and N. Volle. *Jean Barbault*. Exh. cat. Beauvais: Musée départementale de l'Oise, 1974.

Bellay 1994 Bellay, Joachim du. *Antiquitez de Rome*. Trans. Edmund Spenser as *Ruines of Rome*, 1591. Notes by Malcolm C. Smith. Binghamton, NY: Medieval and Renaissance Texts and Studies, Center for Medieval and Early Renaissance Studies, 1994.

Benes 2001 Benes, Mirka. "Pastoralism in the Roman Baroque Villa and in Claude Lorrain." In *Villas and Gardens in Early Modern Italy and France*, ed. Mirka Benes and Dianne Harris, 88–113. Cambridge, Eng.: Cambridge University Press, 2001.

Bénézit 1999 Bénézit, Emmanuel. *Dictionnaire critique et documentaire des peintres, sculpteurs, dessinateurs et graveurs de tous les temps et de tous les pays*. Ed. Jacques Busse. 14 vols. Rev. ed. Paris: Gründ, 1999.

Bensiek 1972 Bensiek, Wolfgang. *Die ästhetisch-literarischen Schriften Fenelons und ihr Einfluss in der ersten Hälfte des 18. Jahrhunderts in Deutschland*. Tübingen: Bönecke-Druck, 1972.

Bihan 1984 Le Bihan, O. "Eloge de Bergeret par Pierre Lacour." *Société Archéologique de Bordeaux* 75 (1984): 155–56.

Binghamton 1979 *Mirror of Marvelous Rome: 16th-century Engravings*. Exh. cat. Binghamton, NY: The State University of New York at Binghamton Art Gallery, 1979.

Birmingham 1995 Birmingham Museum and Art Gallery. *Thomas Gainsborough: The Harvest Wagon*. Exh. cat. Toronto: Art Gallery of Ontario, 1995.

Bizardel 1978 Bizardel, Yvon. *Les Américains à Paris sous Louis XVI et pendant la Révolution: notices biographiques*. Paris: Y. Bizardel, 1978.

Bjurström 1976 Bjurström, Per. *French Drawings: Sixteenth and Seventeenth Centuries*. Trans. Patrick Hort. Stockholm: LiberFörlag, 1976.

Black 2003 Black, Jeremy. *Italy and the Grand Tour*. New Haven, CT: Yale University Press, 2003.

Blankert 1978 Blankert, Albert. *Nederlandse 17e eeuwse Italianiserende landschapschilders*. Soest, Holland: Davaco, 1978.

Blau 1989 Blau, Eve, and Edward Kaufman, eds. *Architecture and Its Image: Four Centuries of Architectural Representation*. Montréal: Canadian Centre for Architecture, 1989.

Blunt 1944 Blunt, Anthony. "The Heroic and the Ideal Landscape in the Work of Nicolas Poussin." *Journal of the Warburg and Courtauld Institutes* 7 (1944): 154–68.

Blunt 1950 Blunt, Anthony. "Poussin Studies 5: 'The Silver Birch Master.'" *Burlington Magazine* 92, no. 562 (January 1950): 69–73.

Blunt 1959 Blunt, Anthony. "Poussin Studies 9: Additions to the Work of Jean Lemaire." *Burlington Magazine* 101, no. 681 (December 1959): 440–45.

Blunt 1967a Blunt, Anthony. *Nicolas Poussin*. 2 vols. New York: Bollingen Foundation, 1967.

Blunt 1967b Blunt, Anthony. *Studies in Renaissance and Baroque Art Presented to Anthony Blunt on His 60th Birthday*. London: Phaidon Press, 1967.

Blunt 1977 Blunt, Anthony. "Rubens and Architecture." *Burlington Magazine* 119, no. 894 (September 1977): 609–21.

Blunt 1980 Blunt, Anthony. "The Silver Birch Master, Nicolas Poussin, Gaspard Dughet and Others." *Burlington Magazine* 122, no. 929 (August 1980): 577–82.

Blunt 1985 Blunt, Anthony, ed. *Diary of Cavaliere Bernini's Visit to France*. Princeton: Princeton University Press, 1985.

Blunt 1999 Blunt, Anthony. *Art and Architecture in France, 1500–1700*. 5th ed. Rev. by Richard Beresford. New Haven, CT: Yale University Press, 1999.

Boisclair 1986 Boisclair, Marie Nicole. *Gaspard Dughet, sa vie et son oeuvre, 1615–1675*. Preface by Jacques Thuillier. Paris: Arthéna, 1986.

Bologna 1983 Biblioteca Comunale dell'Archiginnasio. *L'immagine dell'antico fra settecento e ottocento: libri di archeologia nella Biblioteca Comunale dell'Archiginnasio*. Exh. cat. Bologna: Grafis Edizioni, 1983.

Bonfait 1985 Bonfait, Olivier. "Les collections picturales des financiers à la fin du règne de Louis XIV." *Siècle XVIIe* 151 (1985): 125–51.

Borys 1994 Borys, Stephen D. "Fragonard and the Garden Setting: The Progress of Love at Louveciennes." PhD diss., Montréal: McGill University, 1994.

Borys 2002 Borys, Stephen D. *The Changing Land: Modern British Landscape Painting*. Ottawa, National Gallery of Canada. Exh. cat. Ottawa: National Gallery of Canada, 2002.

Borys 2003 Borys, Stephen D. "Jean-Baptiste Camille Corot's 'The Bridge at Narni.'" In *Treasures of the National Gallery of Canada*, ed. David Franklin. Ottawa: National Gallery of Canada in association with Yale University Press, 2003.

Borys 2005 Borys, Stephen D. "Draft entry for Pierre-Antoine Patel's 'Landscape with Classical Ruins and Figures.'" *AMAM Bulletin* 54, no. 1 (2005).

Boston 1832 Boston Athenaeum. *Sixth Exhibition of Paintings in the Athenaeum Gallery*. Exh. cat. Boston: Athenaeum, 1832.

Boulot 1989 Boulot, Catherine, Jean de Cayeux, and Hélène Moulin. *Hubert Robert et la Révolution*. Exh. cat. Valence: Musée de Valence, 1989.

Boulot 1990 Boulot, Catherine, et al., eds. *Jean-Honoré Fragonard e Hubert Robert a Roma*. Exh. cat. Rome: Palombi, Edizioni Carte Segrete, 1990.

Bowron 1990 Bowron, Edgar Peters. *European Paintings before 1900 in the Fogg Art Museum*. Cambridge, MA: Harvard University Art Museums, 1990.

Bowron 1992 Bowron, Edgar Peters. *Introduction to the Collections*. Rev. ed. Raleigh: North Carolina Museum of Art, 1992.

Bowron 1994 Bowron, Edgar Peters. Review of *Giovanni Paolo Panini, 1691–1765*. *Burlington Magazine* 136, no. 1091 (February 1994): 117–18.

Bowron 2000 Bowron, Edgar Peters, and Joseph J. Rishel, eds. *Art in Rome in the Eighteenth Century*. Philadelphia, Museum of Art; Houston, Museum of Fine Arts. Exh. cat. London: Merrell, 2000.

Boyer 1998 Boyer, Jean-Claude. Review of *Jean Lemaire pittore "antiquario."* *Burlington Magazine* 140, no. 1148 (November 1998): 756–59.

Brejon de Lavergnée 1999 Brejon de Lavergnée, Arnauld. "Une série de muses de l'atelier de Simon Vouet." In *Ex Fumo Lucem: Baroque Studies in Honour of Klára Garas*, ed. Zsuzsanna Dobos, 167–80. 2 vols. Budapest: Museum of Fine Arts, 1999.

Briganti 1983 Briganti, Giuliano, Laura Laureati, and Ludovica Trezzani. *I Bamboccianti: The Painters of Everyday Life in 17th-Century Rome*, 240–41. Trans. Erich Wolf. Rome: Ugo Bozzi Editore, 1983.

Brooke 1995 Brooke, Steven, ed. *Views of Rome*. Essays by Bonna Daix Wescoat, John Varriano, and Malcolm Campbell. New York: Rizzoli, 1995.

Broun 1978 Broun, Elizabeth. *Handbook of the Collection, Helen Foresman Spencer Museum of Art*. Lawrence, KS: University of Kansas, 1978.

Brown 1993 Brown, Beverly Louise, and Paola Marini, eds. *Jacopo Bassano, 1510–1592*. Contributions by Livia Alberton Vinco da Sesso et al. Bassano del Grappa, Museo Civico; Fort Worth, TX, Kimbell Art Museum. Exh. cat. Fort Worth, TX: Kimbell Art Museum, 1993.

Brunel 1976 Pierre Rosenberg, "Quelques nouveautés sur Barbault." In *Piranèse et les Français*, ed. Georges Brunel. Colloquium proceedings, Villa Medici, Rome, 12–14 May 1976.

Bryson 1981 Bryson, Norman. *Word and Image: French Painting of the Ancien Régime*. Cambridge, Eng.: Cambridge University Press, 1981.

Burn 1871 Burn, Robert. *Rome and the Campagna: An Historical and Topographical Description of the Site, Buildings, and Neighbourhood of Ancient Rome*. Cambridge, Eng.: Deighton, Bell and Co., 1871.

Cafritz 1988 Cafritz, Robert, Lawrence Gowing, and David Rosand. *Places of Delight: The Pastoral Landscape*. Washington, DC, Phillips Collection; National Gallery of Art. Exh. cat. Washington, DC: Phillips Collection, 1988.

Cailleux 1966 Cailleux, Jean. *Hubert Robert*. Milan: Fratelli Fabbri, 1966.

Cailleux 1979 Cailleux, Jean. "Un album inedit de croquis d'Hubert Robert." *Burlington Magazine* 121, no. 920 (November 1979): supp. i–vi.

Cairns 1962 Cairns, Huntington, and John Walker, eds. *Treasures from the National Gallery of Art*. New York: Macmillan, 1962.

Cairns 1966 Cairns, Huntington, and John Walker, eds. *A Pageant of Painting from the National Gallery of Art*. 2 vols. New York: Macmillan, 1966.

Cambridge 1931 *Eighteenth-century French Art*. Cambridge, MA.: Fogg Art Museum, 1931.

Carlson 1978 Carlson, Victor. *Hubert Robert: Drawings and Watercolors*. Exh. cat. Washington, DC: National Gallery of Art, 1978.

Cerceau 1576 Cerceau, Jacques Androuet du. *Le premier volume des plus excellents bastiments de France*. Paris: du Cerceau, 1576.

Chambray 1650 Chambray, Roland Fréart de. *Parallele de l'architecture antique et de la moderne* ... Paris: Edme Martin, 1650.

Champa 1991 Champa, Kermit Swiler. *The Rise of Landscape Painting in France: Corot to Monet*. Contributions by Fronia E. Wissman and Deborah Johnson and introduction by Richard R. Brettell. Manchester, Currier Gallery of Art; New York, IBM Gallery of Science and Art; Dallas, Museum of Art; Atlanta, High Museum of Art. Exh. cat. Manchester, NH: Currier Gallery of Art, 1991.

Chaney 1985 Chaney, Edward. *The Grand Tour and the Great Rebellion: Richard Lassels and "The Voyage of Italy" in the Seventeenth Century*. Biblioteca del viaggio in Italia 19. Geneva: Slatkine, 1985.

Chantelou 2001 Chantelou, Paul Fréart de. *Journal de voyage du Cavalier Bernini en France*. Ed. Milovan Stanić. Paris: Macula, L'insulaire, 2001.

Chiarini 1969 Chiarini, Marco. "Gaspard Dughet: Some Drawings Connected with Paintings." *Burlington Magazine* 111, no. 801 (December 1969): 750–54.

Chicago 2002 *The New Encyclopaedia*

Britannica. 15th ed. 32 vols. Chicago: Encyclopaedia Britannica, 2002.

Chong 1993 Chong, Alan. *European and American Painting in the Cleveland Museum of Art: A Summary Catalogue*. Cleveland: Cleveland Museum of Art, 1993.

Clark 1972 Clark, Anthony M. "Pompeo Batoni's Portrait of John Wodehouse." *AMAM Bulletin* 30, no. 1 (Fall 1972): 2–11.

Clark 1981 Clark, Anthony M. *Studies in Roman Eighteenth-century Painting*. Ed. Edgar Peters Bowron. Washington, DC: Decatur House Press, 1981.

Clark 1985 Clark, Anthony M. *Pompeo Batoni: A Complete Catalogue of His Works with an Introductory Text*. New York: New York University Press, 1985.

Clay 1980 Clay, Jean. *Le romantisme*. Paris: Hachette réalités, 1980.

Cleveland 1982 *European Paintings of the 16th, 17th and 18th Centuries*. Cleveland: Cleveland Museum of Art, 1982.

Coffin 1972 Coffin, David R, ed. *The Italian Garden*. Dumbarton Oaks Colloquium on the History of Landscape Architecture. Washington, DC: Dumbarton Oaks, 1972.

Coffin 1979 Coffin, David R. *The Villa in the Life of Renaissance Rome*. Princeton, NJ: Princeton University Press, 1979.

Conisbee 1976 Conisbee, Philip. *Claude-Joseph Vernet, 1714–1789*. London, Kenwood House. Exh. cat. London: Greater London Council, 1976.

Conisbee 1981 Conisbee, Philip. *Painting in Eighteenth-century France*. Ithaca, NY: Cornell University Press, 1981.

Conisbee 1996 Conisbee, Philip, Sarah Faunce, and Jeremy Strick. *In the Light of Italy: Corot and Early Open-Air Painting*. With Peter Galassi, guest curator. Washington, DC, National Gallery of Art; New York, Brooklyn Museum; St. Louis, Art Museum. Exh. cat. Washington, DC: National Gallery of Art, 1996.

Connors 2000 Connors, Joseph. "Poussin detrattore di Borromini." In *Francesco Borromini: Atti del Convegno Internazionale*, ed. Christoph L. Frommel and Elisabeth Sladek. Milan: Electa, 2000.

Constable 1944 Constable, William George. "The Early Work of Claude Lorrain." *Gazette des Beaux-arts* 26 (July 1944): 305–14.

Cooke 1959 Cooke, Hereward Lester. *French Paintings of the 16th–18th Centuries in the National Gallery of Art*. Washington, DC: National Gallery of Art, 1959.

Copenhagen 1977 The Thorvaldsen Museum. *Rome in Early Photographs, the Age of Pius IX: Photographs 1846–1878 from Roman and Danish Collections*. Trans. Ann Thornton. Exh. cat. Copenhagen: Thorvaldsen Museum, 1977.

Cordingly 1976 Cordingly, David. "Claude Lorrain and the Southern Seaport Tradition." *Apollo*, no. 103 (March 1976): 208–13.

Corsiglia 2004 Corsiglia, Christina. Dughet curatorial file, Art Gallery of Ontario, September 2004.

Cotté 1970 Cotté, Sabine *Claude Lorrain's Universe*. Trans. Helen Sebba. Woodbury, NY: Barron's, 1970.

Coural 2001 Coural, Natalie. *Les Patel: Pierre Patel, 1605–1676, et ses fils: le paysage de ruines à Paris au XVIIe siècle*. Preface by Jacques Thuillier. Paris: Arthéna, 2001.

Crelly 1962 Crelly, William R. *The Painting of Simon Vouet*. New Haven, CT: Yale University Press, 1962.

Crow 1985 Crow, Thomas E. *Painters and Public Life in Eighteenth-century Paris*. New Haven, CT: Yale University Press, 1985.

Crown 1992 Crown, Patricia. "An Eighteenth-Century Collaboration: Fragonard, Robert and Abbé Saint-Non." *Muse* 26 (1992): 53–61.

Cuzin 1977 Cuzin, Jean-Pierre. *La diseuse de bonne aventure de Caravage*. Paris, Louvre. Exh. cat. Paris: Editions des musées nationaux, 1977.

Cuzin 1988 Cuzin, Jean Pierre. *Jean-Honoré Fragonard: Life and Work; Complete Catalogue of the Oil Paintings*. New York: Abrams, 1988.

Dacier 1921–29 Dacier, Emile, Jacques Hérold, and Albert Vuaflart. *Jean de Jullienne et les graveurs de Watteau au XVIIIe siècle*. 4 vols. Paris: Société pour l'étude de la gravure française, 1921–29.

Daemmrich 1972 Daemmrich, Ingrid G. "The Ruins as Artistic Device in French Literature: Part 1." *The Journal of Aesthetics and Art Criticism* 30, no. 4 (Summer 1972): 449–57.

Dams 1995 Dams, Bernd H., and Andrew Zega. *Pleasure Pavilions and Follies in the Gardens of the Ancien Régime*. Paris: Flammarion, 1995.

Daniel 1995 Daniel, Sergei, and Natalia Serebriannaya. *Claude Lorrain: Painter of Light*. Bournemouth: Parkstone Press, 1995.

Davies 1948 Davies, Martin. "A Note on Francisque Millet." In *Poussin inconnu: Bulletin de la Société Poussin, December 1948*, 12–26. Paris: Librairie Floury, 1948.

Dayton 1999 *Selected Works from the Permanent Collection*. Dayton, OH: Dayton Art Institute, 1999.

Denison 1993 Denison, Cara D., Myra Nan Rosenfeld, and Stephanie Wiles. *Exploring Rome: Piranesi and His Contemporaries*. New York, Morgan Library; Montréal, Canadian Centre for Architecture. Exh. cat. New York: Pierpont Morgan Library, 1993.

De Piles 1708 de Piles, Roger. *Cours de peinture par principes*. Paris: Jacques Estienne, 1708.

De Piles 1743 de Piles, Roger. *The Principles of Painting*. London: C. March, 1743.

Desgodets 1682 Desgodets, Antoine Baruty. *Les édifices antiques de Rome, dessinés et mesurés très exactement*. Paris: Chez Jean Baptiste Coignard, 1682.

Detroit 1975 Detroit Institute of Arts. *French Painting 1774–1830, the Age of Revolution*. Paris, Grand Palais; Detroit, Institute of Arts; New York, Metropolitan Museum of Art. Exh. cat. Detroit: Wayne State University Press, 1975.

Diderot 1975 Diderot, Denis. *Salons*. 2nd ed. 3 vols. Ed. Jean Seznec and Jean Adhémar. Oxford: Clarendon Press, 1975.

Diderot 1995 Diderot, Denis. *Ruines et paysages: Salons de 1767*. Ed. Else Marie Bukdahl et al. Paris: Hermann, 1995.

Dietmar 1991 Dietmar, Lüdke. *Hubert Robert, 1733–1808, und die Brücken von Paris*. Exh. cat. Karlsruhe: Staatliche Kunsthalle, 1991.

Dilke 1884 Dilke, Lady Emilia Frances Strong. *Claude Lorrain, sa vie et ses oeuvres*. With Mark Pattison. Paris: J. Rouam, 1884.

Dimier 1928–30 Dimier, Louis. *Les peintres français du XVIIIe siècle: histoire des vies et catalogue des oeuvres*. 2 vols. Paris: Les Editions G. van Oest, 1928–30.

Dobroklonsky 1961 Dobroklonsky, Mikhail Vasilevich. "The Drawings of Claude Lorrain in the Hermitage." *Burlington Magazine* 103, no. 702 (September 1961): 394–455.

Dodge 1969 Dodge, Joseph Jeffers. *The Age of Louis XIII*. Jacksonville, FL, Cummer Gallery of Art; St. Petersburg, FL, Museum of Fine Arts. Exh. cat. Jacksonville, FL: Convention Press, 1969.

Duparc 1990 Duparc, Frederik J., and Linda L. Graif. *Italian Recollections: Dutch Painters in the Golden Age*. Exh. cat. Montréal: Museum of Fine Arts, 1990.

Durham 1973 *Moliere Festival Exhibition*. Exh. Durham, NC. Duke University, 21 February–18 March 1973.

Duro 1997 Duro, Paul. *The Academy and the Limits of Painting in Seventeenth-century France*. New York: Cambridge University Press, 1997.

Dussieux 1854 Dussieux, Louis, ed. *Mémoires inédits sur la vie et les ouvrages des membres de l'Académie royale de peinture et de sculpture*. 2 vols. Paris, 1854.

Duvaux 1873 Duvaux, Lazare. *Livre-Journal de Lazare Duvaux*. 2 vols. Rep. ed. Louis Courajod. Paris: F. de Nobele, 1965.

Ehrmann 1986 Ehrmann, Jean. *Antoine Caron: peintre des fêtes et des massacres*. Paris: Flammarion, 1986.

Eisler 1977 Eisler, Colin. *Paintings from the Samuel H. Kress Collection: European Schools Excluding Italian*. Oxford: Phaidon Press, 1977.

el-Abd 1976 el-Abd, Lucrecia N. "Pierre-Nolasque Bergeret (1782–1963)." PhD diss., New York: Columbia University, 1976.

Fagiolo dell'Arco 1996 Fagiolo dell'Arco, Maurizio. *Jean Lemaire pittore 'antiquario.'* Rome: Ugo Bozzi, 1996.

Feigenbaum 2004a Feigenbaum, Gail. "Draft entry for Sébastien Bourdon's 'The Finding of Moses.'" *French Paintings from the Fifteenth through the Eighteenth Centuries.* Washington, DC: National Gallery of Art, forthcoming.

Feigenbaum 2004b Feigenbaum, Gail. "Draft entry for Simon Vouet's 'The Muses Urania and Calliope.'" *French Paintings from the Fifteenth through the Eighteenth Centuries.* Washington, DC: National Gallery of Art, forthcoming.

Félibien 1666–88 Félibien, André. *Entretiens sur les vies et sur les ouvrages des plus excellents peintres anciens et modernes.* 5 vols. Paris: Chez P. Le Petit, 1666–88.

Ficacci 2000 Ficacci, Luigi. *Giovanni Battista Piranesi: The Complete Etchings.* London: Taschen, 2000.

Fleming 1962 Fleming, John. *Robert Adam and His Circle, in Edinburgh and Rome.* London: John Murray, 1962.

Fletcher 1975 Fletcher, Sir Banister. *Sir Banister Fletcher's A History of Architecture.* 18th ed. Rev. J. C. Palmes. New York: Scribner, 1975.

Focillon 1918 Focillon, Henri. *Giovanni Battista Piranesi, essai de catalogue raisonné de son oeuvre.* Paris: H. Laurens, 1918.

Fowle 1970 Fowle, Geraldine Elizabeth. "The Biblical Paintings of Sébastien Bourdon." 2 vols. PhD diss., Ann Arbor: University of Michigan, 1970.

Fox 1941 Fox, Douglas C. *Collection of Walter P. Chrysler, Jr.* Richmond, Virginia Museum of Fine Arts; Philadelphia, Museum of Art. Exh. cat. Richmond: Virginia Museum of Fine Arts, 1941.

Frankfurter 1951 Frankfurter, Alfred M. "Interpreting Masterpieces: Twenty-four Paintings from the Kress Collection." *Art News Annual* 21 (1951): 82–129.

Franklin 2003 Franklin, David, ed. *Treasures of the National Gallery of Canada.* Ottawa: National Gallery of Canada, 2003.

Fredericksen 1998– Fredericksen, Burton B., and Benjamin Peronnet, eds. *Répertoire des tableaux vendus en France au XIXe siècle.* Los Angeles: Provenance Index of the Getty Information Institute, 1998–.

French 1980 French, Anne. *Gaspard Dughet, called Gaspar Poussin, 1615–75: A French Landscape Painter in Seventeenth-Century Rome and His Influence on British Art.* London, Kenwood House. Exh. cat. London: Greater London Council, 1980.

Fried 1980 Fried, Michael. *Absorption and Theatricality: Painting and Beholder in the Age of Diderot.* Berkeley: University of California Press, 1980.

Frommel 1996 Frommel, Christoph L. "Poussin e l'architettura." In *Poussin et Rome,* ed. Olivier Bonfait. Paris: *Actes du Colloque de l'Académie de France à Rome et à la Bibliotheca Hertziana,* 1996.

Gabillot 1895 Gabillot, C. *Hubert Robert et son temps.* Paris: Librairie de l'Art, 1895.

Garms 1995 Garms, Jörg. *Vedute di Roma: dal Medioevo all'Ottocento: atlante iconografico, topografico, architettonico.* In collaboration with Cinzia Ammannato. 2 vols. Naples: Electa, 1995.

Garnier-Pelle 1989 Garnier-Pelle, Nicole. *Antoine Coypel (1661–1722).* Paris: Arthéna, 1989.

Gaxotte 1934 Gaxotte, Pierre, and Georges Wildenstein. *Le siècle de Louis XV, vu par les artistes.* Exh. cat. Paris: Gazette des Beaux-arts, 1934.

Geneva 1979 *Hubert Robert, 1733–1808: dessins et peintures.* Exh. cat. Geneva: Galerie Cailleux, 1979.

Goheen 1988 Goheen, Ellen R. *The Collections of the Nelson-Atkins Museum of Art.* New York: Abrams, 1988.

Goldfarb 2002 Goldfarb, Hilliard Todd, ed. *Richelieu: Art and Power.* Montréal, Museum of Fine Arts; Cologne, Wallraf-Richartz Museum; Ghent, Snoeck-Ducaju & Zoon. Exh. cat. Montréal: Museum of Fine Arts, 2002.

Goldstein 1977 Goldstein, Laurence. *Ruins and Empire: The Evolution of a Theme in Augustan and Romantic Literature.* Pittsburgh: University of Pittsburgh Press, 1977.

Gombrich 1966 Gombrich, Ernst H. *Norm and Form: Studies in the Art of the Renaissance.* London: Phaidon, 1966.

Goncourt 1948 Goncourt, Edmond de, and Jules de Groncourt. *French Eighteenth-Century Painters.* From *L'Art au dix-huitième siècle,* first published 1856–75. Trans. Robin Ironside. London: Phaidon Press, 1948.

Goodman 1995 Goodman, John, ed. and trans. *Diderot on Art.* 2 vols. New Haven: Yale University Press, 1995.

Gordon 1987 Gordon, Jennifer. *A Glimpse of Rococo France: The Amorous Proposal by François Le Moyne.* Exh. cat. Williamstown, MA: Sterling and Francine Clark Art Institute, 1987.

Gottesman 1959 Gottesman, Rita Susswein. "New York's First Major Art Show as Reviewed by Its First Newspaper Critic in 1802 and 1803." *New York Historical Society Quarterly* 43 (July 1959): 289–305.

Grasselli 1984 Grasselli, Margaret Morgan, Pierre Rosenberg, and Nicole Parmentier. *Watteau, 1684–1721.* Washington, DC, National Gallery of Art; Paris, Galeries nationales du Grand Palais; Berlin, Schloss Charlottenburg. Exh. cat. Washington, DC: National Gallery of Art, 1984.

Gregori 1994 Gregori, Mina. *Paintings in the Uffizi and Pitti Galleries.* New York: Bulfinch Press, 1994.

Grenoble 1937 *Chefs-d'oeuvre de l'art français.* Grenoble, Musée de Grenoble. Exh. cat. Paris: Palais national des arts, 1937.

Gross 1990 Gross, Hanns. *Rome in the Age of Enlightenment: The Post-Tridentine Syndrome and the Ancién Regime.* Cambridge, Eng.: Cambridge University Press, 1990.

Hager 1987 Hager, Hellmut, and Susan C. Scott, eds. *Light on the Eternal City: Observations and Discoveries in the Art and Architecture of Rome.* Vol. 2 of *Papers in Art History from the Pennsylvania State University.* University Park, PA: Pennsylvania State University Press, 1987.

Halifax 1986 *In Her Place: Changing Images of Women in Western Society from the Seventeenth to the Twentieth Century.* Exh. cat. Halifax, Nova Scotia: M.S. Vincent University, 1986.

Hall 1992 Hall, Nicholas H. J., ed. *Colnaghi in America: A Survey to Commemorate the First Decade of Colnaghi, New York.* New York: Colnaghi, 1992.

Hardin 1996 Hardin, Jennifer. *The Lure of Egypt: Land of the Pharaohs Revisited.* Exh. cat. St. Petersburg, FL: Museum of Fine Arts, 1996.

Hargrove 1990 Hargrove, June Ellen, ed. *The French Academy: Classicism and Its Antagonists.* Newark, DE: University of Delaware Press, 1990.

Harris 1985 Harris, Ann Sutherland. *Landscape Painting in Rome, 1595–1675.* Contributions by Marcel Roethlisberger and Kahren Hellerstedt. Exh. cat. New York: R. L. Feigen, 1985.

Harris 1990 Harris, Eileen. *British Architectural Books and Writers, 1556–1785.* Assisted by Nicholas Savage. Cambridge, Eng.: Cambridge University Press, 1990.

Harrison 1986 Harrison, Jefferson C. *French Paintings from the Chrysler Museum.* Raleigh, North Carolina Museum of Art; Birmingham, Museum of Art. Exh. cat. Norfolk, VA: Chrysler Museum, 1986.

Harrison 1991 Harrison, Jefferson C. *The Chrysler Museum: Handbook of the European and American Collections; Selected Paintings, Sculpture and Drawings.* Norfolk, VA: Chrysler Museum, 1991.

Harwood 2002 Harwood, Laurie B. *Inspired by Italy: Dutch Landscape Painting, 1600–1700.* Contributions by Christopher Brown and Anne Charlotte Steland. Exh. cat. London: Dulwich Picture Gallery, 2002.

Haskell 1981 Haskell, Francis, and Nicholas Penny. *Taste and the Antique: The Lure of Classical Sculpture, 1500–1900.* New Haven, CT: Yale University Press, 1981.

Hedley 2004 Hedley, Jo. *François Boucher:*

Seductive Visions. London: The Wallace Collection, 2004.

Heideman 1980 Heideman, Johanna. "The Dating of Gaspard Dughet's Frescoes in San Martino ai Monti in Rome." *Burlington Magazine* 122, no. 929 (August 1980): 540–46.

Heil 1934 Heil, Walter. *Exhibition of French Painting from the Fifteenth Century to the Present Day.* San Francisco, California Palace of the Legion of Honor. Exh. cat. San Francisco: Johnck & Seeger, 1934.

Heim 1989 Heim, Jean-François, Claire Béraud, and Philippe Heim. *Les Salons de peinture de la Révolution française, 1789–1799.* Paris: C.A.C. S.A.R.L. Edition, 1989.

Herman 1958 Herman, W. "Antoine Desgodets and the Académie royale d'architecture." *Art Bulletin*, no. 40 (March 1958): 23–53.

Hilaire 1993 Hilaire, Michel. *Century of Splendor: 17th-Century French Paintings in French Public Collections.* Montréal, Montréal Museum of Fine Arts; Rennes, Musée des beaux-arts de Rennes; Montpellier, Musée Fabre. Exh. cat. Montréal: Museum of Fine Arts, 1993.

Hind 1922 Hind, Arthur M. *Giovanni Battista Piranesi: A Critical Study with a List of His Published Works and Detailed Catalogues of the Prisons and Views of Rome.* London: The Cotswold Gallery, 1922.

Hollstein 1949– Hollstein, F. W. H. *Dutch and Flemish Etchings, Engravings, and Woodcuts ca. 1450–1700.* 62 vols. Amsterdam: M. Hertzberger, 1949–.

Holmes 1991 Holmes, Mary Tavener. *Nicolas Lancret, 1690–1743.* New York, Frick Collection; Fort Worth, TX, Kimbell Art Museum. Exh. cat. New York: Abrams, 1991.

Holt 1947 Holt, Elizabeth, ed. *Literary Sources of Art History: An Anthology of Texts from Theophilus to Goethe.* Princeton: Princeton University Press, 1947.

Hornsby 2000 Hornsby, Clare, ed. *The Impact of Italy: The Grand Tour and Beyond.* London: The British School at Rome, 2000.

Hourticq 1925 Hourticq, Louis. *Le paysage français de Poussin à Corot à l'exposition du Petit Palais.* Exh. cat. Paris: Gazette des Beaux-arts, 1926.

Houston 1951 *Twenty Masters of Painting.* Exh. cat. Houston: Museum of Fine Arts, 1951.

Houston 1952 Allied Arts Association. *Annual Art Festival: Masterpieces of Painting through Six Centuries.* Houston, Shamrock Hotel. Exh. cat. Houston: Allied Arts Association, 1952.

Hughes 1998 Hughes, Robert. *Master Paintings: The Phillips Collection.* Washington, DC: Counterpoint, 1998.

Humbert 1989 Humbert, Jean-Marcel. *L'égyptomanie dans l'art occidental.* Paris: ACR Édition, 1989.

Hunter-Stiebel 2004 Hunter-Stiebel, Penelope. *The Triumph of French Painting: 17th-century Masterpieces from the Museums of FRAME.* Portland, OR, Portland Art Museum; Birmingham, AL, Birmingham Museum of Art. Exh. cat. Portland, OR: Portland Art Museum, 2003.

Huntington 1961 Huntington, David Carew, and Helen Davey. *1761: The Year Revisited; Diderot and the Salon des Beaux-arts.* Exh. cat. Northampton, MA: Smith College Art Museum, 1961.

Iacuzzi 1978 Iacuzzi, Alfred. *The European Vogue of Favart: The Diffusion of the Opera-Comique.* New York: AMS Press, 1978.

Ingersoll-Smouse 1926 Ingersoll-Smouse, Florence. *Joseph Vernet: peintre de marine, 1714–1789.* 2 vols. Paris: É. Bignou, 1926.

Ingersoll-Smouse 1928 Ingersoll-Smouse, Florence. *Pater.* Paris: Les Beaux-arts, 1928.

Isarlo 1941 Isarlo, George. *Caravage et le caravagisme européen.* Aix-en-Provence: Dragon, 1941.

Isarlo 1960 Isarlo, George. *La peinture en France au XVIIe siècle.* Paris: Bibliothèque des arts, 1960.

Janson 1980 Janson, Anthony F. *100 Masterpieces of Painting: Indianapolis Museum of Art.* With A. Ian Fraser. Indianapolis: Indianapolis Museum of Art, 1980.

Jerusalem 1965 Israel Museum. *Old Masters and the Bible.* Exh. cat. Jerusalem: Israel Museum, 1956.

Johnson 1951 Johnson, Ellen. "A Fragonard Drawing." *AMAM Bulletin* 9, no. 3 (1952): 71–80.

Johnson 1980 Johnson, Mark M. *Idea to Image: Preparatory Studies from the Renaissance to Impressionism.* Exh. cat. Cleveland: Cleveland Museum of Art, 1980.

Jouin 1883 Jouin, Henry, ed. *Conférences de l'Académie royale de peinture et de sculpture.* Paris: A. Quantin, 1883.

Joyce 1983 Joyce, Hetty. "The Ancient Frescoes from the Villa Negroni and Their Influence in the Eighteenth and Nineteenth Centuries." *Art Bulletin* 65, no. 3 (September 1983): 423–40.

Joyce 1992 Joyce, Hetty. "Grasping at Shadows: Ancient Paintings in Renaissance and Baroque Rome." *Art Bulletin* 74, no. 2 (January 1992): 219–46.

Jullian 1976 Jullian, R. "Le thème des ruines dans la peinture de l'époque néoclassique en France." *Bulletin de la Société de l'histoire de l'art français*, 1976, 261–72.

Kalamazoo 1967 Kalamazoo Institute of Arts. *Alfred Bader Collection: 17th-Century Dutch and Flemish Painting.* Exh. cat. Kalamazoo, MI: Kalamazoo Institute of Art, 1967.

Kalnein 1972 Kalnein, Wend Graf von, and Michael Levey. *Art and Architecture of the Eighteenth Century in France.* Harmondsworth: Penguin Books, 1972.

Keaveney 1988 Keaveney, Raymond. *Views of Rome.* Exh. cat. London: Scala Books, 1988.

Kennedy 1972 Kennedy, Ian G. "Claude and Architecture." *Journal of the Warburg and Courtauld Institutes* 35 (1972): 260–83.

Kettering 1983 Kettering, Alison McNeil. *The Dutch Arcadia: Pastoral Art and Its Audience in the Golden Age.* Totowa, NJ: Allanheld and Schram, 1983.

Kiene 1992 Kiene, Michael. *Panini.* Exh. cat. Paris: Réunion des musées nationaux, 1992.

Kingston 1968 Agnes Etherington Art Centre. *Permanent Collection, 1968.* Kingston, ON: Agnes Etherington Art Centre, 1968.

Kinsey 1984 Kinsey, Joni. *The Spirit of Antiquity: Giovanni Battista Piranesi, Robert Adam, and Charles-Louis Clérisseau.* St. Louis, Washington University Gallery of Art. Exh. cat. St. Louis, MO: Washington University, 1984.

Kitson 1959 Kitson, Michael, and Marcel Roethlisberger. "Claude Lorrain and the Liber Veritatis I." *Burlington Magazine* 101, no. 670 (January 1959): 14–25.

Kitson 1969 Kitson, Michael. *The Art of Claude Lorrain.* Newcastle upon Tyne, Laing Art Gallery; London, Hayward Gallery. Exh. cat. Newcastle upon Tyne: Northern Arts Association, 1969.

Kitson 1978 Kitson, Michael. *Claude Lorrain: "Liber Veritatis."* London: British Museum Publications, 1978.

Kitson 1980a Kitson, Michael. "Gaspard Dughet at Kenwood." *Burlington Magazine* 122, no. 930 (September 1980): 644–51.

Kitson 1980b Kitson, Michael. "Further Unpublished Paintings by Claude." *Burlington Magazine* 122, no. 933 (December 1980): 834–37.

Kitson 2000 Kitson, Michael. *Studies on Claude and Poussin.* London: Pindar Press, 2000.

Klemm 1981 Klemm, Christian. *Gaspard Dughet und die Ideale Landschaft.* Exh. cat. Dusseldorf: Kunstmuseum, 1981.

Knab 1971 Knab, Eckhart. "Observations about Claude, Angeluccio, Dughet, and Poussin." *Master Drawings* 9, no. 4 (Winter 1971): 367–83.

Kofuku 1998 Kofuku, Akira, and Yukitaka Kohari. *Claude Lorrain and the Ideal Landscape.* Tokyo, National Museum of Western Art. Exh. cat. Tokyo: Kokuritsu Seiyo Bijutsukan, 1998.

Kozitka 2000 Kozitka, Laura J., and Catherine A. Steinmann, eds. *Treasures from the Art Institute of Chicago.* Objects

selected by James N. Wood, with commentaries by Debra N. Mancoff. Chicago: Art Institute of Chicago, 2000.

Lablaude 1995 Lablaude, Pierre-André. *The Gardens of Versailles*. London: Zwemmer, 1995.

Laborde 1781–96 Laborde, Jean-Benjamin de, et al. *Description générale et particulière de la France*. 12 vols. Paris: Ph.-D. Pierres, 1781–96.

Lagerlöf 1990 Lagerlöf, Margaretha Rossholm. *Ideal Landscape: Annibale Carracci, Nicolas Poussin, and Claude Lorrain*. Trans. Nancy Adler. New Haven, CT: Yale University Press, 1990.

Lagrange 1864 Lagrange, Léon. *Les Vernet: Joseph Vernet et la peinture au XVIII siècle*. Paris: A. Aubry, 1864.

Laing 2003 Laing, Alastair. *The Drawings of François Boucher*. Foreword by Pierre Rosenberg. Exh. cat. New York: American Federation of Arts in association with Scala Publishers, 2003.

Lanciani 1967 Lanciani, Rodolfo Amedeo. *The Ruins and Excavations of Ancient Rome*. New York: Bell Publishing Company, 1967. (Orig. pub. 1897.)

Landy 1956 Landy, Jacob. "Stuart and Revett: Pioneer Archaeologists." *Archaeology* 9, no. 4 (Winter 1956): 252–59.

Langdon 1989 Langdon, Helen. *Claude Lorrain*. Oxford: Phaidon, 1989.

Lapauze 1925 Lapauze, Henry, Camille Gronkowski, and Adrien Fauchier-Magnan. *Exposition du paysage français de Poussin à Corot*. Paris, Palais des beaux-arts de la ville de Paris. Exh. cat. Paris: Imprimerie Crété, 1925.

Laskin 1987 Laskin, Myron, and Michael Pantazzi, eds. *European and American Painting, Sculpture, and Decorative Arts*. 2 vols. Ottawa: National Gallery of Canada, 1987.

Lavergne-Durey 1989 Lavergne-Durey, Valerie. "Les Titon: mécènes et collectionneurs à Paris à la fin du XVIIe et au XVIIIe siècles." *Bulletin de la Société de l'histoire de l'art français*, 1989, 77–103.

Laverssière 1985 Laverssière, Sylvain. *Le classicisme français: Masterpieces of Seventeenth-century Painting*. Exh. cat. Dublin: National Gallery of Ireland, 1985.

Lawrence 1938–39 Lawrence, Lesley. "Stuart and Revett: Their Literary and Architectural Careers." *Journal of the Warburg Institute* 2 (1938–39): 128–46.

Leclair 1972 Leclair, Anne, and Pierre Rosenberg. "De Jean Dubois à Louis-Jacques Durameau: Note sur la Chapelle de la Trinité de Fontainebleu." *Bulletin de la Société de l'histoire de l'art français*, 1972, 257–68.

Le Comte 1702 Le Comte, Florent. *Cabinet des singularitez d'architecture, peinture, sculpture, et graveure, ou introduction à la connoissance des plus beaux arts, figurés sous les tableaux, les statues et les estampes*. Brussels: L. Marchant, 1702.

Leoncini 1991 Leoncini, Luca. "The Torlonia Vase: History and Visual Records from the Fifteenth to the Nineteenth Centuries." *Journal of the Warburg and Courtauld Institutes* 54 (1991): 99–116.

Letarouilly 1840 Letarouilly, Paul. *Edifices de Rome moderne*. Paris: Didot frères, 1840.

Lévêque 1987 Lévêque, Jean Jacques. *L'art et la Révolution française, 1789–1804*. Neuchâtel: Ides et Calendes, 1987.

Levey 1993 Levey, Michael. *Painting and Sculpture in France, 1700–1789*. New Haven, CT: Yale University Press, 1993.

Levit 1976 Levit, Herschel. *Views of Rome, Then and Now: 41 Etchings by Giovanni Battista Piranesi*. With corresponding photographs and text by the author. New York: Dover, 1976.

Liège 1939 Grande Saison Internationale de l'Eau. *Rétrospective d'art: peinture, sculpture, tapisserie, gravure, art japonais*. Exh. cat. Liège, 1939.

Links 1994 Links, J. G. *Canaletto*. Rev. ed. London: Phaidon, 1994.

London 1881 *Winter Exhibition: Works by Old Masters*. Exh. cat. London: Royal Academy of Arts, 1881.

London 1949 Royal Academy of Arts. *Landscape in French Art, 1550–1900*. Exh. cat. London: The Arts Council, 1949.

London 1956 *Important Paintings of the French Eighteenth Century*. Exh. cat. London: Wildenstein & Co., 21 March–28 April 1956.

London 1960 *Italian Art and Britain*. Exh. cat. London: Royal Academy of Arts, 1960.

London 1977 *Aspects of French Academic Art, 1680–1780*. Exh. cat. London: Heim Gallery, 1977.

London 1996 *France in the Golden Age: Seventeenth-Century French Paintings*. Exh. cat. London: Walpole Gallery, 1996.

London, Ontario 1979 *Development of Landscape*. London, ON: London Regional Art Gallery, 6 December 1978–25 January 1979.

Lossel-Guillien 1988 Lossel-Guillien, A. "A la recherche de l'oeuvre d'Etienne Allegrain, paysagiste de la fin du règne de Louis XIV." *Historie de l'art* 4 (1988): 69–78.

Lugt 1938–87 Lugt, Frits. *Répertoire des catalogues de ventes publiques*. 4 vols. La Haye: M. Nijhoff, 1938–87.

Lyons 2002 Lyons, Claire. *Landscapes of Myth*. Exh. cat. Los Angeles: Getty Research Institute, 2002.

Macaulay 1953 Macaulay, Dame Rose. *Pleasure of Ruins*. London: Weidenfeld and Nicolson, 1953.

MacDonald 1995 MacDonald, William Lloyd, and John A. Pinto. *Hadrian's Villa and Its Legacy*. New Haven, CT: Yale University Press, 1995.

Maggi 1915 Maggi, Giovanni. *Roma al tempo di Urbano VIII; la pianta di Roma Maggi-Maupin-Losi del 1625*. Introduction by Francesco Ehrle. Rome: Danesi, 1915.

Malgouyres 2000 Malgouyres, Philippe. *Peintures françaises du XVIIe siècle: la collection du Musée des beaux-arts de Rouen*. Paris: Somogy, 2000.

Manning 1959 Manning, Robert L. "Some Important Paintings by Simon Vouet in America." In *Studies in the History of Art: Dedicated to William E. Suida on His Eightieth Birthday*, 294–303. London: Phaidon Press, 1959.

Manning 1967 Manning, Robert L. *Vouet to Rigaud, French Masters of the Seventeenth Century*. New York, Finch College Museum of Art. Exh. cat. New York: Finch College Museum of Art, 1967.

Mannocci 1988 Mannocci, Lino. *The Etchings of Claude Lorrain*. New Haven, CT: Yale University Press, 1988.

Manoguerra 2004 Manoguerra, Paul A. *Classic Ground: Mid-Nineteenth-Century American Painting and the Italian Encounter*. Athens, GA, Georgia Museum of Art. Exh. cat. Athens: Georgia Museum of Art, 2004.

Marcel 1906 Marcel, Pierre. *La peinture française au début du dix-huitième siècle*. Paris: Ancienne Maison Quantin, 1906.

Martin 1973 Martin, John Franklin, ed. *J. B. Speed Art Museum Handbook*. Louisville, KY: J. B. Speed Art Museum, 1973.

McClellan 1996 McClellan, Andrew. "Watteau's Dealer: Gersaint and the Marketing of Art in Eighteenth-century Paris." *Art Bulletin* 78, no. 3 (September 1996): 439–53.

McEwen 1998 McEwen, Indra Kagis. "On Claude Perrault: Modernizing Vitruvius." In *Paper Palaces: The Rise of the Renaissance Architectural Treatise*, ed. Vaughan Hart and Peter Hicks, 328–37. New Haven, CT: Yale University Press, 1998.

McGinniss 1976 McGinniss, Lawrence R. *Catalogue of the Earl of Crawford's "Speculum Romanae magnificentiae."* New York: Avery Architectural Library, 1976.

McTavish 1981 McTavish, David, et al. *The Arts of Italy in Toronto Collections, 1300–1800*. Exh. cat. Toronto: Art Gallery of Ontario, 1981.

McTavish 1984 McTavish, David. *Pictures from the Age of Rembrandt: Selections from the Personal Collection of Dr. and Mrs. Alfred Bader*. Exh. cat. Kingston, ON: Agnes Etherington Art Centre, 1984.

McTavish 1988 McTavish, David. *Telling Images: Selections from the Bader Gift of European Paintings to Queen's University*. Exh. cat. Kingston, ON: Agnes Etherington Art Centre, 1988.

McTighe 1996 McTighe, Sheila. *Nicolas Poussin's Landscape Allegories*.

Cambridge, Eng.: Cambridge University Press, 1996.

Meade 1980 Meade, C. Wade. *Ruins of Rome: A Guide to the Classical Antiquities*. Ruston, LA: Palatine Publications, 1980.

Michel 1906 Michel, André, Louis Soullie, and C. Masson. *François Boucher*. Paris: H. Piazza, 1906.

Miller 1970 Miller, Dwight C. *Catalogue of European Paintings*. Indianapolis: Indianapolis Museum of Art, 1970.

Millon 1999 Millon, Henry A., ed. *The Triumph of the Baroque: Architecture in Europe, 1600–1750*. Exh. cat. Milan: Bompiani, 1999.

Milrod 1976 Milrod, Linda. *Works Recorded into the Permanent Collection after the Publication of the Catalogue of Paintings, Drawings, and Sculpture in 1968*. Kingston, ON: Agnes Etherington Art Centre, 1976.

Minneapolis 1966 "Catalogue of Accessions for the Year 1966." *The Minneapolis Institute of Arts Bulletin* 55 (1966): 56–80.

Minneapolis 1971 *Catalogue of European Paintings in the Minneapolis Institute of Arts*. Minneapolis: Minneapolis Institute of Arts, 1971.

Mireur 1911–12 Mireur, Hippolyte. *Dictionnaire des ventes d'art faites en France et à l'étranger pendant les XVIIIme & XIXme siècles*. 7 vols. Paris: Maison D'Éditions d'oeuvres artistiques, 1911–12.

de Mirimonde 1962 de Mirimonde, Albert P. "Statues et emblèmes dans l'oeuvre de Watteau." *La Revue du Louvre et des Musées de France* 1 (1962): 11–20.

Mitchell 1989 Mitchell, Timothy F. "Johann Christian Reinhart and the Transformation of Heroic Landscape, 1790–1800." *Art Bulletin* 71, no. 4 (December 1989): 646–59.

Montaigne 1929 Montaigne, Michel de. *The Diary of Montaigne's Journey to Italy*. Trans. E. J. Trechmann. New York: Harcourt, Brace and Company, 1929.

Montaigne 1962 Montaigne, Michel de. *Oeuvres complètes*. Ed. Albert Thibaudet and Maurice Rat. Paris: Gallimard, 1962.

Montréal 1952 *Six Centuries of Landscape*. Exh. cat. Montréal: Museum of Fine Arts, 1952.

Montréal 1960 *Canada Collects: European Painting, 1860–1960*. Exh. cat. Montréal: Museum of Fine Arts, 1960.

Montréal 1961 *Heritage de France: French Painting, 1610–1760*. Québec, Musée de la Province de Québec; Ottawa, National Gallery of Canada; Toronto, Art Gallery of Toronto. Exh. cat. Montréal: Museum of Fine Arts, 1961.

Montréal 1966 *Masterpieces from Montréal: Selected Paintings from the Collection of the Montréal Museum of Fine Arts*. Sarasota, FL, John and Mabel Ringling Museum of Art; Raleigh, North Carolina Museum of Art; Pittsburgh, Carnegie Museum of Art; Columbus, OH, Museum of Art; New York, Gallery of Modern Art; Rochester, NY, Memorial Art Gallery. Exh. cat. Montréal: Museum of Fine Arts, 1966.

Montréal 1977 Musée des beaux-arts de Montréal. *Guide*. Montréal: Museum of Fine Arts, 1977.

Montréal 1993 Patrick Ramade, ed. *Century of Splendour: Seventeenth-century French Painting in French Public Collections*. Montréal, Museum of Fine Arts; Rennes, Musée des beaux-arts; Montpellier, Musée Fabre. Exh. cat. Montréal: Museum of Fine Arts, 1993.

Morrogh 1994 Morrogh, Andrew. "The Palace of the Roman People: Michelangelo at the Palazzo dei Conservatori." *Römisches Jahrbuch der Bibliotheca Hertziana* 29 (1994): 129–86.

Mortimer 1985 Mortimer, Kristin A. *Harvard University Art Museums: A Guide to the Collections*. Contributions by William G. Klingelhofer. Cambridge, MA: Harvard University Art Museums, 1985.

Mothe-Fénelon 1730 Mothe-Fénelon, François de Salignac de La. "Dialogues sur la peinture." In Simon Philippe Mazière de Monville, *La vie de Pierre Mignard . . .*, 216ff. Paris: J. Boudot et J. Guérin, 1730.

Myrone 1999 Myrone, Martin, and Lucy Peltz, eds. *Producing the Past: Aspects of Antiquarian Culture and Practice, 1700–1850*. Aldershot: Ashgate, 1999.

Nagler 1904–14 Nagler, Georg Kaspar. *Neues Allgemeines Künstler Lexikon*. 25 vols. 2nd ed. Linz: E. Mareis, 1904–14.

Nagy 1998 Nagy, Rebecca Marine, ed. *North Carolina Museum of Art Handbook of the Collections*. Raleigh: North Carolina Museum of Art, 1998.

Nash 1961–62 Nash, Ernest. *Pictorial Dictionary of Ancient Rome*. 2 vols. New York: Praeger, 1961–62.

Nashville 2001 *European Masterworks: Paintings from the Collection of the Art Gallery of Ontario*. Exh. cat. Nashville, TN: The Frist Center for the Visual Arts, 2001.

Near 1981 Near, Pinkney L. *Three Masters of Landscape: Fragonard, Robert, and Boucher*. Exh. cat. Richmond, VA: Virginia Museum of Fine Arts, 1981.

New York 1912 Metropolitan Museum of Art. *J. Pierpont Morgan Collection*. Exh. New York, 1912.

New York 1914 *Guide to the Loan Exhibition of the J. Pierpont Morgan Collection*. New York: Metropolitan Museum of Art, 1914.

New York 1935a *Paintings and Drawings by Hubert Robert*. Exh. cat. New York: Wildenstein & Co., 1935.

New York 1935b Metropolitan Museum of Art. *French Painting and Sculpture of the Eighteenth Century*. Exh. cat. New York: Plantin Press, 1935.

New York 1946 *A Loan Exhibition of French Painting of the Time of Louis XIIIth and Louis XIVth*. Exh. cat. New York: Wildenstein & Co., 1946.

New York 1948 *French Eighteenth-Century Paintings*. Exh. cat. New York: Wildenstein & Co., 1948.

New York 1951 *Wildenstein Jubilee Loan Exhibition, 1901–1951: Masterpieces from Museums and Private Collections*. Exh. cat. New York: Wildenstein & Co., 1951.

New York 1954–55 *Jean-Baptiste Pater*. New York: Wildenstein & Co., 1954–55.

New York 1958 *Fifty Masterworks from the City Art Museum of St. Louis*. Exh. cat. New York: Wildenstein & Co., 1958.

New York 1968 *Gods and Heroes: Baroque Images in Antiquity*. Exh. cat. New York: Wildenstein & Co., 1968.

New York 1978 *European Works of Art*. Exh. cat. New York: Rosenberg & Stiebel, 1978.

New York 1986a *Francois Boucher, 1703–1770*. New York, Metropolitan Museum of Art; Detroit, Institute of Arts; Paris, Grand Palais. Exh. cat. New York: Metropolitan Museum of Art, 1986.

New York 1986b *An Aspect of Collecting Taste*. Exh. cat. New York: Stair Sainty Matthiesen Gallery, 1986.

New York 1987 *American Paradise: The World of the Hudson River School*. New York: Metropolitan Museum of Art, 1987.

New York 1988 *Hubert Robert: The Pleasure of Ruins*. Introduction by Georges Bernier. Exh. cat. New York: Wildenstein & Co., 1988.

New York 1993 IBM Gallery of Science and Art. *Highlights from the Vassar College Collection*. Exh. New York, 1993.

Nolhac 1907 Nolhac, Pierre de. *François Boucher: Premier peintre du roi*. Paris: Manzi, Joyant, 1907.

Nolhac 1910 Nolhac, Pierre de, and Georges Pannier. *Hubert Robert, 1733–1808*. Paris: Goupil, 1910.

Northampton 1952 *Commencement Exhibition*. Exh. cat. Northampton, MA: The Smith College Museum of Art, 1952.

Northampton 1953 *Forty French Pictures in the Smith College Museum of Art*. Northampton, MA: The Smith College Museum of Art, 1953.

Northampton 1961 Smith College Museum of Art. *Bulletin*, no. 41 (1961).

Northampton 1986 *A Guide to the Collections*. Northampton, MA: The Smith College Museum of Art, 1986.

Notre Dame 1972 *Checklist of the Collections: Art Gallery, University of Notre Dame*. Notre Dame, IN: Art Gallery of the University of Notre Dame, 1972.

Notre Dame 1981 *A Guide to the Snite Museum of Art, University of Notre*

Dame. Notre Dame, IN: The Snite Museum of Art, 1981.

Nottingham 1988 *Ruins in British Romantic Art from Wilson to Turner.* Exh. cat. Nottingham: Nottingham Castle Museum, 1988.

Oberhuber 1980 Oberhuber, Konrad, and Beverly Shreiber Jacoby, eds. *French Drawings from a Private Collection, Louis XIII to XVI.* Cambridge, MA, Fogg Art Museum; Malibu, J. Paul Getty Museum; Montréal, Museum of Fine Arts. Exh. cat. Cambridge, MA: Fogg Art Museum, 1980.

Oberlin 1976 "Allen Memorial Art Museum, Oberlin College." *Apollo* 103, no. 168 (February 1976).

Oberlin 1998 Allen Memorial Art Museum. *Masterworks for Learning: A College Collection Catalogue.* CD-ROM. Oberlin, OH: Oberlin College, 1998.

Opperman 1983 Opperman, Hal. *J.-B. Oudry, 1686–1755.* Fort Worth, TX, Kimbell Art Museum. Exh. cat. Seattle: University of Washington Press, 1983.

Osborne 1970 Osborne, Harold, ed. *Oxford Companion to Art.* Oxford: Clarendon, 1970.

Ostrow 1968 Ostrow, Stephen E. *Baroque Painting: Italy and Her Influence.* Providence, Rhode Island School of Design. Exh. cat. New Haven, CT: Eastern Press, 1968.

Ottawa 1965 National Gallery of Canada. *Eighteenth-century French Paintings from the Louvre.* Ottawa, National Gallery of Canada; Montréal, Museum of Fine Arts; Québec, le Musée. Exh. cat. Ottawa: R. Duhamel, 1965.

Ottawa 1973 *The Montréal Museum Lends III: 36 Objects from the Middle Ages to the 18th Century.* Exh. cat. Ottawa, 1973–75; Detroit, 1974–75. Ottawa: National Gallery of Canada, 1973.

Ottawa 1994 *Egyptomania: Egypt in Western Art, 1730–1930.* Contributions by Jean-Marcel Humbert, Michael Pantazzi, and Christiane Ziegler. Paris, Musée du Louvre; Ottawa, National Gallery of Canada; Vienna, Kunsthistorisches Museum. Exh. cat. Ottawa: National Gallery of Canada, 1994.

Palluchini 1973 Palluchini, Rodolfo. "Per gli esordi de Canaletto." *Arte Veneta* 27 (1973): 155–88.

Palm Beach 1952–53 Society of the Four Arts. *Eighteenth-century Masterpieces.* Exh. cat. Palm Beach, FL, 1952–53.

Palmer 1991 Palmer, Rodney. "A Helpful Confrontation: Hubert Robert and Fragonard in Rome." *Apollo* 133, no. 348 (February 1991): 126–28.

Paris 1860 *Tableaux et dessins de l'école française.* Exh. cat. Paris, 1860.

Paris 1912 Galerie Thos. Agnew & Sons, *Exposition d'oeuvres d'Hubert Robert.* Exh. Paris, 1912.

Paris 1925 Palais des beaux-arts. *Exposition du paysage français de Poussin à Corot.* Exh. Paris, 1925.

Paris 1926 Palais des beaux-arts. *Le paysage français de Poussin à Corot.* Paris, 1926.

Paris 1932 *Exposition François Boucher, 1703–1770.* Paris, l'hotel de M. Jean Charpentier. Exh. cat. Paris: Foundation Foch, 1932.

Paris 1956 Ligue nationale contre le taudis. *De Watteau a Prud'hon.* Exh. cat. Paris: Gazette des Beaux-arts, 1956.

Paris 1964 *18th-Century France: Paintings from the Louvre.* Toledo, OH, Museum of Art; Kansas City, William Rockhill Nelson Gallery of Art; Nashville, Tennessee Fine Arts Center; Atlanta, Art Association; Baltimore, Museum of Art. Exh. cat. Paris: Musée du Louvre, 1964.

Paris 1975 Heim Gallery, Paris. *Le choix de l'amateur.* Exh. 31 July 1975.

Paris 1979 Galerie Cailleux. *Un album de croquis d'Hubert Robert, 1733–1808.* Paris: Les Presses Artistiques, 1979.

Paris 1998 *La fascination de l'antique: 1700–1770, Rome découverte, Rome inventée.* Exh. cat. Paris: Somogy éditions d'art, 1998.

Paris Salon 1673–1955 *Paris salon de …* Set of the official volumes of the salons, 1673–1955. Paris: Liepmannssohn et Dufour, 1869.

Parker 1971 Parker, Margaret Koscielny. *Remnants of Things Past.* St. Petersburg, FL, Museum of Fine Arts; Jacksonville, FL, Cummer Gallery of Art. Exh. cat. Jacksonville, FL: Cummer Gallery of Art, 1971.

Patrice 1982 Patrice, Marandel J. "Laban Searching the Belongings of Jacob." *Bulletin, The Museum of Fine Arts, Houston* 8, no. 1 (Spring 1982): 4–8.

Peters 1988 Peters, Susan Dodge, ed. *Memorial Art Gallery: An Introduction to the Collection.* Rochester, NY: Memorial Art Gallery, 1988.

Picart 1958 Picart, Yves. *La vie et l'oeuvre de Simon Vouet.* 2 vols. Paris: Cahiers de Paris, 1958.

Pigler 1974 Pigler, Andor. *Barockthemen: eine Auswahl von Verzeichnissen zur Ikonographie des 17. und 18. Jahrhunderts.* 3 vols. Budapest: Akádémiai Kiadó, 1974.

Pinault 1994 Pinault, Madeleine. "L'Étude de la perspective dans l'histoire de Saint Etienne per Laurent de La Hyre." In *Desargues en son temps,* ed. Jean Dhombres and Joël Sakarovitch. Paris: Librairie Scientifique A. Blanchard, 1994.

Piranesi 1990 Piranesi, Giovanni Battista. *Piranesi: Rome Recorded—A Complete Edition of Giovanni Battista Piranesi's Vedute di Roma from the Collection of the Arthur Ross Foundation.* New York: Arthur Ross Foundation, 1990.

Pirazzoli 1990 Pirazzoli, Nullo. *Luigi Rossini, 1790–1857: Roma antica restaurata.* Ravenna: Essegi, 1990.

Platner 1929 Platner, Samuel Ball, and Thomas Ashby. *A Topographical Dictionary of Ancient Rome.* London: Oxford University Press, 1929.

Plax 2000 Plax, Julie Anne. *Watteau and the Cultural Politics of Eighteenth-century France.* Cambridge, Eng.: Cambridge University Press, 2000.

Plutarch 1920 Plutarch, *Lives.* Trans. Bernadotte Perrin. London: W. Heinemann, 1914–26.

Poirier 1977 Poirier, Anne, and Patrick Poirier. *Domus Aurea: fascination des ruines.* Rennes, Maison de la Culture. Exh. cat. Paris: Presses de la Connaissance, 1977.

Pollak 2000 Pollak, Martha D., ed. *The Mark J. Millard Architectural Collection: Italian and Spanish Books, Fifteenth Through Nineteenth Centuries.* Washington, DC: National Gallery of Art, 2000.

Ponsonailhe 1883 Ponsonailhe, Charles. *Sébastien Bourdon, sa vie et son oeuvre.* Paris: L'Artiste, 1883.

Porter 1987 Porter, Dean A. *Selected Works from the Snite Museum of Art, the University of Notre Dame.* Photography by Stephen Moriarty and Steve Toepp. Notre Dame, IN: Snite Museum of Art, 1987.

Posner 1984 Posner, Donald. *Antoine Watteau.* Ithaca, NY: Cornell University Press, 1984.

Poughkeepsie 1962 Vassar College Art Gallery. *Hubert Robert, 1733–1808.* Exh. Poughkeepsie, NY, 1962.

Poughkeepsie 1967 *Selections from the Permanent Collection.* Exh. cat. Poughkeepsie, NY: Vassar College Art Gallery, 1967.

Poughkeepsie 1977 *Promised Gifts '77.* Exh. cat. Poughkeepsie, NY: Vassar College, 1977.

Poughkeepsie 1983 *Vassar College Art Gallery, Paintings 1300–1900: A Complete Illustrated List of Works in the Art Gallery's Collection.* Poughkeepsie, NY: Vassar College Art Gallery, 1983.

Powell 1998 Powell, Cecilia. *Italy in the Age of Turner: The Garden of the World.* London, Dulwich Picture Gallery. Exh. cat. London: Merrell Holberton, 1998.

Puttfarken 1985 Puttfarken, Thomas. *Roger de Piles' Theory of Art.* New Haven, CT: Yale University Press, 1985.

Radisich 1998 Radisich, Paula Rea. *Hubert Robert: Painted Spaces of the Enlightenment.* Cambridge, Eng.: Cambridge University Press, 1998.

Rand 1997 Rand, Richard, and Juliette M. Bianco. *Intimate Encounters: Love and Domesticity in Eighteenth-century France.* Hanover, NH: Hood Museum of Art, 1997.

Reed 1998 Reed, Sue Welsh. *French Prints from the Age of the Musketeers.* Contributions by Alvin L. Clark, Jr. Boston, Museum of Fine Arts; Ottawa, National Gallery of Canada; Paris, Mona Bismark

Foundation. Exh. cat. Boston: Museum of Fine Arts, 1998.

Regina 1968 Norman Mackenzie Art Gallery. *The French as Seen through Their Art: 1600–1925.* Exh. Regina, SK, Norman Mackenzie Art Gallery, University of Saskatchewan, 24 February–24 March 1968.

Reid 1993 Reid, Jane Davidson. *The Oxford Guide to Classical Mythology in the Arts, 1300–1990s.* With the assistance of Chris Rohmann. 2 vols. New York: Oxford University Press, 1993.

Reinach 1897–1910 Reinach, Salomon. *Répertoire de la statuaire grecque et romaine.* 4 vols. Paris: E. Leroux, 1897–1910.

Remy 1777 Remy, Pierre. *Catalogue des tableaux et desseins précieux des maîtres célèbres des trios écoles.* Paris: Pierre Remy, 1777.

Rennes 1989 Musée des Beaux-arts de Rennes. *Laurent de La Hyre, 1606–1656.* Exh. cat. Rennes: Museum of Fine Arts, 1989.

Rich 1971 Rich, Daniel Catton. "Delights of the *Dix-huitième.*" *Apollo,* n.s., 94 (December 1971): 482–87.

Ripa 1976 Ripa, Cesare. *Iconologia.* New York: Garland, 1976. (Orig. pub. 1611 by P. P. Tozzi.)

Robison 1986 Robison, Andrew. *Piranesi: Early Architectural Fantasies, A Catalogue Raisonné of the Etchings.* Washington, DC: National Gallery of Art, 1986.

Rochester 1948 Memorial Art Gallery of the University of Rochester. *A Group of Old Master Paintings.* Exh. Rochester, NY, 1948.

Rochester 1965 *In Focus: A Look at Realism.* Exh. cat. Rochester, NY: Memorial Art Gallery of the University of Rochester, 1965.

Rochester 1968 *Handbook Supplement: Acquisitions, 1962–68.* Rochester, NY: Memorial Art Gallery of the University of Rochester, 1968.

Rochester 1976 *Harris K. Prior Memorial Exhibition.* Rochester, NY: Memorial Art Gallery of the University of Rochester, 1976.

Roethlisberger 1961 Roethlisberger, Marcel. *Claude Lorrain: The Paintings.* 2 vols. New Haven, CT: Yale University Press, 1961.

Roethlisberger 1965 Roethlisberger, Marcel. "Master Works in Canada." *Canadian Art* 20 (May/June 1965): 50.

Roethlisberger 1968 Roethlisberger, Marcel. *Claude Lorrain: The Drawings.* 2 vols. Berkeley: University of California Press, 1968.

Roethlisberger 1972 Roethlisberger, Marcel. "Nuovi aspetti di Claude Lorrain." *Paragone* 23, no. 273 (November 1972): 24–36.

Roethlisberger 1975 Roethlisberger, Marcel, and Doretta Cecchi. *L'Opera completa di Claude Lorrain.* Milan: Rizzoli, 1975.

Roethlisberger 1982 Roethlisberger, Marcel. "Around a Landscape by Claude Lorrain." *Register of the Spencer Museum of Art* 5, no. 10 (Spring 1982): 10–27.

Roethlisberger 1983 Roethlisberger, Marcel. *Im Licht von Claude Lorrain: Landschaftsmalerei aus drei Jahrhunderten.* Munich, Haus der Kunst. Exh. cat. Munich: Hirmer Verlag, 1983.

Roethlisberger 1986 Roethlisberger, Marcel. *Tout l'oeuvre peint de Claude Lorrain.* Paris: Flammarion, 1986.

Roland Michel 1978 Roland Michel, Marianne. "De l'illusion à 'l'inquiétante étrangeté': quelques remarques sur l'évolution du sentiment et de la representation de la ruine chez des artistes français à partir de 1730." In *Piranesi et les Français: colloque tenu à la Villa Médicis,* ed. Georges Brunel, 475–90. Rome: Edizioni dell'Elefante, 1978.

Roland Michel 1984 Roland Michel, Marianne. *Lajoüe et l'art rocaille.* Preface by Jacques Thuillier. Neuilly-sur-Seine: Arthena, 1984.

Rome 1976 Villa Medici. *Piranèse et les Français, 1740–1790.* Rome, Villa Medici; Dijon, Palais des États de Bourgogne; Paris, Hôtel de Sully. Exh. cat. Rome: Edizioni dell'Elefante, 1976.

Rosenberg 1964 Rosenberg, Pierre. "Quelques tableaux inédits du XVIIe siècle français par Jacques Stella, Charles Mellin, Jean Tassel et Sébastien Bourdon." *Art de France* 4 (1964): 297–99.

Rosenberg 1972 Rosenberg, Pierre. *French Master Drawings of the 17th and 18th Centuries in North American Collections.* Ontario, Art Gallery of Ontario. Exh. cat. London: Secker & Warburg, 1972.

Rosenberg 1974a Rosenberg, Pierre, and Jacques Thuillier. "Laurent de La Hyre: *The Kiss of Peace and Justice.*" *The Bulletin of the Cleveland Museum of Art* 61, no. 9 (November 1974): 300–308.

Rosenberg 1974b Rosenberg, Pierre, N. Reynaud, and I. Compin. *Catalogue illustré des peintures, ecole française, XVII et XVIII siècles.* Paris: Musée du Louvre, 1974.

Rosenberg 1975 Rosenberg, Pierre. *The Age of Louis XV: French Painting, 1710–1774.* Toledo, OH, Museum of Art; Chicago, Art Institute; Ottawa, National Gallery of Canada. Exh. cat. Toledo, OH: Toledo Museum of Art, 1975.

Rosenberg 1978 Rosenberg, Pierre. "Quelques nouveautés sur Barbault." In *Piranèse et les Français,* ed. Georges Brunel, 499–506. Rome: Edizioni dell'Elefante, 1978.

Rosenberg 1982 Rosenberg, Pierre. *France in the Golden Age: Seventeenth-century French Paintings in American Collections.* Paris, Galeries nationales du Grand Palais; New York, Metropolitan Museum of Art; Chicago, Art Institute. Exh. cat. New York: Metropolitan Museum of Art, 1982.

Rosenberg 1984 Rosenberg, Pierre. *Vies anciennes de Watteau.* Paris: Hermann, 1984.

Rosenberg 1988 Rosenberg, Pierre. *Fragonard.* Paris, Galeries nationales du Grand Palais; New York, Metropolitan Museum of Art. Exh. cat. New York: Metropolitan Museum of Art, 1988.

Rosenberg 1989–90 Rosenberg, Pierre, and Jacques Thuillier. *Laurent de La Hyre, 1606–1656: L'homme et l'oeuvre.* Musée de Grenobel; Musée de Rennes; Musée de Bordeaux. Exh. cat. Geneva: Skira, 1989–90.

Rosenberg 1996 Rosenberg, Pierre, and L.-A. Prat. *Antoine Watteau, 1684–1721: Catalogue raisonné des dessins.* Milan: Leonardo Arte, 1996.

Rosenberg 2003 Rosenberg, Pierre. "Fragonard, *La fête à Saint-Cloud,* Louis-Pierre Marchal de Sainscy et la Banque de France." In *Place des Victoires,* ed. Isabelle DuBois and Alexandre Gady. Paris: Éditions de la Maison des sciences de l'homme, 2003.

Rosenblum 1984 Rosenblum, Robert, and H. W. Janson. *19th-century Art.* New York: Abrams, 1984.

Rosenthal 1964 Rosenthal, Earl Edgar. "The Antecedents of Bramante's Tempietto." *Journal of the Society of Architectural Historians* 23, no. 2 (May 1964): 55–74.

Rosenthal 1987 Rosenthal, Donald A. *La grande manière: Historical and Religious Painting in France, 1700–1800.* Rochester, NY, Memorial Art Gallery; New Brunswick, NJ, Jane Voorhees Zimmerli Art Museum; Atlanta, High Museum of Art. Exh. cat. Rochester, NY: Memorial Art Gallery, 1987.

Rossi 1974 Rossi Bortolatto, Luigina, ed. *L'Opera completa di Francesco Guardi.* Milan: Rizzoli, 1974.

Roth 1997 Roth, Michael S. *Irresistible Decay: Ruins Reclaimed.* With Claire Lyons and Charles Merewether. Exh. cat. Los Angeles: The Getty Research Institute for the History of Art and the Humanities, 1997.

Rouen 1999 Musée des beaux-arts de Rouen. *Autour de Claude-Joseph Vernet: La marine à voile de 1650 à 1890.* Exh. cat. Arcueil: Anthèse, 1999.

Russell 1982 Russell, H. Diane. *Claude Lorrain, 1600–1682.* Washington, DC, National Gallery of Art; Paris, Galeries nationales du Grand Palais. Exh. cat. Washington, DC: National Gallery of Art, 1982.

Sahut 1979 Sahut, Marie-Catherine, and Nicole Garnier-Pelle. *Le Louvre d'Hubert Robert.* Paris, Musée du Louvre. Exh. cat. Paris: Éditions de la Réunion des musées nationaux, 1979.

Salerno 1975 Salerno, Luigi, ed. *L'opera completa di Salvator Rosa.* Milan: Rizzoli, 1975.

Salerno 1977–78 Salerno, Luigi. *Landscape*

Painters of the Seventeenth Century in Rome. 3 vols. Rome: U. Bozzi, 1977–78.

Salerno 1978 Salerno, Luigi. *Pittori di paesaggio a Roma.* Exh. cat. Rome: Galleria Gasparrini, 1978.

Salmi 1956 Salmi, Mario. *Il Seicento europeo: realismo, classicismo, barocco.* Rome, Palazzo delle Esposizioni. Exh. cat. Rome: De Luca, 1956.

Salmon 2000 Salmon, Frank. *Building on Ruins: The Rediscovery of Rome and English Architecture.* Burlington, VT: Ashgate, 2000.

Sandrart 1925 Sandrart, Joachim von. *Academie der Bau-, Bild- und Mahlerey-Künste von 1675. Leben der berühmten Maler, Bildhauer und Baumeister* [1675–1679], ed. Alfred R. Peltzer. Munich: G. Hirth's Verlag, 1925.

Sawyer 1941 Sawyer, Charles Henry, Perry Blythe Cott, and Calvin S. Hathaway. "The Theodore T. and Mary G. Ellis Collection." *Worcester Art Museum Annual* 4 (1941): 6–33.

Schaefer 1987 Schaefer, Scott, and Peter Fusco. *European Painting and Sculpture in the Los Angeles County Museum of Art: An Illustrated Summary Catalogue.* With the assistance of Paula-Teresa Wiens. Los Angeles: Los Angeles County Museum of Art, 1987.

Schleier 1983 Schleier, Erich. "La peinture française du XVIIe siècle dans les collections américaines." *Kunstchronik* 36, no. 5 (May 1983): 227–37.

Schloder 1980 Schloder, John E. "Un artiste oublié: Nicolas Prévost, peintre de Richelieu." *Bulletin de la Société de l'histoire de l'art français,* 1980, 59–69.

Schnapper 1967 Schnapper, Antoine. *Tableaux pour le Trianon de marbre 1688–1714.* Paris: La Haye, Mouton, 1967.

Schnapper 1979–80 Schnapper, Antoine. "The Moses of Antoine Coypel." *AMAM Bulletin* 37, no. 2 (1979–80): 59–67.

Schnapper 1988–94 Schnapper, Antoine. *Collections et collectionneurs dans la France du XVIIe siècle.* 2 vols. Paris: Flammarion, 1988–94.

Scott 1980 Scott, Glenn. *Man and Nature, a View of the Seventeenth Century.* Exh. cat. Hamilton, ON: Art Gallery of Hamilton, 1980.

Scott 1995 Scott, Jonathan. *Salvator Rosa: His Life and Times.* New Haven, CT: Yale University Press, 1995.

Scudéry 1646 Scudéry, Georges de. *Cabinet de Mr de Scudéry.* Paris: Augustin Courbé, 1646.

Serlio 1540 Serlio, Sebastiano. *Il terzo libro ... sulle antichità di Roma ...* Venice: Francesco Marcolini, 1540.

Serra 1997 Serra, Joselita Raspi. "I 'pensionnaires' e l'antichità romana: disegni di Clérisseau, Suvée e Chays alla Biblioteca Nazionale di Madrid." In *Scritti in onore*

di Alessandro Marabottini, ed. Teresa Pugliatti, 305–10. Rome: De Luca, 1997.

Seymour 1961 Seymour, Charles. *Art Treasures for America: An Anthology of Paintings and Sculpture in the Samuel H. Kress Collection.* London: Phaidon, 1961.

Sharf 1950 Sharf, Alfred. *The Fantastic Visions of Monsù Desiderio.* John and Mabel Ringling Museum of Art. Exh. cat. Sarasota, FL: Florida Graphic Arts, 1950.

Sheard 1979 Sheard, Wendy Steadman. *Antiquity in the Renaissance.* Exh. cat. Northampton, MA: Smith College Museum of Art, 1979.

Shearman 1960 Shearman, John. "Gaspard, Not Nicolas." *Burlington Magazine* 102, no. 688 (July 1960): 326–29.

Shoolman Slatkin 1957 Shoolman Slatkin, Regina. *François Boucher: An Exhibition of Prints and Drawings.* Exh. cat. New York: Charles E. Slatkin Galleries, 1957.

Shoolman Slatkin 1974 Shoolman Slatkin, Regina. *François Boucher in North American Collections: 100 Drawings.* Washington, DC, National Gallery of Art; Chicago, Art Institute. Exh. cat. Washington, DC: National Gallery of Art, 1974.

Sievernich 1989 Sievernich, Gereon, and Hendrik Budde. *Europa und der Orient, 1800–1900.* Berlin, Martin-Gropius-Bau. Exh. cat. Gütersloh: Bertelsmann Lexikon Verlag, 1989.

Simpson 1987 Simpson, Lisa A. *From Arcadia to Barbizon: A Journey in French Landscape Painting.* Memphis, Dixon Gallery and Gardens; Oberlin, OH, Allen Memorial Art Museum; Louisville, J. B. Speed Museum. Exh. cat. Memphis, TN: Dixon Gallery and Gardens, 1987.

Smith 1837 Smith, John. *A catalogue raisonné of the works of the most eminent Dutch, Flemish, and French painters; in which is included a short biographical notice of the artists, with a copious description of their principal pictures; a statement of the prices at which such pictures have been sold at public sales on the continent and in England; a reference to the galleries and private collections in which a large portion are at present; and the names of the artists by whom they have been engraved; to which is added a brief notice of the scholars and imitators of the great masters of the above schools.* London: Smith and Son, 1837.

Smith 1960 Smith, Robert Chester. *The Ruins of Rome.* Exh. cat. Philadelphia: University Museum, 1960.

Smith 2000 Smith, Adam M. *The Antiques of Athens as Definitions of Ancient Truth.* Honors thesis, Oberlin, OH: Oberlin College, May 2000.

Spear 1969 Spear, Richard. "A 'Landscape with Flight into Egypt' by Domenichino." *AMAM Bulletin* 26, no. 3 (Spring 1969): 91–102.

Spear 1982 Spear, Richard E. *Domenichino.*

New Haven, CT: Yale University Press, 1982.

Spielmann 1966 Spielmann, Heinz. *Andrea Palladio und die Antike. Untersuchung und Katalog der Zeichnungen aus seinem Nachlass.* Munich: Deutscher Kunstverlag, 1966.

Stair Sainty 1987 Stair Sainty, Guy, and Alan Wintermute. *François Boucher: His Circle and Influence.* Exh. cat. New York: Stair Sainty Mathiesen, 1987.

Stechow 1954 Stechow, Wolfgang. "A Landscape by Paul Bril." *AMAM Bulletin* 12, no. 1 (Fall 1954): 23–31.

Stechow 1964a Stechow, Wolfgang. "Italianate Dutch Artists in the Allen Art Museum." *AMAM Bulletin* 22, no. 1 (Fall 1964): 3–22.

Stechow 1964b Stechow, Wolfgang. *Italy Through Dutch Eyes: Dutch Seventeenth-Century Landscape Artists in Italy.* Exh. cat. Ann Arbor: The University of Michigan Museum of Art, 1964.

Stechow 1966 Stechow, Wolfgang. *Dutch Landscape Painting of the Seventeenth Century.* London: Phaidon, 1966.

Stechow 1967 Stechow, Wolfgang. *Catalogue of European and American Paintings and Sculpture in the Allen Memorial Art Museum.* Introduction by John R. Spencer. Oberlin, OH: Oberlin College, 1967.

Stechow 1968 Stechow, Wolfgang. "Dutch Drawings of the Seventeenth and Eighteenth Centuries in the Allen Memorial Art Museum." *AMAM Bulletin* 26, no. 1 (Fall 1968): 11–26.

Stechow 1976a Stechow, Wolfgang. *Catalogue of Drawings and Watercolours in the Allen Memorial Art Museum.* Oberlin, OH: Oberlin College, 1976.

Stechow 1976b Stechow, Wolfgang. "Varieties of Landscape." *Apollo* 103, no. 168 (February 1976): 115.

Steland-Stief 1980 Steland-Stief, Anne Charlotte. "Zum zeichnerischen Werk des Jan Asselijn: Neue Funde und Forschungsperspektiven." *Oud Holland* 94, no. 4 (1980): 213–58.

Steland-Stief 1989 Steland-Stief, Anne Charlotte. *Die Zeichnungen des Jan Asselijn.* Fridingen: Graf Klenau, 1989.

Sterling 1955–67 Sterling, Charles, and Margaretta M. Salinger. *A Catalogue of French Paintings.* 3 vols. Cambridge, MA: Published for the Metropolitan Museum of Art by Harvard University Press, 1955–67.

St. Louis 1938 "Museum Buys $12,500 Painting." *St. Louis Globe-Democrat,* 29 April 1938.

St. Louis 1991 *Handbook of the Collections.* St. Louis: St. Louis Art Museum, 1991.

Stockho 1981 Stockho, Thelma R. *French Paintings of the Seventeenth and Eighteenth Centuries.* St. Louis, MO: St. Louis Art Museum, 1981.

Summerson 1980 Summerson, John. *The Classical Language of Architecture*. Rev. ed. London: Thames and Hudson, 1980.

Sutton 1962 Sutton, Denys. "Gaspard Dughet: Some Aspects of His Art." *Gazette des Beaux-arts* 60, no. 1122–23 (July–August 1962): 269–312.

Sutton 1977 Sutton, Denys. *Treasures from Rochester*. New York, Wildenstein Galleries. Exh. cat. Rochester, NY: Memorial Art Gallery, 1977.

Sutton 1986 Sutton, Peter C. *A Guide to Dutch Art in America*. Grand Rapids, MI: Eerdmans Publishing Co. and Netherlands-American Amnity Trust, 1986.

Sweetser 1878 Sweetser, Moses Foster. *Claude Lorrain*. Boston: Houghton, Osgood, 1878.

Taggart 1969 Taggart, Ross E., ed. *The Taste of Napoleon*. Introductory essay by Lincoln Kirstein. Exh. cat. Kansas City, MO: The Nelson-Atkins Museum of Art, 1969.

Talbot 1970 Talbot, William S. *Jasper F. Cropsey, 1823–1900*. Washington, DC: Smithsonian Institution Press, 1970.

Teyssèdre 1957 Teyssèdre, Bernard. *Roger de Piles et les débats sur le coloris au siècle de Louis XIV*. Paris: Bibliothèque des arts, 1957.

Thieme 1907–50 Thieme, Ulrich, and Felix Becker, eds. *Allgemeines Künstler-Lexicon der Bildenenden Künstler*. 10 vols. Leipzig: W. Engelmann, 1907–50.

Thompson 1993 Thompson, James. *Nicolas Poussin*. New York: Metropolitan Museum of Art, 1993.

Thuillier 1964 Thuillier, Jacques. "The Quarrel of Color versus Drawing." In *French Painting: From Le Nain to Fragonard*, ed. Jacques Thuillier and Albert Châtelet. Geneva: Skira, 1964.

Thuillier 1990 Thuillier, Jacques, Barabara Brejon de Lavergnée, and Denis Lavalle. *Vouet*. Paris, Galeries nationales du Grand Palais. Exh. cat. Paris: Éditions de la Réunion des musées nationaux, 1990.

Thuillier 2000 Thuillier, Jacques. *Sébastien Bourdon, 1616–1671: catalogue critique et chronologique de l'oeuvre complet*. Montpellier, Musée Fabre; Strasbourg, Musées de Strasbourg. Exh. cat. Paris: Réunion des musées nationaux, 2000.

Thuillier and Châtelet 1964 Thuillier, Jacques, and Albert Châtelet, eds. *French Painting: From Le Nain to Fragonard*. Geneva: Skira, 1964.

Thurber 2001 Thurber, T. Barton, and Adrian W. B. Randolph. *Antiquity in Rome from the Renaissance to the Age of Enlightenment: Selections from Dartmouth's Collections*. Exh. cat. Hanover, NH: Hood Museum of Art, Dartmouth College, 2001.

Toledo 1946 *The Spirit of Modern France: Essay on Painting in Society, 1745–1946*. Museum of Art. Exh. cat. Toledo: Museum of Art, 1946.

Toledo 1976a *A Guide to the Collections*. Toledo: Toledo Museum of Art, 1976.

Toledo 1976b *European Paintings*. Toledo: Toledo Museum of Art, 1976.

Toronto 1950 *Fifty Paintings by Old Masters*. Exh. cat. Toronto: Art Gallery of Toronto, 1950.

Toronto 1954 *Paintings by European Masters from Public and Private Collections in Toronto, Montréal and Ottawa*. Toronto, Art Gallery of Toronto; Montréal, Museum of Fine Arts; Ottawa, National Gallery of Canada. Exh. cat. Toronto: Art Gallery of Toronto, 1954.

Toronto 1974 *Handbook*. Preface by William J. Withrow and introduction by Richard J. Wattenmaker. Toronto: Art Gallery of Ontario, 1974.

Toronto 1990 *Selected Works*. Toronto: Art Gallery of Ontario, 1990.

Traulos 1971 Traulos, Ioannes N. *Pictorial Dictionary of Ancient Athens*. New York: Praeger, 1971.

Tuckerman 1867 Tuckerman, Henry T. *Book of the Artists: American Artistic Life, Comprising Biographical and Critical Sketches of American Artists*. New York: G. P. Putnam and Sons, 1867.

Turner 1966 Turner, Richard. *The Vision of Landscape in Renaissance Italy*. Princeton, NJ: Princeton University Press, 1966.

Turner 1996 Turner, Jane, ed. *The Dictionary of Art*. 34 vols. New York: Grove, 1996.

Utica 1967 *European Paintings from the Rochester Memorial Art Gallery*. Exh. Utica, NY: Munson-Williams-Proctor Institute, Museum of Art, January–September 1967.

Valenciennes 2004 Musée des Beaux-Arts de Valenciennes. *Watteau et la fête galante*. Valenciennes: Museum of Fine Arts, 2004.

Valentiner 1956 Valentiner, Wilhelm Reinhold. *Catalogue of Paintings, Including Three Sets of Tapestries*. Raleigh: North Carolina Museum of Art, 1956.

Vasi 1747–61 Vasi, Giuseppe. *Delle magnificenze di Roma antica e moderna . . .* Rome: Chracas, 1747–61.

Vasseur 1982 Vasseur, Dominique H. *The Lithographs of Pierre-Nolasque Bergeret*. Exh. cat. Dayton, OH: Dayton Art Institute, 1981.

Verdi 1995 Verdi, Richard. *Nicolas Poussin, 1594–1665*. Essay by Pierre Rosenberg. Exh. cat. London: Zwemmer, 1995.

Vignola 1611 Vignola, Giacomo Barozzi da. *Le due regole della prospettiva pratica*. Rome: Stamperia Camerale, 1611.

Vignola 1619 Vignola, Giacomo Barozzi da. *Regola delli cinque ordini d'architettura*. Rome: Giovanni Battista de' Rossi, ca. 1619.

Viljoen 2004 Viljoen, Madeleine. "Prints and False Antiquities in the Age of Raphael." *Print Quarterly* 21, no. 3 (September 2004): 235–47.

Volle 1974 Volle, Nathalie, and Pierre Rosenberg. *Jean Barbault, 1718–1762*. Beauvais, Musée départemental de l'Oise; Angers, Musée des beaux-arts; Valence, Musée des beaux-arts. Exh. cat. Beauvais: Musée Départemental de l'Oise, 1974.

Voss 1953 Voss, Hermann. "François Boucher's Early Development." *Burlington Magazine* 95, no. 600 (March 1953): 80–93.

Waagen 1854 Waagen, Gustav Friedrich. *Treasures of Art in Great Britain*. London: J. Murray, 1854.

Waddingham 1963 Waddingham, Malcolm R. "The Dughet Problem." *Paragone* 14, no. 161 (May 1963): 37–54.

Wakefield 1984 Wakefield, David. *French Eighteenth-century Painting*. London: Gordon Fraser, 1984.

Walker 1984 Walker, John. *National Gallery of Art, Washington*. Rev. ed. New York: Abrams, 1984.

Ward 1946 Ward, Clarence. *AMAM Bulletin* 3, no. 1 (February 1946): 17.

Ward 1984 Ward, Roger. Vernet curatorial file. New York: Nelson-Atkins Museum of Art, 1984.

Ward 1993 Ward, Roger B., and Patricia J. Fidler. *The Nelson-Atkins Museum of Art: A Handbook of the Collection*. New York: Hudson Hills Press, 1993.

Washington, DC 1959 *Paintings and Sculpture from the Kress Collection*. Washington, DC: National Gallery of Art, 1959.

Washington, DC 1960 *The Splendid Century: French Art, 1600–1715*. Washington, DC, National Gallery of Art; Toledo, OH, Toledo Museum of Art; New York, Metropolitan Museum of Art. Exh. cat. Washington, DC: National Gallery of Art, 1960.

Washington, DC 1961 Samuel H. Kress Foundation. *Exhibition of Art Treasures for America from the Samuel H. Kress Collection*. Exh. cat. Washington, DC: National Gallery of Art, 1961.

Washington, DC 1965 *Summary Catalogue of European Paintings and Sculpture*. Washington, DC: National Gallery of Art, 1965.

Washington, DC 1982 *Claude Lorrain, 1600–1682*. Paris, Grand Palais. Exh. cat. Washington, DC: National Gallery of Art, 1982.

Washington, DC 1985 *European Paintings: An Illustrated Catalogue*. Washington, DC: National Gallery of Art, 1985.

Washington, DC 1992 *National Gallery of Art, Washington*. Washington, DC: National Gallery of Art, 1992.

Watkin 1982 Watkin, David. *Athenian Stuart: Pioneer of the Greek Revival*. London: George Allen and Unwin, 1982.

Watson 1979 Watson, Ross. *National Gallery of Art, Washington*. London: Orbis, 1979.

Watson 1980 Watson, Wendy M. *Images of Italy: Photography in the Nineteenth Century*. Exh. cat. South Hadley, MA: Mt. Holyoke College Art Museum, 1980.

Wheler 1682 Wheler, George, Esq., in the company of Dr. Spons of Lyons. *A Journey into Greece.* London, 1682.

Wiebenson 1978 Wiebenson, Dora. *The Picturesque Garden in France.* Princeton, NJ: Princeton University Press, 1978.

Wiebenson 1993 Wiebenson, Dora, ed. *The Mark J. Millard Architectural Collection: French Books, Sixteenth Through Nineteenth Centuries.* Washington, DC: National Gallery of Art, 1993.

Wieseman 1994 Wieseman, Marjorie E. "A Seventeenth-Century Artist's Sketchbook in the Collection of the Allen Memorial Art Museum." *AMAM Bulletin* 38, no. 1 (1994): 3–24.

Wieseman 1996 Wieseman, Marjorie E. "Charles F. Olney and the Collecting of Curiosities." *AMAM Bulletin* 49, no. 2 (1996): 3–42.

Wieseman 2004 Wieseman, Marjorie E. "Pursuing and Possessing Passion: Two Hundred Years of Collecting Rubens's Oil Sketches." In *Drawn by the Brush: Oil Sketches by Peter Paul Rubens,* by Peter Sutton, Marjorie E. Weiseman, and Nico van Hout. New Haven, CT: Yale University Press, 2004.

Wildenstein 1924 Wildenstein, Georges. *Lancret: Biographie et catalogue-critiques.* Paris: G. Servant, 1924.

Wildenstein 1964 Wildenstein, Daniel. "L'oeuvre gravé des Coypel, II." *Gazette des Beaux-arts* 6, no. 64 (1964): 142.

Wilson 1985 Wilson, Michael. *French Paintings before 1800.* London: National Gallery, 1985.

Wilton 1996 Bignamini, Ilaria, and Andrew Wilton. *The Grand Tour: The Lure of Italy in the Eighteenth Century.* Exh. cat. London: Tate Gallery, 1996.

Wilton-Ely 1994 Wilton-Ely, John. *Giovanni Battista Piranesi: The Complete Etchings.* San Francisco: Alan Wolfsy Fine Arts, 1994.

Wine 1994 Wine, Humphrey. *Claude: The Poetic Landscape.* Exh. cat. London: National Gallery, 1994.

Wine 2001 Wine, Humphrey. *The Seventeenth-Century French Paintings.* London: National Gallery, 2001.

Wine 2004 Wine, Humphrey. "Quarrel of the Ancients and Moderns." *The Grove Dictionary of Art Online.* Oxford University Press, accessed November 2004, http://www.groveart.com.

Wintermute 1990 Wintermute, Alan, ed. *Claude to Corot: The Development of Landscape Painting in France.* Essays by Michael Kitson et al. Exh. cat. New York: Colnaghi, 1990.

Wintermute 1999 Wintermute, Alan. *Watteau and His World: French Drawing from 1700 to 1750.* Essays by Colin B. Bailey et al. New York, Frick Collection; Ottawa, National Gallery of Canada. Exh. cat. London: Merrell Holberton, 1999.

Woodward 2001 Woodward, Christopher. *In Ruins.* New York: Pantheon Books, 2001.

Worcester 1974 Worcester Art Museum. *European Paintings in the Collection of the Worcester Art Museum.* Worcester, MA: Worcester Art Museum, 1974.

Wright 1984 Wright, Christopher. *Poussin Paintings: A Catalogue Raisonné.* London: Jupiter Books Ltd., 1984.

Wright 1985a Wright, Christopher. *The French Painters of the Seventeenth Century.* London: Orbis, 1985.

Wright 1985b Wright, Christopher. *Masterpieces of Reality: French 17th-century Painting.* Exh. cat. Leicester: Leicestershire Museums Art Gallery and Records Service, 1985.

Yarwood 1987 Yarwood, Doreen. *A Chronology of Western Architecture.* London: Batsford, 1987.

Zafran 1983 Zafran, Eric. *The Rococo Age: French Masterpieces of the Eighteenth Century.* Exh. cat. Atlanta: High Museum of Art, 1983.

Zafran 1998 Zafran, Eric M. *French Paintings in the Museum of Fine Arts, Boston,* vol. 1, *Artists Born before 1790.* With the assistance of Katherine Rothkopf and Sydney Resendez. Boston: Museum of Fine Arts, 1998.

Zrebiec 2000 Zrebiec, Alice, and Scott Erbes. *Conquest and Glory: Tapestries Devoted to Louis XIV in the Collection of the Speed Art Museum.* Louisville, KY: Speed Art Museum, 2000.

Zucker 1968 Zucker, Paul. *Fascination of Decay; Ruins: Relic, Symbol, Ornament.* Ridgewood, NJ: Gregg Press, 1968.

Zwollo 1973 Zwollo, Annie. *Hollandse en Vlaamse Veduteschilders te Rome, 1675–1725.* Assen: Van Gorcum, 1973.

Illustrated Architectural Books from before 1900

*Adam, Robert. *Ruins of the Palace of the Emperor Diocletian at Spalatro in Dalmatia.* London: Printed for the author, 1764.

Baiardi, Ottavio Antonio, and Pasquale Carcani, eds. *Delle antichità di Ercolano.* 8 vols. Naples: Nella Regia stamperia, 1757–92.

Barbault, Jean. *Les plus beaux monuments de Rome ancienne.* Rome: Bouchard & Gravier, 1761.

Barbault, Jean. *Recueil de divers monuments anciens répandus en plusieurs endroits de l'Italie.* Rome: Bouchard & Gravier, 1770.

Bartoli, Pietro Santi. *Gli antichi sepolcri overo mausolei romani, et etruschi, troccati in Roma & in altri luoghi celebri.* Rome: Stamperia di Antonio de Rossi, 1697.

Bellori, Giovanni Pietro. *Le pitture antiche del sepolcro de Nasonii nella via Flaminia: disegnate, ed itagliate alla similitudine degli antichi originali.* Rome: Printed for Giovanni Battista Bussotti, 1680.

*Cassas, Louis François. *Travels in Istria and Dalmatia.* Trans. Joseph Lavallée. London: Printed for R. Phillips, 1805.

Cassas, Louis-François. *Voyage pittoresque de la Syrie, de la Phénicie, de la Palestine, et de la Basse Egypte.* 2 vols. Paris, 1799.

Cassas, Louis-François. *Voyage pittoresque et historique de l'Istrie et de Dalmatie.* Paris: P. Didot, 1802.

Caylus, Comte de Anne-Claude-Phillippe. *Recueil d'antiquités égyptiennes, étrusques, grecques et romaines.* 7 vols. Paris: Desaint & Saillant, 1752–67.

Cerceau, Jacques Androuet du. *Le premier volume des plus excellents bastiments de France.* Paris: du Cerceau, 1576.

Choiseul-Gouffier, Comte de Marie-Gabriel-Auguste-Florent. *Voyage pittoresque de la Grèce.* 2 vols. Paris: J. J. Blaise Libraire, 1782–1822.

*Clérisseau, Charles-Louis. *Antiquités de la France.* Paris: P. D. Pierres, 1778.

David, Jacques-Louis. *Drawings of Antiquities, Studies after Old Masters, Italian Landscapes and Views of Rome.* Album 11 of 12. 1775–85. J. Paul Getty Museum, Los Angeles.

*Desgodets, Antoine Baruty. *Les édifices antiques de Rome, dessinés et mesurés très exactement.* Paris: Chez Jean Baptiste Coignard, 1682.

Dézallier d'Argenville, Antoine-Joseph. *Abrégé de la vie des plus fameux peintres …* Paris: De Bure l'aîné, 1745.

*Dézallier d'Argenville, Antoine Nicolas. *Voyage pittoresque de Paris.* Paris: de Bure, 1778.

Dézallier d'Argenville, Antoine-Nicolas. *Voyage pittoresque de Paris.* Rep. Geneva: Minkoff Reprint, 1972.

Dodwell, Edward. *Alcuni Bassirilievi della Grecia: descritti e pubblicati in otto

*Clarence Ward Art Library, Oberlin College
†Allen Memorial Art Museum, Oberlin College

tavole. Rome: Presso l'incisore F. Mori e S. Piale negoziante, 1812.

Dupérac, Étienne, et al. *Speculum Romanae magnificentiae*. 5 vols. Rome: Antoine Lafréry, ca. 1544–1602.

*Fréart, Roland, Sieur de Chambray. *Parallèle de l'architecture antique et de la moderne. Avec un recueil des dix principaux auteurs qui ont écrit des cinq orders*. Paris: Chez Pierre Emery, 1702. (Orig. pub. 1650.)

*Le Roy, David. *Les ruines des plus beaux monuments de la Grèce*. Paris: H. L. Guerin & L. F. Delatour, 1758.

Le Roy, Julien-David. *Vedute pittoriche della Grecia*. Paris, 1796.

Maggi, Giovanni. *Ædificiorum et ruinarum Romæ ex antiquis atque hodiernis monimentis*. 2 vols. Rome: Jacobus de Rubeis formis, 1649.

*Major, Thomas. *The Ruins of Pæstum, otherwise Posidonia, in Magnia Græcia*. London: T. Major, 1768.

*Montfaucon, Bernard de. *L'antiquité expliquée et représentée en figures*. 5 vols. Paris: Chez Florentin Delaulne, 1719.

Palladio, Andrea. *Le antichità di Roma*. Venice: Printed for Matthio Pagan, 1555.

*Perrier, François. *Cent statues dessinées et gravées a Rome en 1638*. Paris: Morel, n.d.

Perrier, François. *Segmenta nobilium signorum et statuarum*. Rome, 1638.

Peyre, Marie-Joseph. *Recueil de morceaux d'architecture et de divers fragmens de monumens antiques faite en Italie*, ca. 1753–85.

†Piranesi, Giovanni Battista. *Alcune vedute di Archi Trionfali, ed altri monumenti*. Rome, 1778.

†Piranesi, Giovanni Battista. *Antichità d'Albano e di Castel Gandolfo*. Rome, 1764.

†Piranesi, Giovanni Battista. *Antichità di Cora*. Rome, 1764.

†Piranesi, Giovanni Battista. *Carceri*. Rome, 1749–50. (Piranesi's edition, Rome, ca. 1761.)

†Piranesi, Giovanni Battista. *Carceri d'invenzione*. Rome, 1761.

†Piranesi, Giovanni Battista. *Della Magnificenza ed Architettura de'Romani*. Rome, 1761.

†Piranesi, Giovanni Battista. *Descrizione e Disegno dell'Emissario del Lago Albano*. Rome, 1762.

†Piranesi, Giovanni Battista. *Différentes vues de Pesto*. Rome, 1778.

†Piranesi, Giovanni Battista. *Diverse maniere d'adornare i cammini*. Rome, 1769.

†Piranesi, Giovanni Battista. *Il Campo Marzio dell'Antica Roma*. Rome, 1762.

†Piranesi, Giovanni Battista. *Le Antichità Romane: I–IV*. Rome, 1784.

†Piranesi, Giovanni Battista. *Le rovine del Castello dell'Acqua Giulia*. Rome, 1761.

†Piranesi, Giovanni Battista. *Prima Parte di Architetture e Prospettive*. Rome, 1748.

†Piranesi, Giovanni Battista. *Vasi, candelabri, cippi, sarcofagi*. Rome, 1778.

†Piranesi, Giovanni Battista. *Vedute di Roma*. Rome, 1748–78.

Pronti, Domenico. *Nuova raccolta di 100 vedutine antiche della città di Roma e su vicinanze*. 2 vols. Rome: Presso il sud.o Incisore, 1795.

Recueil d'antiquités romaines, ou, Voyage d'Italie. Paris: Ches Basan, 1771.

Ruins of Athens, with Remains and Other Valuable Antiquities in Greece. London: Printed for Robert Sayer, 1759.

Sadeler, Aegidius. *Vestige delle antichità di Roma, Tivoli, Pozzulo, et altri luochi*. Rome: G. J. de Rossi, 1660.

Saint Non, Jean-Claude-Richard de. *Voyage pittoresque, ou, Description des royaumes de Naples et de Sicile*. 5 vols. Paris: Impr. De Clousier, 1781–86.

Schenk, Peter. *Roma Aeterna*. Amsterdam, ca. 1690–99.

Serlio, Sebastiano. *Il terzo libro . . . sulle antichità di Roma . . .* Venice: Francesco Marcolini, 1540.

Society of Dilettanti. *Ionian Antiquities*. London: T. Spilsbury and W. Haskell, 1769.

Stuart, James, and Nicholas Revett. *The Antiquities of Athens*. 4 vols. London: J. Haberkorn, 1762–1816.

Vasi, Giuseppe. *Delle magnificenze di Roma antica e moderna . . .* Rome: Chracas, 1747–61.

Venuti, Ridolfino. *Accurata, e succinta descrizione topografica delle antichità di Roma*. 2 vols. Rome: G. B. Bernabò & G. Lazzarini, 1763.

*Vignola, Giacomo Barozzi da. *Le due regole della prospettiva pratica*. Rome: Stamperia Camerale, 1611.

Vignola, Giacomo Barozzi da. *Regola delli cinque ordini d'architettura*. Rome, 1563.

Wheler, George, Esq., in the company of Dr. Spons of Lyons. *A Journey into Greece*. London, 1682.

*Wood, Robert. *The Ruins of Balbec, otherwise Heliopolis in Cœlosyria*. London, 1757.

*Wood, Robert. *The Ruins of Palmyra, otherwise Tedmor, in the desert*. London, 1753.

*Wood, Robert. *The Ruins of Palmyra and Balbec*. London: W. Pickering, 1827.

Zanetti, Antonio Maria. *Delle antiche statue Greche e Romane*. 2 vols. Venice: Eccelentissimo Senato, 1740–43.

*Clarence Ward Art Library, Oberlin College
†Allen Memorial Art Museum, Oberlin College

INDEX

Note: Page numbers in italics denote illustrations.

Produced by Wilsted & Taylor Publishing Services, Oakland, California

PROJECT MANAGEMENT: Christine Taylor

COPY EDITING: Rachel Bernstein

DESIGN AND COMPOSITION: Melissa Ehn

PRINTING AND BINDING: Regal Printing Ltd. in Hong Kong
through Stacy Quinn of QuinnEssentials Books and Printing, Inc.